OF THE PACIFIC

HAWAII

POLYNESIA

MARQUESAS

SAMOA

FIJI

SOCIETIES

COOKS

TONGA

AUSTRALS

EASTER

NEW ZEALAND

THE FULLER COLLECTION OF PACIFIC ARTIFACTS

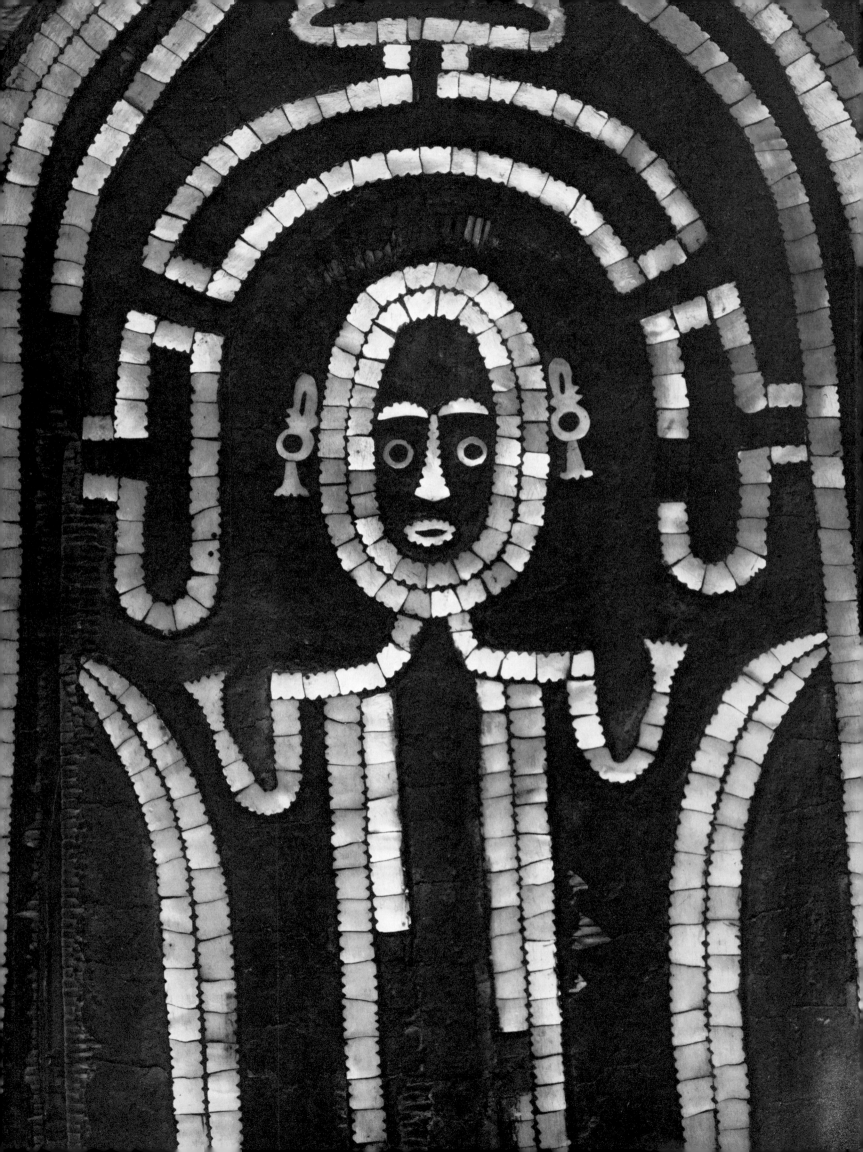

The Fuller Collection of Pacific Artifacts

Roland W. Force and Maryanne Force

PRAEGER PUBLISHERS

New York · Washington

BOOKS THAT MATTER

Published in the United States of America in 1971
by Praeger Publishers, Inc., 111 Fourth Avenue,
New York, N.Y. 10003

First published in Great Britain in 1971
by Lund Humphries Publishers Limited, London

Library of Congress Catalog Card Number: 75-131354

Printed in Great Britain

The publishers gratefully acknowledge the support of the Field Museum of
Natural History in Chicago which has made this publication possible.

Frontispiece
Solomon Islands Shield Detail (276870)

To Estelle Winifred Fuller

The guiding principle in forming my collections has been, and is, the study of comparative technology and the evolution of design, more especially in relation to the material culture of the races of the Pacific area.

From this it will be gathered that mere artistic quality or rarity is not my aim, although such objects take a place, and an important place, in the whole; and that, comparatively, unimportant specimens are of equal value and, in many cases, equally rare. This latter quality is especially true as regards objects in the making – partly fashioned or incompletely decorated – and those of a primary or primitive type.

So far as the 'cultural period' is concerned, the endeavour has been to select specimens of 'Neolithic Man', that is to say, formed prior to contact with the 'Whites' or uninfluenced, or very slightly influenced, by such contact, both as regards ideas and methods of manufacture. A few pieces have been included, however, of 'later' times for comparative purposes.

The collection, being formed on these lines, has the additional value as a criterion for old, original ethnological objects as distinguished from those of the transitional period, which usually confuse present-day collectors and curators.

A.W.F. Fuller

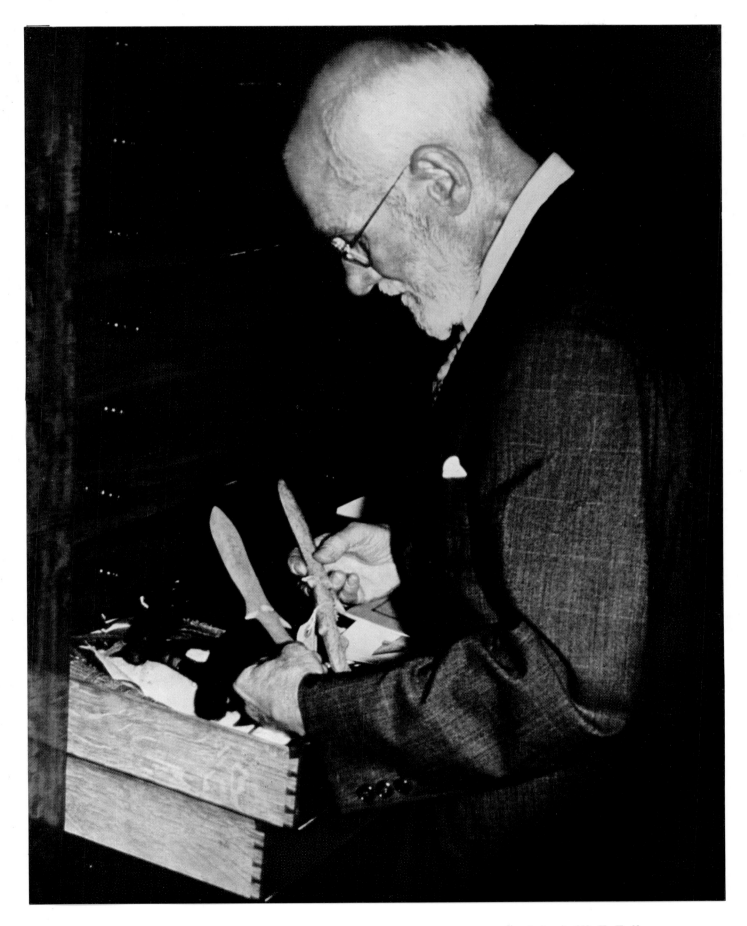

Captain A. W. F. Fuller
March 29, 1882 – December 13, 1961

NOTE

Catalogue numbers are taken from the records of the Field Museum. They are only given in the text for specimens illustrated in the book.

Where these catalogue numbers are given in the text, figures appear in the margin which indicate the pages on which the specimens are reproduced.

Measurements of illustrated specimens, unless otherwise specified, refer to length.

Grateful acknowledgment is made to Genevieve A. Highland and Sadie J. Doyle, Bishop Museum Press, for their editorial assistance, and also to Dr. James W. Van Stone, Science Editor, Fieldiana, Field Museum of Natural History, for his efforts.

CONTENTS

He was the most lovable and admirable of men and I know that I shall never see another like him. I think I shall most remember him for his everlasting pursuit of truth and the prodigious memory in which it was stored away as he found it.

I fear a very large proportion of his knowledge must have been lost irrevocably, even though he shared it so generously with others.

W. B. FAGG
Keeper of Ethnography
British Museum

PREFACE

Man is an acquisitive animal. From antiquity he has collected things, and in all ages there have been men who have made noted collections. The museums and galleries of the world are the richer for the outstanding collections made by such persons. Captain Alfred Walter Francis Fuller was one of these.

I first met Captain Fuller at his home in London in 1957, when I was the Curator of Oceanic Archaeology and Ethnology at the Field Museum of Natural History (then called Chicago Natural History Museum). By then he had outlived most of those with whom he had sought and vied for Pacific artifacts. I consider my five years at Field Museum (1956-61) invaluable ones; and Captain Fuller and his collection played no small part. Unquestionably, he was one of the most memorable persons I have ever met. He made come alive for me (considerably his junior in years) a past which I had only known through books. With him I relived rich, personal experiences with Edge-Partington, Beasley, Oldman, Joyce, and many others equally distinguished. Although his approach to science differed somewhat in theoretical orientation and jargon from that of contemporary American anthropology, I always appreciated his special role and important contributions. What to him had become 'degenerate' was to me but another aspect of 'acculturation.' In a like manner he could not entirely understand my interests in social organization and political change, but he respected them. We shared a mutual attraction to and immersion in the ethnology of the Pacific world. The last specimen he collected, in July of 1961, he gave to me because he believed (rightly) that I would appreciate the indigenous repair to one of its parts.

Captain and Mrs. Fuller, Mrs. Force, and I worked on field cataloguing and documenting the Fuller Collection from February to July of 1958. Although by then Captain Fuller was well into his seventies, and not in the best of health, we catalogued every one of the more than 6,500 items in the collection. By the use of recording tapes, a record was kept of all specimens along with the Captain's detailed personal comments. All related documents, references to the literature, and other notes which had any

relevance were included in the catalogue. Although these activities caused him considerable fatigue, Captain Fuller was tireless in his efforts to preserve any and all information about the specimens.

Those who appreciate the Fuller Collection owe a debt of gratitude not only to the man who formed it, but also to the late Mr. Stanley Field, President of the Board of Trustees of the Field Museum, and Colonel Clifford C. Gregg, then Director, for accepting the recommendation that the collection be obtained by the Museum and for assuming financial and other institutional responsibilities. An expression of gratitude is owed the Board of Trustees of the Museum and those others who, as donors to the Fuller Collection Purchase Fund, assured the collection's acquisition. I am grateful for the support given the preparation of this volume by the Director of Field Museum, Mr. E. Leland Webber.

A special indebtedness to Mr. Robert Trier [deceased, 1968], a Contributing Member of the Museum, should be mentioned. It was he who, through his acquaintance with Captain and Mrs. Fuller and his interest in the Field Museum, brought collector and institution together. So firm did this association of man and Museum become that in 1958 the Board of Trustees, in recognition of Captain Fuller's great service to science and to the Museum, elected him a Patron of the Museum, a distinction shared at that time with but fourteen other individuals whose service could be said to be truly eminent. Captain Fuller was deeply appreciative of this distinction and could not have felt a greater personal identification with any institution. Tangible evidence of his sentiments and those of Mrs. Fuller may be seen in the several non-Pacific items which have been placed in the Museum's collections and especially in Mrs. Fuller's presentation in 1963 of the Captain A. W. F. Fuller African Ethnological Collection. Captain Fuller was also a Benefactor and Corporate Member of the Museum. Mrs. Fuller was named a Patron and Corporate Member in 1962 and a Benefactor in 1963.

The purpose of this volume is to characterize the A. W. F. Fuller Collection of ethnological and archaeological Pacific artifacts through illustration and description. It is not an exhaustive itemized catalogue of the pieces, nor does it purport to be a general ethnography of the Pacific. Field Museum hopes to publish a complete listing of the collection at a later date. Fundamentally, what follows is designed to give to the collection the prominence it deserves and to pay tribute to the collector. Perhaps it will

serve also as an inspiration to other collectors or would-be collectors. It is hoped that technologists and art historians alike will find it of value and that it will aid the collector and the curator in identifying and making comparisons with similar material when actual objects are not available for comparison.

Any characterization short of total listing risks being considered incomplete from some point of view. What follows is selective. It samples, and makes no attempt to be exhaustive. The sample is subjective in the sense that even decisions as to which objects should be photographed and which should not, involved personal decisions. So it was also with the presentation. To illustrate, although there are more than one thousand war clubs in the Fuller Collection, only a few exemplary specimens are featured here. They are exceptional objects, but they are also representative. Others unillustrated are equally fine, and there are many other clubs which fill out the balance of that segment of the collection which, although less distinguished from the standpoint of photography, are of equal scientific value.

There are other materials which are not emphasized, but which form important segments of the collection. As with clubs, spears are present in abundance, but they are only sparsely represented here. Bark cloth and bark-cloth beaters comprise an extensive portion of the collection, but they have been excluded from treatment. Bark cloth can only be presented meaningfully through color photography. The same may be said of certain other materials, such as greenstone artifacts. A number of outstanding Maori jade items are not featured here, principally because they tend not to photograph as well as bone, shell, and wooden objects. The comparative technologist may study the broad range of fishhooks, weapons, or paddles in the collection to good advantage. He may not do so by consulting this volume. He must work with the collection itself.

Those who are familiar with the collection may feel that certain items not shown should have been, or that more emphasis should have been given a particular range of materials. It is hoped that such reactions will be few and that the reasons for selecting the illustrations which are included, as well as the limitations upon space for treatment, will be understood. In every case criteria such as excellence of craftsmanship, patina, history, representativeness or aberrance from pattern, beauty of form, or technological significance not only governed selection, but mode of presentation, for which the authors assume full responsibility.

The photography in this volume is the result of the combined

talents of Field Museum staff photographers John Bayalis and Homer V. Holdren. The excellence of the illustrations that follow is a reflection of both the superb quality of the subject matter and the many hours of effort in the photography studio and laboratory which complement this quality.

Finally, an apology. When I learned of Captain Fuller's death I intended to offer some words of tribute in an obituary notice for publication in an appropriate journal. I found the task difficult and it was never completed. I found it impossible to adequately offer a characterization in the brief space allowed for such observations. Or perhaps this is sheer rationalization. Some words are more difficult to produce than others. I should prefer to emphasize the living legacy of his collection than to lay stress upon man's mortal nature. Through his collection, Captain Fuller still lives.

ROLAND W. FORCE
Director, Bishop Museum
Honolulu, Hawaii
September, 1967

THE MAN AND HIS COLLECTION

From the time of its founding, the Field Museum of Natural History has been known for its outstanding collections. Although its genesis was in an impermanent entity – the World's Columbian Exposition of 1893 at Chicago – there was never any question of the Museum's permanence as an institution. It was particularly fitting that, as a result of the observance of the four-hundredth anniversary of the discovery of America, there should be founded an institution dedicated to the procurement, preservation, and study of the physical accoutrements of man's natural and cultural surroundings, with its ultimate object the discovery of new knowledge.

The Columbian Exposition ended on October 26, 1893. On June 2, 1894, the new Museum's doors were opened in the Palace of Fine Arts which had been erected for the exposition. As with its first building, the nucleus of the institution's collections was derived from the exposition. The Museum's Department of Anthropology was a direct outgrowth of the exposition's Department of Ethnology. Despite this valuable legacy, the new Museum's need was for additional collections. It is noteworthy that just as the British Museum benefited so greatly from the Henry Christy Collection, so did the Field Museum profit in its early years from the collecting endeavor of a private citizen when Mr. Edward E. Ayer, the first President of the Museum, presented his North American Indian collection.

At the time of its founding Field Museum could still acquire many ethnographic materials by field expeditions to parts of the world where flourishing native cultures yet survived. In many areas, however, the submergence of native cultures as a result of the rapid spread of European culture meant that no amount of field work could produce a valid cultural assemblage.

As a result of the Joseph N. Field South Pacific Expedition to Melanesia in the years 1909 to 1913, the Melanesian – particularly New Guinea North Coast – collections at Field Museum remain today among the finest and most extensive in the world. Following the tragic loss of some similar collections in Europe during World War II, the value of this excellent material is even greater. Despite the quantity and quality of the Melanesian collection, and that of the Indonesian and Philippine Islands materials secured primarily by Dr. Fay-Cooper Cole, the remainder of the Pacific world was represented but sparsely. Over the years, through purchase, gift, exchange, and a few collecting ventures in the field, some Polynesian and Micronesian materials were amassed. Among the finest items were those from outliers such as Wuvulu

(Matty) and Aua (Durour), Rennell, Bellona, and others. These were mostly acquired with Melanesian collections by virtue of the geographical placement of the islands in Melanesia. Prior to 1958, the Pacific collections of Field Museum suffered a distinct imbalance. For Micronesia, there was little hope of major expansion. Except for a few old collections in German museums which had survived the war, virtually no other materials of quality were in existence. Polynesia, however, was a different matter.

Because of the special relationship between Great Britain and Polynesia in the late 18th century and throughout the 19th, more Polynesian artifacts found their way to England than to any other part of the world. English explorers, missionaries, traders, and colonists were perhaps the world's greatest souvenir collectors, and in many instances a measure of scholarship allowed for some documentation. The Royal Anthropological Institute early recognized the important role the traveler, businessman, clergyman, or civil servant might play in providing information about native cultures when it issued its *Notes and Queries,* a questionnaire designed for use by the nonethnologist whose duties placed him in a position to observe and record. Casual souvenir acquisition or major collecting efforts resulted in the amassing in England of an enormous wealth of native objects, many from the islands of the Pacific. The Fuller Collection was formed by many years of discriminating purchases, and occasional fortunate gifts and exchanges of outstanding specimens. Sales in private homes, the selling up of the inventories of small provincial museums throughout England and Scotland, the famous auction rooms of London, and the shops of dealers both in Britain and on the Continent were the sources of the pieces which came to comprise the Fuller Collection.

Those intrepid souls who ventured into the 'savage South Seas' in early days in search of fame, fortune, knowledge, or souls provided a scattered legacy whose value was recognized by few. Just as island populations were reduced by foreign diseases, so did their cultures undergo change. It was because of the impact of change that there resulted such a great rarity of objects truly representative of pre-European times in the Pacific. This rarity, together with the need to provide balance in its Oceanic collections, made the Fuller Collection of special value to the Field Museum. With its acquisition in 1958, the Museum gained possession of one of the finest collections of Pacific ethnographic materials in the world and has achieved an enviable balance. An

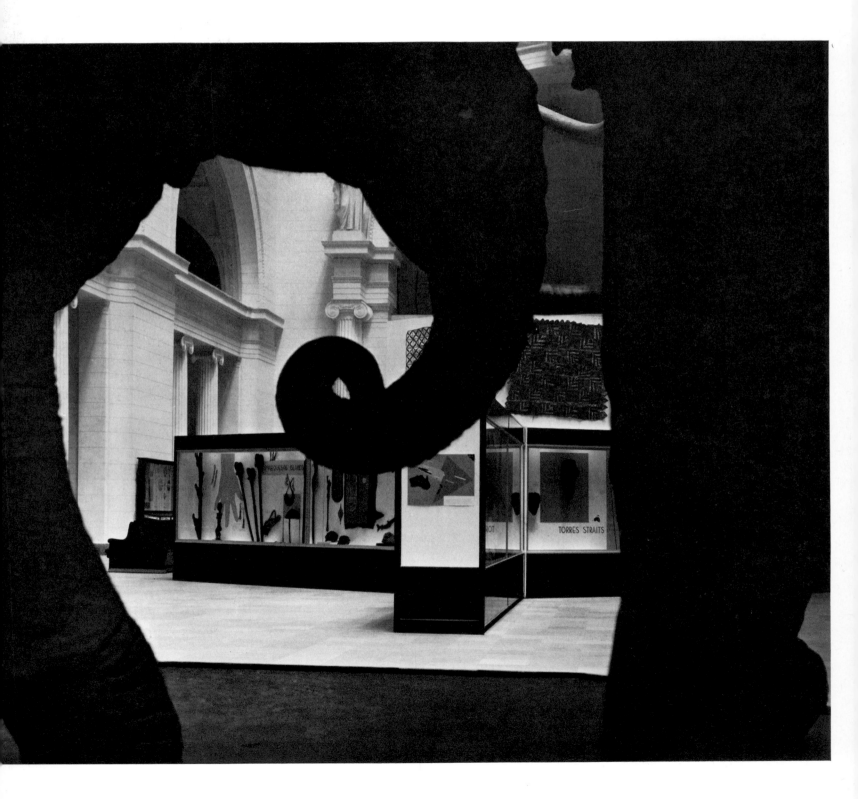

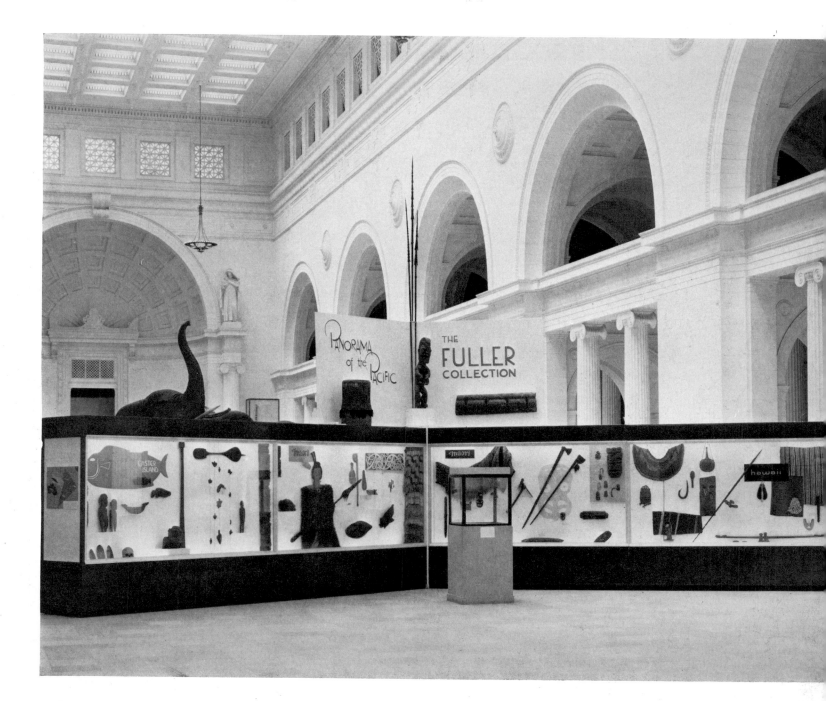

5

official from a museum that wished to acquire the Fuller Collection more than thirty years ago once wrote the chairman of his board of trustees as follows: ' . . . the Fuller Collection would supply articles that we have not got and cannot possibly get otherwise. It would build our collection up into a commanding position and probably make it second only to that of the British Museum.'

The Fuller Collection contains items from all major areas of the Pacific, islands in adjacent oceans, and Australia. Great strength of representation is provided by Polynesian materials, especially those from New Zealand. Those from Easter Island and Hawaii, while not so numerous, are of marked quality. Objects from both eastern and western central Polynesia are fine, as are also a sizable number from Fiji. Some of the Polynesian Outliers have also contributed to the collection. Melanesian materials are particularly numerous from the Solomon Islands and the Massim area of New Guinea. Although the range of items is much smaller, areas such as the Admiralties, New Ireland, New Caledonia, and the New Hebrides make up for scant quantity with the highest quality. Papua is represented, and there is even a rare item from the New Guinea Highlands. A small but vitally important segment of the collection derives from the Torres Strait. This segment includes two of the finest masks in existence. Australian specimens form a significant block of the collection. All areas from Queensland to the Swan River far in the west are credited with pieces. A modest group of articles from Tasmania was secured early in the 19th century and includes some of the rarest items in the collection. Several are human craniums. Others are crude stone tools. Micronesia is but slightly represented. There are several belts from the Carolines, some Marshall Islands fishhooks, a dozen tortoise-shell spoons from Palau, and ornaments, weapons and armor from the Gilberts. The area is not one of strength. Neither is Malaysia, although several interesting items from Borneo – a carved wooden bowl and a bead-covered container – demonstrate interesting curvilinear decorative treatments. Ancestor carvings from the area near to and south of Timor are excellent. One rather distant, but related locale – that of the Andaman Islands – is represented by a trophy human skull and several other objects. The addition of these items to the Field Museum collections is fitting because it holds the Andaman Islands collection made many years ago by Professor A. R. Radcliffe-Brown.

Several things contribute to the form any collection takes. Certainly the orientation, taste, and diligence of the collector are

6

governing factors. Beyond this, the history of national overseas involvement provides an important influence. Just as one would expect that more elements of Indonesian material culture would have found their way to the Netherlands, because of her administration of the Netherlands East Indies, than to England, so might we suppose more Maori items to have gotten to England than to the Netherlands. Any pervasive program such as colonial administration, commercial endeavor, or missionary activity will tend, insofar as it is limited to a given area, to make items from the area available to collectors. In Great Britain the great 19th-century missionary movement prompted numerous individuals to travel to, live in, and bring back objects from the South Seas. Had no such program existed we may imagine there would have been vastly fewer objects from the Pacific for Fuller to collect in England. As it was, some of his finest pieces stemmed from missionary endeavors such as those of the London Missionary Society.

The content of a collection may also be governed by the nature and quality of the artifactual inventory of one area as compared with another. Some are notably richer than others. Groups living on atolls, for example, tend not to have as rich a cultural inventory as do groups living on volcanic islands where raw materials are more abundant. There is the matter, too, of cultural emphasis. The culture which tends to stress nonmaterial features of life will not provide as physically tangible a record of its achievements as one which, for example, gives great attention to megalithic structures. Sheer size of population is another factor of importance. New Guinea is heavily represented in the Fuller Collection. This may be explained by the mere fact of population numbers. Today, for instance, there are five or six times as many people in eastern New Guinea alone as there are in all of insular Oceania. More people are likely to produce more artifacts – hence representation in collections will tend to be larger by virtue of greater availability.

One must also note the special situation as a factor in determining the content of any collection. The fortuitous opportunity to acquire a collection or an item in a collection made by others, and which represents a specific area or theme, is an illustration. In Fuller's case we may point to numerous examples. In some instances he acquired a single specimen, or but a few. In others he secured the entire collection. Some of the principal sources of Fuller Collection artifacts are listed: the Chichester Museum, the Rosehill Collection of Lord Northesk, the *Basilisk* materials

collected by Admiral John Moresby, the Hemming Collection, the Bompas Collection, the Daisy Bates Collection, the Edge-Partington Collection, the Ling Roth Collection, the Major-General Robley Collection, the Page Rowe Collection, the Newport Literary Society and the Isle of Wight Museum, the Dundas Castle Collection, the Turner-Turner Collection, the Corner Collection, the Colonel Gaskill Collection, the Alexander Grubb Collection, the Lord Somers Collection, the Banff Museum in Scotland, the Gruning Collection, the Colonel Loftus Thackwell Collection, the J. Holmes Collection, the L. P. Robin materials from the Melanesian Mission Society, objects collected by Rear-Admiral Lowther, the Carleton House Museum, the Silver Birches Collection, Lord Avebury's Collection, artifacts collected by Admiral John Erskine, the collection of Lord Amherst, Sir Harry Veitch's Collection, the Queens Park Museum, the Turvey-Abbey Collection, the Captain J. P. Younger materials, the Wilfred Powell Collection, Minister Atlee Hunt's Collection, the Cohn Collection, the Kent Collection, the Collyer Collection, the Sir H. E. M. James Collection, and the Duke of Leeds Collection.

Missionaries such as the Reverend Dr. R. Wardlaw Thompson, the Reverend William Wyatt Gill, and the Reverend James Calvert are connected with the early acquisition of Fuller Collection artifacts in the field. Special friendships with Pacific scholars such as Dr. A. C. Haddon and with dealers and collectors like W. D. Webster and W. O. Oldman accounted for numerous additions. Also there is the special situation of personal communication with an individual whose location allows for intensive field collecting and documentation in a single or limited area. Percy Edmunds played this role in the building of the Easter Island segment of the Fuller Collection. Whether or not the collector is steadfast in his interests also governs the form a collection takes. In Fuller's case, there was never any deviation from his interest in the Pacific.

The Pacific collections at the Field Museum are the finer because throughout the formation of the Fuller Collection careful attention was paid to technology, the delineation of regularities and differences in design and motif, specific stylistic emphases, authenticity, historical background, and literary reference. Virtually every material available to islanders for the manufacture of tools, weapons, clothing, utensils, implements, and ornaments was included. Shell, tortoise shell, stone, coral, bone, teeth, hair, fur, skin, feathers, and wood and other vegetable fibers are present. These materials, worked by so-called 'stone-age'

artisans, are all the more remarkable because they were created without the benefit of metal tools. The Pacific craftsman had a rather simple tool assemblage, among which the adz played a principal part. Pump drills, awls, hammerstones, stone chisels, coral files, rasps of abrasive skin, needles of bone and wood, beaters, anvils, scrapers, and so on – which seem crude compared with metal tools – were all that were available. With them, however, he created items of great utility and exceptional beauty. Although it may seem paradoxical, it was with the introduction of metal, which replaced stone or shell adz blades, that the quality of carving diminished. Fuller Collection materials and others reflect this fact. Iron or steel blades may have enabled more artisans to produce objects; they may have made carving a task which could be achieved in a shorter period; or the introduction of such materials may have been coincident with other kinds of cultural change which lessened the sacred quality of craftsmanship and severed inspirational ties with the supernatural. For whichever or all of these reasons or others, the old stone- or shell-cut items are always superior in quality to those carved with iron or steel.

Today the quality of artifacts from Oceania is more broadly recognized than previously. No longer are these magnificent specimens prized only by scholar and artist. We are indebted to Captain Fuller, and a very few others like him, whose perception and appreciation prompted them to seek the so-called 'curiosities' of their age and to preserve them for the future.

Collectors are variously motivated, but upon one principle they can be said to agree: they seek the superlative – the oldest, the largest, the most beautiful, the only. Rarity of some sort or uniqueness always is sought. But canons of taste are individualistic and, as such, quite divergent. Judgments by collectors are at times colored by extremely personal predilections – some of which must be considered less than scientifically valid. So far as ethnographic materials are concerned, it is clear that most collecting zeal has tended to center on indigenous art, either representational or decorative. However, from the first, Fuller conceived of his collection as consisting of scientific specimens. His guiding principles were the study of comparative technology and the evolution of design. Artistic quality as such was not a criterion, yet he was well aware of the beauty of some artifacts, and appreciated it. That the materials he collected from various parts of the world were of artistic merit is evidenced by the fact that they constituted nearly one third of the exhibition of traditional

'Stevens's. That was the happy hunting ground for all us collectors in those days'

12

The First Portion of the
COLLECTION OF ETHNOGRAPHICAL AND OTHER CURIOS,

formed by Colonel Loftus Thackwell. To be sold without reserve.

NEW IRELAND.

221 A very large (8ft. 8in.) carved wood totem post, of 3 full-length figures, animal and bird decoration
222 A ditto (4ft. 2in.), a single figure with bow and head-dress with hair
223 A ditto, ditto, with bird and animal decoration
224 A ditto, ditto, smaller
225 A ditto, ditto
226 A ditto, ditto
227 A 4-ft. 6-in. ditto overdoor
228 A ditto ditto
229

NEW GUINEA.

230 An elaborately carved wood (from the solid) drum, with figure ends and sinnet decoration
231 A ditto dancing paddle and bull roarer
232 A small ceremonial paddle, bamboo pipe and ditto quiver
233 A very fine shell adze, 10-in. blade
234 A small ditto, with long handle
235 Two basalt ditto, with handles

HERMIT ISLAND.

236 Shark's tooth spear
237 A ditto tomahawk

NEW BRITAIN.

238 A finely-carved wood war drum, with lizard skin
239 A headdress, cassawary feathers, Australian woomerah, and small wooden boomerang shield

13

BORNEO.

240 A carved hardwood tappa beater, and a dit bowl
240A A small carved wood paddle, used by wom medicine man's bamboo wand, engraved a

SARAWAK.

241 Dyak Tongkin receptacle for chewing ingr knife, and ditto powder flask Du
242 A very fine specimen palm hat, decorated with small cowrie shells

ADMIRALTY ISLANDS.

243 Two long obsidian headed spears
244 A dyak, carved and painted pres ated with human hair, a fine s
245 Two New Britain stone-headed c

SOLOMON ISLAN

246 Three carved wood paddles
247 Dyak carved wood processi
248 A fine specimen of a Hermi
249 A medicine man's Mancing feathers and bell rattle
250 Three carved wood paddle
251 Three ditto
252 Four ditto
253 Two fishing spears, an
254 Two carved wood carved cocoanut b
255 New Guinea ditto s

256 An exceptionall cessional plac masks, etc.
257 A collection figures (A.

art of the British colonies, held at the Royal Anthropological Institute in 1949.

To Fuller, his collection represented a continuum of material culture. He especially sought old pieces because they were the product of a technology developed apart from and prior to contact with the Western world. For comparative purposes he obtained some recent works to demonstrate differences in styles, designs, and technologies. Fuller began his collecting by securing the relatively mundane utilitarian items of everyday life. He did not limit his interest, as so many collectors have, to the comparatively dramatic sculptural representations, although some of the most outstanding of such items are to be found in his collection. Rather, he ardently sought items that might differ only slightly in their attributes from dozens he might already possess. To him, the most minor difference was of the greatest interest because it helped demonstrate the range of variation within a given category or type.

The formation of his various collections, of which the Pacific materials were pre-eminent, was Captain Fuller's life. All other interests and obligations were subsidiary. As with the few other great private collections which have been made, it is virtually impossible to separate the collection from the collector. The peculiar genius of the man is reflected in the object of his creativity – the assemblage, the collection.

Simply to acknowledge Fuller's discriminating and zealous approach to his collecting is, however accurate, woefully inadequate. Some elaboration is called for. Captain Fuller was an anachronism in mid-20th century. He was a gentleman in the most complimentary sense of the term. He was courtly and formal; even Victorian in his view of life. His values and manners – indeed his collecting bent – were representative of an era gone by; a time when the gentry flourished in England. This was a time of national efflorescence, of world leadership; of political and economic eminence. In some ways this was a gentler time – a time with opportunity for contemplation and speculative reflection. Perhaps, too, it was a time when there was an acceptable – even desired – level of eccentricity to which one might aspire. We may conclude that Fuller was eccentric, and the characterization seems both natural and positive. The qualities which dignified and graced the era Fuller represented have almost ceased to exist. One is left with a wistful nostalgia for a time when homes were spacious and their occupants gracious; when traditions were upheld and honor and integrity complemented interpersonal relations.

The second son of the Reverend Alfred Fuller, M.A. (1832-1927), Alfred Walter Francis Fuller was born on March 29, 1882, in Sussex, where his family had lived in the city of Chichester for many generations. He numbered several ancestors who had made scientific or intellectual contributions to England over the years.

Reverend Alfred Fuller
(1832-1927)

One was Thomas Fuller, D.D., the author, and another was Thomas Fuller, M.D., who was physician to Queen Anne.

Eventually, in order to devote himself more to intellectual pursuits and the care of his various collections, the Reverend Alfred Fuller retired from his ministry in Itchenor, Sussex, to Chichester. He was greatly interested in natural history, particularly entomology. As the younger Fuller grew up, he was exposed to his father's ardent collecting interests. He lived in a house filled with fossils and bones, butterflies and scientific engravings, as well as assorted artifacts. The Reverend Mr. Fuller served as Honorary Curator of and benefactor to the Chichester Museum and it was in these surroundings that his son counted some of his earliest recollections.

The result of such a childhood might either be a devotion to science or an abhorrence of it. For Captain Fuller the former was the case. In fact his relationship with his father was extremely close and they collaborated in the formation of the Pacific and

other collections. Fuller's other collecting interests centered on Africa (particularly Benin materials), the Northwest Coast Indians of North America, official seals, and books about and illustrations of Sussex. His library of Pacific publications, prints, and other illustrations complemented the ethnographic materials he so arduously sought. It was Fuller's custom for many years to spend the quiet hours of the night until dawn immersed in his library. He then would retire to arise at mid-day. Until the time of his death on December 13, 1961, Fuller traveled about London seeking new acquisitions. He added some extremely valuable and rare items to his collection after it had arrived at the Field Museum. The compulsive quality of his devotion to collecting was remarkable. To him the search was exciting, the discovery fulfilling. And the appreciation gained by examination, comparison, and study was without parallel. His life-long pattern was the devotion of many hours to reading, research, and the production of his own copious notes either on catalogue tag, card, or publication page. Fuller was a firm believer in the value of documentation. For this reason his collection is without question one of the most thoroughly supported ones ever made.

Despite his great immersion in the literature and the material culture of the Pacific, Fuller never traveled in the Pacific. Had he done so, he could not have found as many superb specimens there as he did in his homeland. Because of their early and continued contact in the South Seas, the British took back to England more old and valuable material illustrating the native arts and crafts than did the citizens of any other nation.

In 1894, while Fuller was still quite young, his family moved to Sydenham Hill near London. His father continued his collecting propensities and Fuller actively joined him in these adventures. In 1896, while he was ill, Fuller acquired his first Pacific specimen as a gift from his father. It was a Fijian club (catalogue number 274264) and it formed the nucleus of a Pacific collection which came to be known the world over. Captain Fuller always acknowledged that his father actually began the Pacific collection, and until his death, the Reverend Mr. Fuller provided financial assistance in its formation. Aided first by his father and later by his wife (whose own special interests led her also to create both Oriental and Scandinavian collections), collecting became for Fuller an all-encompassing pursuit that dominated his life.

Following his formal education at Dulwich College, Fuller entered a venerable London law firm. During the next five years he passed his law examinations and was admitted as a solicitor of

the High Court. He continued both in the law and in collecting until 1913, when he joined the army. Although a member of a profession with a respected position, it was typical of Fuller's unorthodox approach to life that he joined the army as a private, as he put it, 'at a shilling a day.' He passed through noncommissioned grades and was ultimately recommended for a com-

A. W. F. Fuller
as a young man

mission. His choice of service is understandable. He was following in the footsteps of an older brother, John F. C. Fuller, a Sandhurst graduate and career soldier, who was later to achieve the rank of Major-General and became the author of numerous military treatises. Following training, Fuller entered his brother's regiment (Oxford and Buckinghamshire Light Infantry) and served with it throughout World War I. His specialization in explosives and trench warfare took him to the Salonica front in March, 1917, and later to the Carpathian Mountains. These activities made for military success in Serbia and Bulgaria, but they returned Fuller to England in December, 1918, in broken health. As a result of his wartime service he was pensioned shortly after the armistice. His commission as a Captain in the infantry was a title he would retain throughout his life. In his youthful retirement, Fuller served as Honorary Curator at the British Museum at the request of the Keeper of the Ethnological Department.

On July 6, 1924, Miss Estelle Winifred Cleverly and Captain

Fuller were wed, thus fulfilling a bond of friendship and courtship of long standing. Even as a girl, Miss Cleverly and her husband-to-be shared an interest in scholarly collecting. And through the years, it was she who, as earlier his father had done, aided and assisted Fuller in his all-consuming attention to collecting.

Captain Fuller's wartime service resulted in a partial deafness which prevented his return to his work as a solicitor. The main work of his life was 'collecting.' As his Pacific collection grew and its scope and worth became known abroad, scholars from Europe, America, New Zealand, and Hawaii visited the Fuller home to study it. As the artifacts began to be counted in the thousands rather than hundreds, they literally began to dominate the house. Fortunately, Mrs. Fuller was tolerant and continued to provide energetic assistance with improving the collection. That such a magnificent assemblage was formed is all the more remarkable in that only modest financial resources were available to Captain and Mrs. Fuller. Fuller's disability, coupled with the general reversals in wealth suffered by many families in England following World War I, precluded his purchase of highly priced specimens. His greatest joy was when he found a 'bargain.'

As the years passed Fuller became increasingly concerned with the ultimate disposition of his collection. Sir Peter Buck, who systematically studied the collection in the mid-1930's, sensed this concern even then. Fuller wished his collection to be kept intact and to be placed in an institution where it would be properly cared for, studied, exhibited, and generally appreciated. Because of his great affection for his native country, he would have liked nothing better than to be able to present his collection to the British Museum, and for many years he entertained this notion. But this was not to be. As world economic conditions changed, it became clear to Fuller that he no longer would have the freedom to present his immensely valuable collection as a gift to the institution of his choice. Had financial gain been his principal motivation, he could have realized most for his collection if he had been willing to see it separated and sold at auction. He could also have acceded to various requests to part with one or more especially notable specimens whose value as 'art' pieces to other private collectors or dealers would have been measured in terms which would have made such a sale most lucrative. This Fuller would never do, for he strove to stress the fact that art, however important as an aspect of culture, should be considered as less important than how the various items came to be developed and integrated into a cultural context. He laid stress upon the functional rather

than the formal. For this reason, it was important to him that a scientific museum house his collection in its entirety.

Over the years at least eight different museums in five countries and a number of private individuals expressed interest in acquiring the Fuller Collection. But none were to fulfill the hopes of both Captain and Mrs. Fuller for the collection's continued care and scholarly use until the Field Museum was able to accept the challenge and responsibility. This followed the development of close ties of friendship between the Fullers and a number of Americans, especially during and following World War II. In acknowledging his having been named a Patron of the Museum, Fuller wrote the Director in 1959, as follows: 'An additional factor for the pride I feel in now being directly associated with the Museum in this distinguished manner, is that I am a citizen of a foreign state, albeit a most friendly one with all thinking and informed classes in it. Throughout the lives of my Father and myself we have been your firm friends and advocated the closest union between our two countries. By a fortunate chance during the late war my wife and I were able to do a little towards this end by throwing open our cottage in a very lonely situation on the South Downs of Sussex to all ranks of those heroes of the Light Tanks who were the first "cavalry" to land at the very beginning of D-Day. Alas! Many never returned.'

On July 31, 1958, sixty-two years after a young boy in England had secured his first Fijian war club, a freighter set out from London, bound for Chicago. Packed securely in her hold were 71 crates weighing more than 16 tons. A month later the Fuller Collection arrived safely at Field Museum. For the next year the tape recordings made by Captain Fuller during the documentation period in England were transcribed into nearly two dozen volumes as a part of the Museum's permanent record of the collection.

As cataloguing and assimilation of the collection in the Pacific Research Laboratory of the Department of Anthropology proceeded, a temporary first showing was held (May 8 – October 15, 1959), and plans were executed for the installation of a new exhibit hall devoted to the cultures of Micronesia and Polynesia. On April 28, 1961, the hall, featuring the Fuller Collection, was opened on the occasion of the annual Member's Night. Final cataloguing of the entire collection was completed in November of 1961, just a few weeks before Captain Fuller's passing.

Captain Fuller was a compulsive man. He could not *not collect*. He wished always to share his special interests, and this aspect of his compulsion allowed him to look at the culmination of his life's

work and see that, through the Field Museum, it was indeed being broadly shared. He had the satisfaction of knowing that his collection had joined other fine materials – to complement and be complemented by them – in one of the world's great museums. He knew his collection was completely catalogued and that the documentation he had provided was incorporated. He knew that his collection was featured in a new permanent exhibit. And he knew that what he, his father, and his wife had striven to achieve was valued by others and would be preserved.

Captain Fuller achieved what few collectors are able to achieve or – all too often – even to recognize. He followed the course recommended by a man of similar temperament whom he had never met and probably had never read. In an obscure little book published years ago when Fuller's collecting career was yet young, a man named Straley from a small town in the Great Plains of the United States was deeply interested in man and his works and had something he wanted to say. Because he was not a professional scholar, he set his own type, printed, and bound the slim volume he called *Paragraphs from a Collector's Note-Book*. What he said was this: 'The collector who faithfully preserves with correct data the material discovered in his neighborhood, enjoys through many years his . . . pursuits, and when he is through with his collection [places it in] a worthy institution, renders science a service and perpetuates his own name.'

For Alfred Walter Francis Fuller and those like him – the true collectors – there is no separation of the man and his collection. Nor should there be.

POLYNESIA

NEW ZEALAND

Only recently have archaeologists found important new evidence of cultural connection between New Zealand and east central Polynesia confirming and, in some cases, modifying details of the long-postulated migration of Maoris southward. The richness of the resources in the new homeland was matched by a richness of craftsmanship. Cultural assemblages from New Zealand demonstrate a remarkable versatility of decoration. Curvilinear designs and intricate anthropomorphs and zoomorphs abound. Materials range from greenstone (a form of nephrite) through wood, whalebone, whale teeth, shark teeth, ray skin, reeds, native flax, *Haliotis* shell, and soil pigments to dog hair, feathers, human bone, bird bone, and many others. Postcontact artisans incorporated metal, leather, and even sealing wax in the items they made.

There are close to six hundred Maori items in the Fuller Collection. Two of the most remarkable specimens from New Zealand (a neck ornament and a weapon) were acquired in 1958, and presented to the Museum by Captain and Mrs. Fuller in 1959 and in 1961. Nearly half a century earlier, in 1912, Fuller had acquired another remarkable Maori piece, this one an adz. The quality of the three objects is of the highest and it is a testimony to his perseverance that their addition to his collection should mark both his early and his late collecting years. His association with the adz even predates his collecting bent, for it was a part of the Chichester Museum collection in which surroundings Fuller spent his early youth.

This exceptional old ceremonial adz (catalogue number 273685) *26, 27* matches the excellence of Maori carving in wood with the perfection of their work in greenstone. The blade is affixed to the handle with a binding of flax cord and the haft is decorated with white dog's hair. Atop the haft is a finely carved *manaia* head. The Chichester Museum record is unclear as to which of three gifts of New Zealand 'war hatchets' or 'battle axes' this particular adz is, but it was of early date in any case. The earliest date of accession would have been 1833; the latest, 1866. Fuller acquired it with other Chichester materials on June 4, 1912, and thought so highly of it that he awarded it the first number in his collection.

Among the rarest of Maori artifacts are decorated gourd containers. Owing to their fragile nature, few have survived. Number 273904 is dull red in color. Large gourds were used for the storage of food, often fat rendered from birds. Carved wooden 'mouthpieces' such as 273906 were sometimes affixed to the opening. Such gourds, because of their generally spherical shape, required additional support by four wooden stakes. An example is 273907; most, however, were not carved. Digging sticks, used as agricultural implements for breaking and loosening soil, have been used in planting and cultivation in many parts of the world. The digging stick in the Fuller Collection is roughly carved of light-colored wood.

The Maori artisan took his stimuli from a number of sources, including animals. Representations of dogs, lizards, and birds are not uncommon in Maori carving. An old and weathered wooden figure (273930) with four legs, a large head, and prominent teeth may have been meant to portray either a dog or a pig. There are several humanoid figures in the collection. One, with bone teeth and *Haliotis*-shell eyes, is 273933. It was formerly in the Chichester Museum. Still another carved figure (273934) is a gable ornament. What may possibly be a god-stick is a carved weathered image (273935) of light-colored wood. An exceptionally fine old carved 'mask' (273929) has shell eyes and a perforated lug on the back.

As was true in a number of other Polynesian cultures, the Maori tattooed their bodies and faces. Tattooing was more closely associated with warfare than with social rank and was related to supernatural beliefs. This sacred quality resulted in the observance of stringent taboos during the tattooing process. The individual being tattooed was prohibited from feeding himself. Elaborately carved feeding funnels like 273905 were used to pass soft foods between his lips. This specimen is one of but a few such items which have survived.

An artifact of distinctive design which may have served as a container for greasy tattoo pigment or tinder is 273674. The lid of the box is tanged and fits into the mouth of the figure. Maori facial tattooing was distinctive with intricate symmetrical curvilinear incised markings. An example is seen in a plaster cast of the neck and head of a Maori from Otago (273948). The cast was used to create the manikin illustrated on page 34. The Fuller Collection also contains some materials used as pigment in the tattooing process: amber-colored gum from the *kauri* pine and several 'vegetable caterpillars' (*Cordiceps robertsii*).

Warfare was emphasized in pre-European New Zealand and

28

29

29

32

30, 31

30

61

33

34

35

34

21

heads were taken in battle. Some such trophies, along with the heads of beloved chiefs, wives, or children, were preserved by steaming, smoking, and anointing after removing the cranial contents. The Fuller Collection contains such a head (273944). *36* A companion piece (277599) is a carved wooden face which Fuller *37* recognized as a copy of the facial portion of the preserved head in his collection and purchased at auction in 1935, twenty-two years after having acquired the head itself. Fuller concluded that the wooden carving, atypical for New Zealand, could only be spurious and even determined the identity of the carver and secured his prosecution as a producer of 'fakes.' The same individual produced other spurious, but highly ingenious artifacts, some thirteen of which Fuller acquired as examples of such work.

The many types of Maori weapons indicate the emphasis they gave to warfare. Their weapons were designed for hand-to-hand combat and skill in their use was ardently sought. The main classes of Maori weapons are spears, and long and short clubs. Maori spears of any type are rare. There are nine in the collection. Number 273596 is two-pronged and most rare. Seven of the spears *38* are from the Chichester Museum and all are of early date. Number 273597 may be a throwing stick (*kotaha*), used to propel *59* spears.

Of the several types of long clubs the *taiaha* (exemplified by 273480) are most numerous. There are more than sixty such *38* weapons in the Fuller Collection. Of the *pouwhenua* in the collection, number 273535 is quite remarkable because of the *40* raised-relief carving on the shaft near the blade. Of the *tewha-tewha* type of club, several deserve mention. Numbers 273546 and *39, 40* 273554 are representative of the type. Number 273560 is more *39, 40, 43* unusual because it is made of whalebone. It is broken at the point of incised carving on the shaft. This rare old specimen was collected by Captain Moresby of HMS *Basilisk* in 1874. A number of different kinds of short clubs (*patu*) of stone, whalebone, and wood are found in the collection. Whalebone *patu* are twenty-eight in number. Many are exceedingly old. One quite fine weapon in this series is 273426, a club of the *wahaika* type, with finely *41-42* executed modeling. Several whalebone clubs of the type called *kotiate* are represented, as are basalt hand clubs called *patu onewa*. Two (273437 and 41) of the twenty in the collection are illustrated. *46* Three greenstone hand clubs or *mere pounamu* (273454-56) are also *47* shown. Altogether there are seventeen short clubs of wood in the collection. Eight are of the *wahaika* type (see 273458-59) and two *49* are of the *kotiate* type (see 273463). Four weapons are of the *48*

48 *patuki* type, but 273466 is not covered with surface carving, as is
49, 48 usual with such clubs (see 273467-68). A post-European adaptation
to Maori weaponry was the creation of iron ax-blade hand 'clubs.'
50 *Kakauroa* (273562-63) are long-handled fighting axes and *patiti*
51 (273565-67) are short-handled fighting hatchets.

Personal ornaments from New Zealand are among the finest and most beautiful in the Pacific. Much is owed, of course, to superb artistic creativity and craftsmanship, but the occurrence of nephrite, a variety of jade called greenstone, and bowenite (a softer material) on the South Island is another factor which is related. The Maori used this hard stone to make adzes and chisels, but its use in the manufacture of ornaments made those of the Maori exceptionally distinctive.

There were two classes of pendants – those which were suspended from the ears and those suspended from the neck. The segment of the Fuller Collection which features ornaments includes eleven straight greenstone pendants of the *kuru* type. There are three examples of the pendant type known as *kapehu* or *kapeu* with a curve at the lower end, one S-shaped pendant, three small miscellaneous ear pendants, and two chisels which have been pierced for suspension as ear ornaments. Other jade ornaments include a pendant of the *pekapeka* type, a leg ring for a pet bird called a *poriakaka* made of translucent bowenite (*tangiwai*), and a hook-form neck pendant (*hei-matau*).

Probably the most well-known pendants of jade from New Zealand are those called *hei-tiki* (hanging human form), grotesque, highly stylized humanoid figures with large heads set askew, and large shell-inlay eyes. Neck pendants of this type were valued as heirlooms and were passed from generation to generation, symbolizing ancestral owners. Sometimes an adz blade provided the material for such a pendant and its form may be detected in the finished object. This collection contains eleven *hei-tiki* pendants.

On January 20, 1958, in a London sale room, Captain Fuller
52, 53 successfully bid for a *hei-tiki* (64514) of the highest quality and of great size. No history was available, but the piece was clearly of early date and distinguished workmanship. Especially noteworthy is the fine detailed finishing of the specimen and the open work in the neck area. This remarkably beautiful piece was added to the collection by Captain and Mrs. Fuller in 1959.
52 A smaller ornament of similar type (273856) was probably collected by Captain Cook. This indication is provided by an old parchment label which accompanies the specimen and which

notes its having been the 'largest and finest' such item in the Leverian Museum. This reference is to the private museum of Sir Ashton Lever, which was located in London during the time of Cook's voyages. This *hei-tiki* has a small suspension hole at the top, but the heavy flax cord is too large for it and is placed through another aperture instead. The collection includes two old bird-bone toggles for pendants. Maori pendants carved of human cranial bone are rare. Two in the collection were formerly in Major-General Robley's collection. Maori ornamental combs were of whalebone and wood, both of which types are to be found in this series.

In addition to greenstone ear pendants, the Maori also made ear ornaments of sharks' teeth. In post-European times red sealing wax was used to cover the root area. Two simulated shark-tooth pendants are present. One is carved of whale ivory and the other is porcelain and of European manufacture. Porcelain ornaments were produced for trade in emulation of actual shark teeth.

Flax cloaks were secured at the wearer's neck with curved mat pins which pierced the garments and held them in place. The Fuller Collection contains eleven such pins made of boars' tusks, one of *Haliotis* shell, and one of bone. There are also several of the objects of whale ivory which were ornaments, suspended in clusters from the shoulder area of cloaks.

Maori clothing represents an adaptation to a temperate climate by immigrants from tropical islands. Both the requirements of daily life and the materials of manufacture were dramatically different. Native flax (*Phormium tenax*) provided material for the manufacture of cloaks. Feathers, dogskin, and reeds also were used. Catalogue number 273927 is a weaving pin or stake. Although the *61* true loom was not present in New Zealand, a simple 'loom' was created by placing two pins in the ground and suspending a weft line between them. Cloaks of native flax were produced by finger weaving. The relief carving on this specimen features two lizards on opposite sides of the shaft. It was formerly a Chichester Museum piece.

Maori clothing in the collection consists of a rain cape (273598), *56* kilts, *kiwi* feather cloaks, woven mantles (including 273614, 21, *54* and 22), garments described by Ling Roth as 'jupes,' and two belts. *55* All are of flax. Additional items of woven fiber are carrying straps, baskets, bags (one is 273638), and a small swatch cut from *57* a flax mantle or cloak.

The Maori carver and painter seems to have had a passion to decorate intricately even utilitarian objects. For example, a bird

24

58 snare (273903) has stylized carved faces at both ends. Two other
32 such everyday objects are a carver's mallet (273918) and a ray-skin
59 rasp (273924).

The adz was the principal tool of the Maori carver. Adz blades were made of jade and of basalt. There are more than 100 in the collection. There are also three complete adzes and several greenstone chisels. Other nonjade tools include scrapers, whetstones, blades, and flakes.

Some of the finest carving of the Maori is seen in treasure boxes. Preserved in the Fuller Collection are more than twenty such boxes which were used for the safekeeping of valued heirlooms, ornaments of jade, bone, or feathers, and even weapons. Several types are represented. The largest, and one of the finest of its type,
66 is 273652. Flax cord was used to repair a crack in the lid. Number
65 273653 has a lid with approximately fifty separate perforations.
65 All shell inlay pieces are present. Also illustrated are 273663 and
66 273669, the latter, according to an affixed label, dates to 1832, and was formerly in the Isle of Wight Museum. Fuller collected two
63, 62 types of Maori flutes – *putorino* (273919-20) and *koauau* (273921-22).

As Polynesians, the Maori had a knowledge of the sea. But the great double-hulled canoes of migration accounts came to be replaced by large dugouts up to 80 feet in length which plied the waters of rivers and the ocean areas close to shore. Great *kauri* or *totara* logs allowed for long double ranks of paddlers and for large and intricately carved stern and prow pieces as well as high hulls. Such craft were used in warfare. Canoe models in the collection demonstrate the beauty of Maori craftsmanship and artistry and their integration into a unified construction. The prows of fishing canoes were of quite a distinctive design. Such a prow, from a
69 model, is 273911. The collection includes three canoe bailers, two
69, 60 of which (273914-15) are carefully carved.

Maori paddles are characterized by long slender blades with tapered points. Some blades are completely covered with carving
68 (273570), and handles at times were carved so as to be 'wavy' with
68 offset grips. Smooth or carved knobs (273581) at the proximal end of the handle are frequently found, as are stylized carvings on the shaft of the handle just above the junction with the blade, as in
60 273584. The Fuller Collection contains a large steering paddle and twenty-seven canoe paddles, some of which were earlier in such collections as those of the Chichester Museum, Edge-Partington, and Lord Northesk. Other marine items are more than fifty fish-hooks, several of which have wooden shanks faced with *Haliotis* shell, human-bone points, and flax cord bindings.

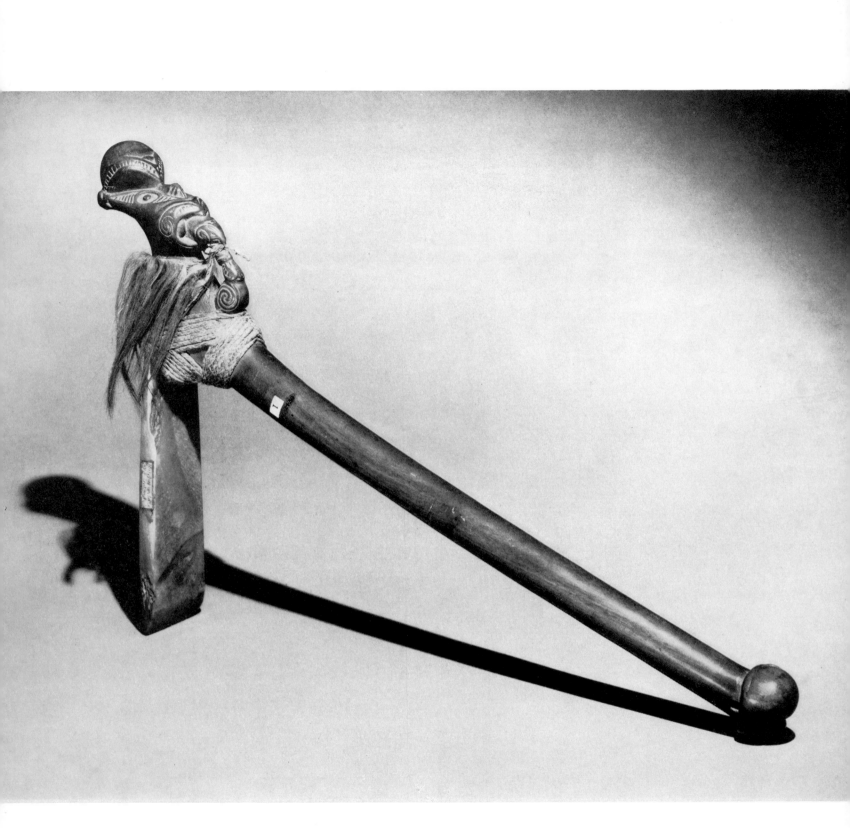

Ceremonial Adz
273685
57.5 cm.

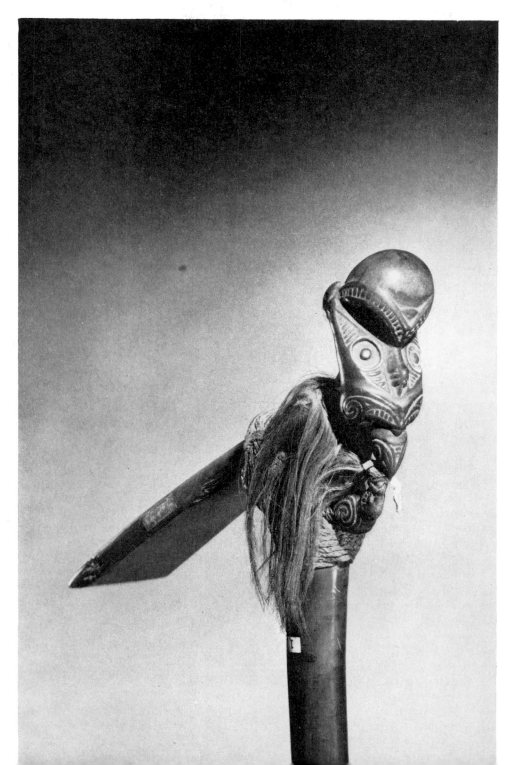

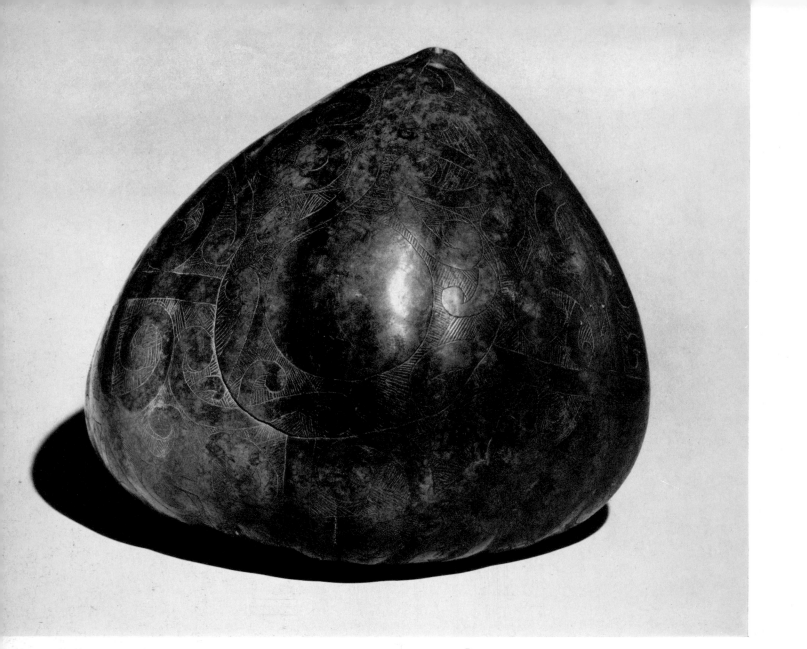

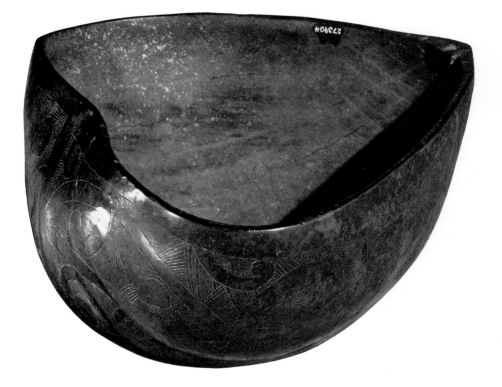

Gourd Container
273904
25.0 cm.

28

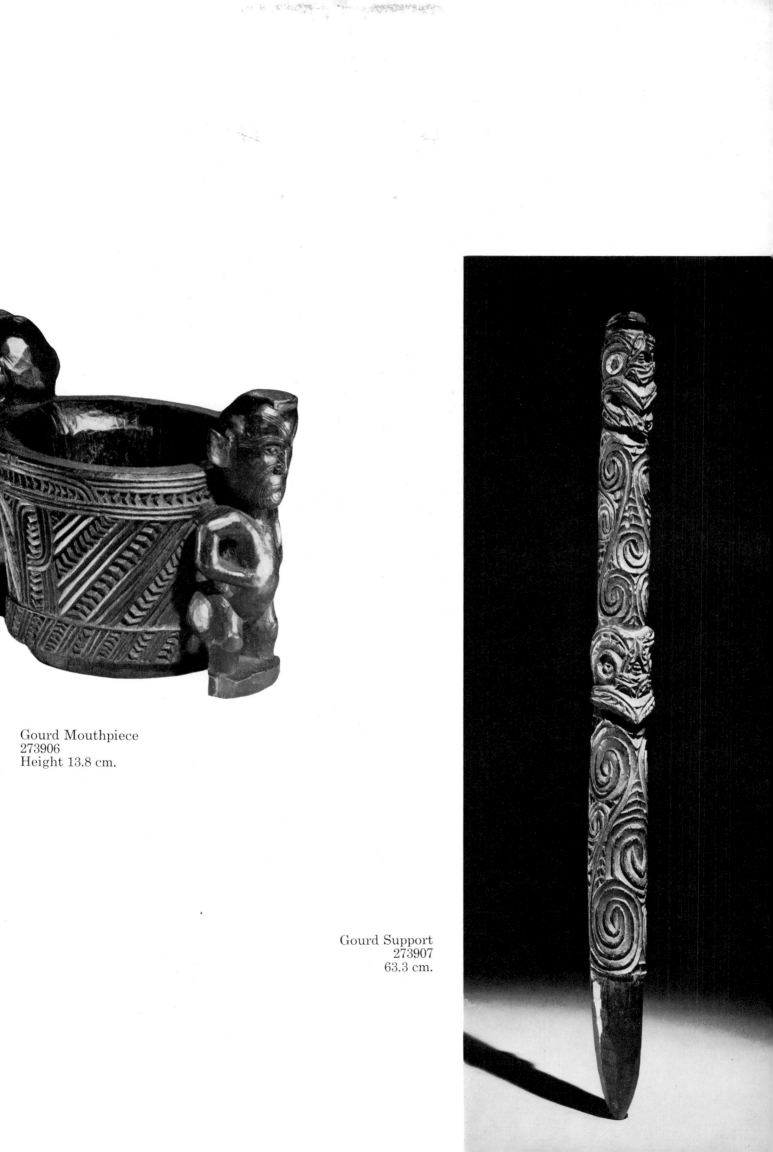

Gourd Mouthpiece
273906
Height 13.8 cm.

Gourd Support
273907
63.3 cm.

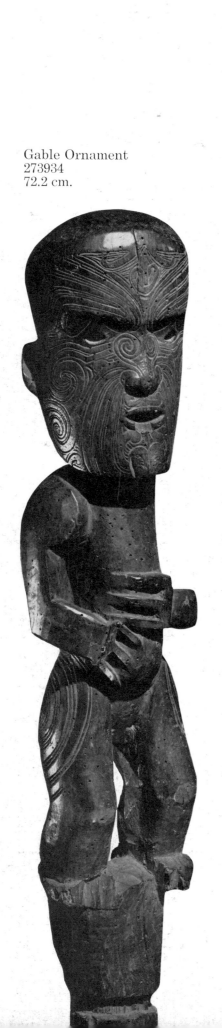

Gable Ornament
273934
72.2 cm.

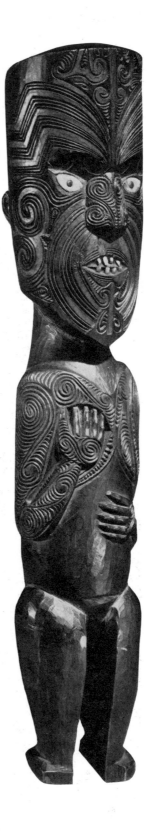

Carved Figure
273933
44.0 cm.

Detail
273933

Animal Carving
273930
39.3 cm.

Carved Mask
273929
Height 12.1 cm.

Pounder or Mallet
273918
32.6 cm..

32

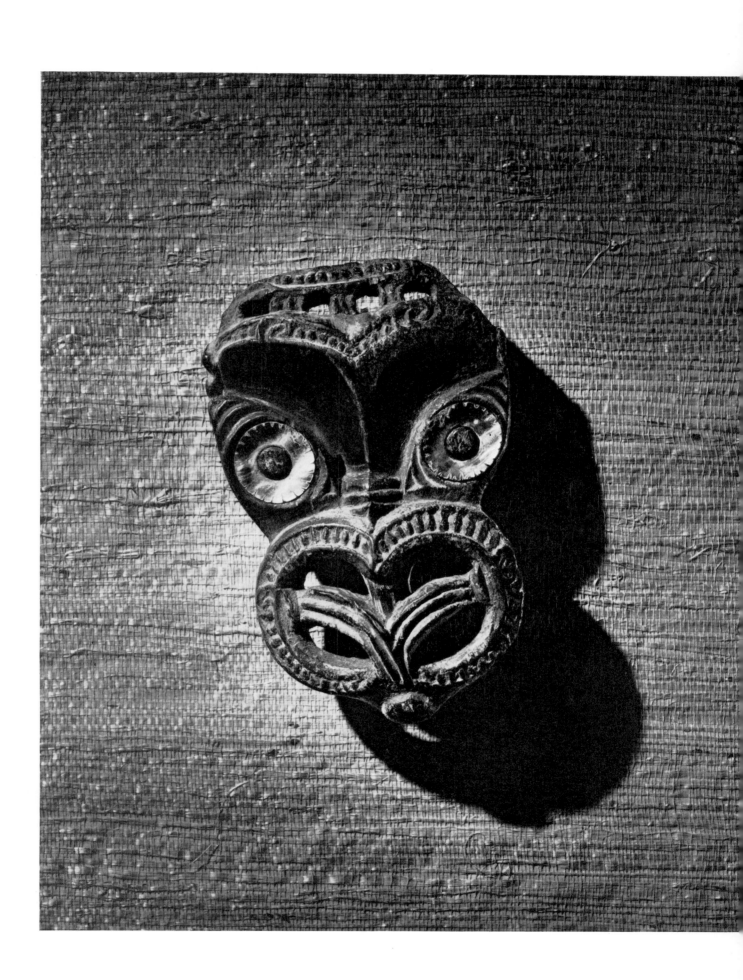

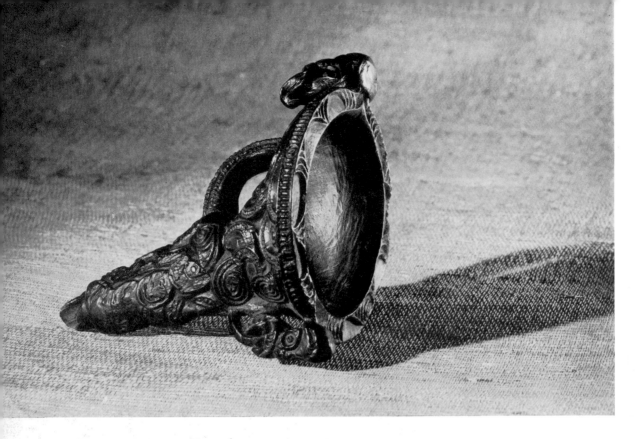

Tattooing Funnel
273905
12.7 cm.

Manikin 273948
Hei-tiki 273857
Greenstone Ear Ornament 273883

34

Box
273674
Height 13.9 cm.

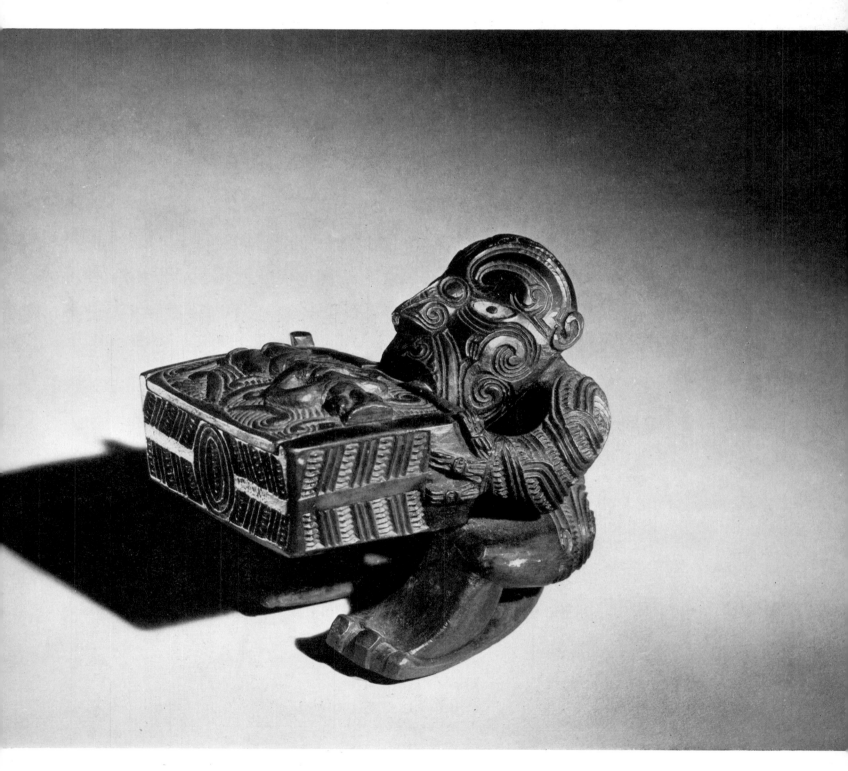

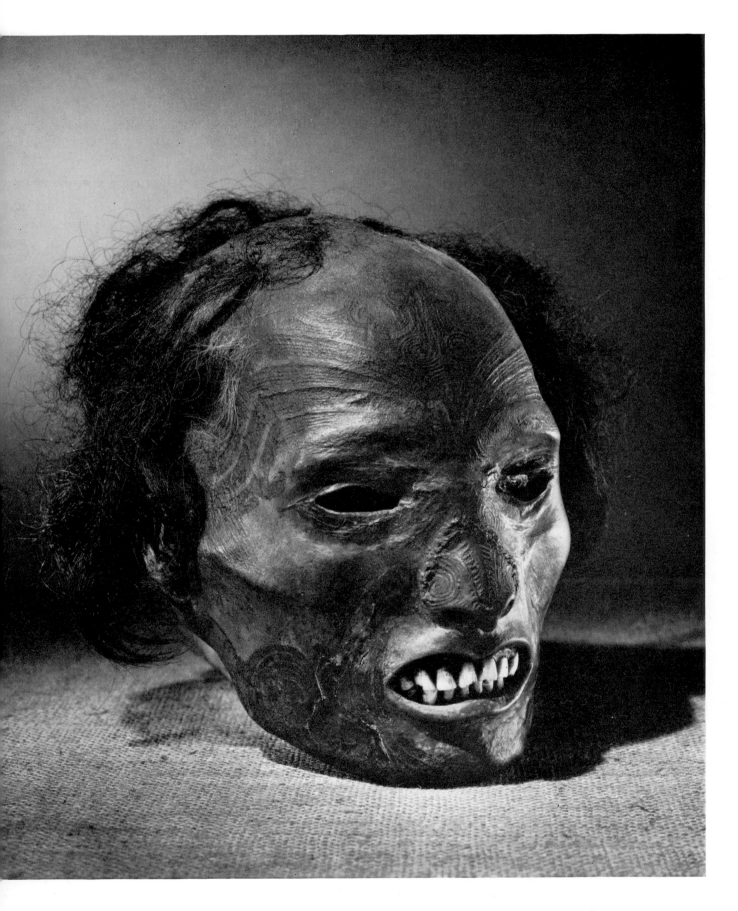

Preserved Head
273944

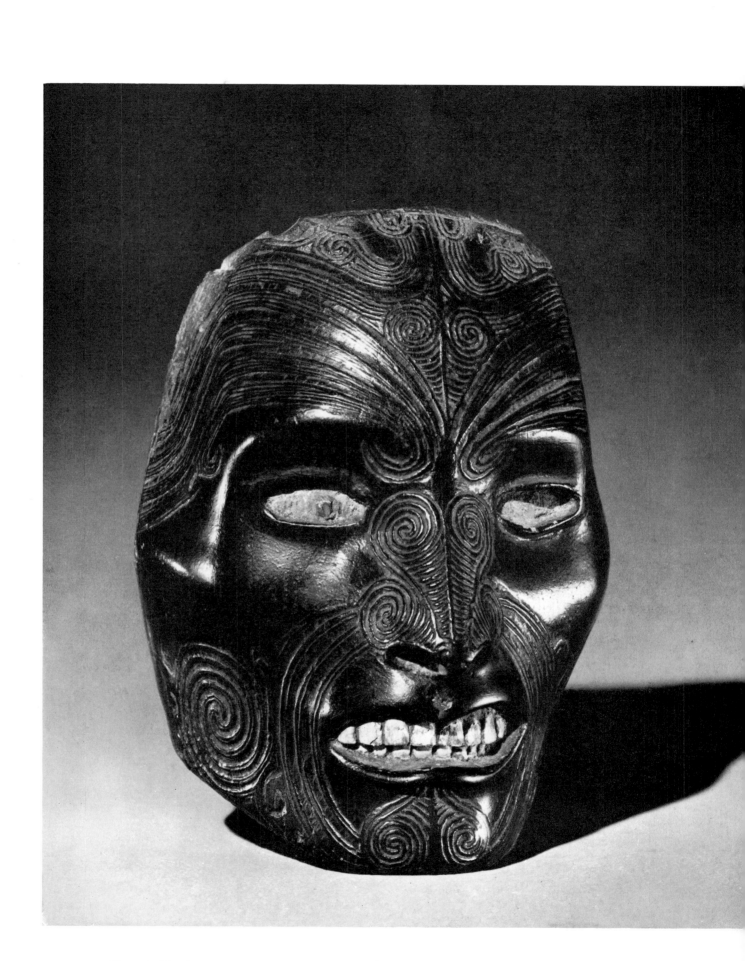

Carved Mask
277599

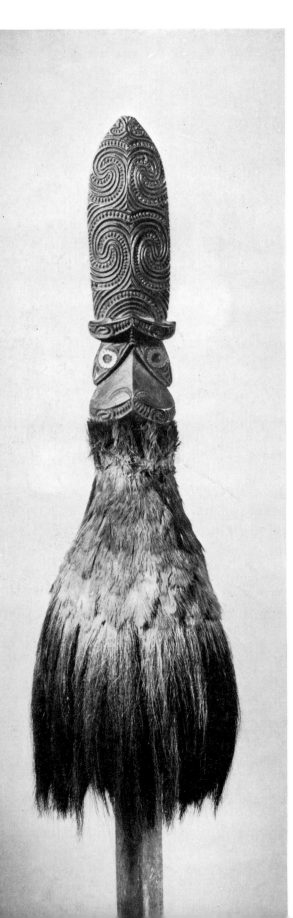

Weapon *Taiaha*
273480
158.7 cm.

Spear
273596
234.4 cm.

Weapons *Tewha-tewha*
273554 131.0 cm.
273546 165.4 cm.

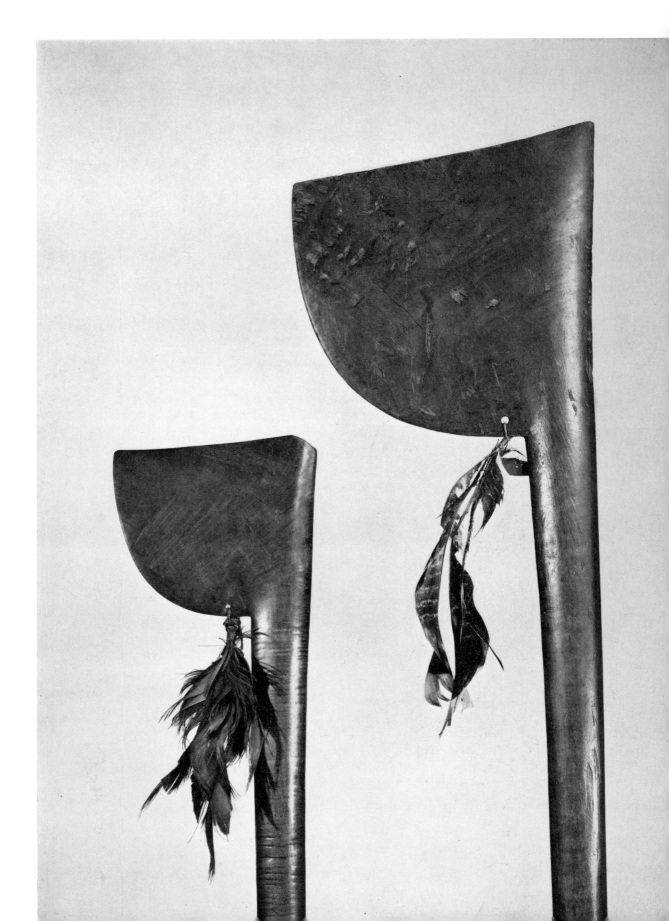

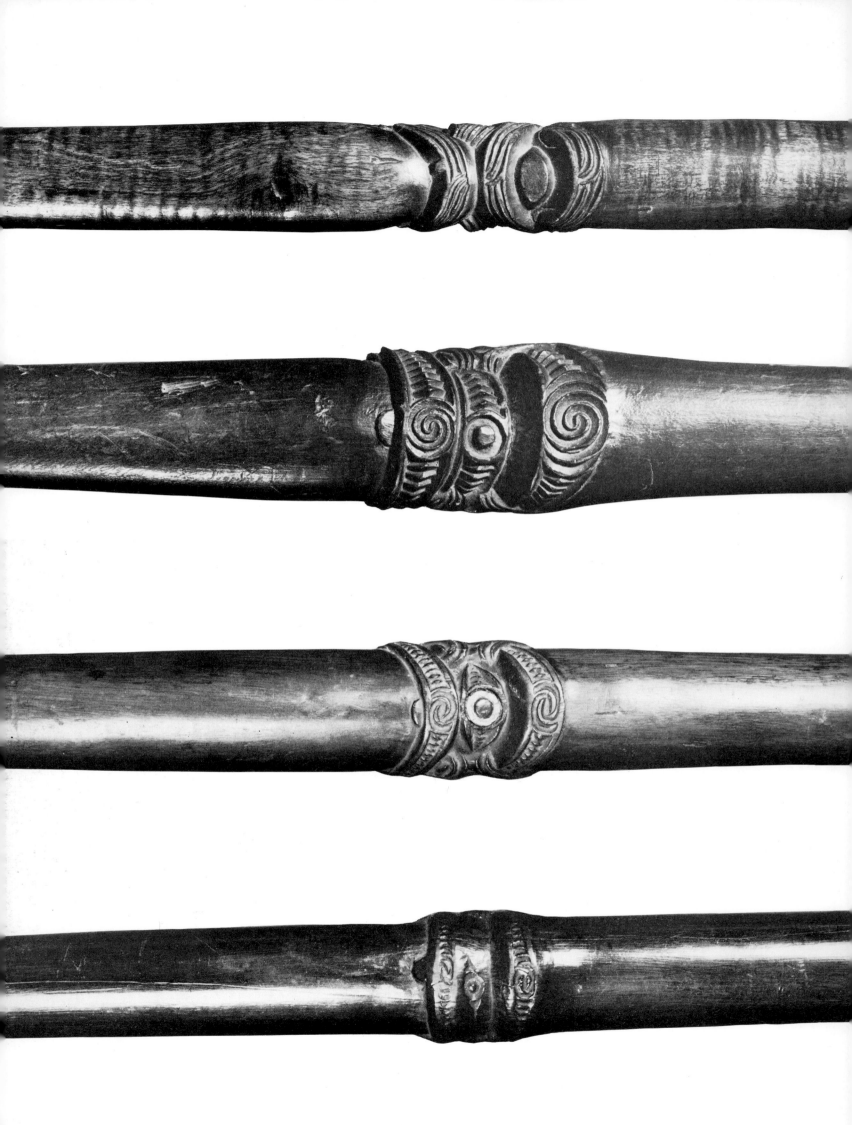

Detail
Tewha-tewha
273554

Detail
Tewha-tewha
273546

Detail
Whalebone Club
273426

Detail
Pouwhenua
273537

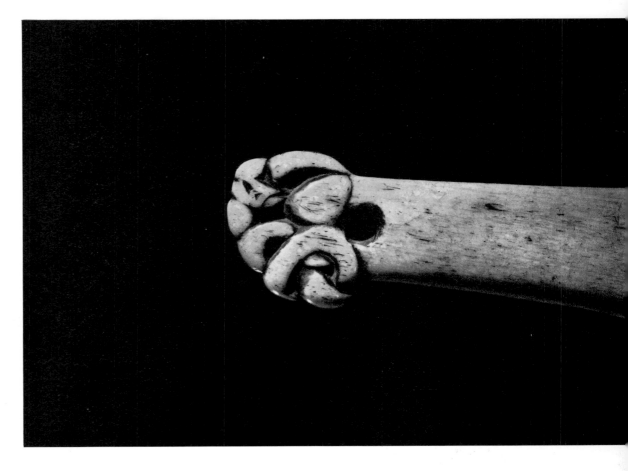

Detail
Pouwhenua
273535

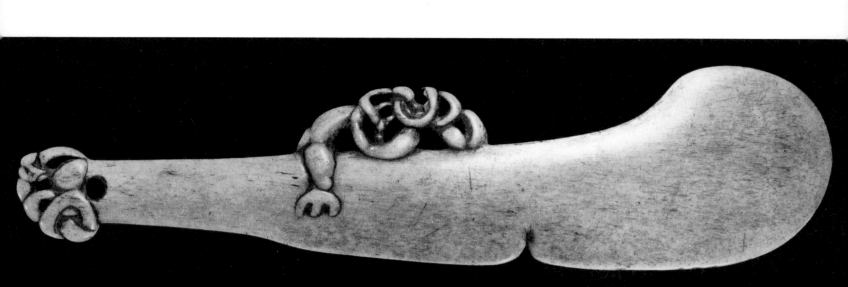

Whalebone Hand Club
273426
36.7 cm.

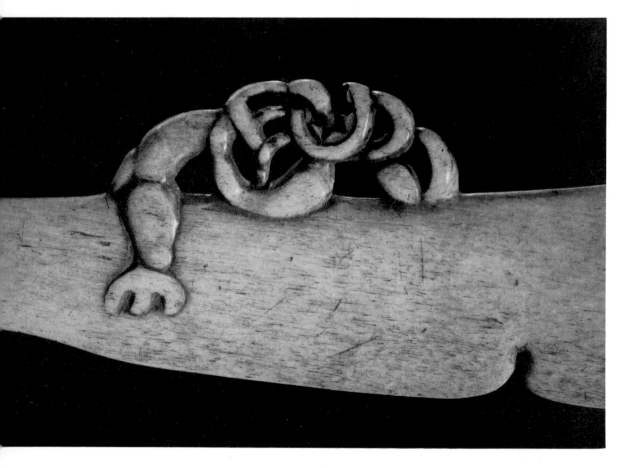

Detail
273426

42

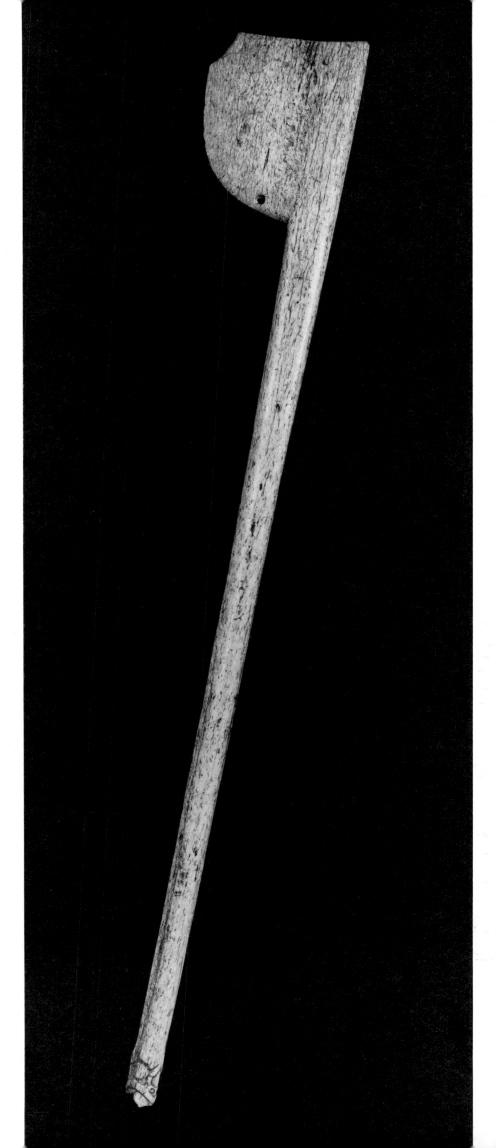

Whalebone Club
273560
79.3 cm.

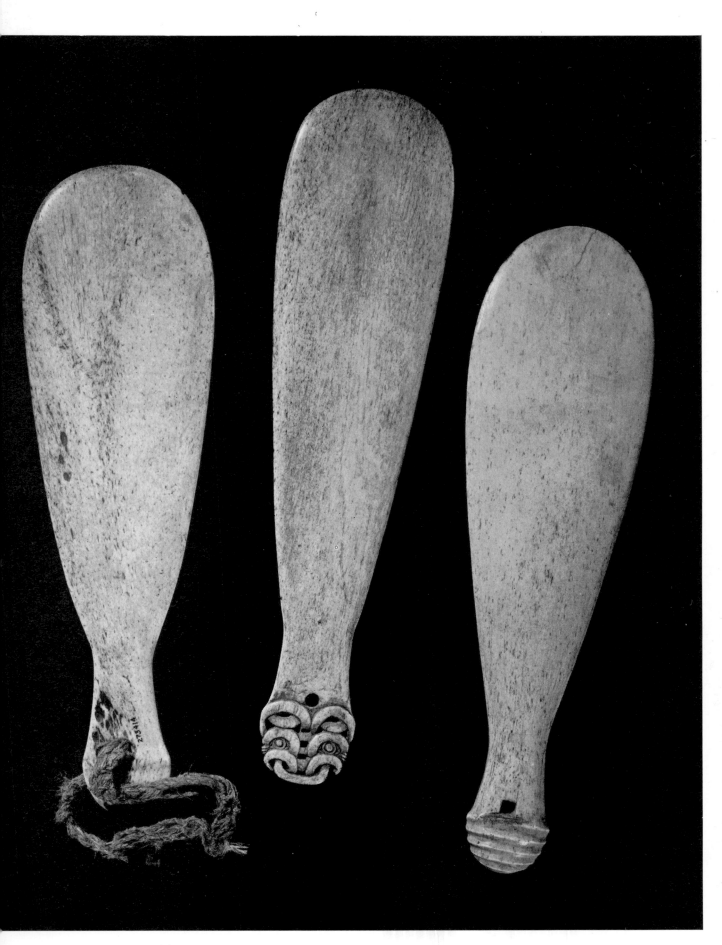

44

Whalebone Hand Clubs
273414 (left)
273425 (center)
273409 (right)

Whalebone Weapon
64515
120.0 cm.

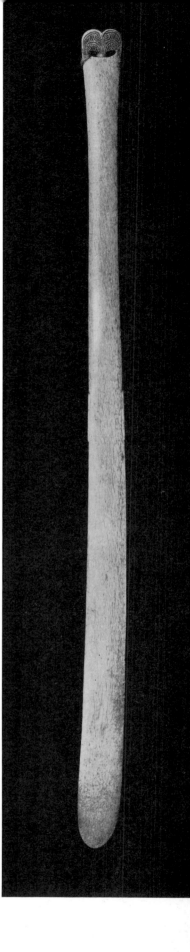

Detail
64515

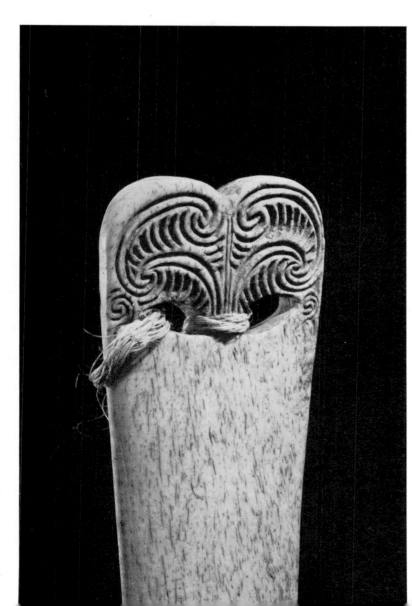

45

Patu Onewa
273437 37.7 cm.
273441 36.7 cm.

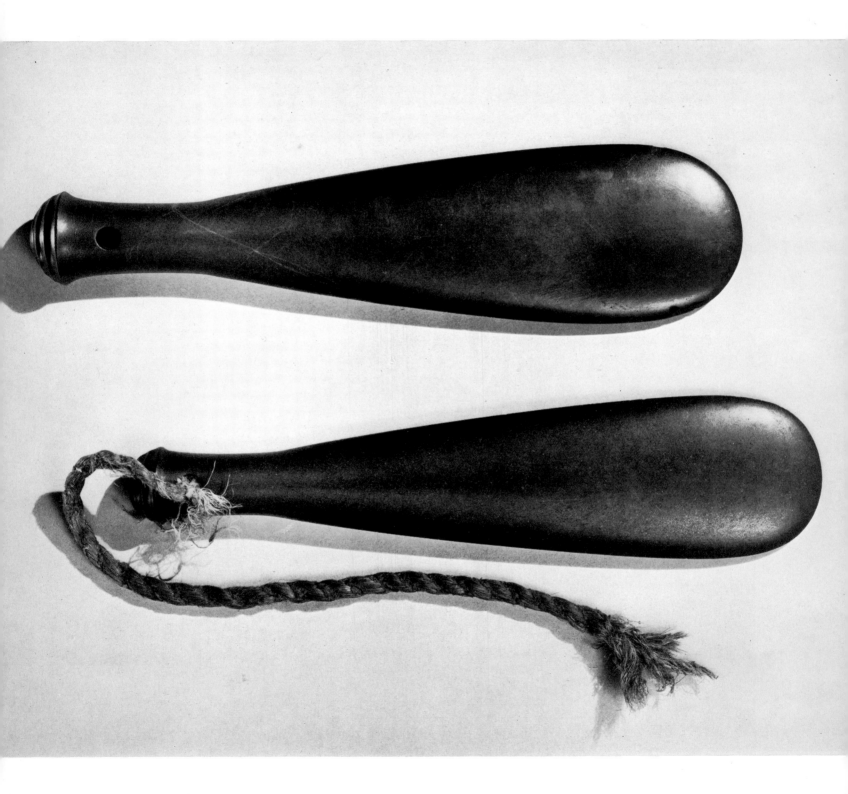

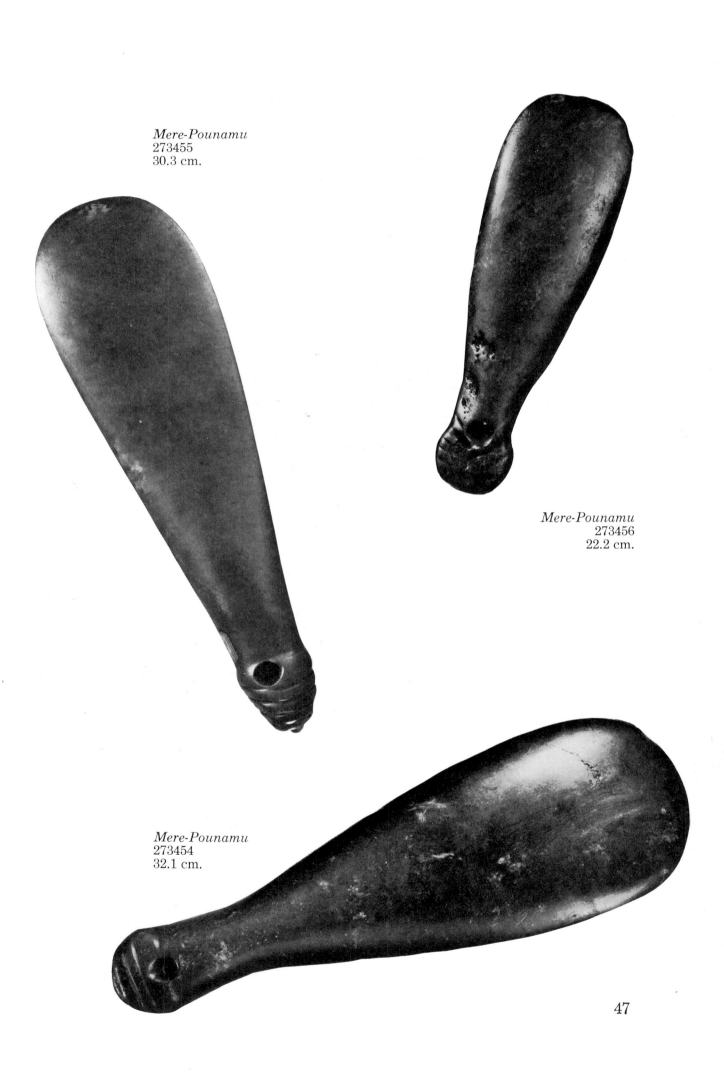

Mere-Pounamu
273455
30.3 cm.

Mere-Pounamu
273456
22.2 cm.

Mere-Pounamu
273454
32.1 cm.

47

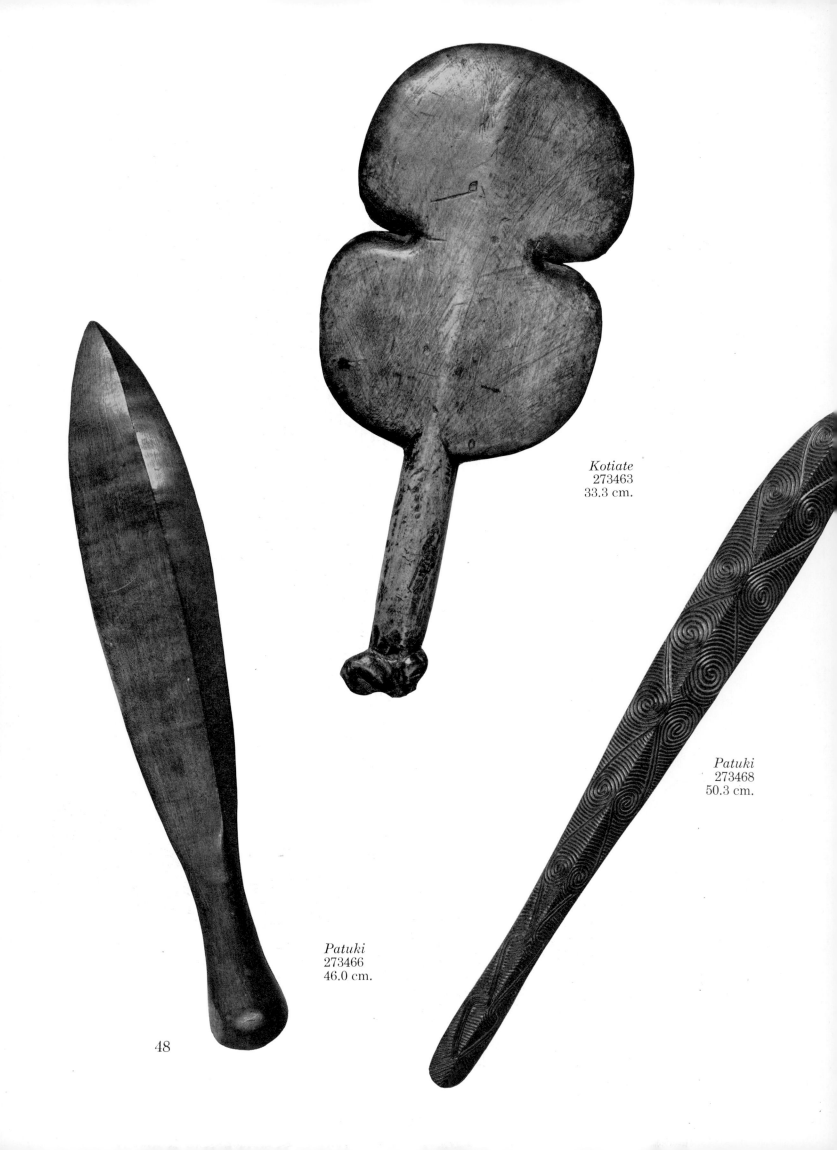

Kotiate
273463
33.3 cm.

Patuki
273468
50.3 cm.

Patuki
273466
46.0 cm.

48

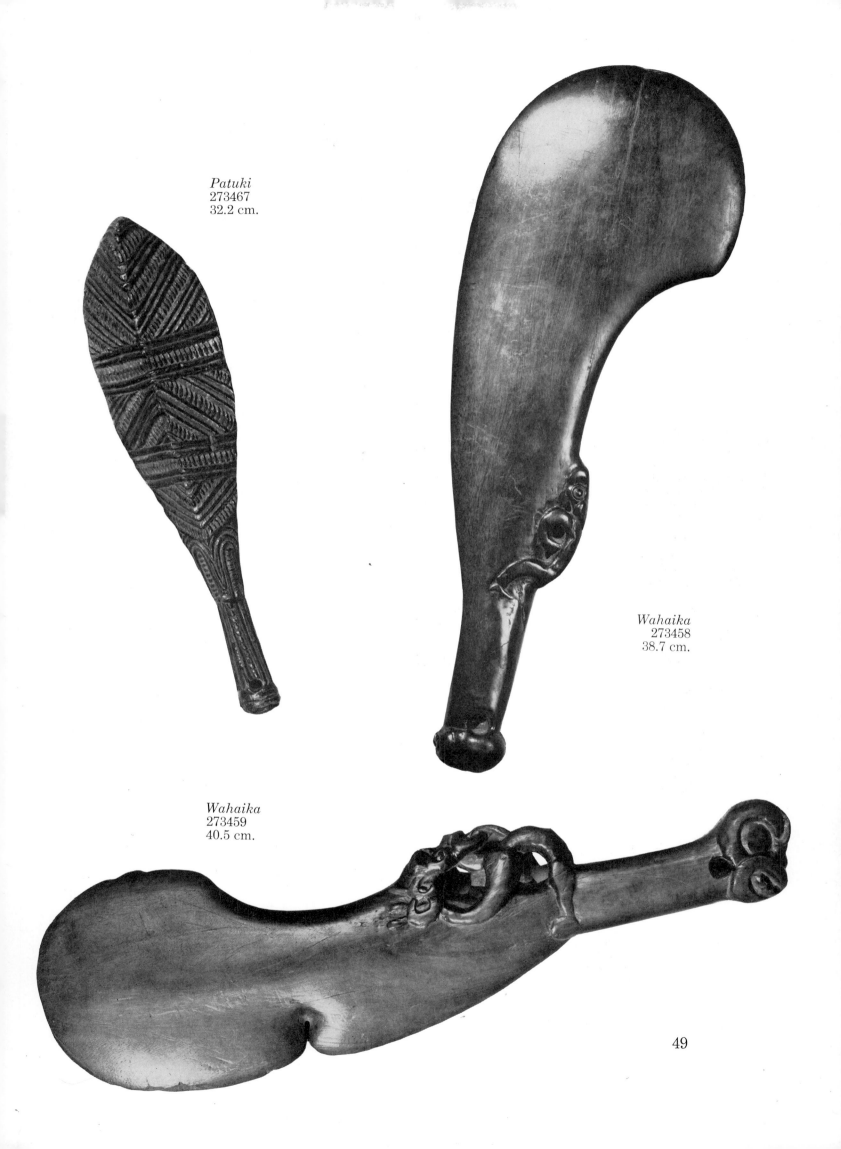

Patuki
273467
32.2 cm.

Wahaika
273458
38.7 cm.

Wahaika
273459
40.5 cm.

49

Fighting Axes
Kakauroa
273562 (left) 115.0 cm.
273563 (right) 141.0 cm.

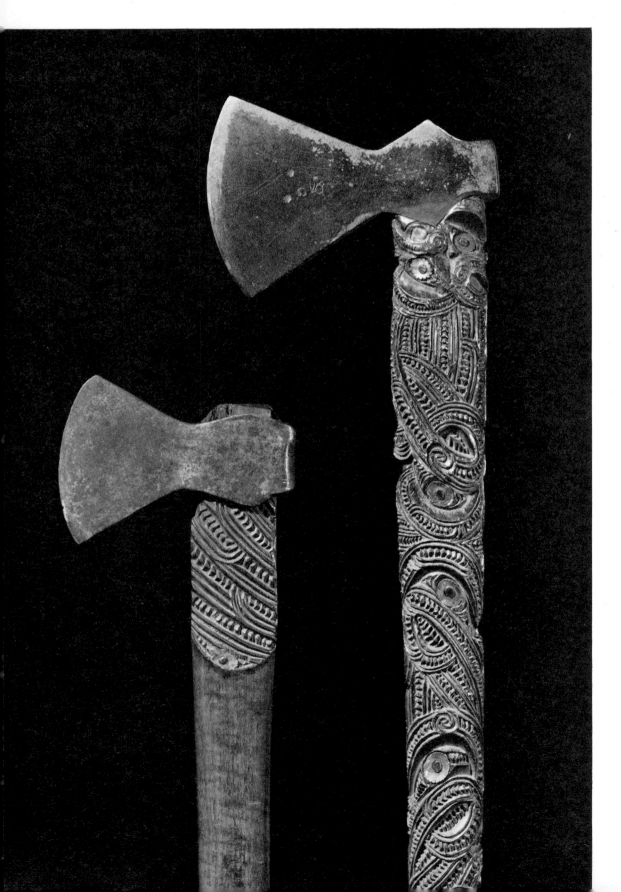

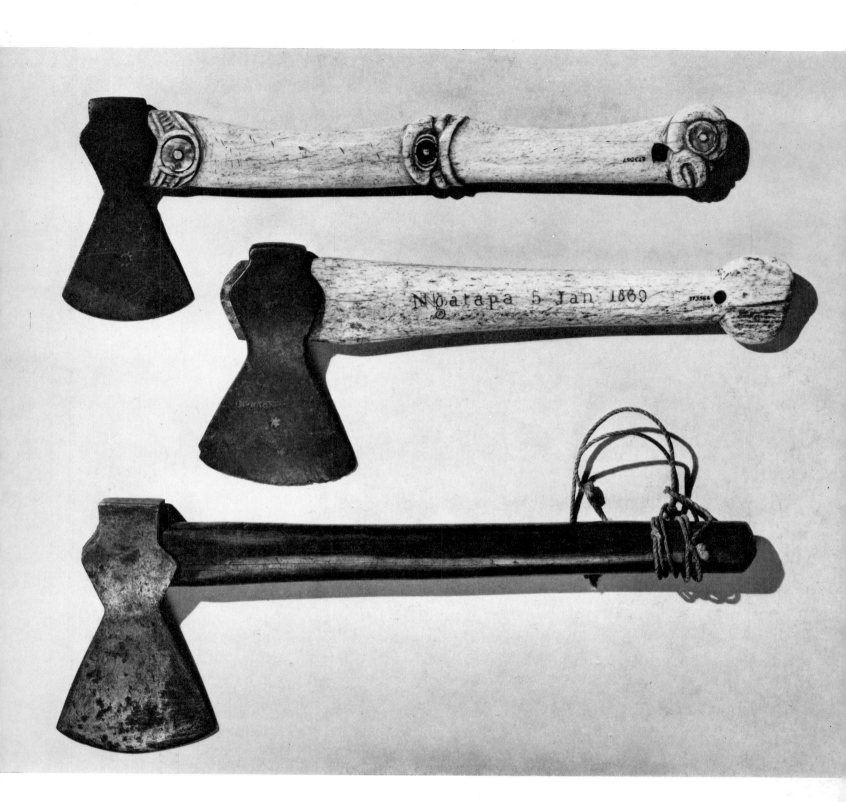

Fighting Hachets
Patiti
273567 (top) 35.7 cm.
273566 (center) 31.6 cm.
273565 (bottom) 37.1 cm.

51

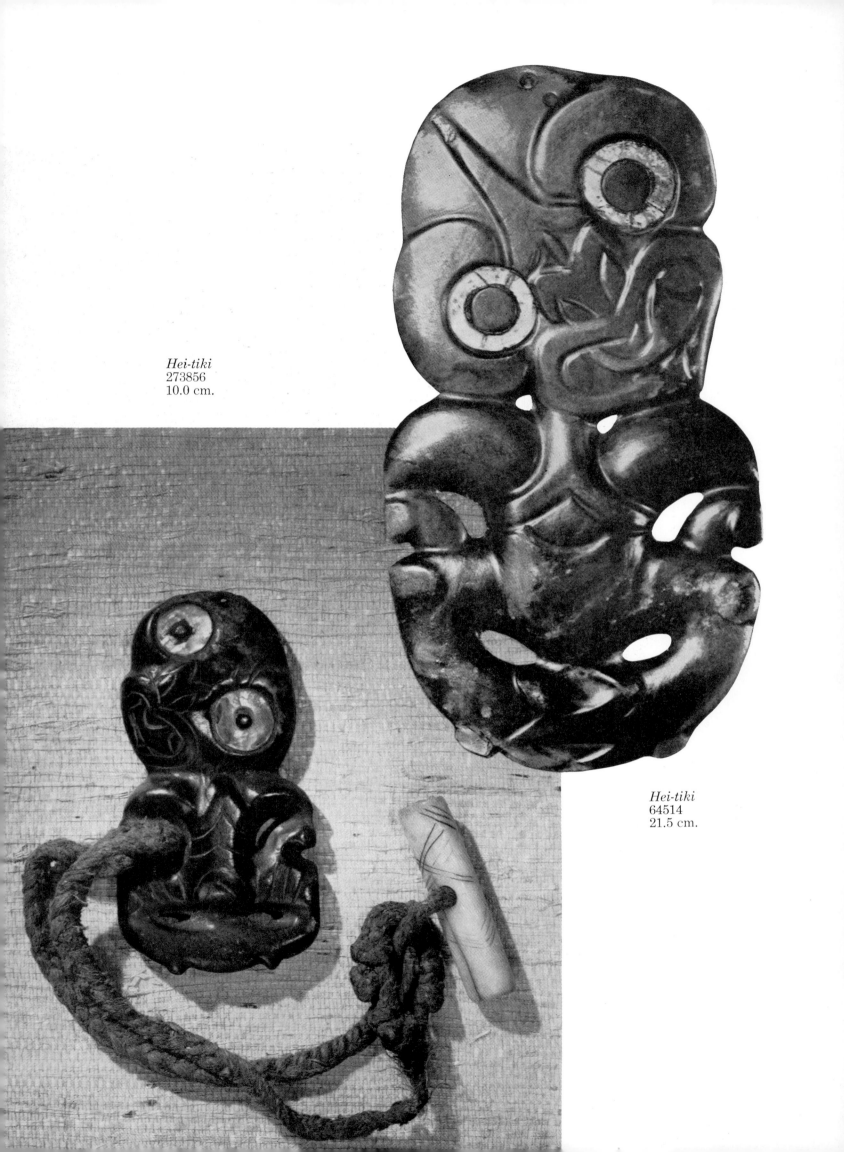

Hei-tiki
273856
10.0 cm.

Hei-tiki
64514
21.5 cm.

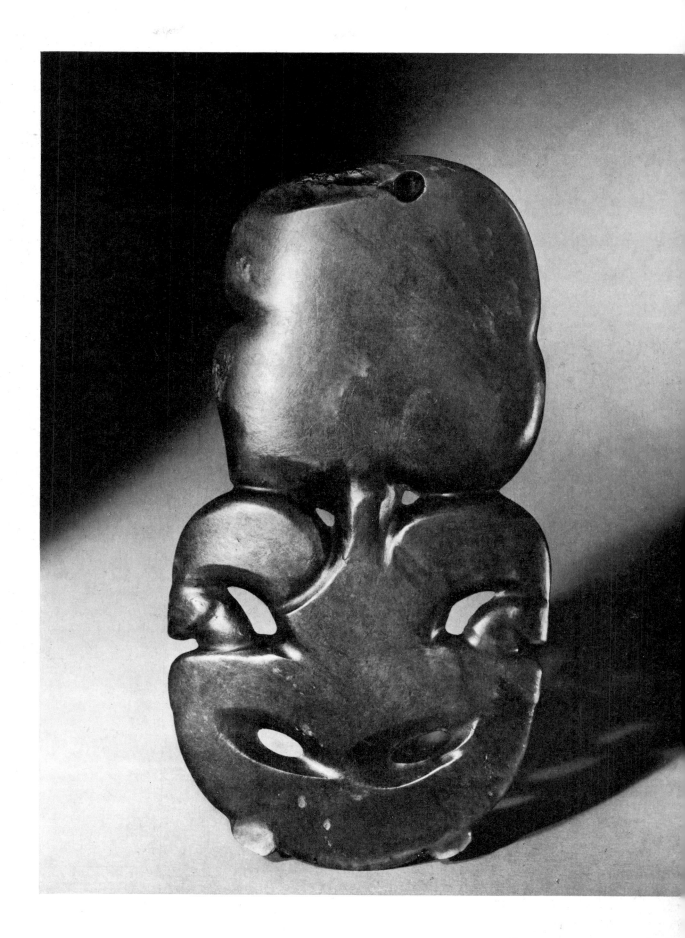

Back View
64514

53

Flax Mantle
273614

Taniko Border
273621

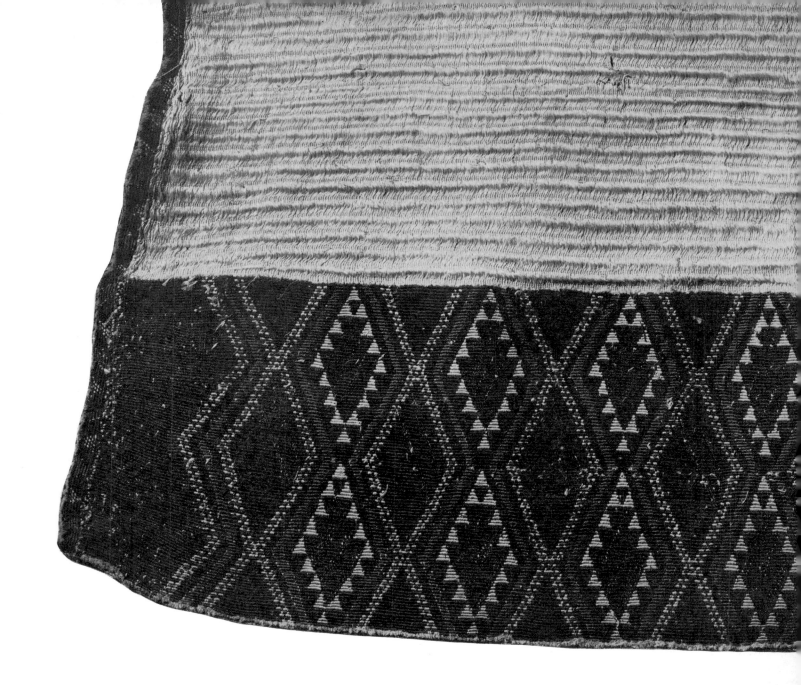

Taniko Detail
273622

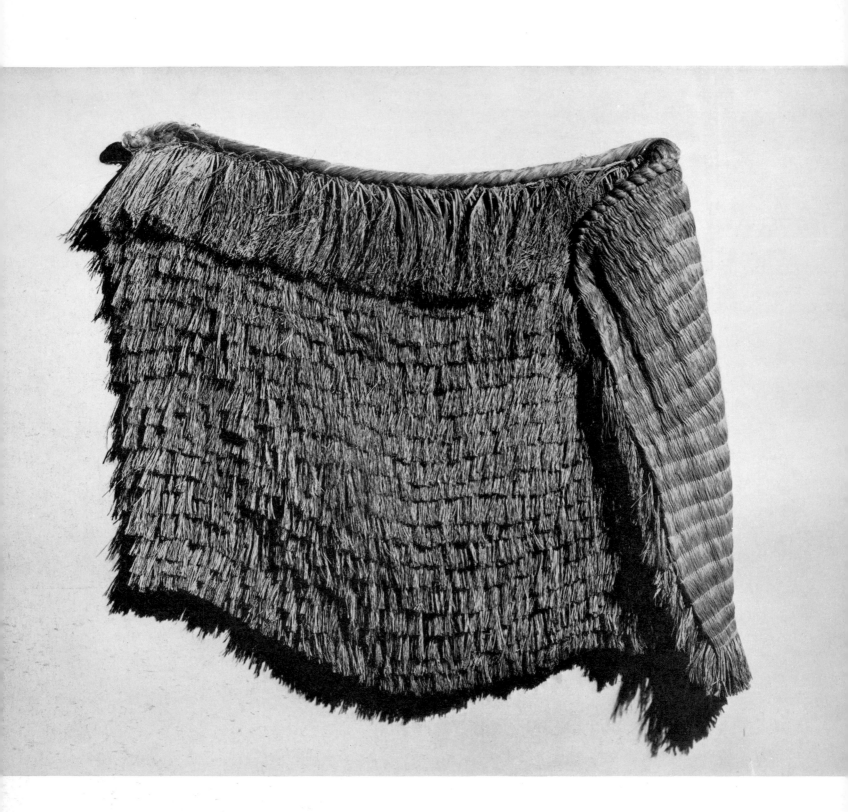

Rain Cape
273598
68.0 cm.

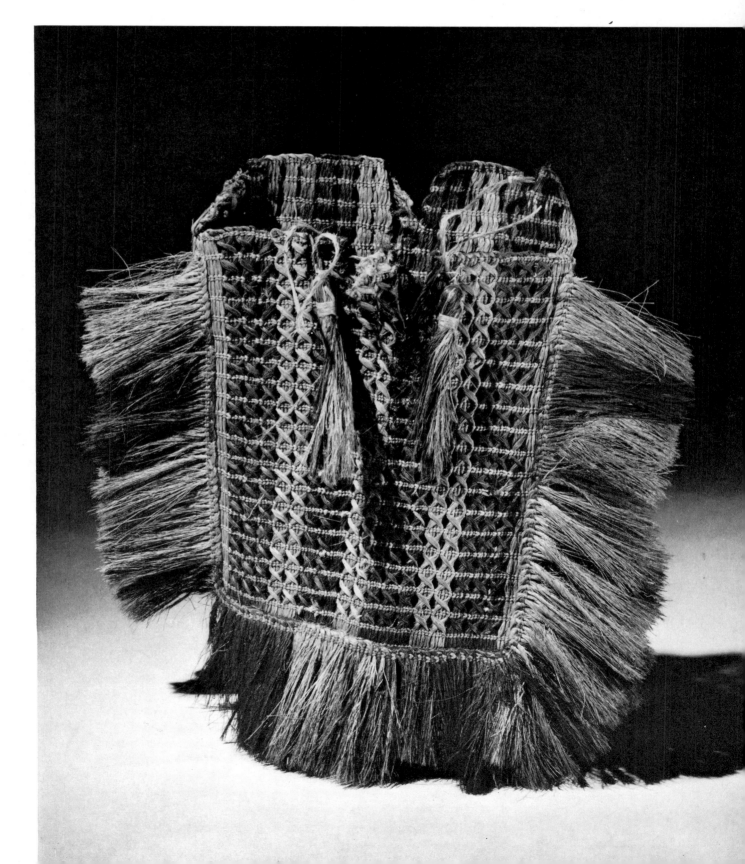

Bird Snare
273903
26.0 cm.

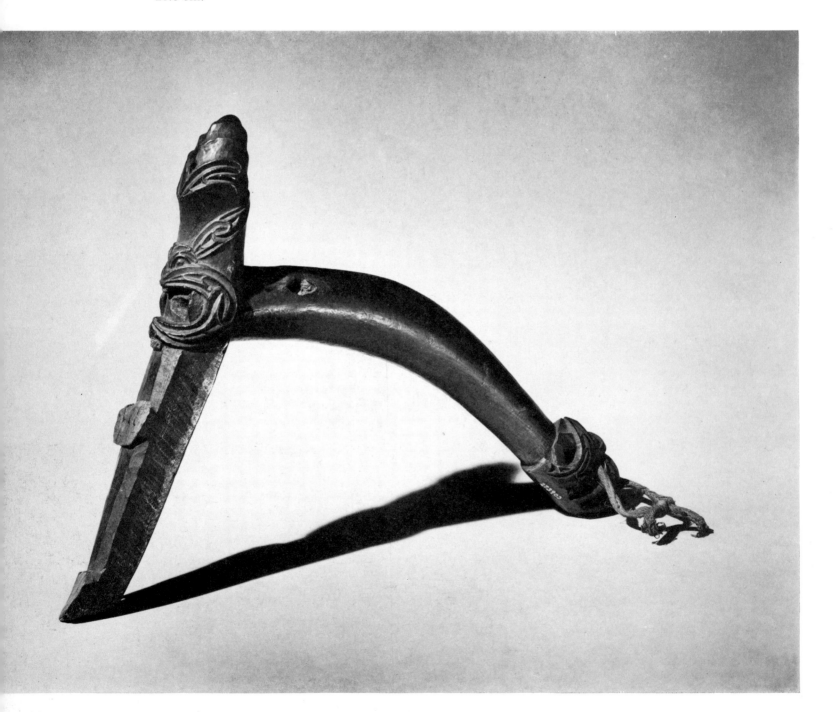

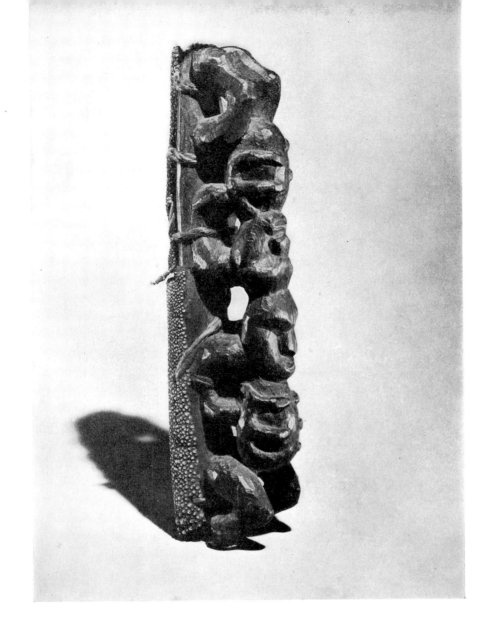

Ray-skin Rasp
273924
19.5 cm.

Spear-thrower Detail
273597
30.4 cm.

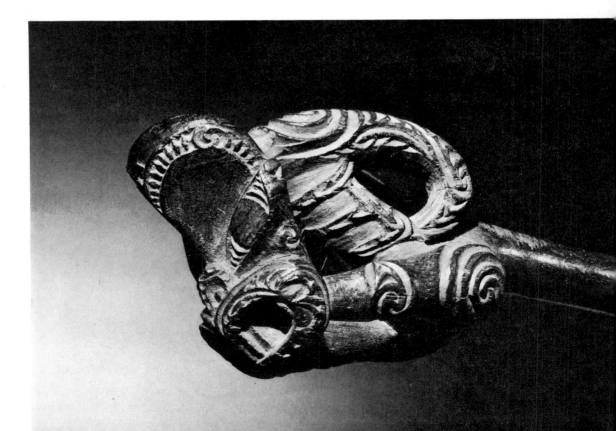

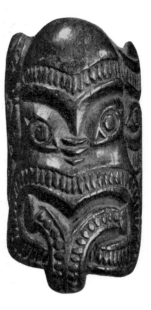

Detail
Paddle Shaft
273584

Canoe Bailer
273915

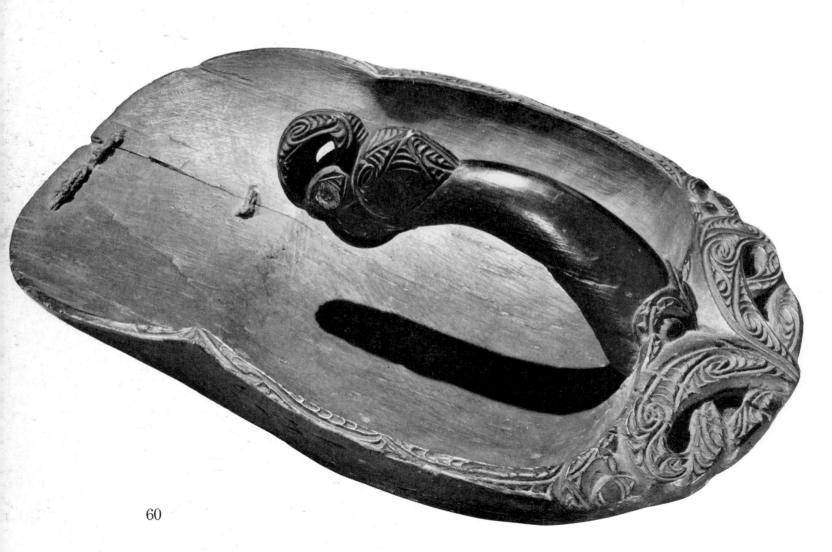

60

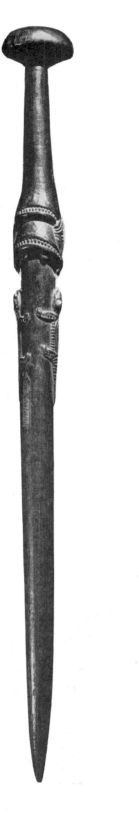

Weaving Pin
273927
52.1 cm.

Wooden Image
273935
45.7 cm.

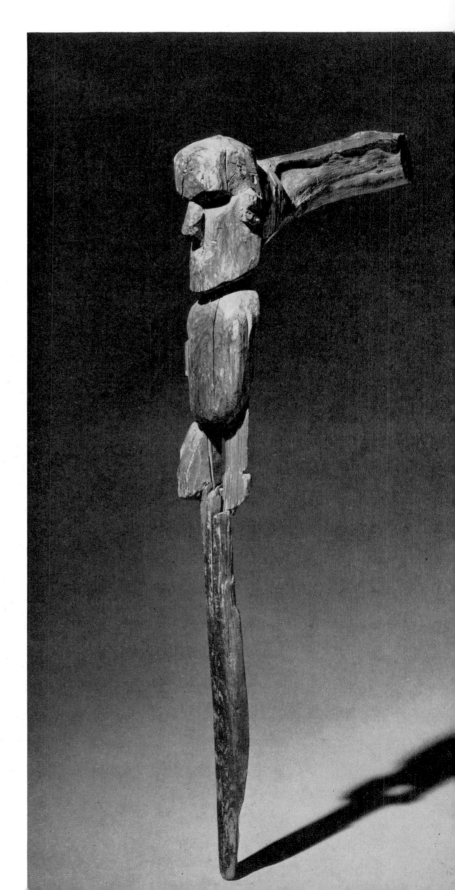

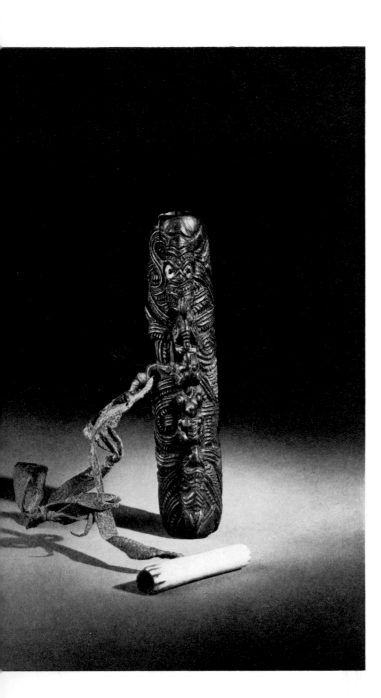

Flutes
273921
12.6 cm.

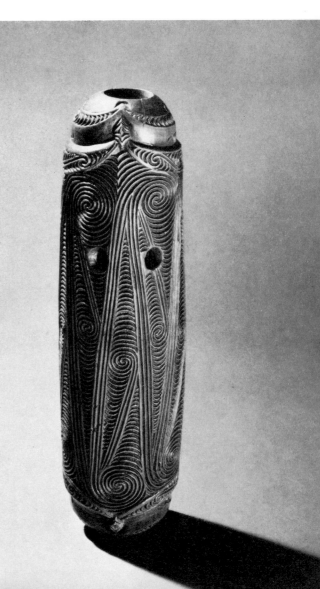

273922
15.7 cm.

62

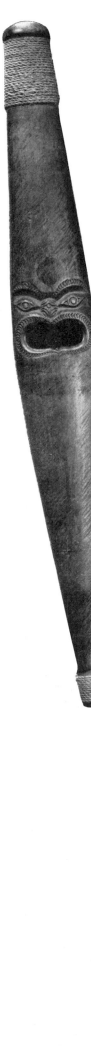

273920
36.8 cm.

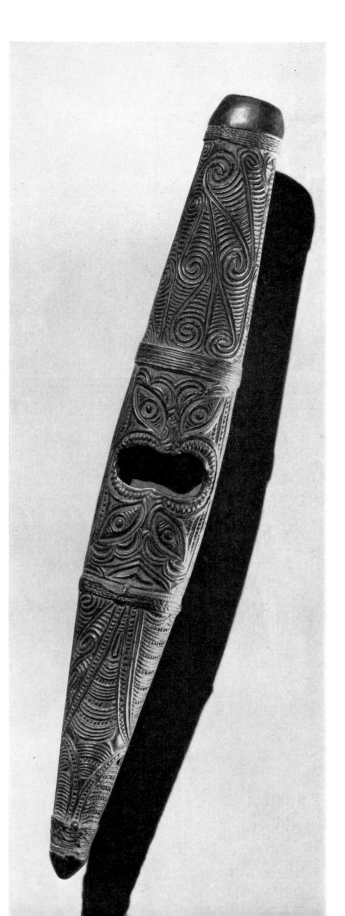

273919
35.0 cm.

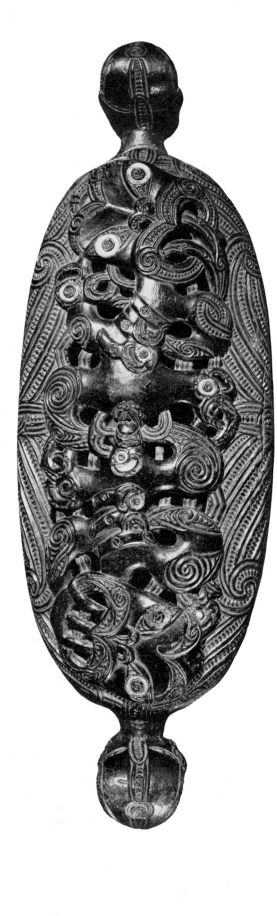

Lid Detail
273653

Detail
273663

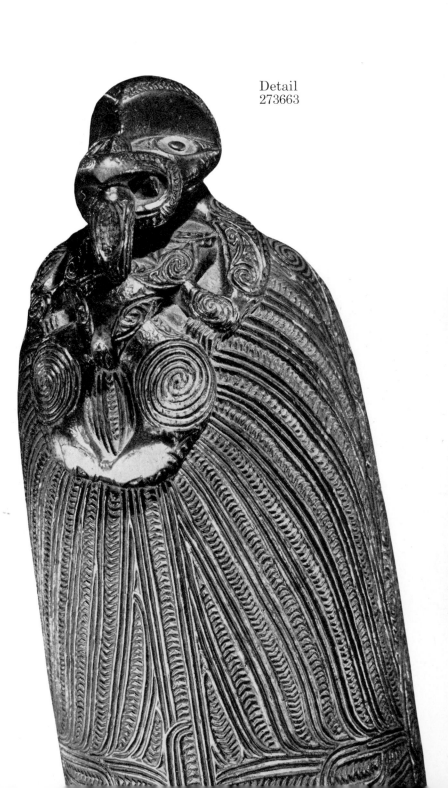

64

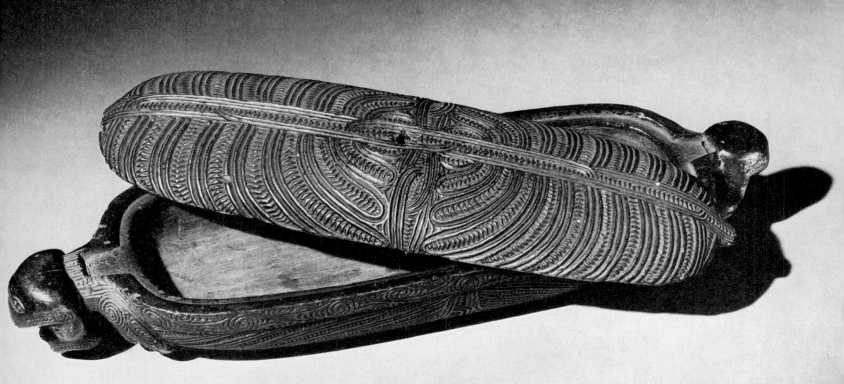

Treasure Box
273663
42.6 cm.

Treasure Box
273653
56.5 cm.

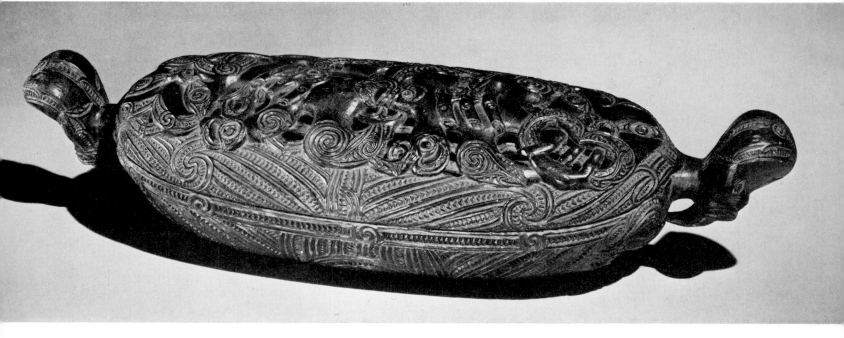

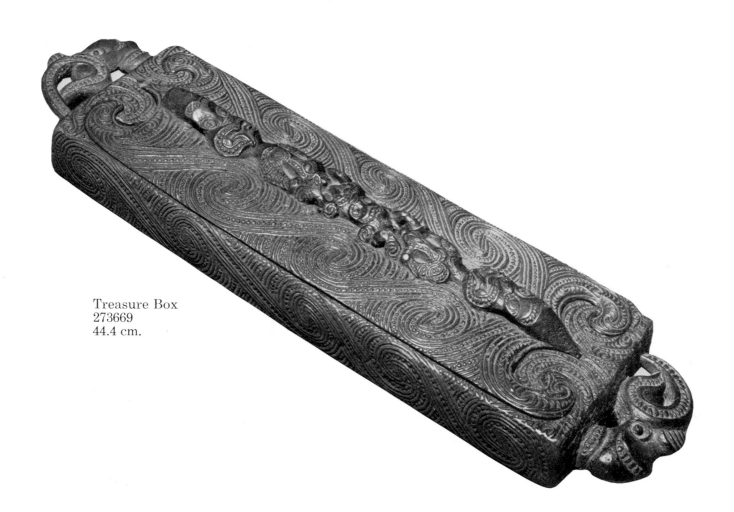

Treasure Box
273669
44.4 cm.

Treasure Box
273652
65.8 cm.

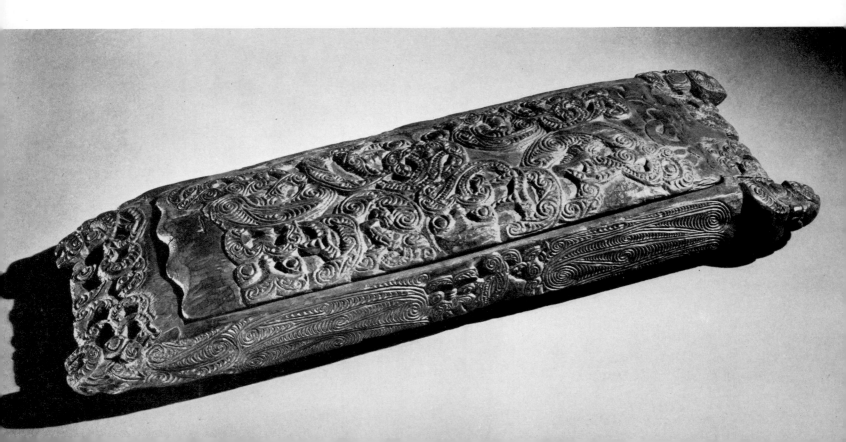

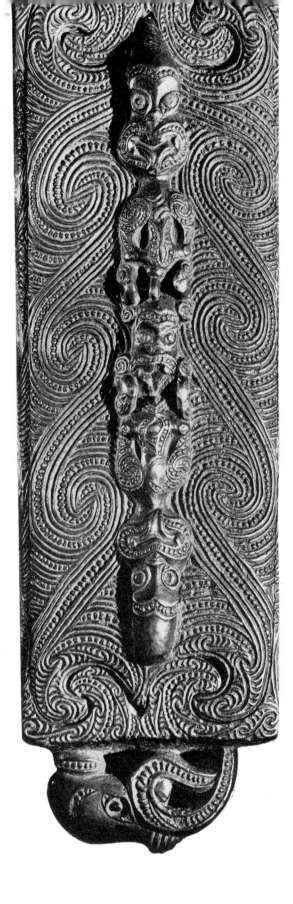

Detail
273669

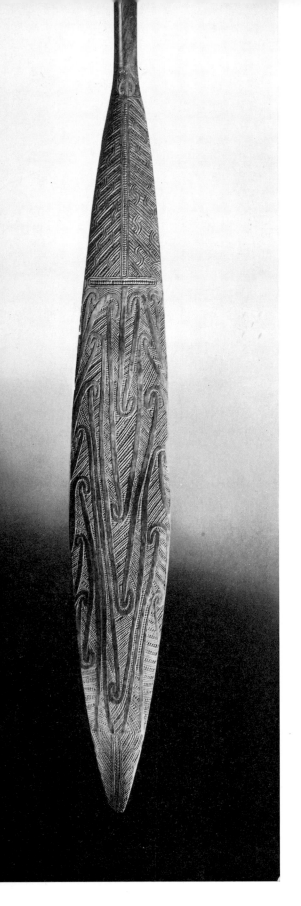

Canoe Paddle
273570
166.0 cm.

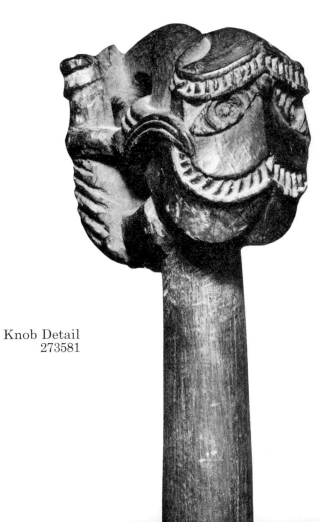

Knob Detail
273581

68

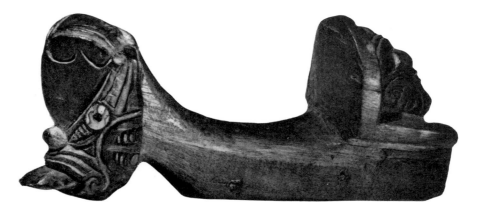

Fishing Canoe
Model Prow
273911
12.9 cm.

Canoe Bailer
273914
42.1 cm.

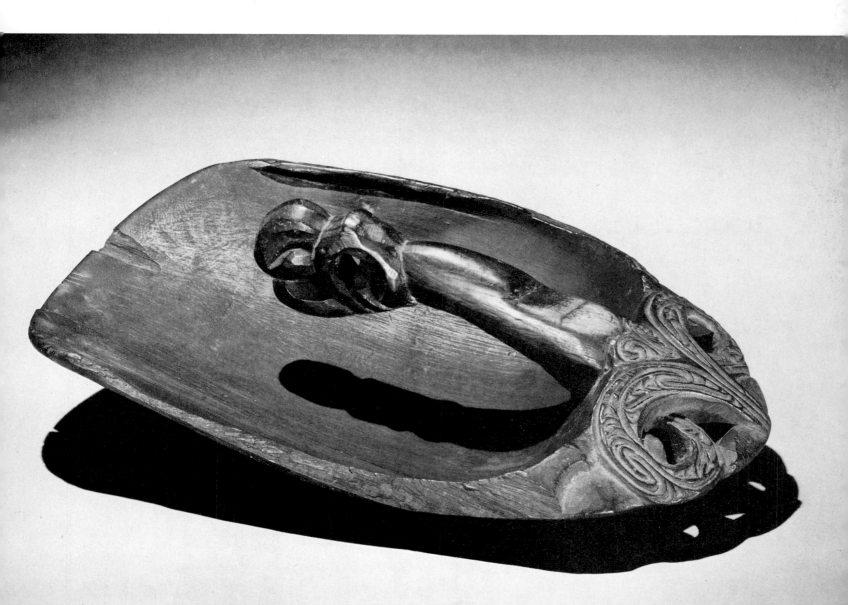

EASTER ISLAND

In all of the many thousands of Pacific Islands there is none other like Easter Island. Its grassy slopes and shore-line platforms are studded with huge stone figures whose somber gaze surveys the steep descent of the island into the sea with its absence of protective reefs. It is still shrouded in mystery nearly 250 years after its discovery by Jacob Roggeveen on Easter Day, 1722. So it is likely to remain except for archaeological evidence, the accounts of a few visitors and scholars, and the scattered cultural remnants in museums. Easter Island material culture is distinguished by unique carvings, incised script, and obsidian implements.

Some of the Easter Island materials are among the rarest and most outstanding pieces in the Fuller Collection. Not only did Fuller seek such pieces in England and on the Continent, but also through his close friend, the late Percy H. Edmunds, manager of a cattle ranch on Easter Island. Fuller became acquainted with Edmunds about the turn of the century and maintained a steady correspondence, sending him trade goods and receiving in return artifacts discovered on the island. This relationship continued through the quarter of a century Edmunds lived on Easter Island. It was later, through Mr. Edmunds, that Mr. Robert Trier met Captain and Mrs. Fuller, putting into effect a chain of events leading to the placement of the collection in the Field Museum.

There is a series of carved male and female figures of highly polished wood in the collection. However, there are two images which stand out from the others. The first is an ancestral figure (273234) in dark brown wood. Figures of this emaciated type have *71-72* been the subject of much conjecture as to what stimulated the style of carving. Attention to detail and finish set this specimen apart from others. Fuller believed it to be one of the finest, if not the finest, image of its type. Its eyes were formed by inlaying a fish vertebra in the socket and then placing a piece of obsidian in its center. The frigate-bird motif carved in low relief on the top of the head is a special feature.

Another outstanding image of hard, dark brown wood with excellent carving and a fine patina is 273235. The figure is a *74-75* combination of anthropomorphic and zoomorphic treatments. Its

Ancestral Figure
273234
43.9 cm.

70

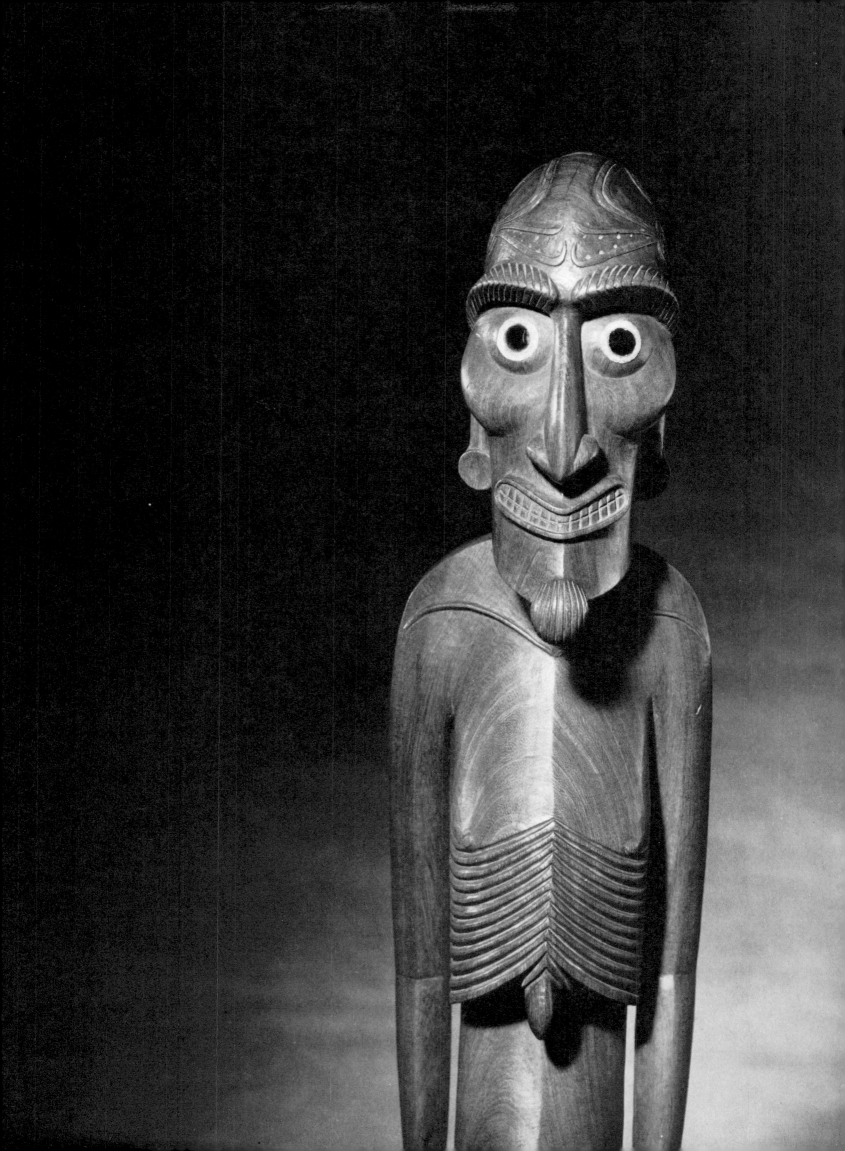

Ancestral Figure
273234
43.9 cm.

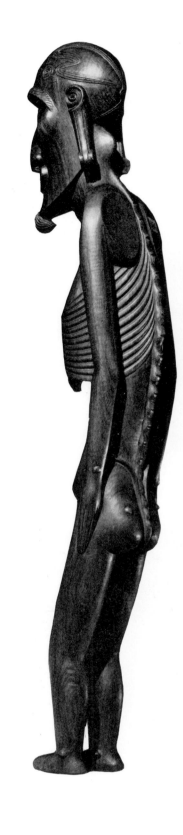
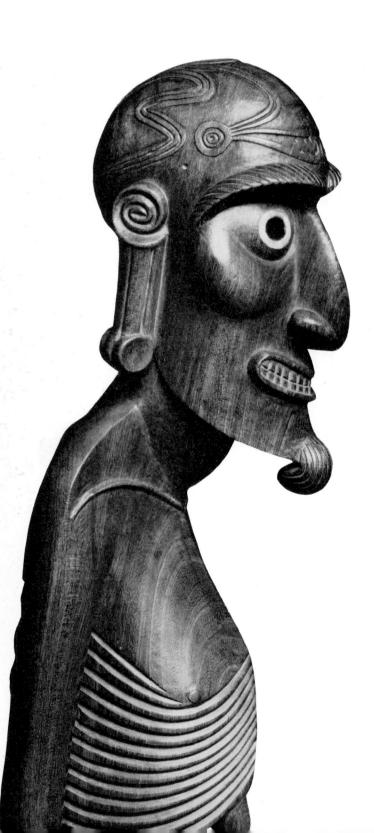

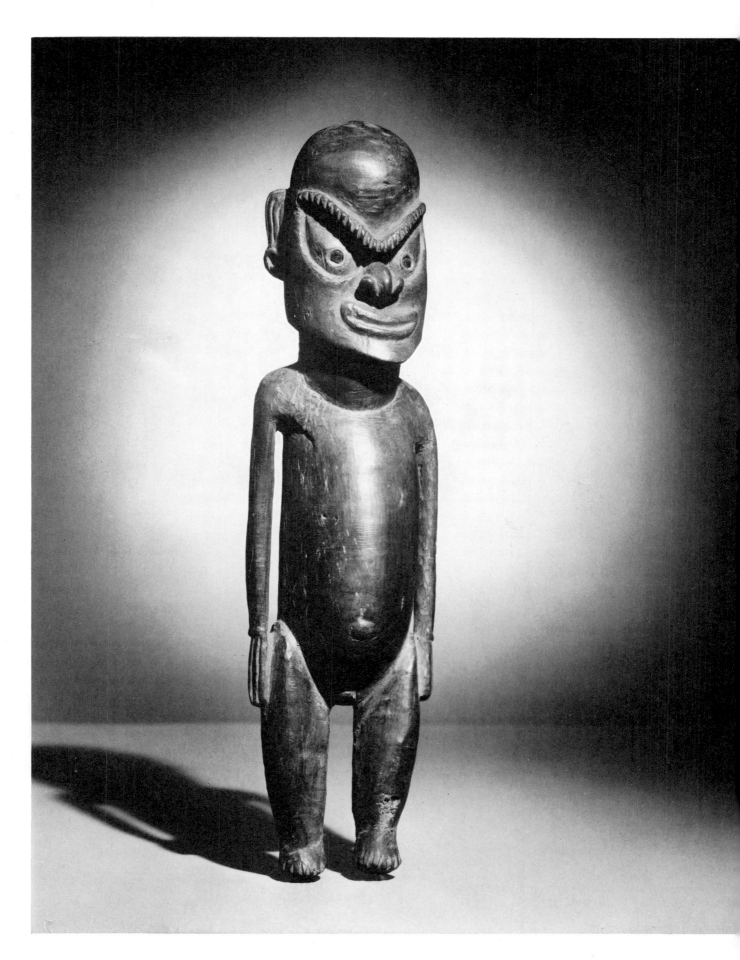

Carved Male Figure
273237
41.0 cm.

Lizard Image
273235
47.2 cm.

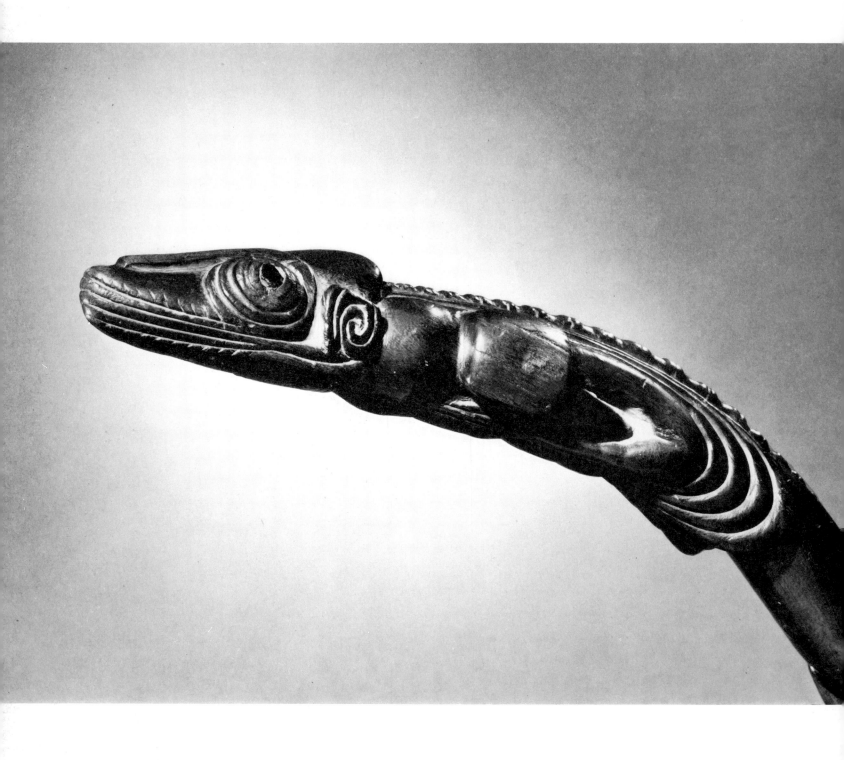

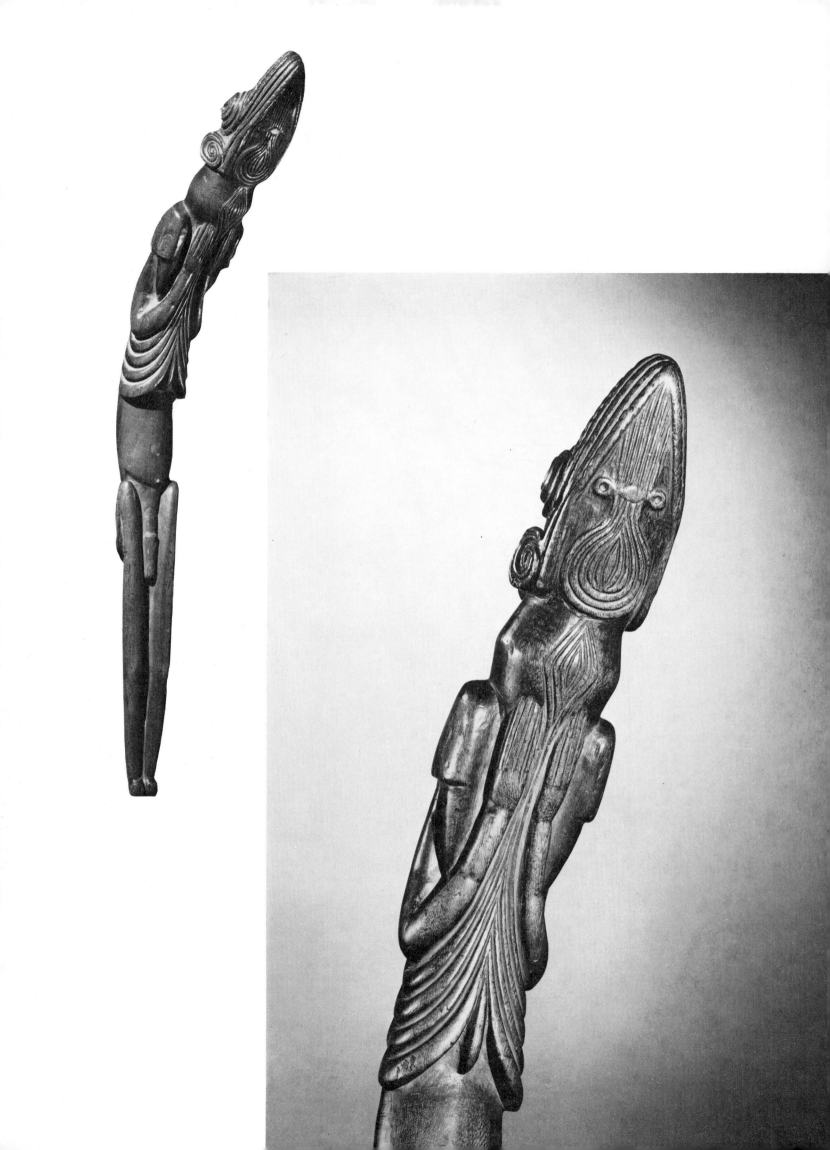

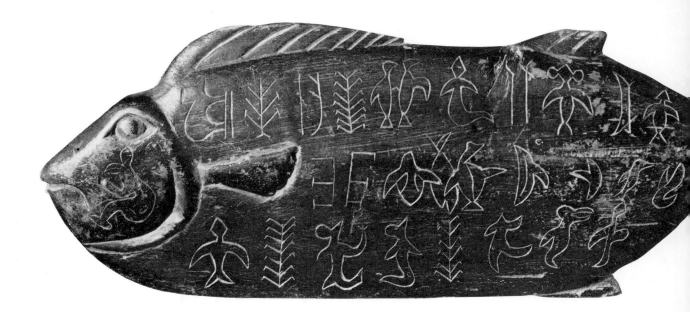

Script
273245
27.7 cm.

Obsidian Tool
273320
23.0 cm.

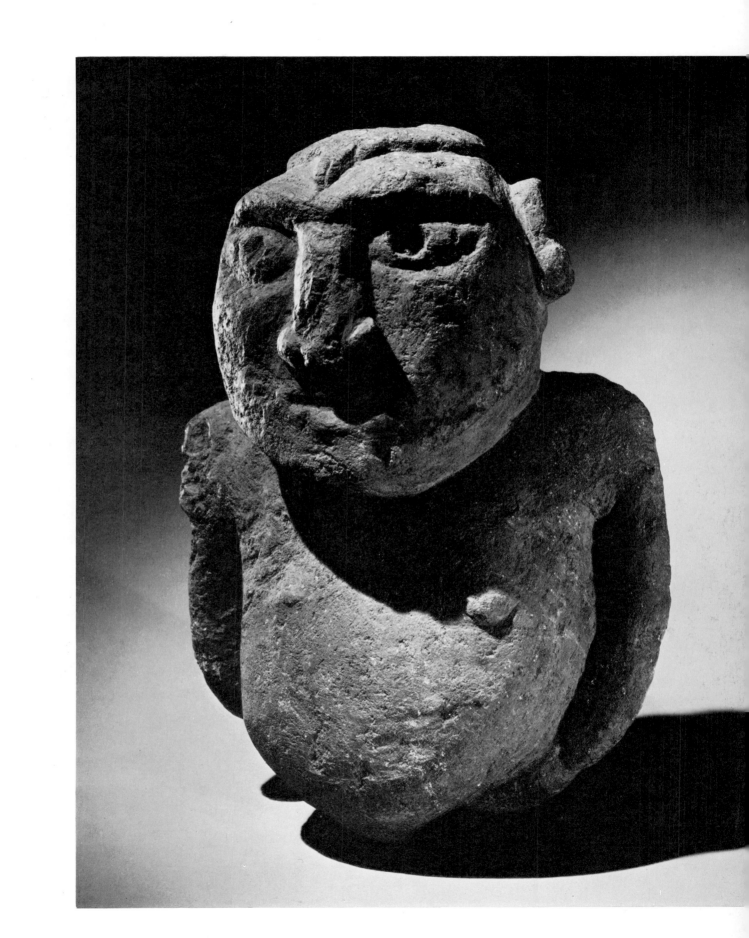

Stone Image
273266
28.6 cm.

77

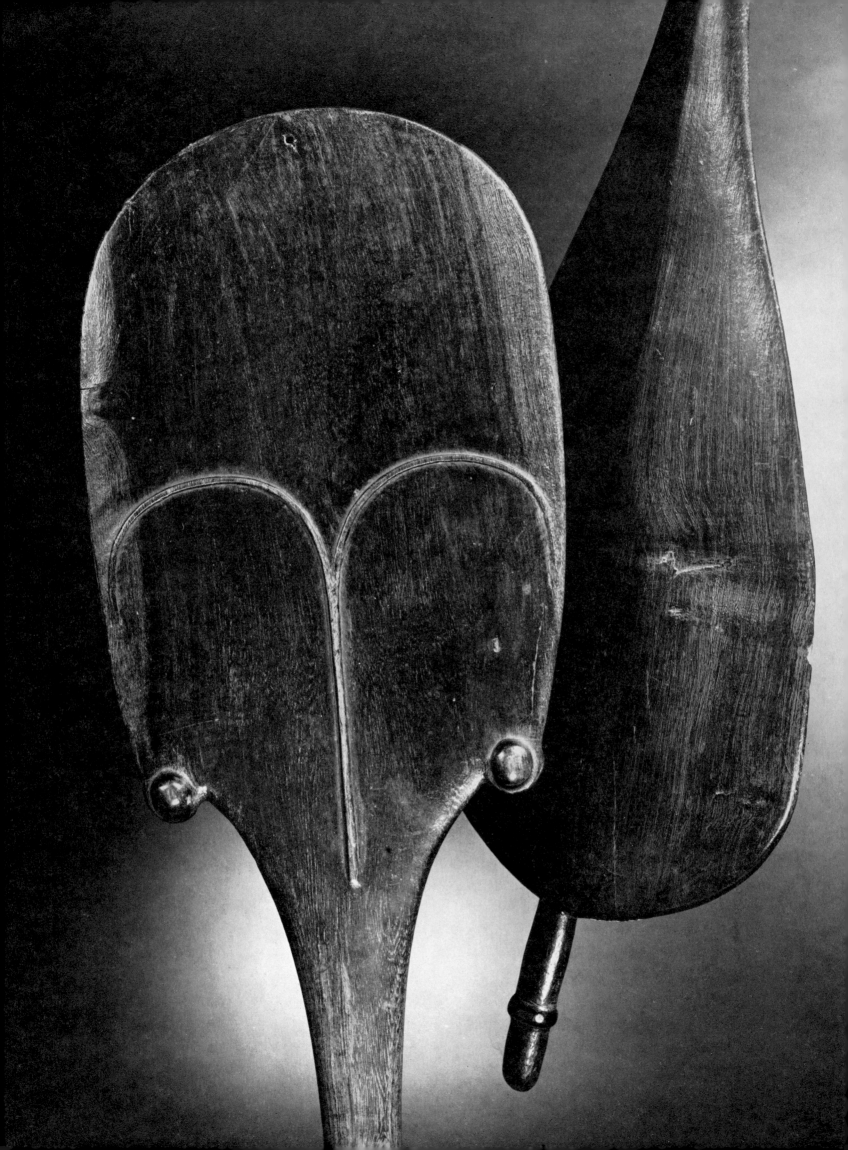

Detail
273253 (left)
273254 (right)

273254
81.7 cm.

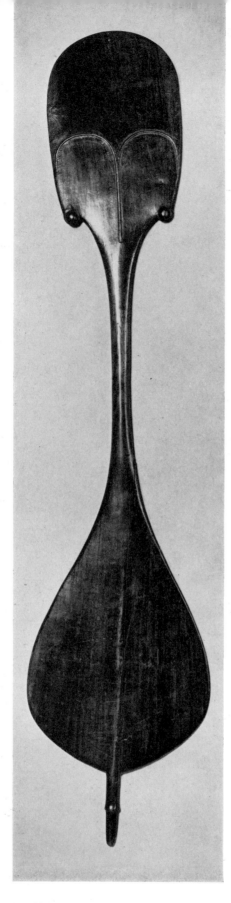

273253
91.0 cm.

Dance Paddles

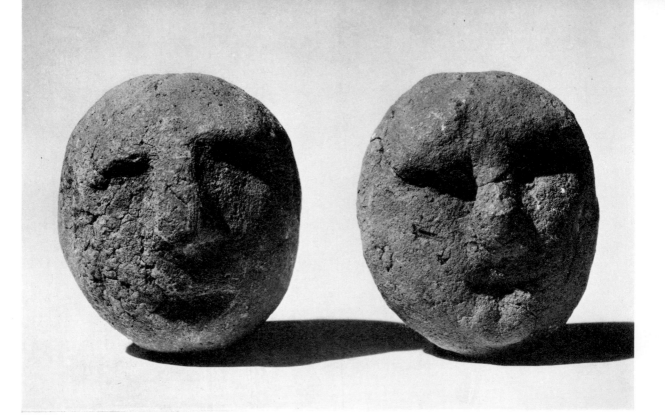

Modeled Pigment Balls
273255 (left) 8.8 cm.
273256 (right) 9.1 cm.

Pumice Image (left)
273257 9.6 cm.

Clay Image (right)
273258 10.2 cm.

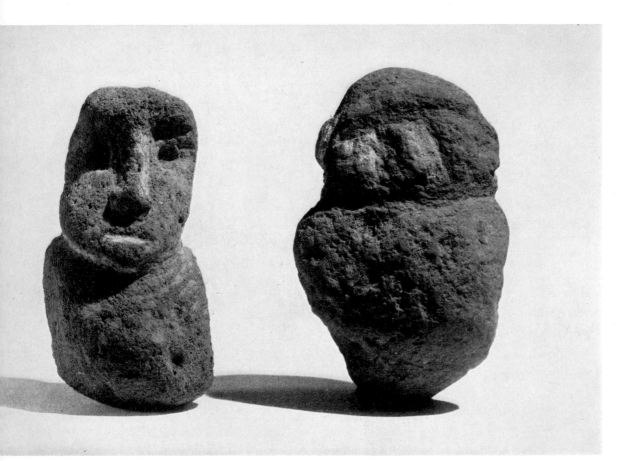

80

head is clearly that of a lizard with crudely chipped obsidian inlay for eyes. With its hands and arms folded over its chest, it has two sets of legs – one human, the other animal. A tail extends the length of the legs. There is a perforation for suspension under the lumbar vertebrae area and a fan-shaped carving is executed in the region of the sacrum. Other such carvings are known from Easter Island, but none equals the workmanship of this piece.

73 Another image (273237) represents a different type. Edmunds secured this male figure on Easter Island. It was thought to have been made prior to 1850. He also secured other figures, a breast *76* ornament, and a carved tablet (273245). Although made in 1925, this fish-shaped object features traditional script elements. Easter Island carvers produced distinctive staves or clubs which are represented in the collection. The four dance paddles in the Fuller *78-79* Collection (see 273253-54) represent the finest craftsmanship.

Several interesting stone images were collected by Edmunds. These differ from the gigantic images so often associated with the island. They resemble more the rough carvings of the Society *77* Islands. One is a crudely carved image (273266) with a stylized bird in relief on top of the head. Smaller images are of pumice and unfired clay. Two other pieces, described as pigment balls, have human features pressed into the surface. All of these and other materials of stone were deemed authentic by Edmunds. However, he acknowledged that even in his day the islanders were more than pleased to make objects for the infrequent visitors, a practice which has now become quite standard.

Edmunds also obtained nearly 150 adz blades of stone, chisels and other cutting tools, obsidian implements, and spear heads. In addition, Fuller acquired about fifteen obsidian implements, *76* including one hafted specimen (273320) from the Hemming Collection, which contained stone artifacts exclusively. Other items of special ethnographic interest are fishhooks, two tattooing implements, a number of bone needles, an awl, several netting needles, and most especially, two bark-cloth cloaks.

Finally, the incised human skulls in the collection are worthy of mention. The rarity of such items was increased when the Routledge specimens, housed in the Royal College of Surgeons in London, were destroyed during World War II.

THE HAWAIIAN ISLANDS

The Hawaiian Islands were among the last to be discovered by Europeans. To Captain James Cook, the islands he discovered in January of 1778 and named the Sandwich Islands in honor of his patron, the Earl of Sandwich, were the culmination of his three great voyages of discovery in the Pacific. They also were his nemesis. In the years following Cook's death a number of British ships called at Hawaii. Some of these were under command of such masters as Portlock, Dixon, Meares, Mortimer, Vancouver, and Broughton.

England maintained an active commercial and diplomatic courtship of the islands and her influence was felt in many ways, not the least of which was the emulation of European royalty by 19th-century Hawaiian monarchs. In the light of this history it is not surprising that some outstanding Hawaiian materials found their way to Great Britain. So it was with a feather god-image (272591) which was one of Fuller's most prized pieces. This extremely *83* rare image is a god representation, once the possession of a chief. It has a wickerwork frame with a fiber mesh covering to which are affixed red, yellow, and black feathers. It is the smallest of the few specimens of its type which remain. It is well preserved and generally red with a yellow band at the base of the neck. The crest is formed of yellow and black feathers. The eyes are of pearl shell with carved wooden pupils. The teeth are small shark teeth. A wicker prop of two pieces is visible through the mouth aperture.

Fuller finally obtained the specimen in about 1926 from a family named Bate who lived near Portsmouth, England. He had known of the image for some years and it had been in the Bate family for several generations. The family tradition was that it had been collected by a member of Cook's third voyage who then gave it to one of the ancestral Bates. A very old script on several pieces of wood which served to ring the specimen around the base indicated that the piece was a 'Feathered Idol [from the] Sandwich Isles . . . South Seas: See . . . Cooke's [*sic*] Last Voyage.' It should be noted that the records of the Royal Society of 1768 spelled Cook's name with an 'e.'

Feather God Image
272591
26.5 cm.

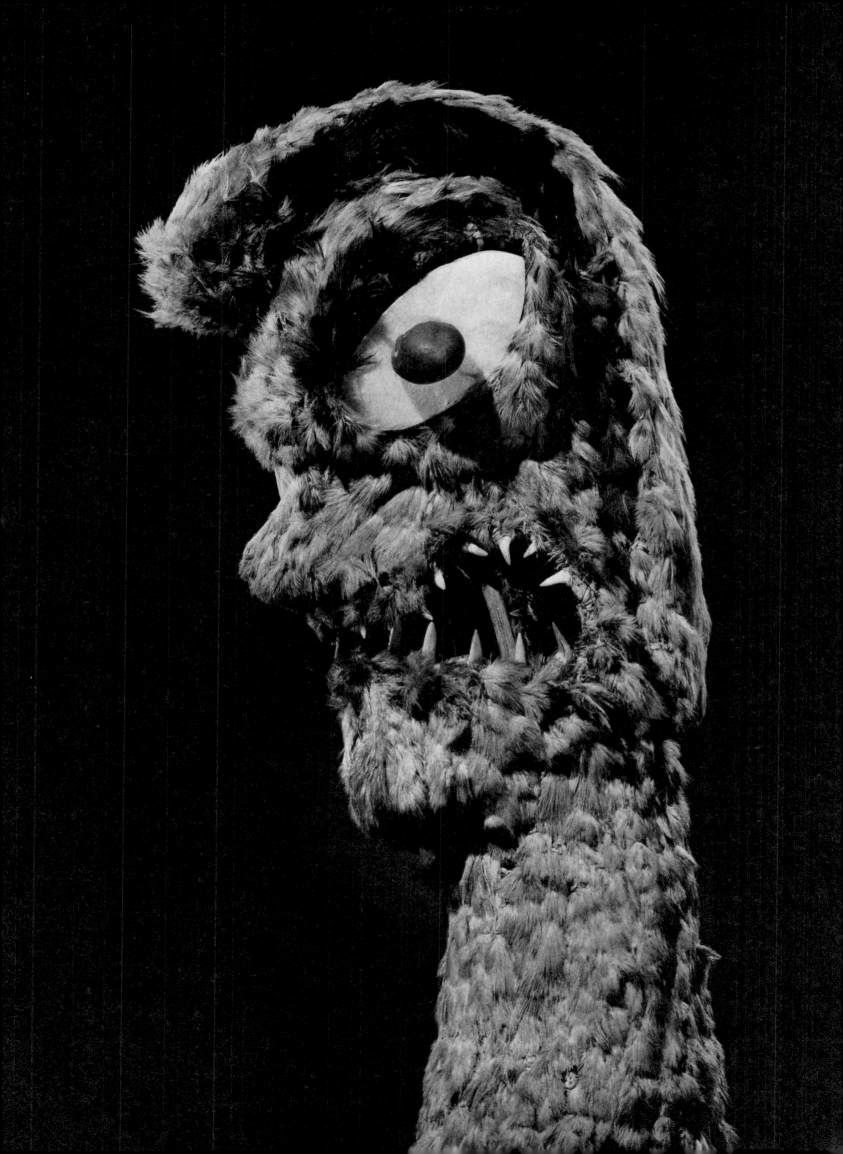

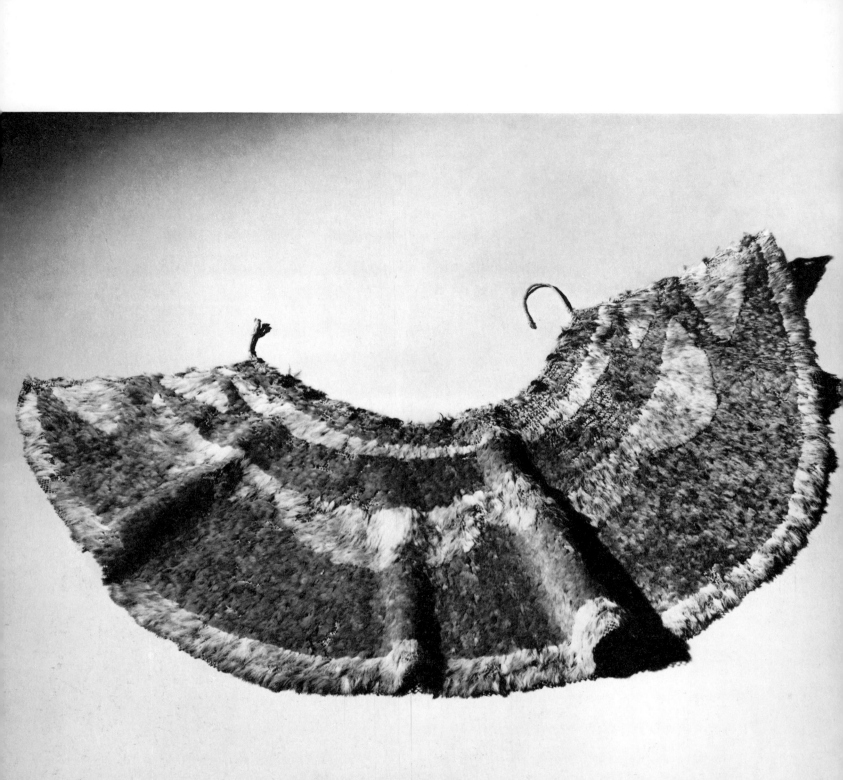

Feather Cape
272588
Height 32.0 cm.
Width 73.0 cm.

84

Feather Cape
272589
Height 28.0 cm.
Width 55.0 cm.

Wrist Ornament
272601
5.1 cm.

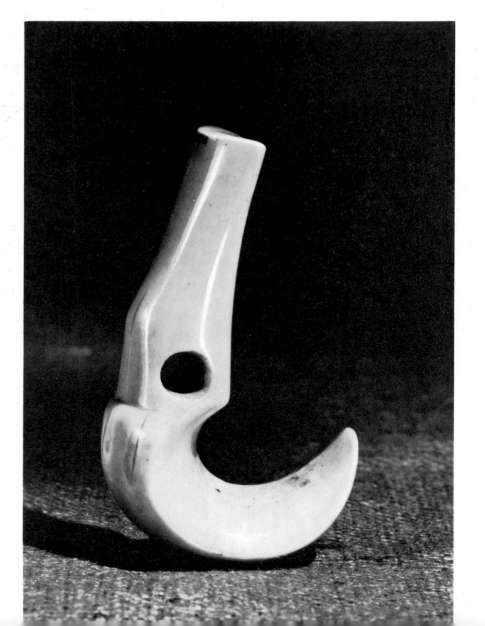

Hook Pendant
272598
11.0 cm.

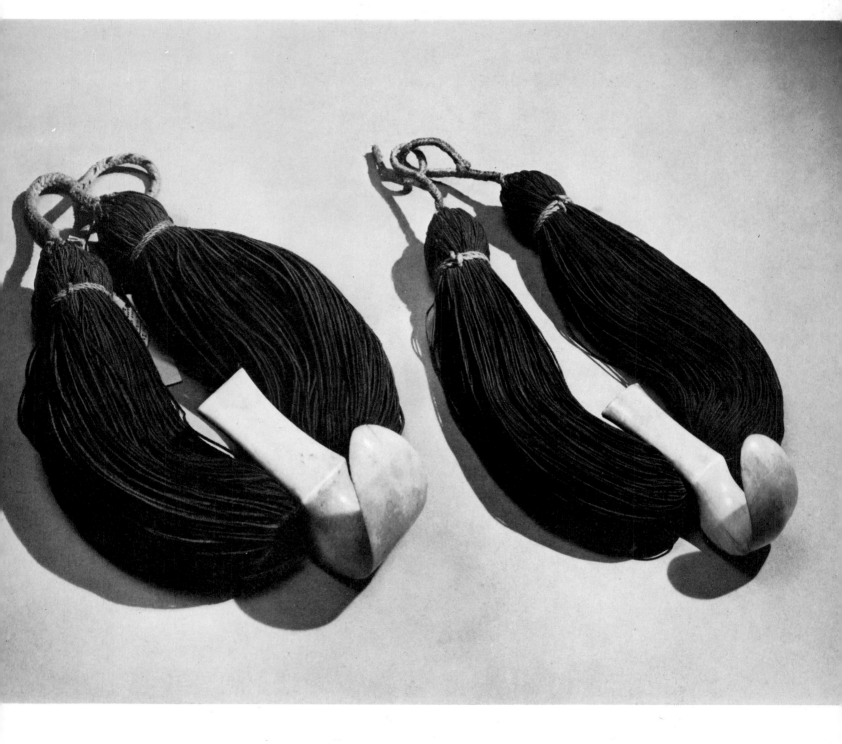

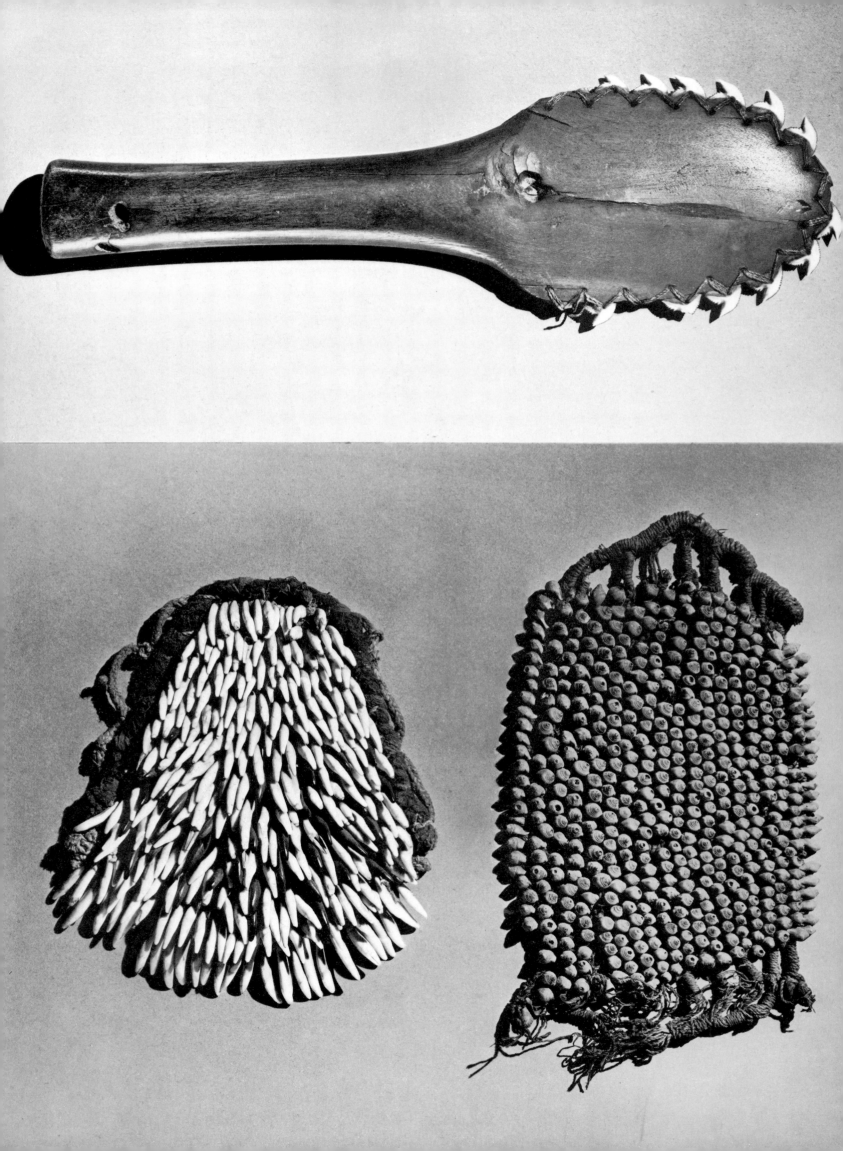

Weapon
272596
26.0 cm.

Dance Ornaments
272603 (left)
272604 (right)

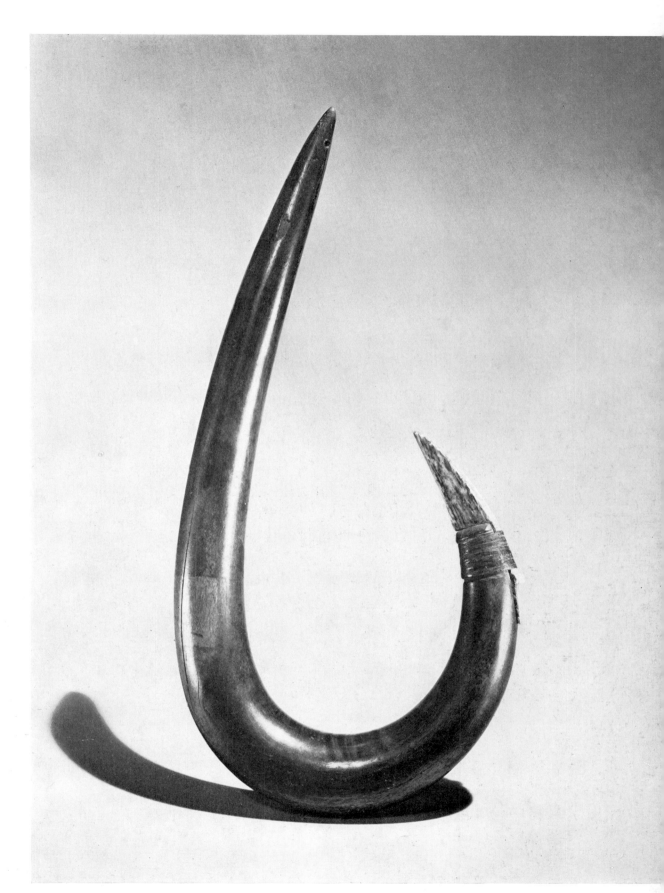

Shark Hook
272592
30.0 cm.

89

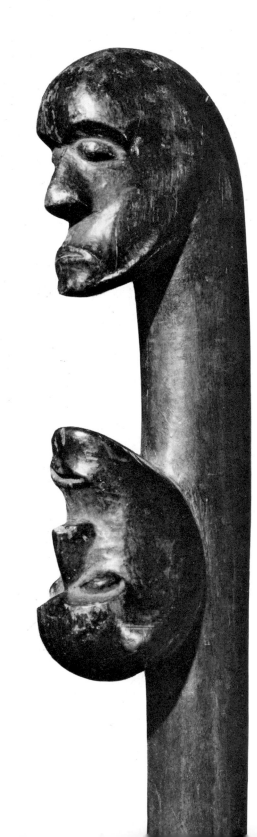

Detail Carrying Pole
272597
163.0 cm.

90

Spear Rest or Drum Support
272602
23.0 cm.

Temple Image
272689
133.0 cm.

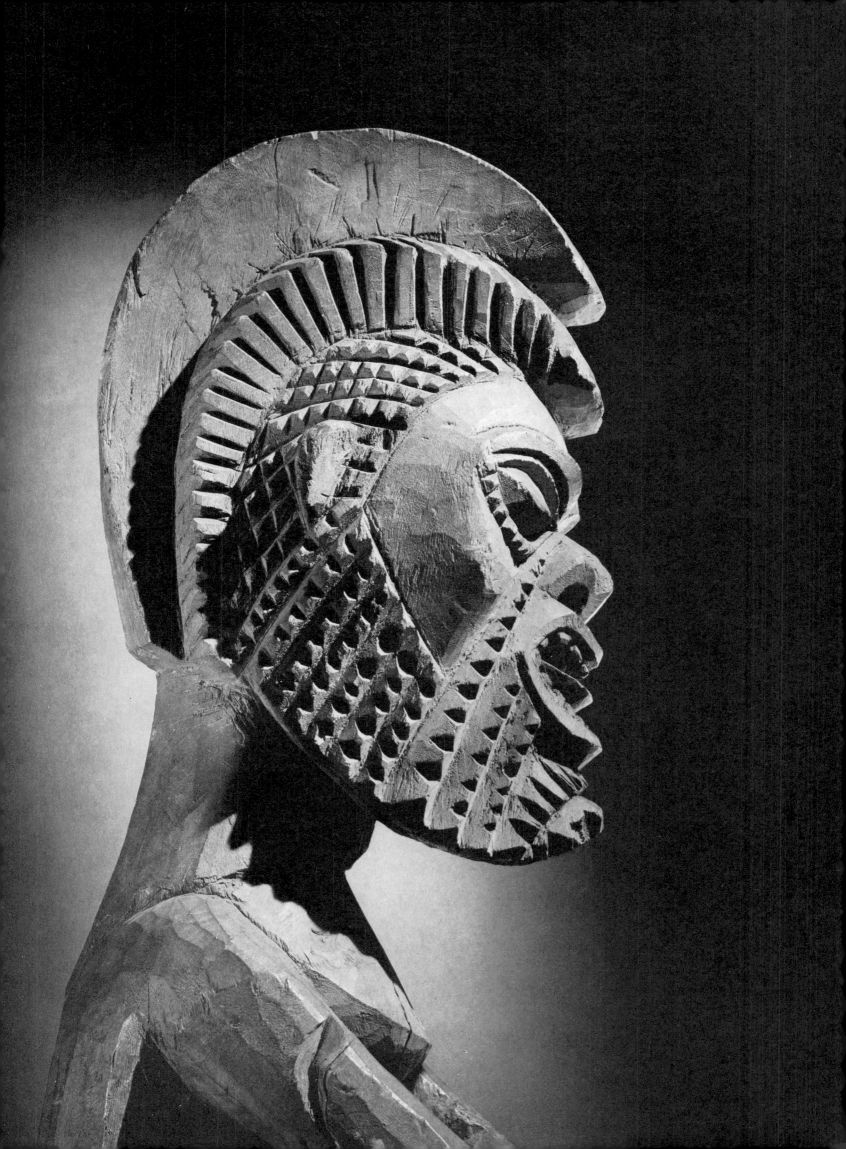

The approximately eighty artifacts from Hawaii in the Fuller Collection are among the finest in the assemblage. They range from the exceedingly rare and ceremonial feather god-image to two utilitarian canoe paddles of early date. Weapons, calabashes and gourd containers, ornaments, bark cloth and bark-cloth beaters, adz blades, fishhooks, images, game stones, pounders, dance rattles, and garments are included.

One of two feather capes is 272588, formerly in the Chichester *84* Museum. This slightly eroded cape is mostly of red feathers with intrusive yellow ones. It was brought to England in 1824 by Kamamalu, wife of Liholiho, Kamehameha II, and was given by her to King George IV. An old handwritten label attached to the specimen and dated March 1 (or 12), 1826, reads on one side 'This Tippet was given by the late Queen of the Sandwich Islands to His Majesty Geo. 4th. The King presented it to the Hon[oura]ble Miss Paget, by whom it was given to the Duchess of Richmond.' The other side reads 'A Feather Tippet worn by the late Queen of the Sandwich Islands presented by Her Grace the Duchess of Richmond. Certhia Vestiaria.'

Fuller supplied this further history. The Duchess of Richmond gave the cape to Mr. E. Humphrey, who left it to his nephew, Mr. Humphrey Freeland, who presented it to the Chichester Museum on February 24, 1853. On June 4, 1912, Fuller acquired the entire ethnological collection of the Chichester Museum and the cape with it.

Feather garments were produced in Polynesia in but three locations – New Zealand, the Society Islands, and Hawaii. In each location both the nature of the garment and its mode of manufacture were different. The quality of Hawaiian featherwork was unsurpassed.

A second cape (272589) of mostly yellow feathers with a large *85* central crescent and four small frontal triangles of red, has a cervical and frontal border of red, yellow, and black feathers. Formerly in the J. Edge-Partington Collection, it was acquired by Fuller on March 7, 1913.

One small item (272602), also from the Edge-Partington Collec- *91* tion, invites discussion. It may have served as a spear rest, as Edge-Partington's label, which is affixed, reads: 'Hawaiian Is. Chief's spear rest for fixing outside houses.' Its form suggests, however, that it may equally as well have served as a part of a drum support.

Whale ivory was used by Pacific craftsmen to produce a variety of decorative objects. In Hawaii some of the most distinctive items

of adornment were necklaces of multiple strands of braided human hair from which carved hooklike pendants *(lei niho palaoa)* of great beauty were suspended. Walrus tusks were later adapted to this use. The Fuller Collection incorporates two complete neck-
87 laces (272599, of whale ivory, and 272600, of walrus ivory) and one
86 hook pendant of walrus ivory (272598). Walrus ivory also came to
86 be used for wrist ornaments, as with 272601.

In ancient Hawaii dancers wore leg ornaments which featured row after row of dog teeth, drilled at the root end and tied to the
88 base tight against others. Such a specimen is 272603. Not only does this specimen contain 268 dog canine teeth (a contribution of at least 69 dogs as one dog has but four such teeth), but present also
88 are 37 simulated dog teeth carved of wood. Less common is 272604, an ornament covered with small sea shells rather than teeth.

Not only did Hawaiians use dog teeth in the manufacture of artifacts, but shark teeth also were used to produce weapons and tools. One such piece, originally incorporating sixteen shark
88 teeth, is 272596. Along with several gourd containers, this speci-men was acquired by Fuller from the Duke of Leeds Collection, Hornby Castle. This noted 18th-century collection is thought to have included Cook pieces.

89 Sharks were caught with large composite hooks such as 272592. The shank of hardwood ended in a bone point. Fuller obtained this hook and many other fine old pieces, including Hawaiian adz blades, from the Rosehill Collection of Lord Northesk. Rosehill was the name of the country house of the Northesk family which formed a private collection probably in the late 18th century. The Rosehill Collection was sold at auction in 1924. Sir Henry Wellcome purchased most of it. After his death, many items from his collection, including Rosehill materials, were sold. This sale, in 1939, enabled Fuller to secure a great number of Rosehill pieces.

Carrying poles were used to carry burdens in Hawaii. Cala-bashes, cradled in mesh, were suspended from either end. In some cases the ends of the poles were handsomely carved with human likenesses. These heads or faces have been said to be a form of portraiture. Not all carrying poles were graced by the elegance of
90 treatment seen on 272597.

Hawaiian bark cloth *(kapa)* was as fine as any produced in the Pacific and, in some examples, without parallel in its decoration. The Fuller Collection contains small swatches of *kapa* said to have been collected by Cook and larger segments anciently cut from full sheets. The bold dramatic designs of these samples are striking.

Artifacts of wood round out the Hawaiian materials. Two canoe

paddles were derived from early collections. One stemmed from the Banff Museum in Scotland. The other was formerly in the William Bullock Collection which was dispersed in 1819. An image (272689) of special historical significance deserves comment. This *92-93* large male figure is the mate to the Bloxam image in Bishop Museum. It is likely that both were secured from the royal mausoleum (*Hale O Keawe*) in the City of Refuge at Honaunau on the Island of Hawaii where they probably flanked an altar. Andrew Bloxam and his brother, the Chaplain on the *Blonde,* took the image which now bears their family name to England where it remained for many years. Later it was cared for by a relative in New Zealand before it was returned to Hawaii in 1924, 100 years after its departure. The Fuller image is virtually identical in form and treatment. Fuller secured the carving in 1911 from a Mr. F. G. Springer of Springerhill Court, Southampton. Springer had secured it from an 'old family' in whose possession it had formerly been. The lady from whom Mr. Springer obtained the figure said that it had descended to her through two generations and was of the opinion that it had originally been collected by a member of Captain Cook's third voyage. It is likely that she confused this voyage with that of the *Blonde* which called at the temple on Hawaii in 1825, while paying a sentimental call at the neighboring site of Cook's death.

THE MARQUESAS ISLANDS

Six main islands and as many small ones make up this group in east-central Polynesia north and east of the Societies. Mendaña, who discovered the southern Marquesas in 1595, named them Las Islas de Marquesas de Mendoza, after the wife of the Viceroy of Peru. Other islands in the group were discovered in the late 18th century by British, French, and American voyagers. France has maintained political control since 1832. The islands are volcanic and fertile.

The ancient Marquesans were ardent warriors, practiced cannibalism, and emphasized body tattooing. The remnants of Marquesan culture which have survived reflect preoccupation with stylized design in worked materials of bone, wood, and stone. Bark cloth, feathers, tortoise shell, and human hair, as well as porpoise and whale teeth, were also used in the manufacture of objects of great aesthetic appeal.

The evidence of creative vigor in the Marquesas of old is matched to some degree by evidence of vigorous destructive behavior. Warriors were fierce, their weapons cruel. Tribal strife was the rule. Revered men were accorded a special distinction in that their skulls were preserved after death. It is also possible that some heads were preserved as victory trophies. Accounts allow *101* for either interpretation. A preserved skull (272749) forms the nucleus of the Marquesas portion of the Fuller Collection. It is much-handled and brown with age. A wad of tapa cloth is in the nasal aperture and a finely braided construction of sennit cord binds the mandible to the cranium. When Fuller acquired the specimen in 1926, it had been in a storage repository for forty years.

Not only did the Marquesans adorn their bodies with designs, but they provided a range of ornaments to be worn so as to enhance their appearance. Among these were finger ornaments of white *102* tropic-bird feathers, sennit, and human hair (272789-91). Pearl shell *103* was used to create head ornaments such as 272779-80. Ear orna- *104* ments were made of whale ivory (272786-87), boars' tusks (272788), *108* and porpoise teeth (272784-85). Trade beads were sometimes affixed to such ornaments. Head ornaments were made of black

cock feathers, as were gorgets like 272781. This specimen was *109*
collected by Rear-Admiral W. Brabazon Lowther in 1852. It is
embellished by small worked whale teeth which are affixed to the
ties. Other ornaments in the collection are of human hair and one
is a necklace of boars' tusks.

Cords of braided sennit were used to suspend coconut containers.
Small, carved, tubular ornaments of human bone and seeds were
strung on the cords. Numbers 272782 and 83 are excellent *105*
examples. Human hair was used not only to adorn the body, but
also to enhance the appearance of artifacts such as war clubs,
shell trumpets (272753), drums (272756), and staves (272758). An *110, 107, 111*
additional staff in the collection is almost bereft of the human hair
knob which once adorned its top. The band of woven sennit on
272758 displays two lizards and several geometric patterns. *111*

Two exceedingly rare items are harpoon heads of whalebone
(272776-77). Sculpture from the Marquesas is generally dramatic. *106*
A wooden figure (272755) is reminiscent of older canoe-prow *100, 113*
carvings. The blades of Marquesas canoe paddles (272764-65) *112*
terminate in bulky projections.

Marquesan war clubs were of several types. The type called *uu*
with stylized faces for heads and sennit-wrapped grips are of
dense, hard wood. Most are deep brown or black. Numbers
272759-61 and 63 are of fine quality and represent the pre-European *114, 115*
period. Tufts of white human beard hair and black human hair at
times adorned the grips of such weapons. Several *pa'ahua* or
paddle-clubs are present, some from a 19th-century collection. The
seven footrests for stilts in the collection (272795-801) present a *116, 117*
good range of variation. This segment consists of slightly more
than fifty pieces.

Carved Figure
272755
67.0 cm.

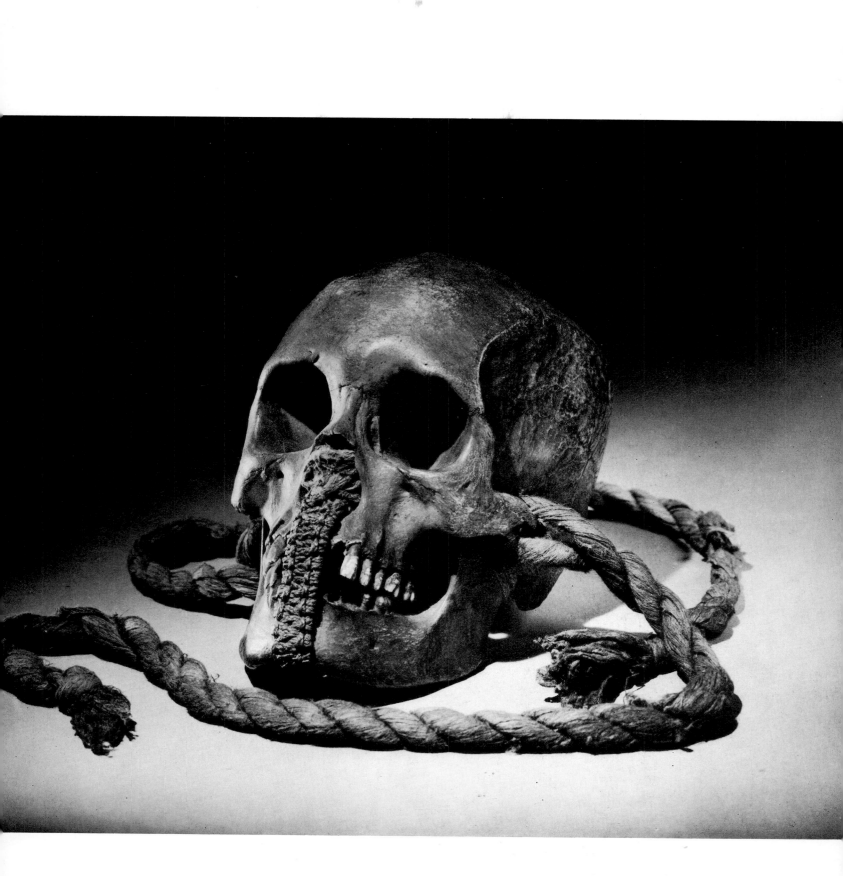

Preserved Skull
272749

Finger Ornaments
272789 (left)
272791 (center)
272790 (right)

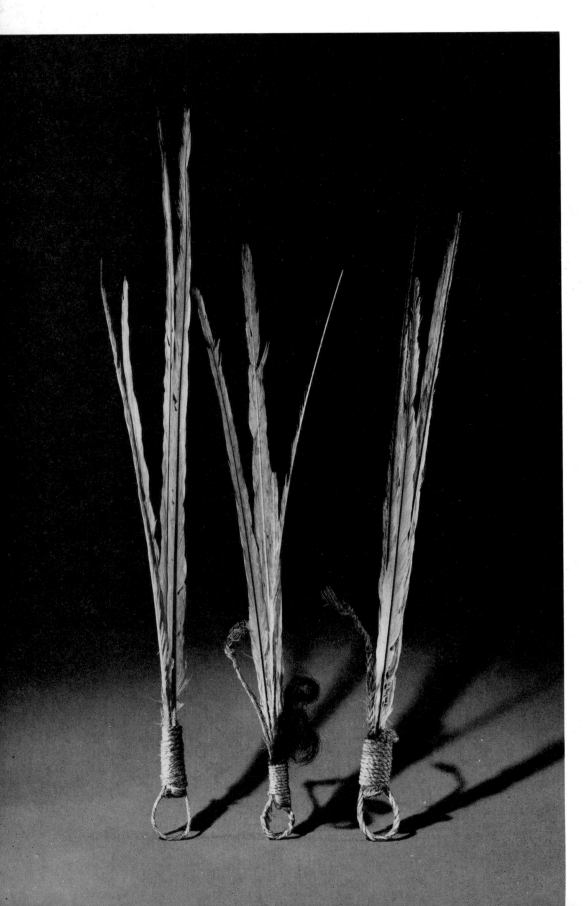

Head Ornament
272780

Head Ornament
272779

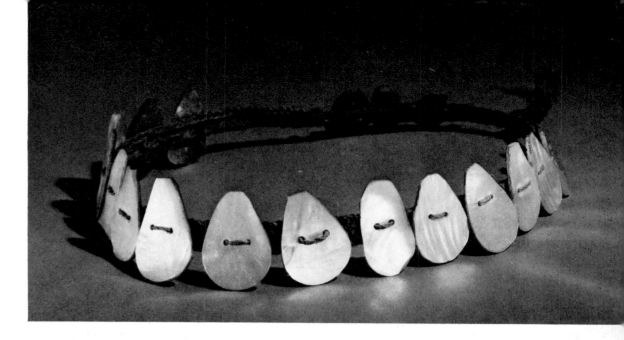

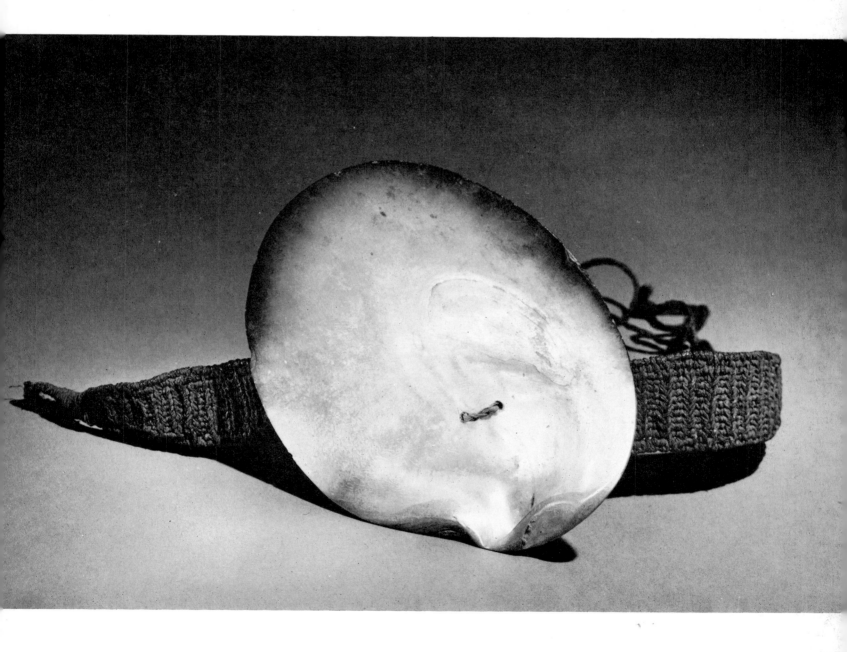

Ear Ornaments
272786
4.5 cm.

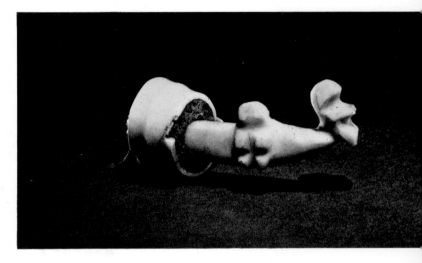

Ear Ornament
272788
5.8 cm.

Ear Ornaments
272787
8.9 cm.

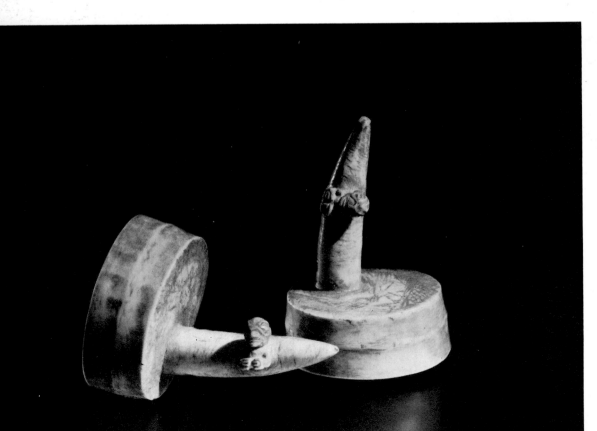

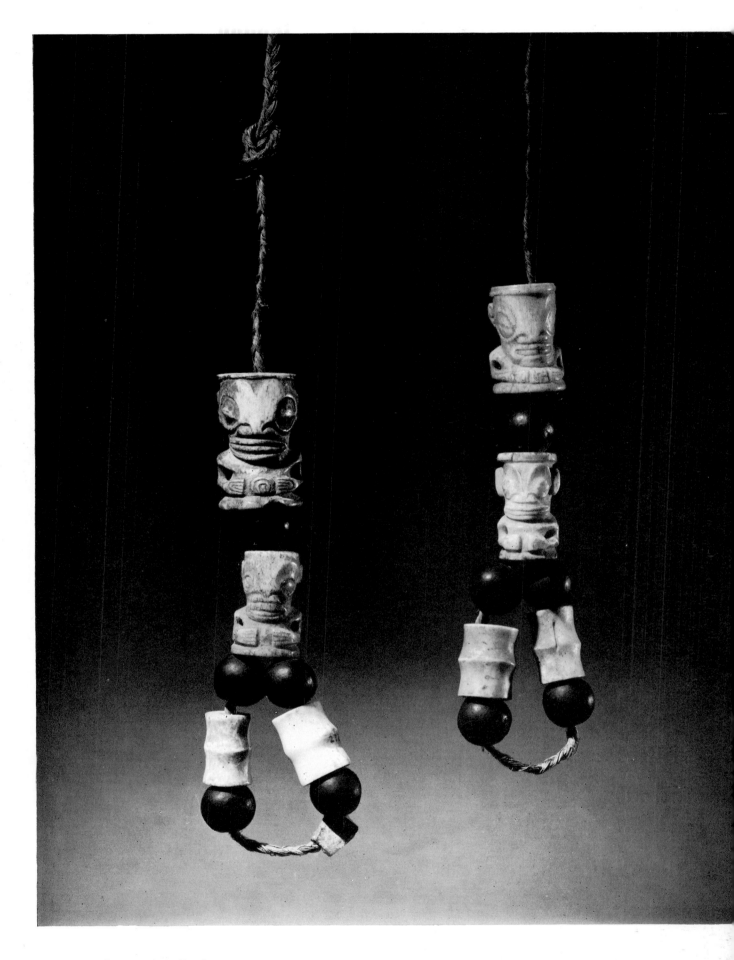

Suspension Cords
272783 (left)
272782 (right)

Butt Detail
272776

Harpoon Heads
272777 34.1 cm.
272776 31.0 cm.

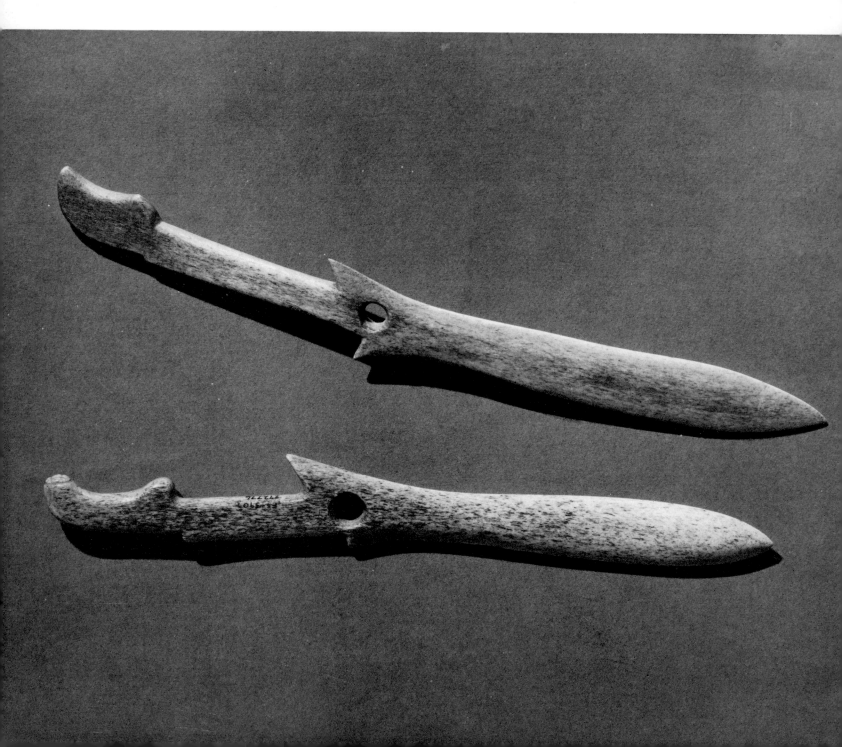

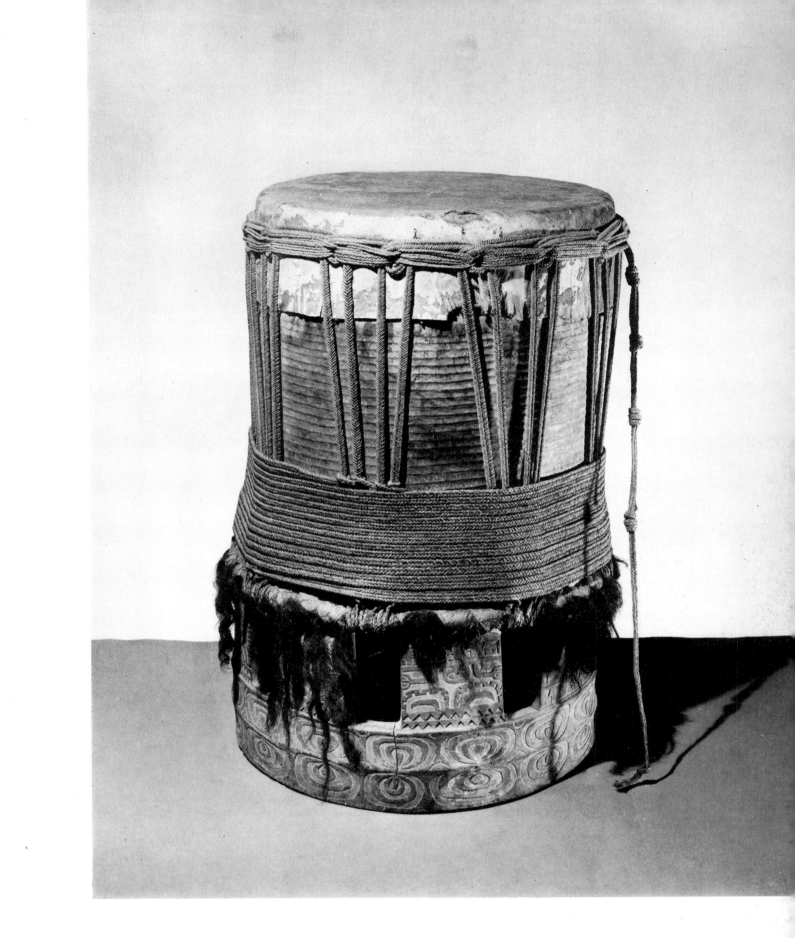

Drum
272756
68.0 cm.

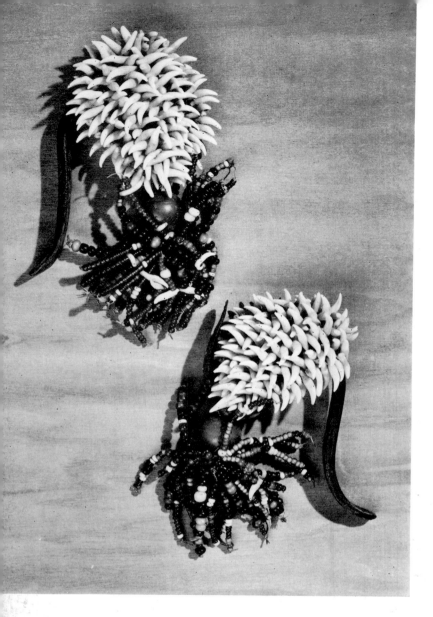

Breast Ornament
272781 69.0 cm.

Ear Ornaments
272784

Ear Ornaments
272785 7.0 cm.

108

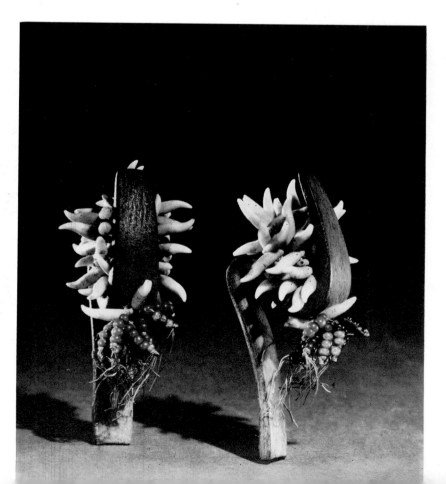

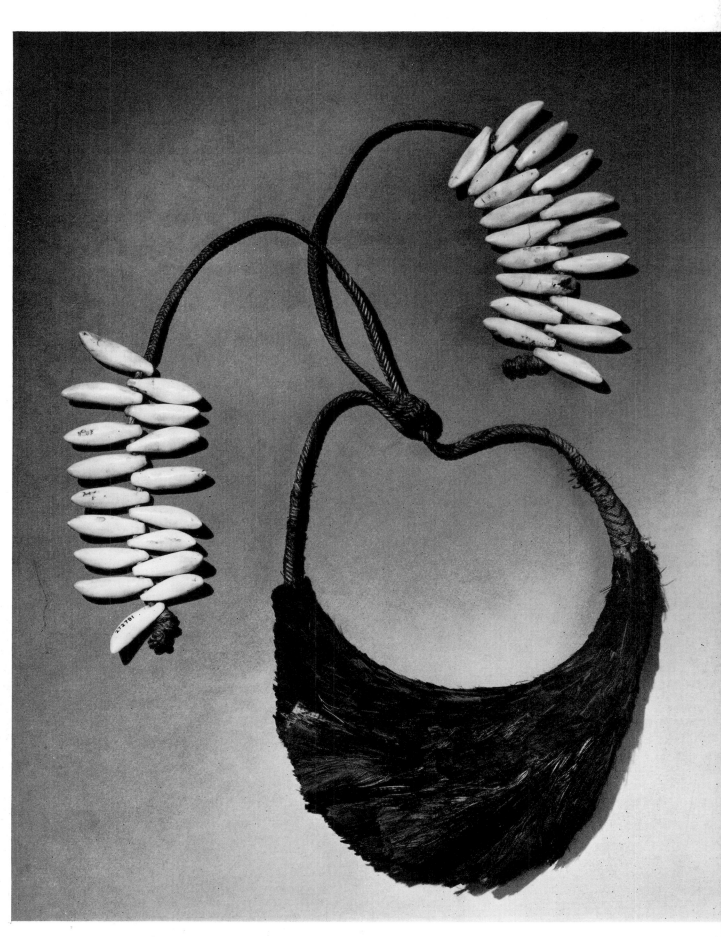

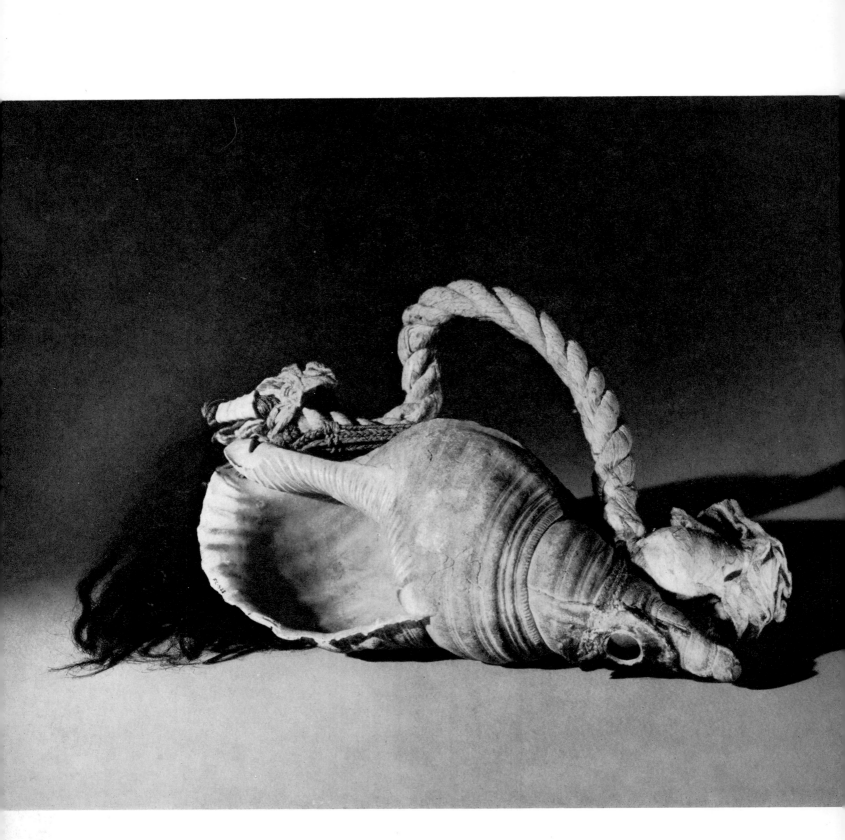

Shell Trumpet
272753

110

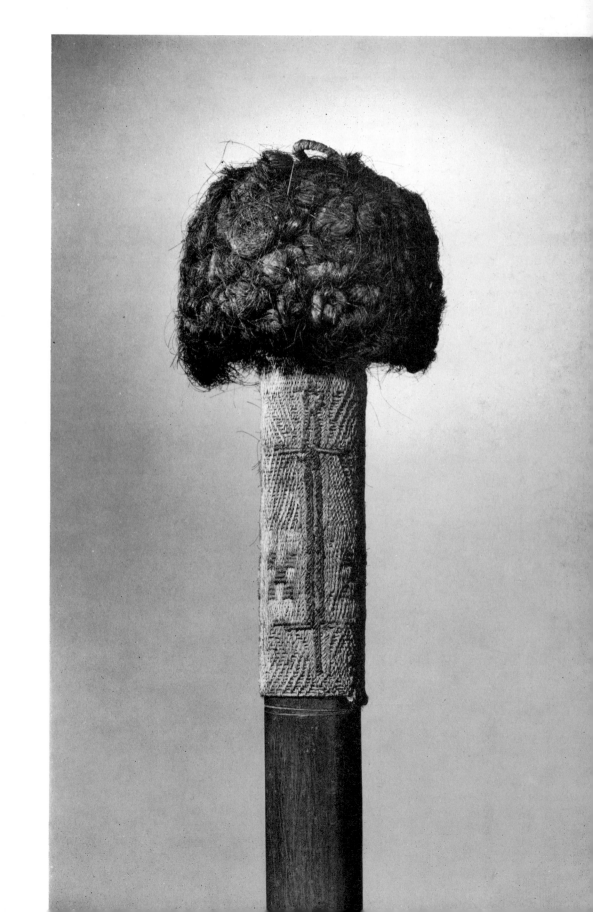

Canoe Paddles
272764 (left) 135.7 cm.
272765 (right) 166.0 cm.

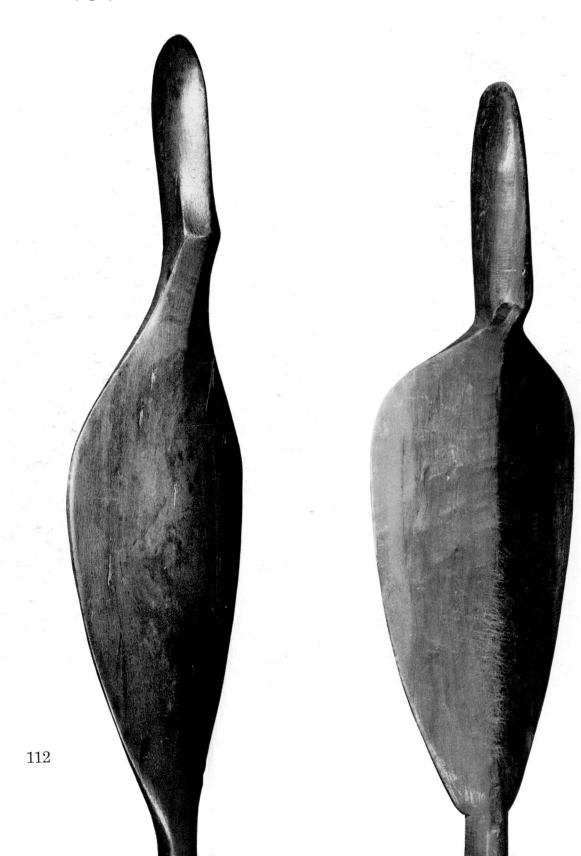

112

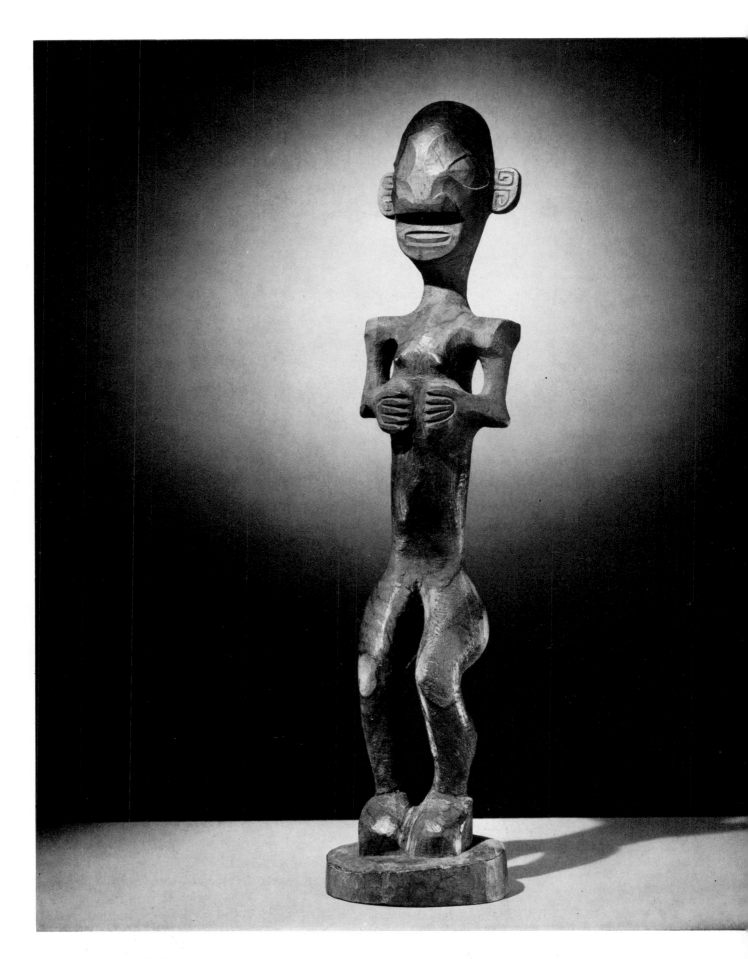

Carved Figure
272755
67.0 cm.

Carved Clubs (left to right)
272763 140.2 cm.
272759 135.8 cm.
272761 140.6 cm.
272760 149.4 cm.

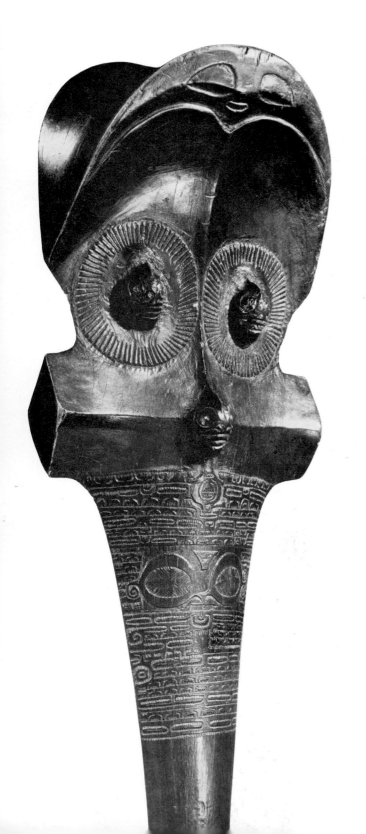
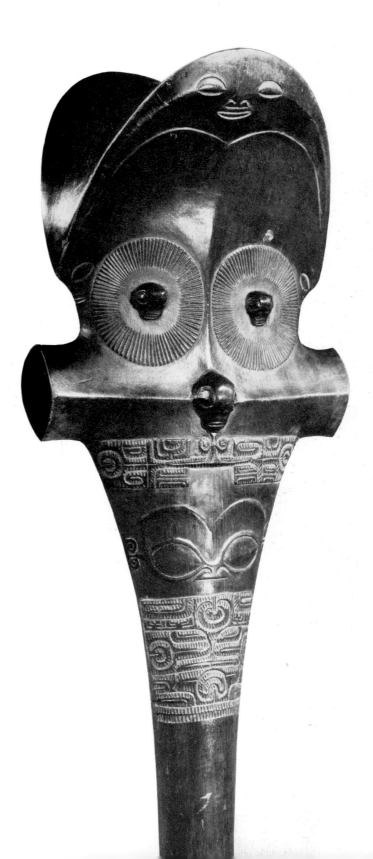

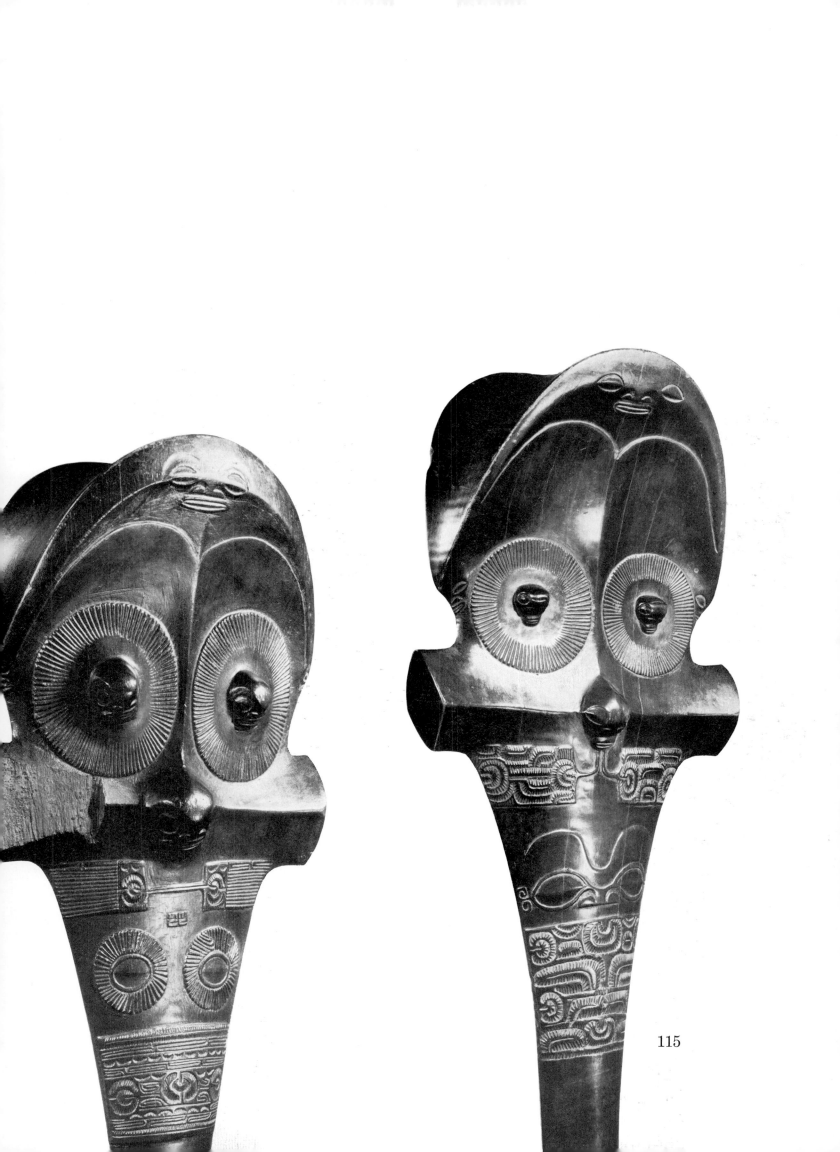

115

Stilt Steps
272798 (left) 33.5 cm.
272801 (right) 28.8 cm.

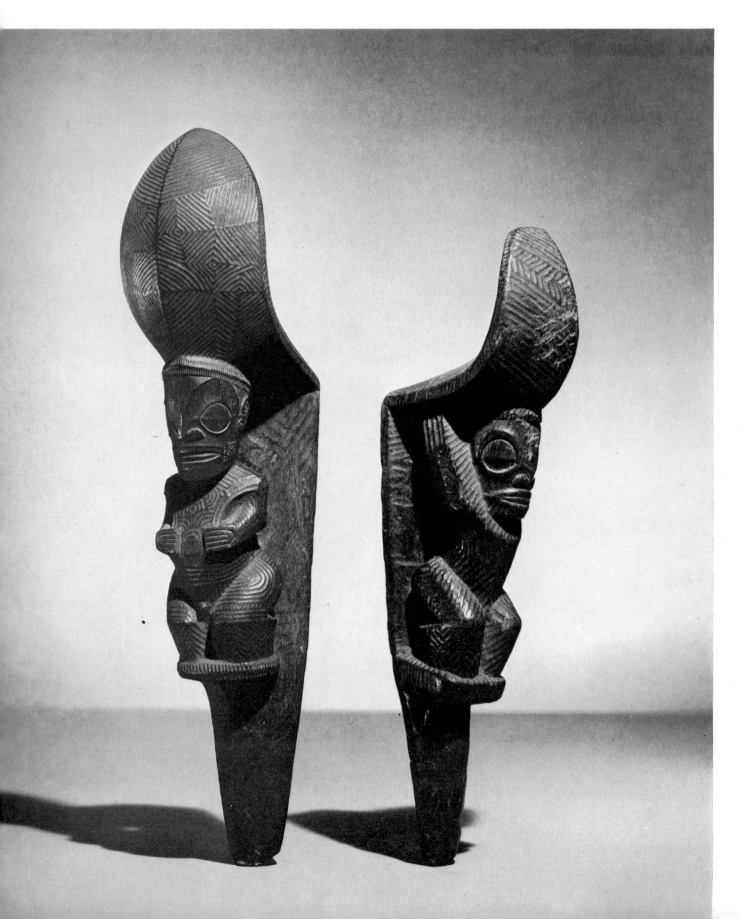

Stilt Steps (left to right)
272798 33.5 cm.
272801 28.8 cm.
272797 34.5 cm.
272799 35.0 cm.
272800 26.6 cm.
272795 43.0 cm.
272796 36.0 cm.

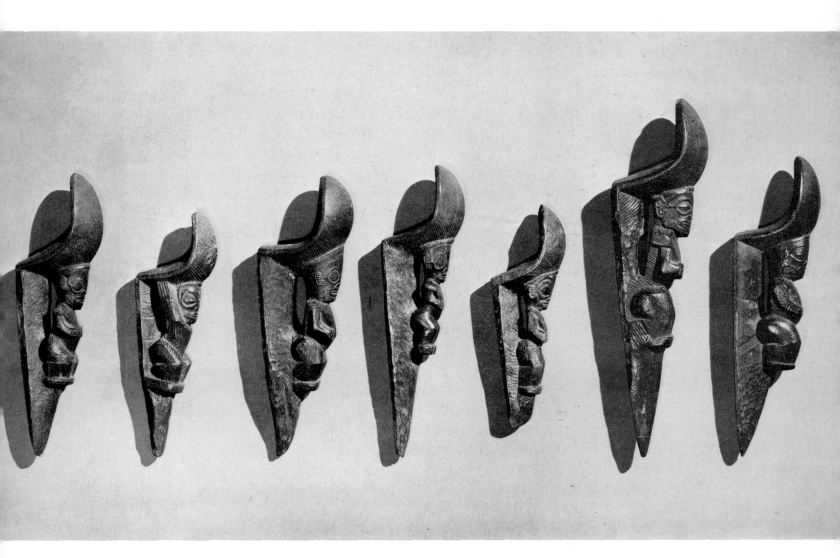

THE SOCIETY ISLANDS

The Society Islands, situated in central Polynesia and today a part of French Polynesia, have a special significance for culture historians. They provided the point of origin for many migrating groups of Polynesians who ultimately settled the more far-flung reaches of the great triangle we know as Polynesia. In this way, then, these islands spawned emigrants. Centuries later they were host to immigrants – missionaries particularly, whose activities sometimes included the retrieval of elements of material culture. At the time of their arrival in the islands, the early missionaries were able to discover objects representative of traditional culture, yet unaffected by European influences.

For the most part the materials in the Fuller Collection from these islands have the attribution of Tahitian provenience. This may be because Tahiti, the largest of the Windward Islands of the Society Archipelago, is perhaps best known and has often been equated with all of the Societies. The range of Society Island materials in the Fuller Collection is not large, but the quality of the objects is superior. Four wooden headrests (272977-80) are of *120, 121* excellent workmanship. Specimen 272977 was formerly in the *121* Museum of the Royal Botanical Society in Regents Park and is attributed to Huahine. Specimen 272978 is recorded as having *121* been brought back to England by the Reverend John Williams about 1834. It was presented by him to the Reverend E. Prout who in turn gave it to his son, the Reverend Edward S. Prout, from whom it passed to W. O. Oldman, who sold the item to Fuller in 1909. Headrests of open carving, such as these two, are quite rare.

There are two artifacts which are representations of gods. One of stone (272973) contrasts sharply with one of sennit and feathers *125* (273017). The latter was placed in the Chichester Museum in 1862. *122* Also of great rarity are the quiver and arrows (273001 A-Q). The *123* quiver is of bamboo and was formerly in the United Service Museum from which it was purchased in 1896 by the British Museum. Later it was passed to Edge-Partington and thence to Fuller. The stopper is made of a coconut and came with thirteen of the arrows from the London Missionary Society Collection. They were secured by Fuller in 1910. The other two arrows were in the

118

Chichester Museum. Edge-Partington ascribed an 18th-century date to the quiver. Finely ground basalt adz blades and food pounders of distinctive shape were produced in the Society Islands.

125, 124 Catalogue numbers 272982, 83, and 85 are examples of the latter.

123 Eight working·adzes, including 272991 from the Dundas Castle Collection, are present. Three shark-tooth weapons are listed as stemming from the Society Islands as are nearly forty fishhooks, a spear, a staff, three bows, baskets and bags, and breadfruit cutters.

Headrests (left to right)
272980 26.0 cm.
272979 23.2 cm.
272977 34.0 cm.
272978 23.5 cm.

120

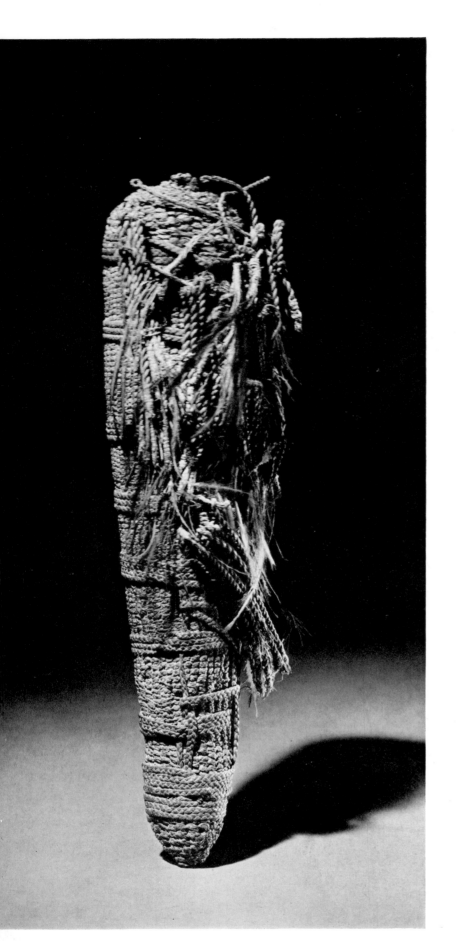

Sennit God
273017
30.0 cm.

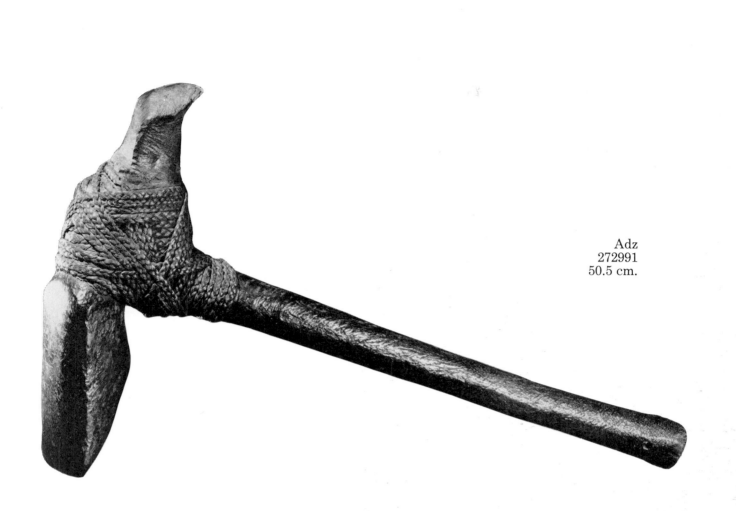

Adz
272991
50.5 cm.

Quiver and Arrows
273001 A-Q
99.8 cm.

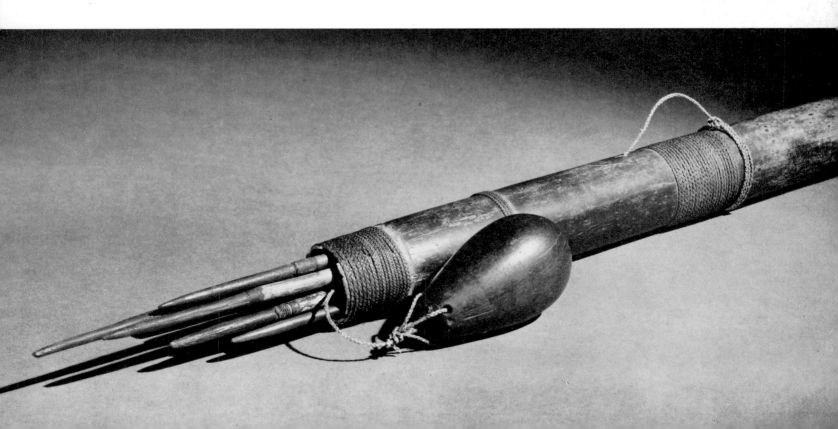

Food Pounders
272985 (left) 15.0 cm.
272983 (right) 13.0 cm.

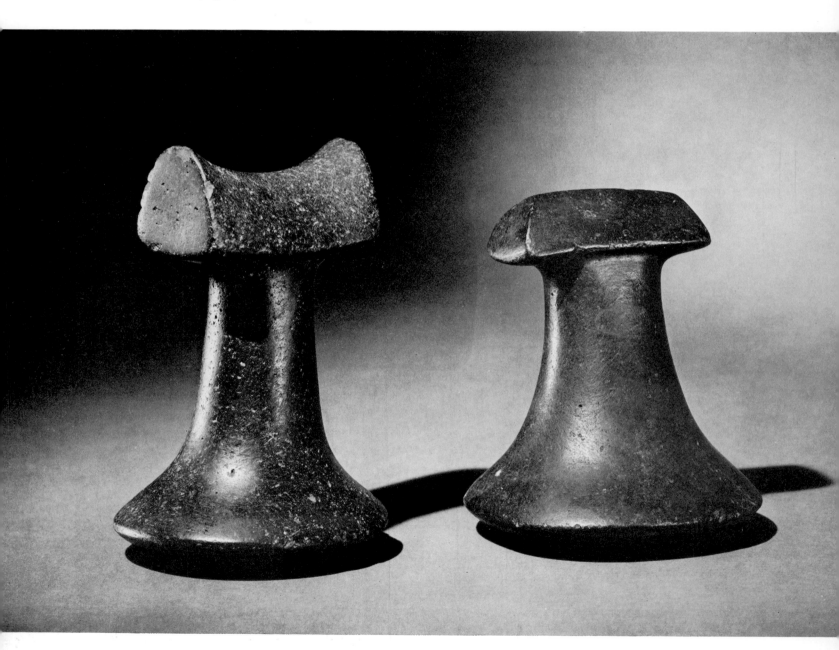

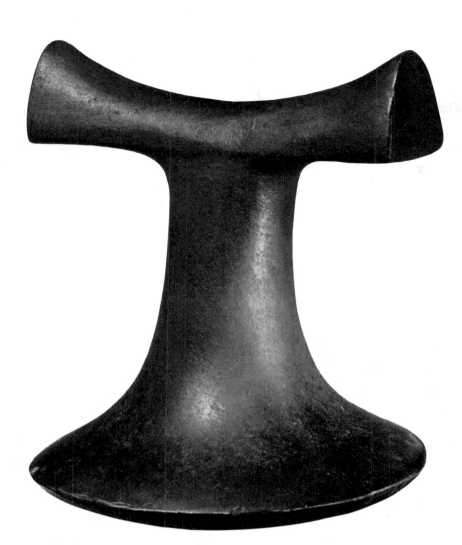

Food Pounder
272982
16.8 cm.

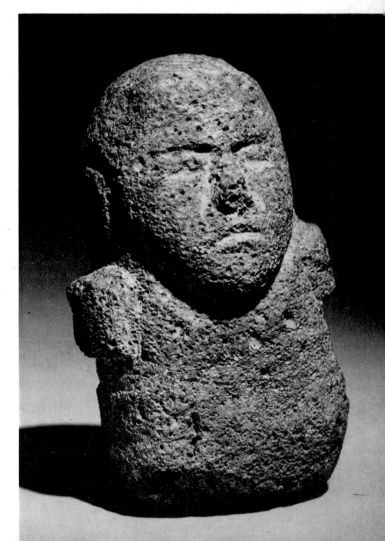

Stone Image
272973
15.8 cm.

Fan
273135
45.2 cm.

THE COOK ISLANDS

South and west of the Societies, north and west of the Australs, and due east of Tonga lie the scattered islands known as the Cooks. They are of both volcanic and coral types and are usually divided into the Northern and the Southern (sometimes called the Lower) Groups. The Northern Group includes Pukapuka, Rakahanga,and Manihiki. The Southern Group includes Mangaia, Rarotonga, Mauke, Mitaro, Manuae, Takutea, Aitutaki, and Atiu. It is the Southern Group that most often concerns the ethnologist interested in material culture. Various islands in the two groups were discovered intermittently over a 228-year span from Mendaña's visit to the area in 1595 until the missionary John Williams found Rarotonga in 1823. Cook made discoveries of islands on both his second and third voyages. In 1773, he located the atoll of Manuae. He called it Herveys Island in honor of Captain Hervey, R.N., one of the Lords of the Admiralty. The entire Southern Group was known for some years as the Hervey Islands, having taken its name from the atoll similarly named by Cook. Later the name for both groups officially became the Cook Islands.

One of the rarest specimens in the Fuller Collection, and one of nine such artifacts known to exist, was purchased by Fuller in June of 1960 and presented by him and Mrs. Fuller to the Field 129 Museum. It is a carved wooden slab (111709), which is probably a representation of a deity from Aitutaki. Buck (1944) noted the presence of three such slabs in the British Museum and indicated their earlier presence in the London Missionary Society Collection. The Society catalogue listed the slabs as 'carved flat club formed idols.' The Fuller 'idol' shares several features with those already known. It also possesses its own distinctive features, such as the raised relief carving and the sennit cord affixed to the handle.

Another object with probable sacred significance is a huge ornamental *Ruvettus* fishhook. It was collected by the Reverend William Wyatt Gill and was secured by Fuller in 1908, after Gill's death. This, Fuller recorded, was the only specimen which Gill retained throughout his life, and that therefore it must have had some special significance for him. This hook was illustrated by Buck (1944) and by Beasley (1928). The latter featured most of

Fuller's fishhooks in his extensive treatment, but the Fuller Collection actually contains a much more comprehensive assemblage of hooks than would be supposed from the listing by Beasley. For one thing, a number were added between 1928 and 1958. Then, too, the hooks identified in Beasley as imThurn hooks were in reality Fuller's. Sir Everard imThurn had previously presented Fuller with his collection of fishhooks assembled while on government service in the Pacific.

There are more than twenty ceremonial adzes from Mangaia in the Fuller Collection plus a few more handles from which the blades are missing. Number 273111 is illustrated. Of the six or *131* seven working adzes in the collection which stem from Mangaia, two are shown. One (273099) is usual; the other (273085) is less so, *130* in that the handle is covered with an intricate and patterned lashing of sennit cord. The collection includes a series of adzes.

Whale-ivory pendants of great beauty and distinctive form, affixed to a composite neck cord of sennit and human hair, formed one of the more distinctive Mangaian manufactures. Such a necklace (273130) in the Fuller Collection is one of fewer than *132* twelve known to exist. Two other objects of adornment from Mangaia are pearl-shell breast ornaments (273021-22) suspended *133* from cords of sennit and braided human hair. Two serrated clubs, also credited to Mangaia, are shown. One (273155) was formerly *136* in the London Missionary Society Collection. The other is 273156. *136* A unique serrated club from Mangaia is 273126. *134-135*

Carved seats were made in all the islands of the Cook Group except Mangaia. Number 273128 was collected in Atiu prior to *137* 1906 by E. L. Gruning. On the strength of this information, Fuller attributed the same provenience to 273127. Gruning operated a *137* copra plantation on Atiu in the early years of this century and traveled extensively in the Pacific making a small collection in the process. Some of his materials repose in the British Museum. Others were secured from him by Fuller. Additional Cook Island materials in the collection which are worthy of note are more than a dozen serrated clubs from Rarotonga. More than half are from early English collections, as is a staff from Rarotonga which once was in the London Missionary Society Collection. A group of nine long, slender clubs from Atiu are included. Many of them, along with other objects in the Cook segment of the Fuller Collection, are illustrated in Buck (1944). Finally, from Manihiki in the Northern Cooks there are two model canoes, three canoe paddles of palm wood with pearl-shell inlay, a tridacna-shell adz blade collected by the Reverend William Wyatt Gill in 1881, and a bowl.

Carved Slab
111709
50.0 cm.

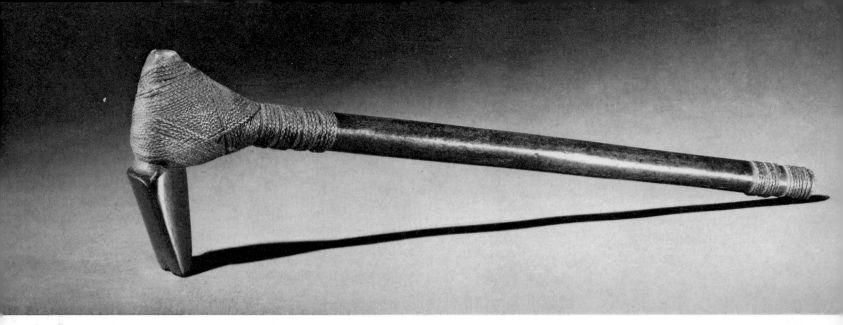

Working Adz
273099
37.2 cm.

Working Adz
273085
64.3 cm.

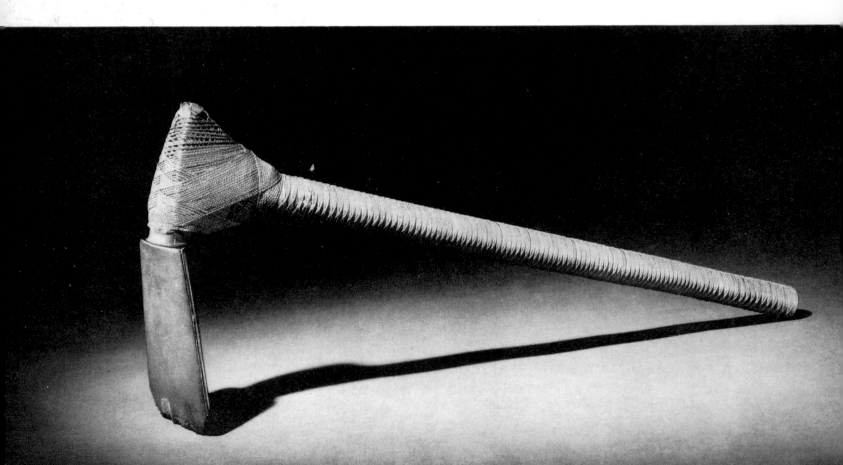

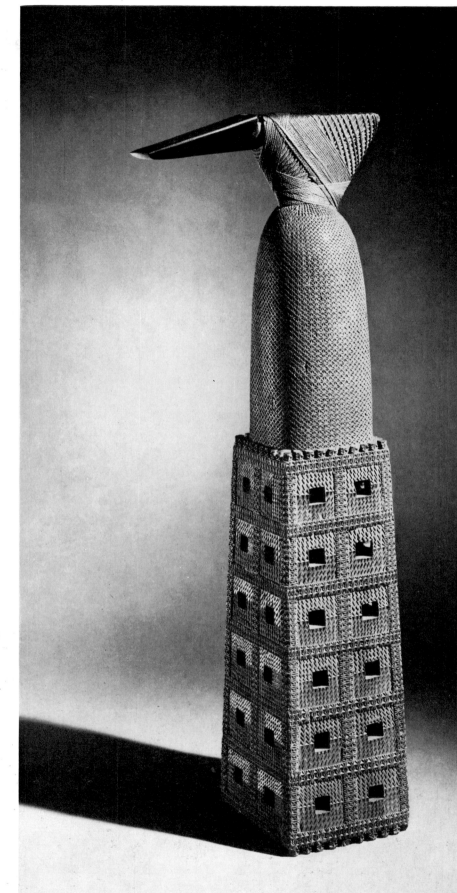

Ceremonial Adz
273111
63.2 cm.

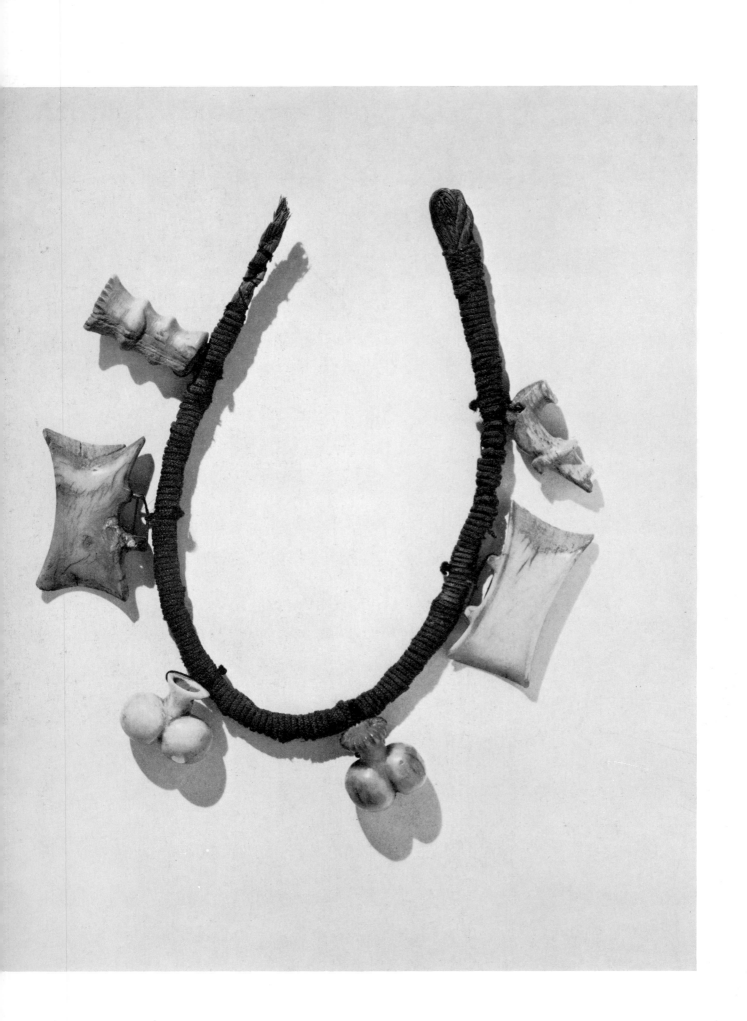

Necklace
273130
32.8 cm.

Breast Ornament
273021 28.5 cm.

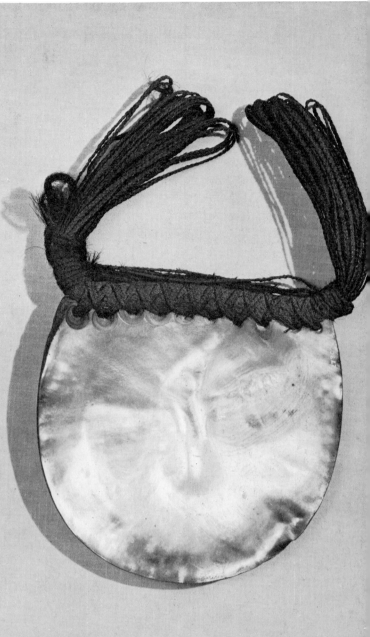

Breast Ornament
273022 17.3 cm.

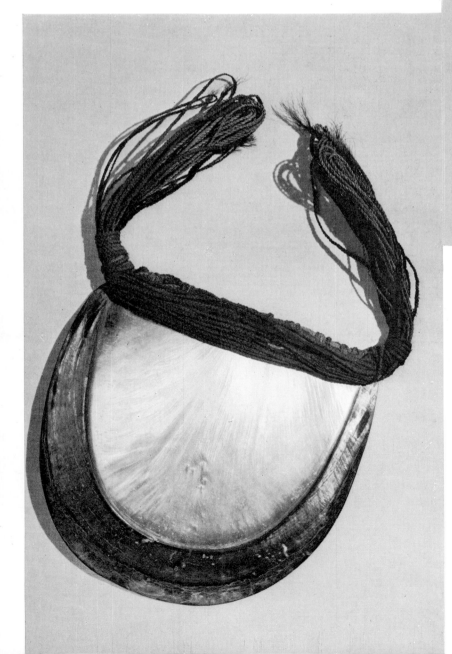

133

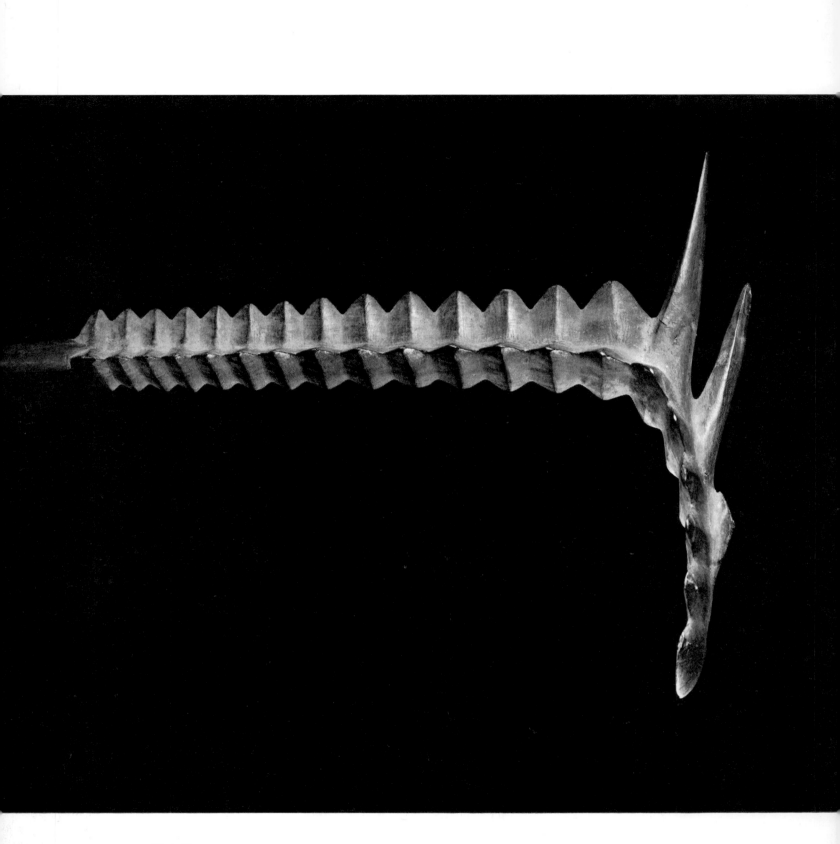

Detail
273126

134

Serrated Club
273126
75.0 cm.

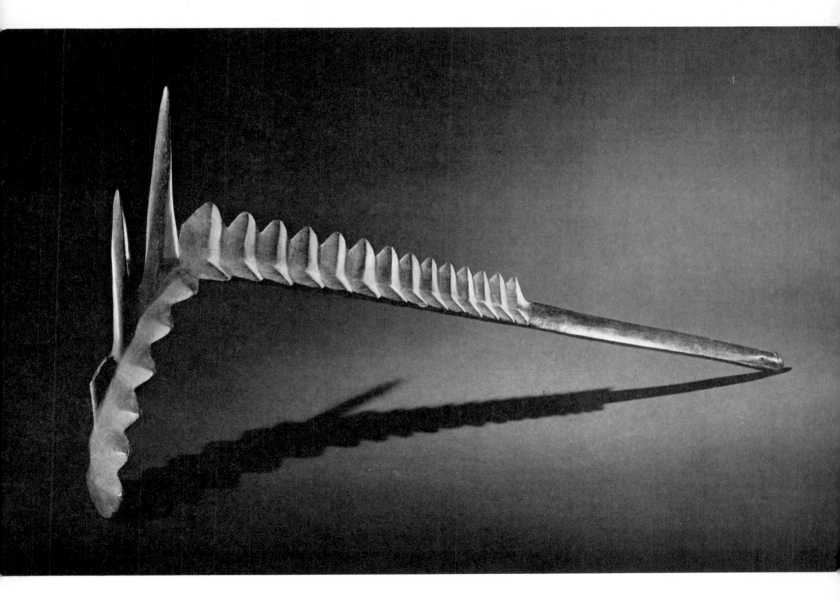

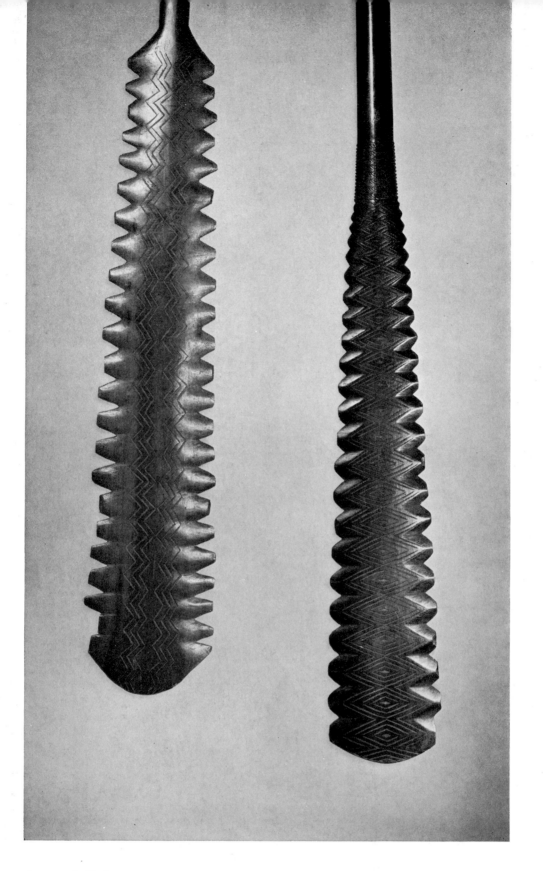

Serrated Clubs
273156 (left) 144.1 cm.
273155 (right) 159.0 cm.

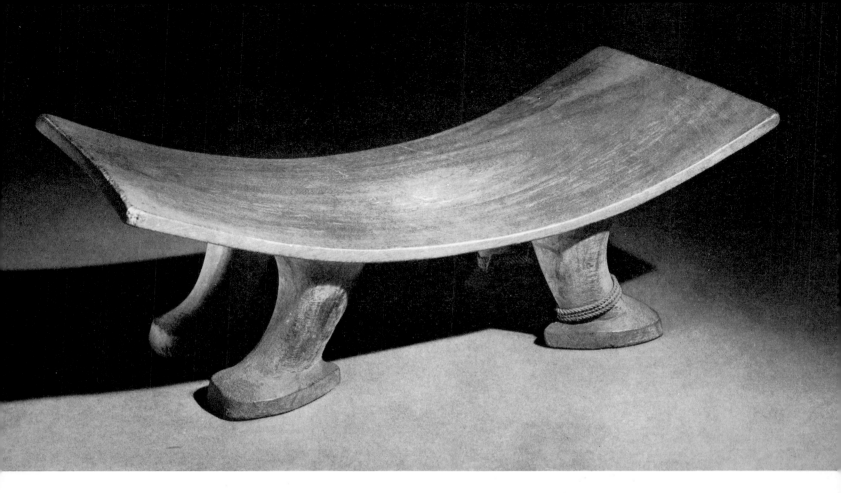

Carved Seat
273128
47.5 cm.

Carved Seat
273127
43.0 cm.

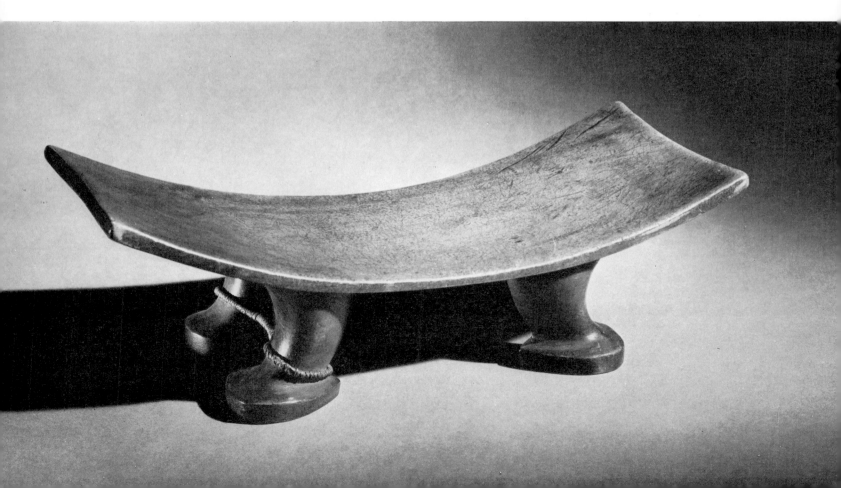

THE AUSTRAL ISLANDS

Three hundred miles due south of the Societies and southeast of the Cooks lie several small islands called the Australs. Early accounts of the inhabitants of these islands characterize them as having been truculent, fierce, and withdrawn. First visited by Europeans in the late 18th century, the islands were subjects of missionary endeavor a few years later.

A magnificent range of more than sixty carved ceremonial paddles comprises the bulk of the Austral Islands material in the Fuller Collection. Many were collected in the early 19th century. The distinctive low relief goemetric designs which cover the surface of Austral paddles are also typical of the treatment given food bowls. Such bowls from the Australs had long handles, 140, 141, 142 similar to 273079-81, short handles, like that of 273083, and no 143 handles, as with 273082.

The collection also boasts several spears and spear-clubs, a beautifully carved walking staff, some adz blades, and two fine 145, 144 drums (273124-25), said to be from Raivavae, with shark-skin heads and sennit tightening cords. These instruments are less elaborate than some Austral Islands drums and, in their simplicity, suggest an affinity with Society Islands drums. In this connection, 126 a fan (273135) shown with Society Islands materials is virtually identical with one in the British Museum which is attributed to Tahiti. The Fuller fan was secured by him in 1905 from the Orphans Working School, Maitland Park, along with both of the drums just described. This offers no guarantee as to ultimate provenience, but it is of interest.

143 A particularly rare artifact is 273129, a game-stick or club. A virtually identical club was one of two such items in the Oldman Collection. Another apparently identical specimen was reported by K. P. Emory (1927) as having been discovered in a Rurutu cave in 1926. It is described as having been 80.0 centimeters long, while the one in the Fuller Collection measures 81.9 centimeters in length. It is a remarkable coincidence that the Rurutu specimen should come to light in 1926 and that the next year Fuller should have purchased a club so similar. Oldman notes a reference by Ellis in his *Polynesian Researches* to a game somewhat similar to hockey having been played in the Australs.

Food Bowl
273081
75.5 cm.

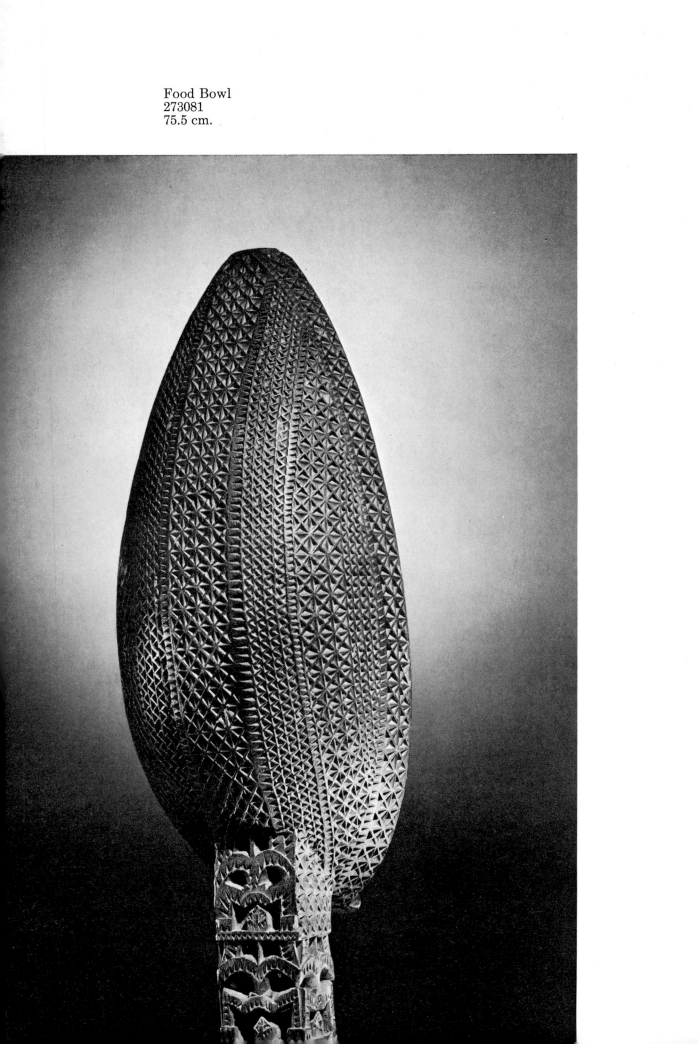

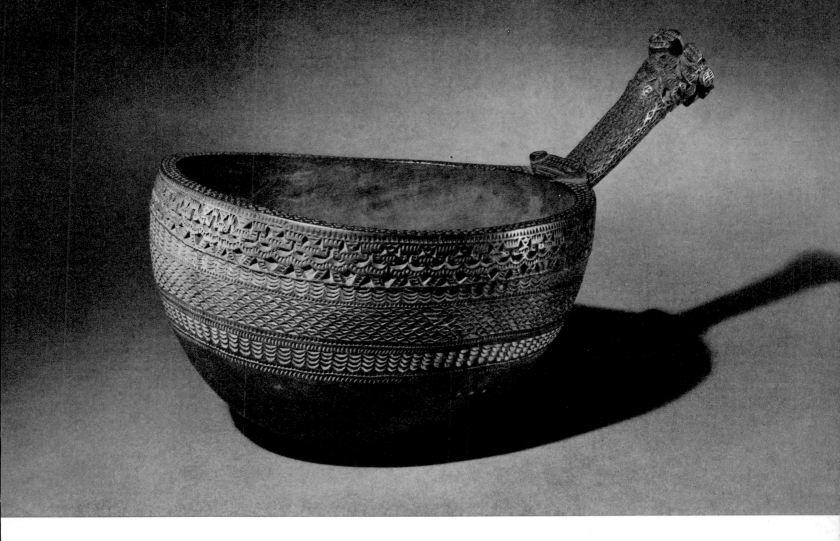

Food Bowl
273083
28.0 cm.

Detail
273083

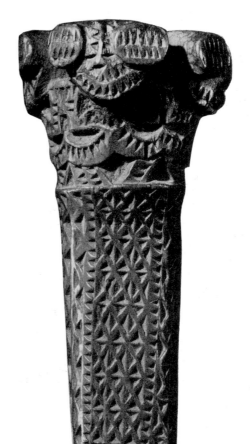

141

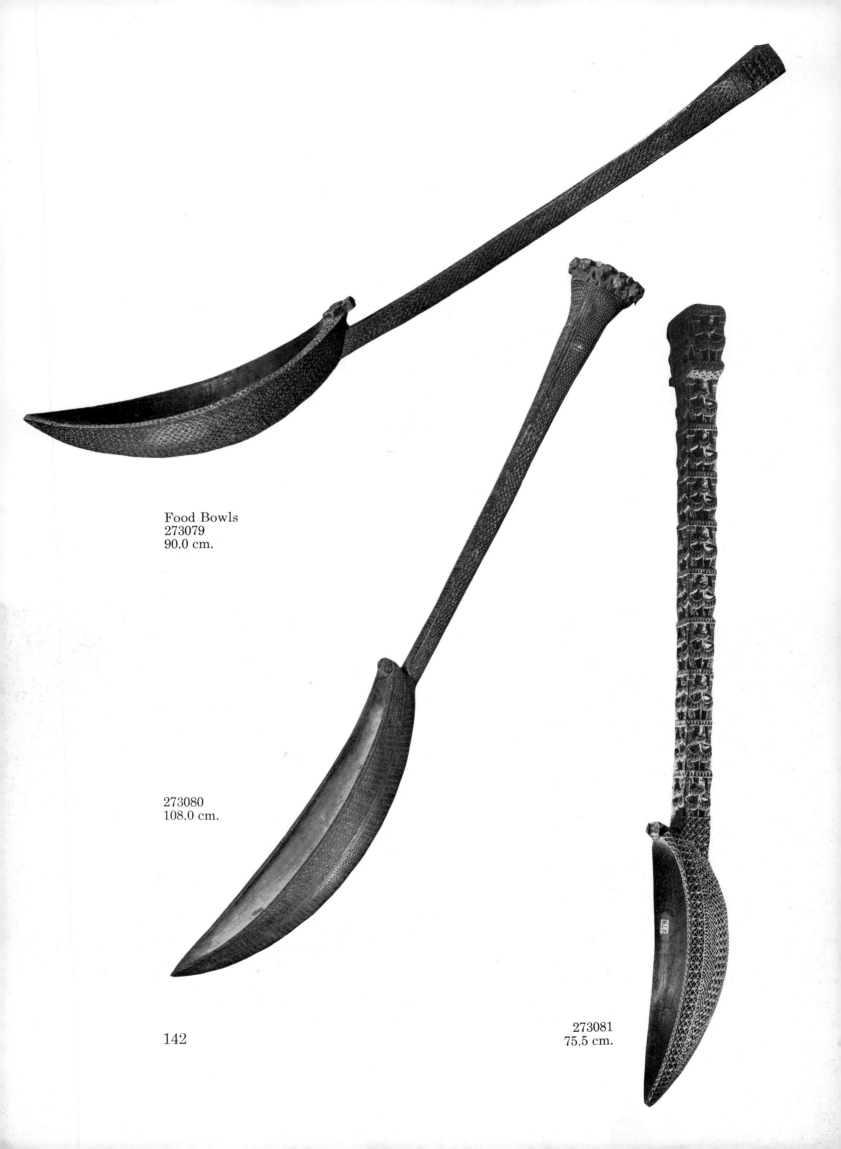

Food Bowls
273079
90.0 cm.

273080
108.0 cm.

142

273081
75.5 cm.

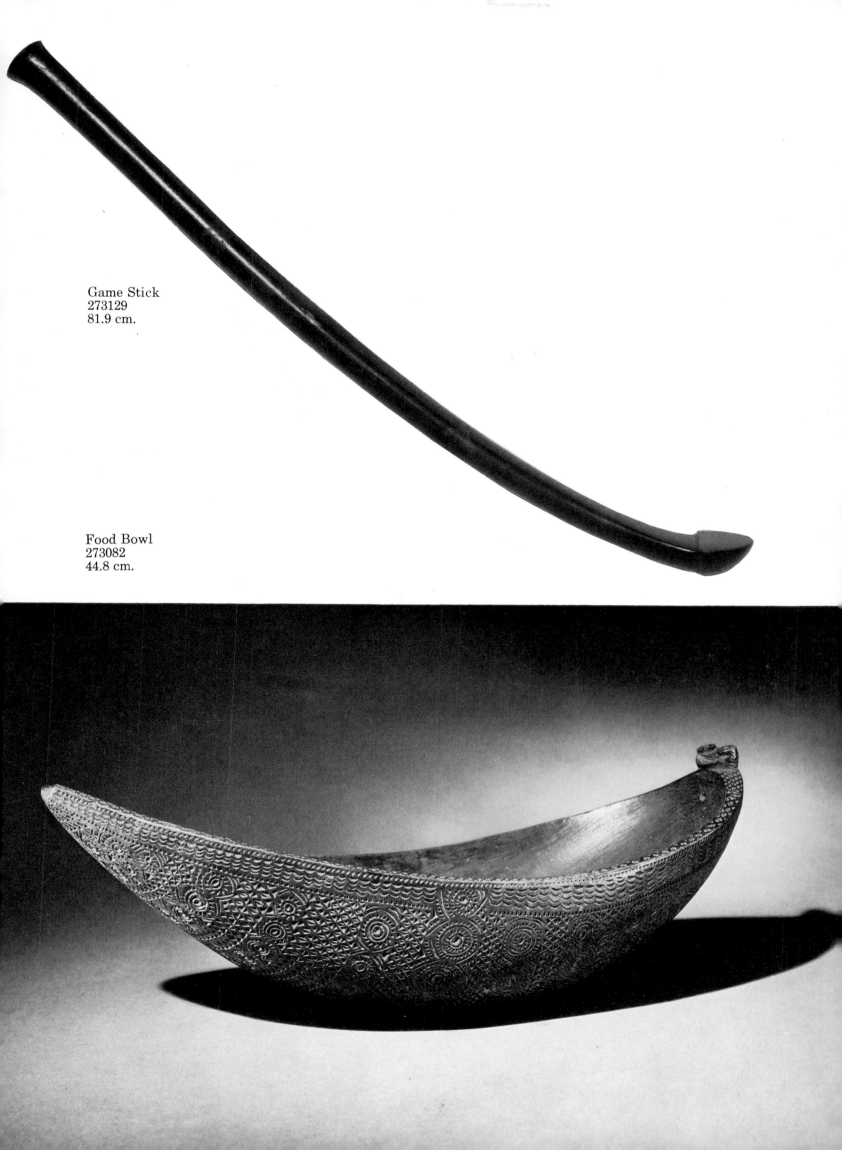

Game Stick
273129
81.9 cm.

Food Bowl
273082
44.8 cm.

Drums
273125
49.0 cm.

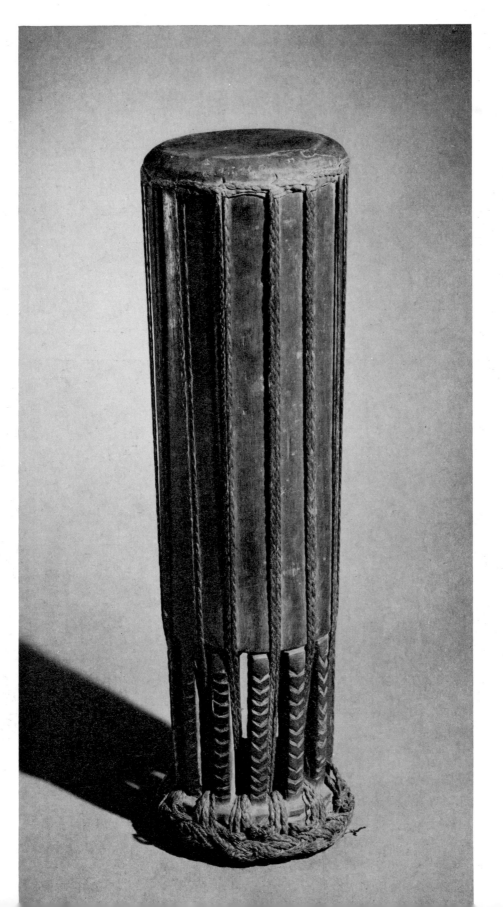

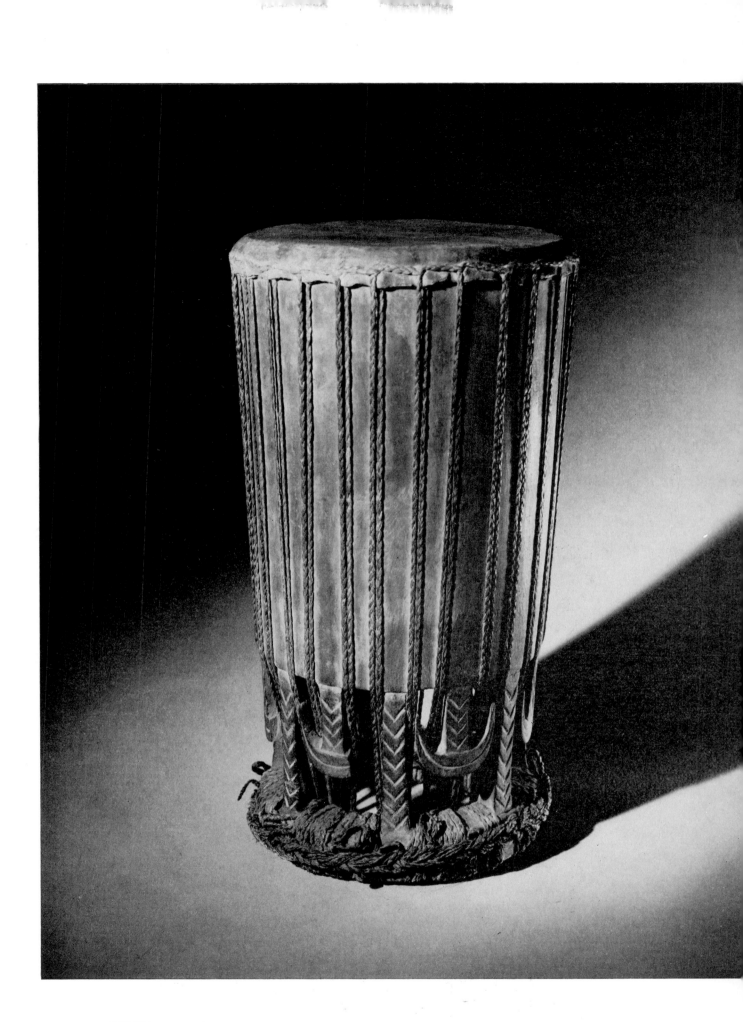

273124
47.7 cm.

SAMOA

The islands known as Samoa were visited by Roggeveen in 1722 and again sixty-five years later by La Pérouse. They are about 130 miles north of Tonga and 500 miles northeast of Fiji. The three largest islands in the group are Savaii, Upolu, and Tutuila. The portion of the Fuller Collection from Samoa numbers more than 130 pieces. The greater number of these are war clubs of rich brown woods, well polished and incised. However, spears, throwing stones, a bow, head ornaments, human hair pieces, combs, fishhooks, kava bowls, and staves, as well as fans, fly whisks, tapa and tapa-making equipment, adzes, and adz blades are also included.

The many clubs are representative of the various types from Samoa. Several were originally associated with missionary activity which began in Samoa with the arrival of two Tongan Wesleyan teachers in 1828, and with the Reverend John Williams of the London Missionary Society in 1830. One club, for example, is said to have been brought to England by Williams in 1834. Others stem from the London Missionary Society Collection. Several notable collections from which clubs were drawn were the Kelso Museum in Scotland, the Isle of Wight Museum, the Edge-Partington Collection, the Chichester Museum, the Turvey-Abbey Collection, and the Duke of Leeds Collection. Clubs are mostly of paddle, billet, carinated, coconut-stalk, *Talavalu,* or erratic types. Types are identified according to Churchill's classification.

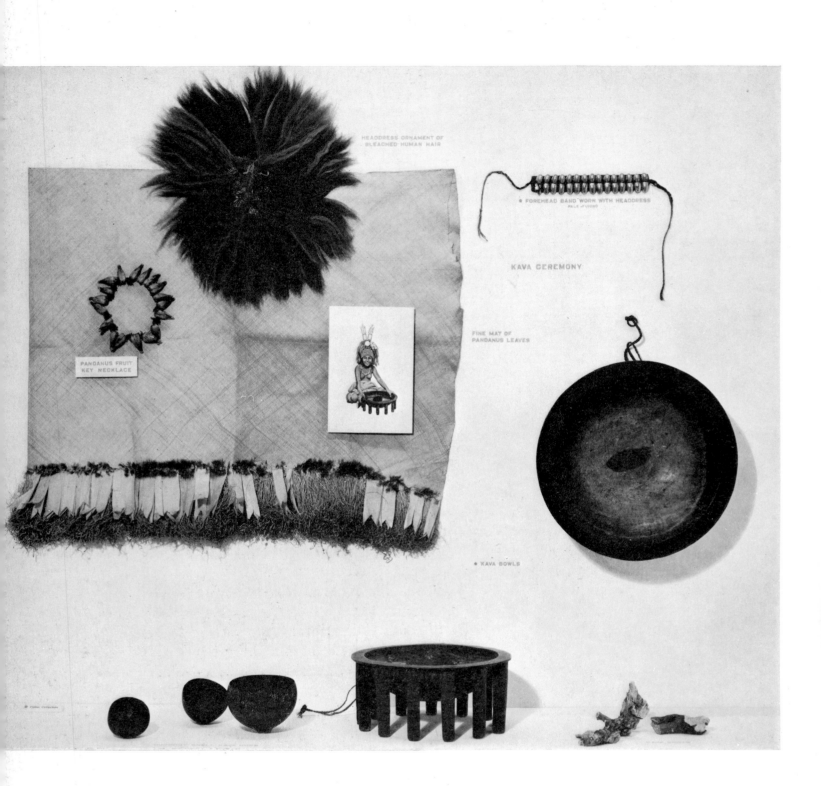

Field Museum Exhibits
Featuring Samoan Materials
From the Fuller Collection

148

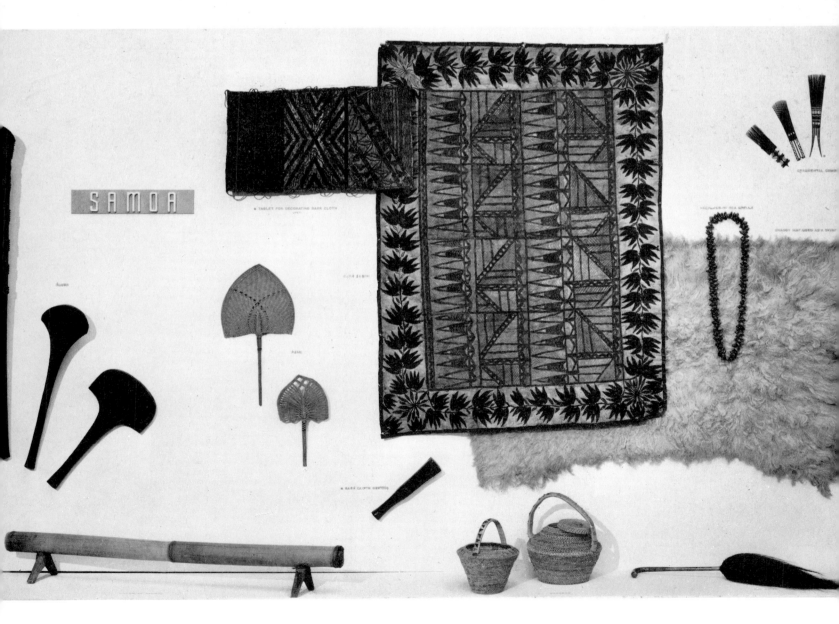

SAMOA

TONGA

Discovered in 1643, by Tasman, the Tongan Islands were visited more than a century later by Cook. The people of these islands are noted for their fine artistry which finds its expression in bark-cloth designs and in the fineness of wood carving and whale-ivory inlay. The form of a number of artifacts is shared with neighboring groups, but almost invariably the Tongan manufactures possess a delicacy and perfection surpassing that of similar objects produced elsewhere.

Among the products of the Tongan craftsman were goddesses of wood and ivory. Fewer than ten of the wooden ones are known. One of these (274478) in the Fuller Collection is from the Haapai Group and possesses a rich brown color and a fine old polish. The shell inlay is missing from the eyes, as are the toes of the left foot, two fingers of the right hand and three from the left. Two small wooden inlay pieces are to be found on the right shoulder. Such inlay work is typical of Tongan craftsmanship and may be seen in 274066, a necklace of whale-ivory beads. Such beads are often identified as Fijian in origin, as 274065 may be. Two small well-executed inlays of ivory on two of the beads in the necklace, however, lend weight to a Tongan attribution. Buck (1944, p. 116) notes a similar necklace in burial association on Atiu in the Cook Islands.

The Tongan segment of the collection contains more than a dozen combs with tines of coconut-leaf midribs bound together with coconut-husk fiber of different hues, thus creating patterns. Sennit cord was used also in the ornamentation of baskets of coiled canework like 274483. More practical than decorative are the sennit bindings which secure wooden legs to a cross-member made of a walrus tusk in a headrest (274497) from the Caton Lee Collection. Two other headrests (274498-99), more typically Tongan, are carved out of a solid block of wood. As in Samoa, sennit fiber provided material for fly whisks. Two are represented in the collection. One has a handle of bone, the other of wood.

The arts and crafts of Tonga and Samoa are strikingly similar. An example may be noted in 274563, the grip of which is carved in Tongan fashion. The form of the club is, however, carinated, and

152

155
155

157

159
158

154

is much more identified with Samoa than with other island areas.

156 Especially fine large fishhooks (274604 and 8) with whalebone shanks, faced with pearl shell, and bearing tortoise-shell points, are of a type found only in Tonga. Other items of note are fish lures, bows, arrows, a rasp, adzes, breadfruit cutters, and a nose flute.

About eighty of the Tongan specimens are war clubs, many of considerable age with fine low relief, incised designs which often *153* incorporate small human and animal figures (see 274568). Throwing clubs are found in Fiji as well as Tonga, but those from the latter are particularly well finished. The nearly thirty in the collection average about forty centimeters in length. Some of these may, in fact, be Fijian rather than Tongan. Two are said to have been collected by the Reverend James Calvert, who went to Fiji as a missionary in 1838. Billet clubs, paddle clubs, coconut-stalk clubs, and rootstock clubs are present in good series. Some were collected before 1824 by Thomas P. Younger, a whaling captain.

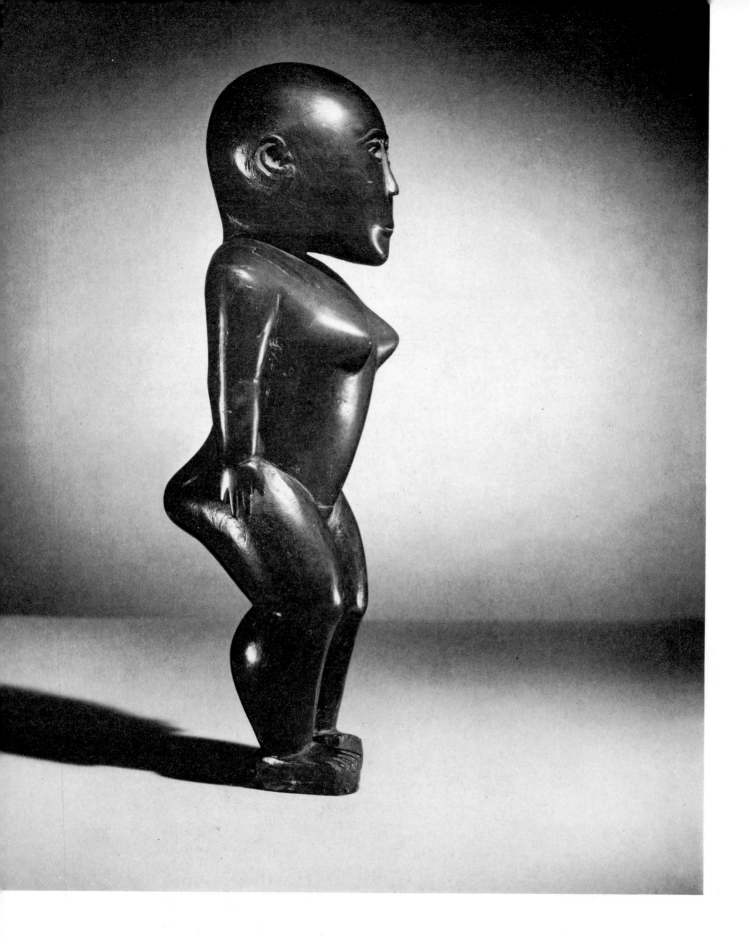

Goddess
274478
37.8 cm.

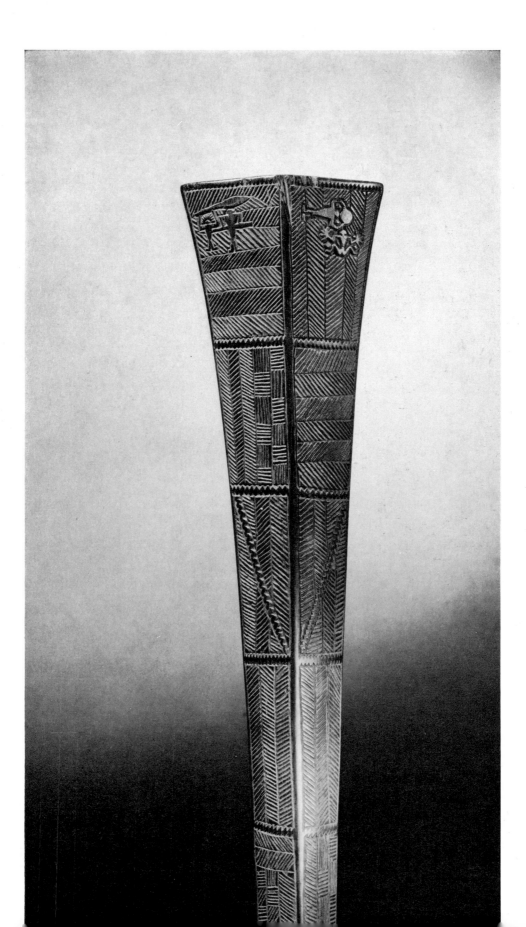

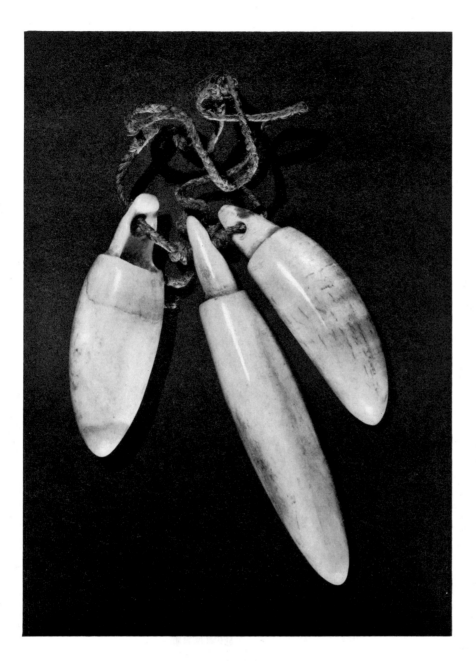

Whale-ivory Dart Heads
274116
Length range 8.1 – 12.2 cm.

Club Grip Detail
274563
125.6 cm.

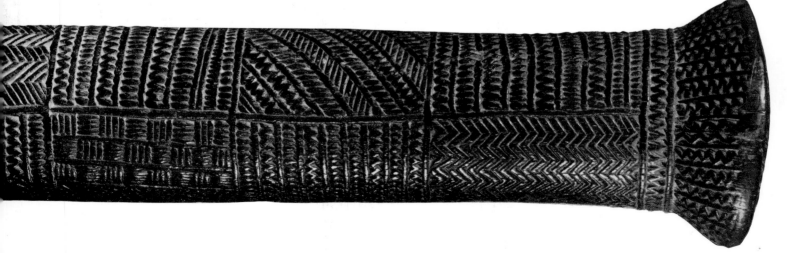

Whale-ivory Beads
Necklace 274066
Bead 274065 4.9 cm.

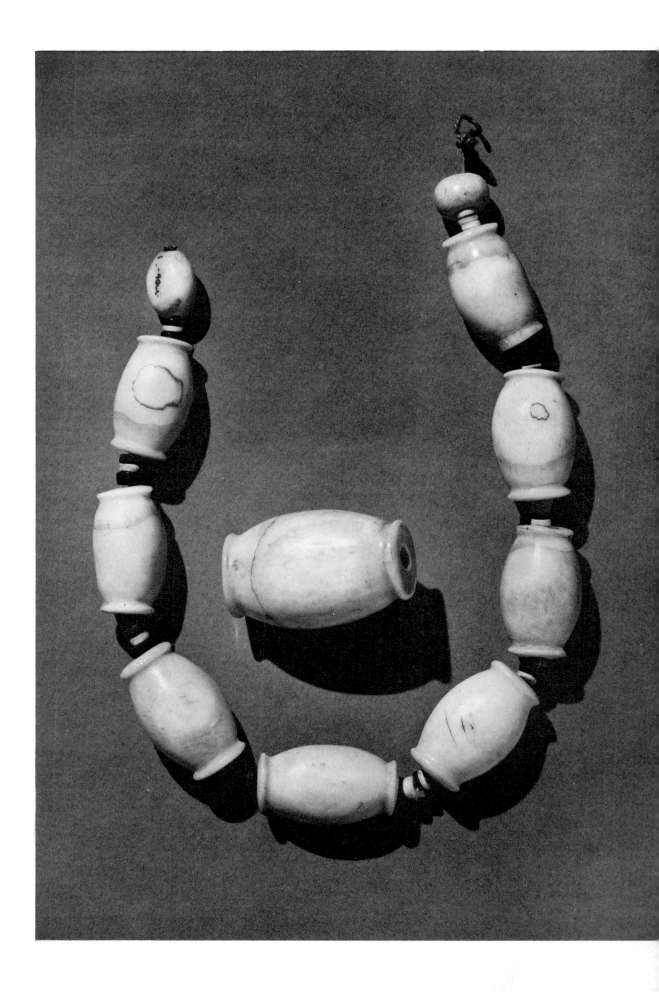

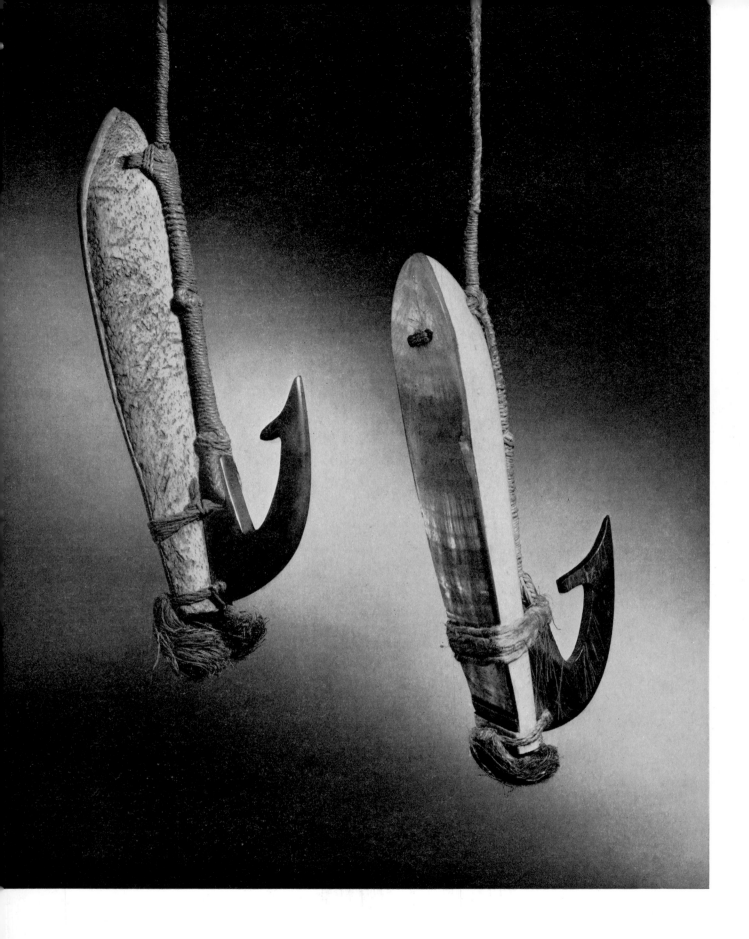

Fishhooks
274604 16.0 cm.
274608 15.9 cm.

156

Basket
274483
Dia. 39.0 cm.

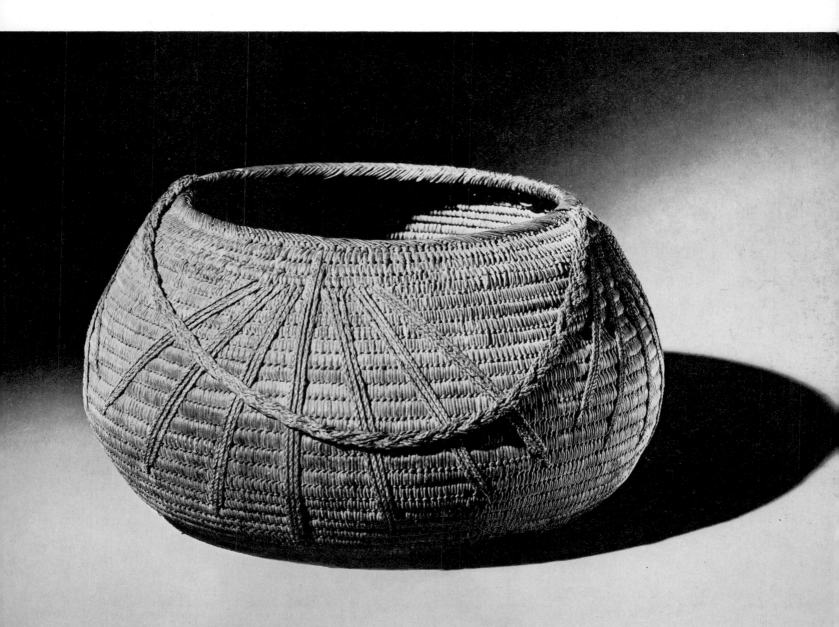

Headrests
274498 (left) 45.4 cm.
274499 (right) 37.5 cm.

274497
39.8 cm.

FIJI

More than 300 islands in the Fiji Group lie astride the line which separates the culture areas of Polynesia and Melanesia. For centuries Fijians have stood figuratively with a foot in each area. Culturally and linguistically Fijians have been closer to Polynesian norms than to Melanesian. In physical terms they often resemble Melanesians more than Polynesians. The culture-area concept is a helpful one, but lines on a map do not present barriers which impede physical movement or cultural interchange.

Although Tasman reached the northern islands of the group in 1643, he did not explore. The islands remained isolated from other European attention until Cook's surveys of the late 18th century. The Wilkes expedition provided the first reasonably accurate attempt at mapping the islands in 1840. The 19th century was a time of intensive contact with the outside world. Commercial enterprise promoted this, as did missionary activity – a pattern familiar in the Pacific during the era.

Fijian material culture incorporates many materials, but wooden artifacts predominate. Fijians were great makers of war clubs. Wooden containers, called oil dishes, were created in great proliferation. One, 273955, is unique. It is carved out of a single *163* block of wood, a ring linking the two halves together. It was collected by the Reverend James Calvert and is illustrated in *Fiji and the Fijians* by Williams and Calvert (1858, p. 60). Calvert presented the dish to the Reverend G. S. Rowe, the editor of the book. Later it was passed along with other Calvert materials to his son, W. Page Rowe, an acquaintance of Fuller's. Upon his death, the Page Rowe Collection was presented to Fuller. A particularly attractive oil dish is 273959. A good range of such artifacts is *164* included in the collection. An artifact peculiar to Fiji, and one elaborately carved, is the so-called cannibal fork. Illustrated are 274003, 6, and 8, the latter of which is from the Calvert Collection. *162*

There are more than two dozen ceremonial whale teeth (*tambua*) in the collection. One (274094) from Lord Amherst's Collection is *164* shown. Several necklaces formed of worked whale teeth are also present, as are boars' tusks which, having grown into circles, are considered valuable ornaments. Other ornaments are breast

167 pendants of pearl shell with embellishment of whale ivory (274044)
166 and whalebone (274045-46). Golden cowries were much sought after as breast ornaments. Three are found in the Fuller materials.

Kava or *yangona* was a feature of Fijian life. Fijian kava bowls were of a particular type, usually with four legs and a heavy
168 suspension lug. Number 273983 is quite large. Food hooks were hung from the rafters of houses to keep provisions free of rodents.
171 One such hook is 273985. Utilitarian objects in the collection are balanced by objects with supernatural associations. Number
170 274153 is a temple model made of sennit cord formed over a stiff cane frame. Among the eight tattooing instruments in the Fuller
172 Collection, 274124-25 have bone heads, while 274126 has a head of tortoise shell. Also in the collection are three nose flutes, several coconut-leaf fans, two dozen headrests, numerous tapa beaters, tapa cloths, whalebone needles, two human hair wigs, combs, fiber armlets, a shell trumpet, a number of coconut kava cups, pottery containers, and adzes and adz blades.

The history of culture contact in the Fiji – Tonga – Wallis area makes precise identification of some objects as to origin quite
173 impossible. So it is with dance wands or paddles such as 274155 and 57 which are representative of the area in general.

If weaponry may be considered a measure of a culture's character, we must assume Fijians to have been extremely belligerent. One of several club types is called pandanus or pineapple. Thirty-four
165 such clubs are represented by 274257, which has a completely carved shaft and a conical point of whale ivory. It is finished with a flower-shaped ivory inlay on the butt. Another club which displays
169 fine inlay on the butt is a crescentic club (274469). Of the four
174 staves in the collection, two (274200 and 2) are illustrated. There
174 are more than sixty lipped clubs, of which 274433 is shown as an
175 example. Ax-bit clubs, similar to 274448, which is quite exemplary, are not so numerous, but there is a good series. There are a few small hand clubs which do not qualify as throwing clubs, of which there are nearly forty in the collection. There are about seventy billet clubs, more than forty of the rootstock variety, and seven-
176-177 teen paddle clubs. An exceptional carinated club (274159) is illustrated. A detail of the grip is shown, as well as both sides of the blade. The specimen is from the old Dundas Castle Collection. It was Fuller's opinion that this specimen was the finest Pacific club in existence.

Finally, spears from Fiji are massive with long heads such as
171 274213. Altogether there are nearly two dozen such spears in the collection.

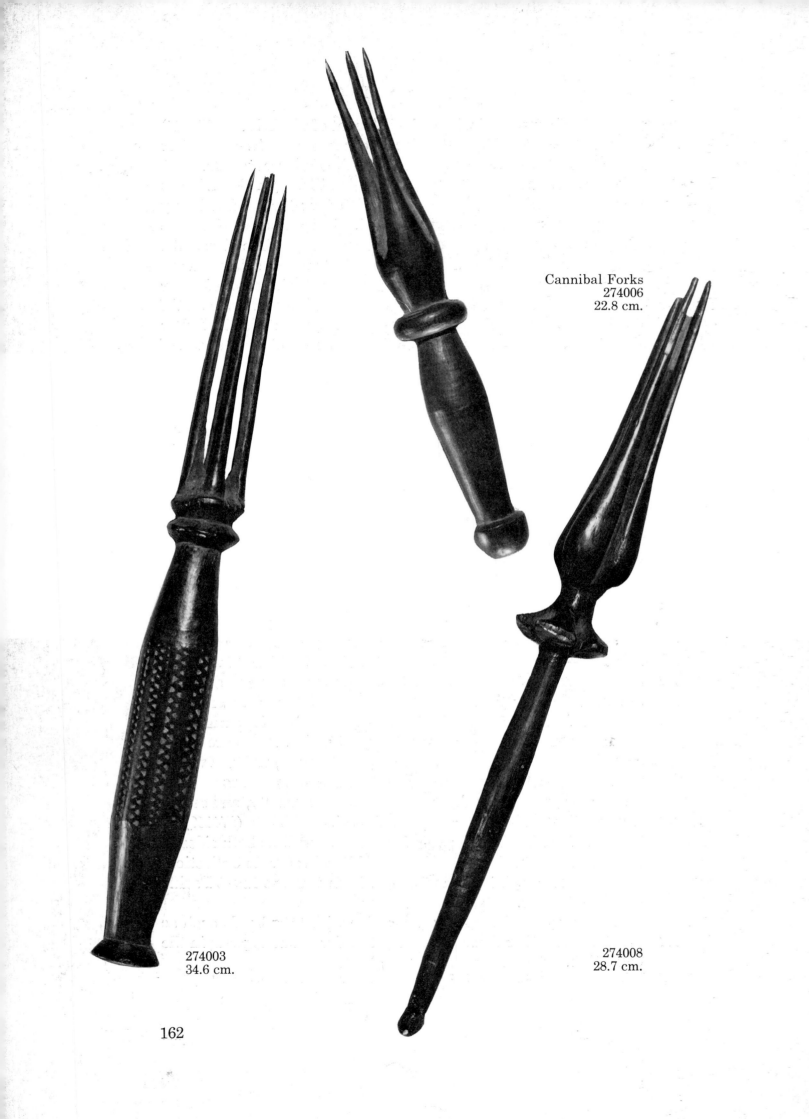

Cannibal Forks
274006
22.8 cm.

274003
34.6 cm.

274008
28.7 cm.

162

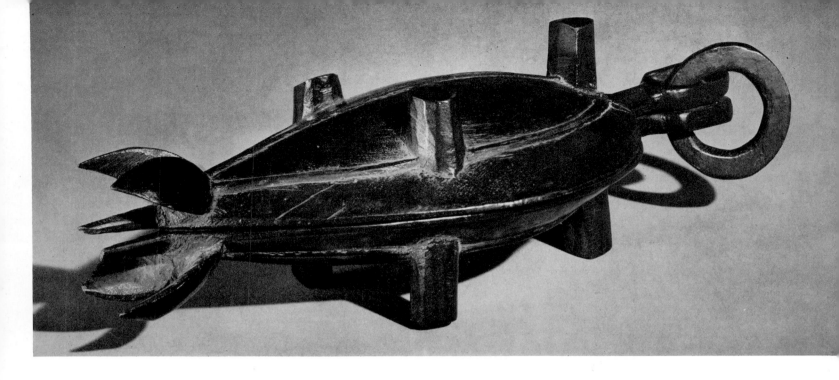

Oil Dish
273955

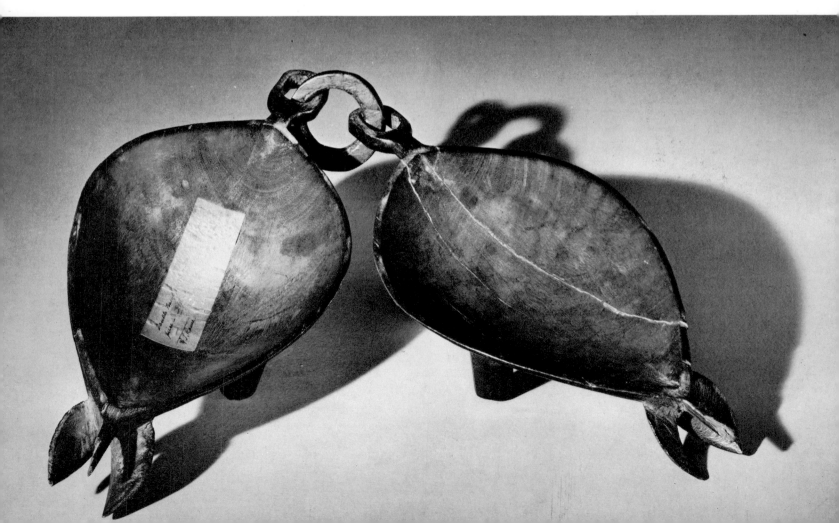

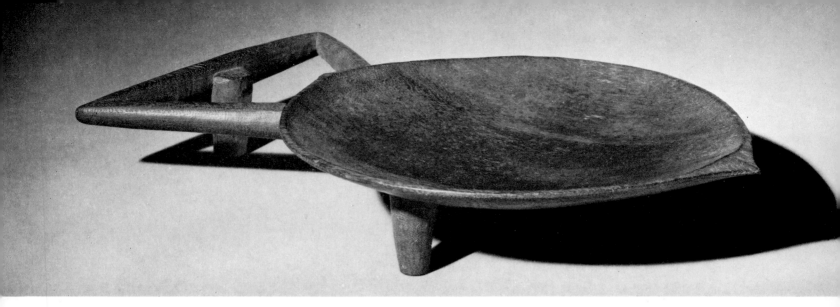

Oil Dish
273959
39.4 cm.

Ceremonial Whale Tooth
274094
20.2 cm.

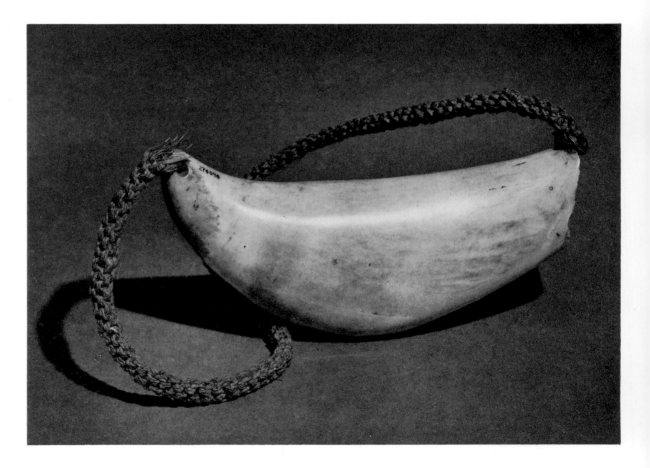

164

Pandanus Club
274257
88.8 cm.

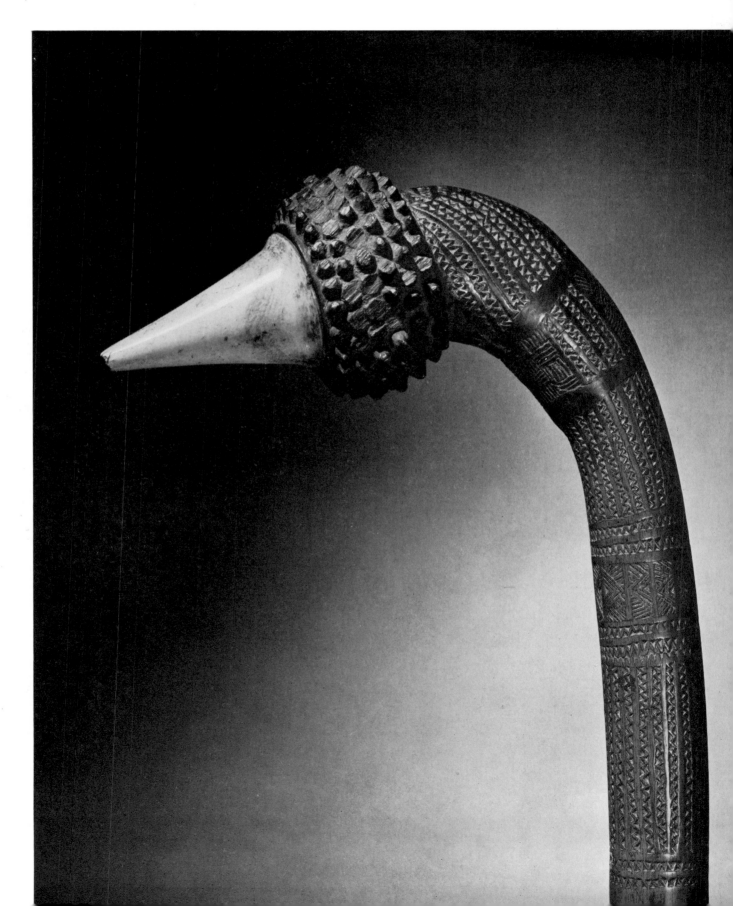

Breast Ornaments
274045 (left) Dia. 21.3 cm.
274046 (right) Dia. 19.2 cm.

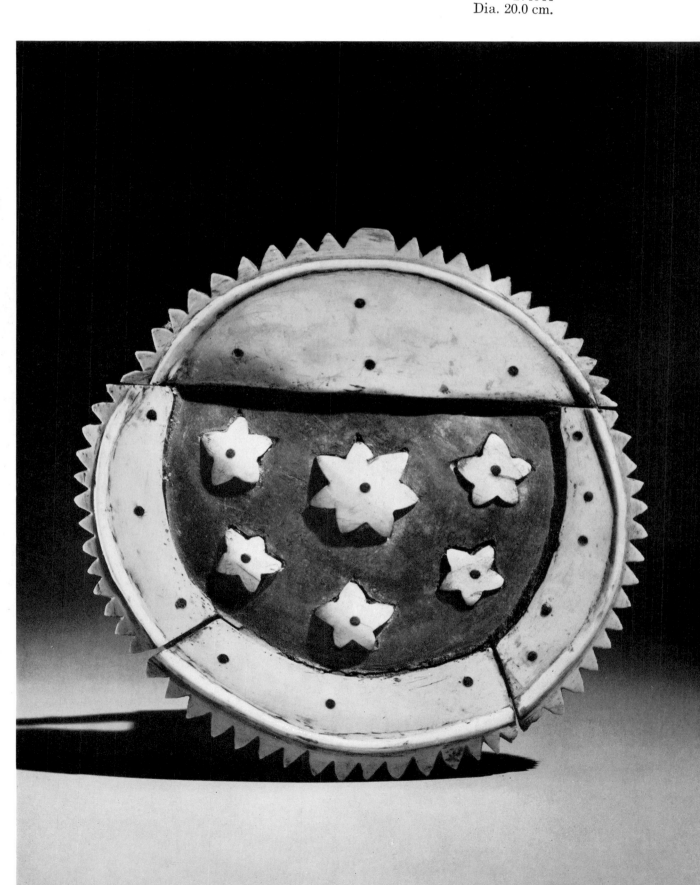

Kava Bowl
273983
Dia. 82.0 cm.

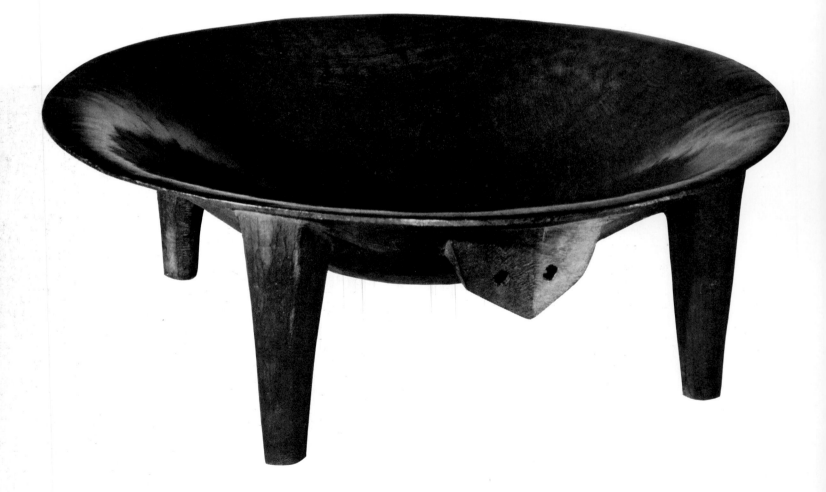

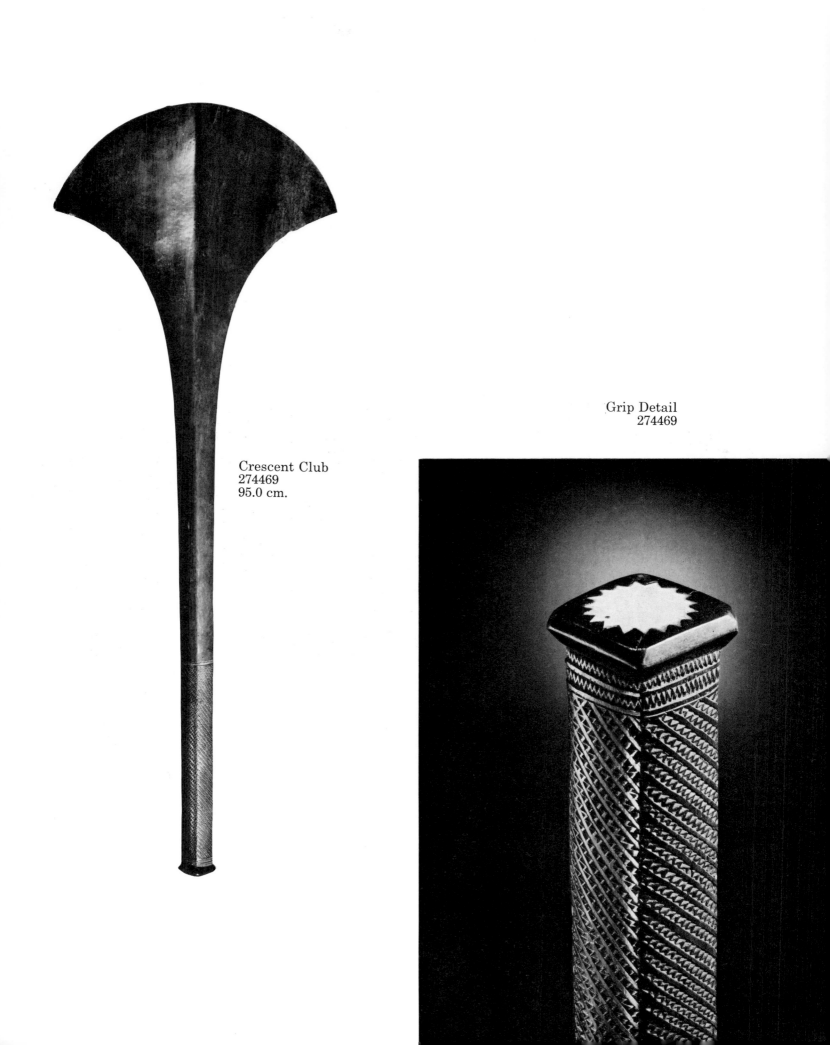

Crescent Club
274469
95.0 cm.

Grip Detail
274469

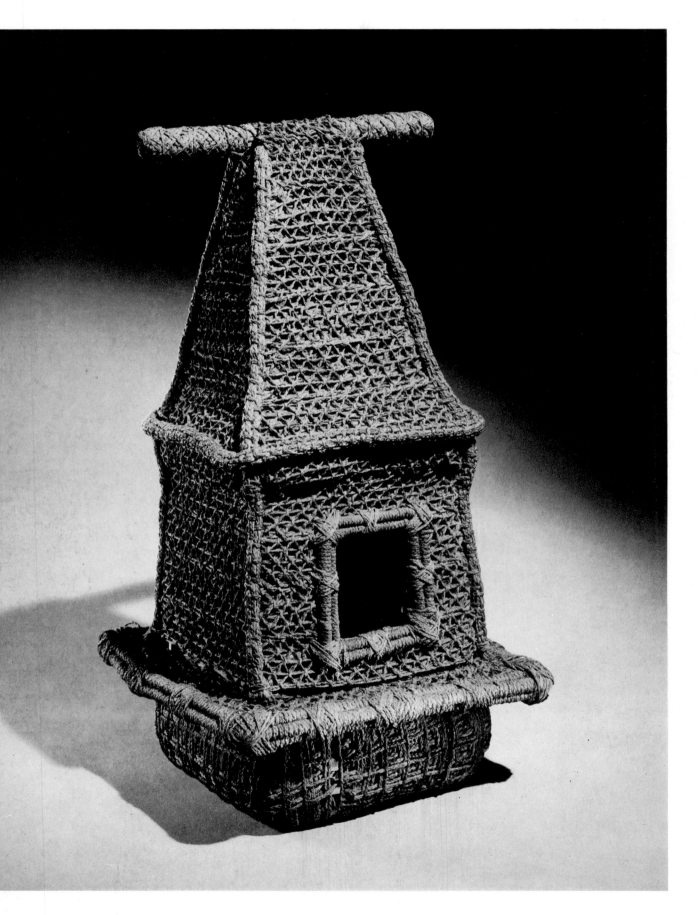

Sennit Temple
274153
65.5 cm.

170

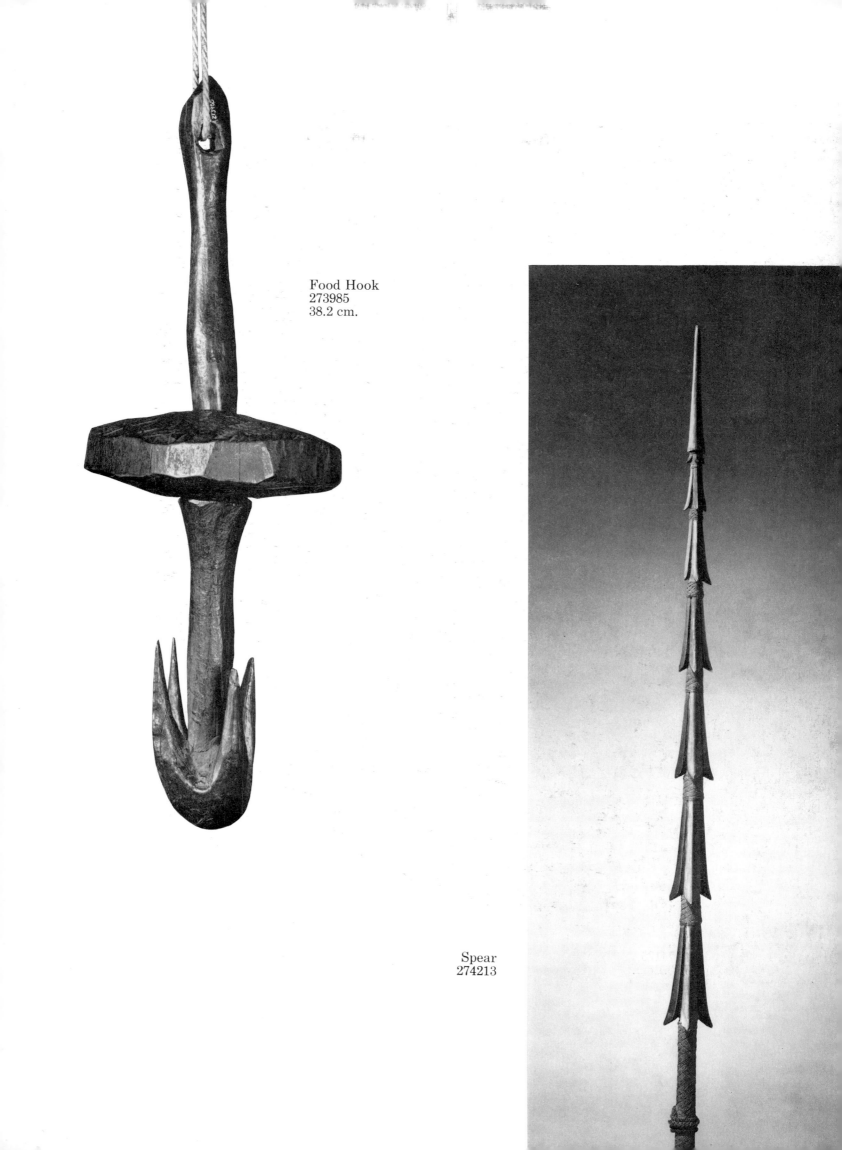

Food Hook
273985
38.2 cm.

Spear
274213

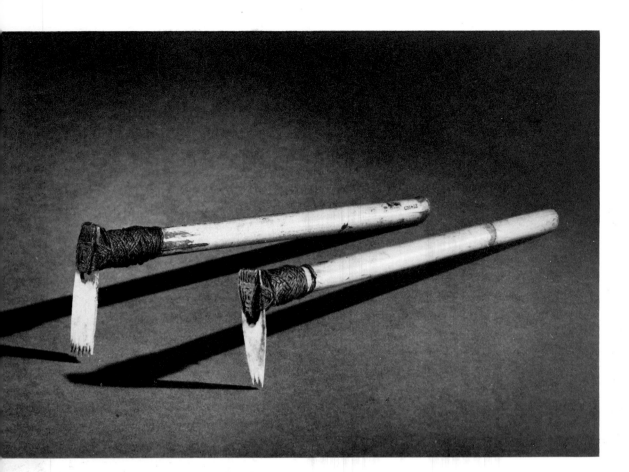

Tattooing Instruments
274125 (left) 20.4 cm.
274124 (right) 22.2 cm.

274126
20.1 cm.

172

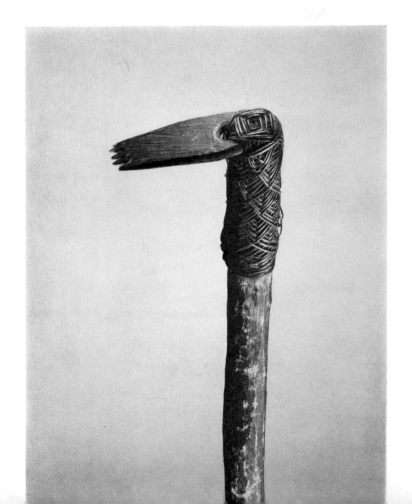

Dance Paddles
274157 (left) 73.6 cm.
274155 (right) 73.2 cm.

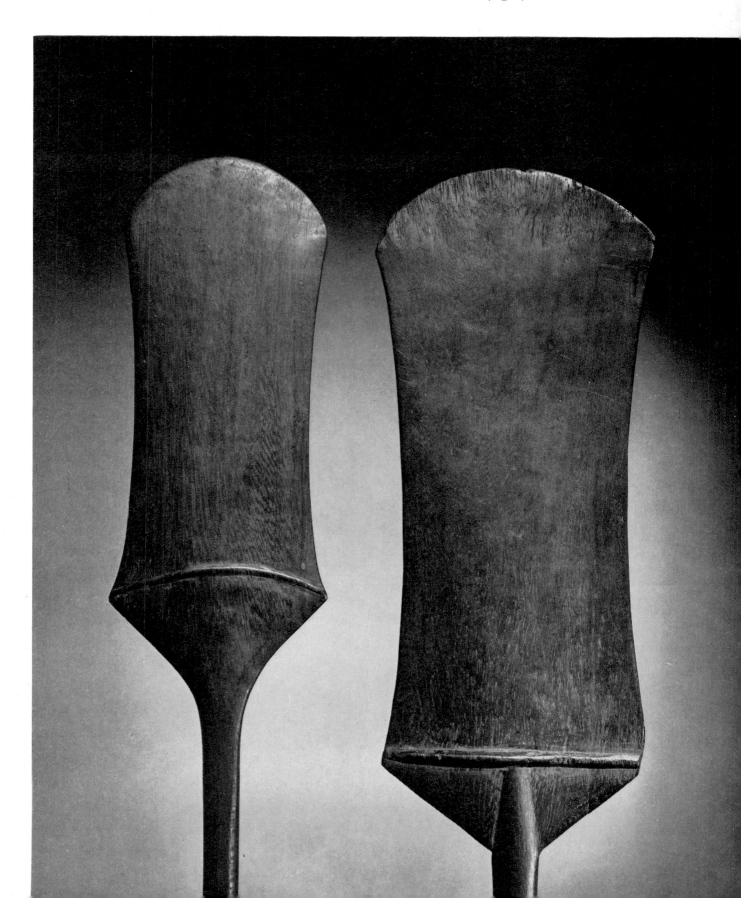

Staves
274202 104.7 cm.
274200 155.6 cm.

Lipped Club
274433
114.1 cm.

174

Ax-bit Club
274448
110.3 cm.

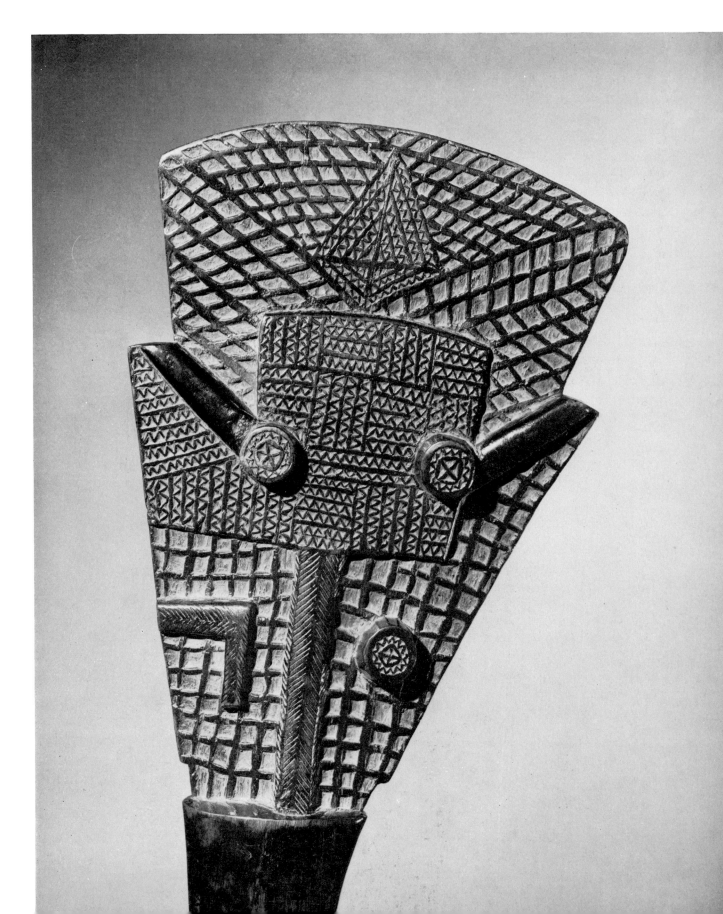

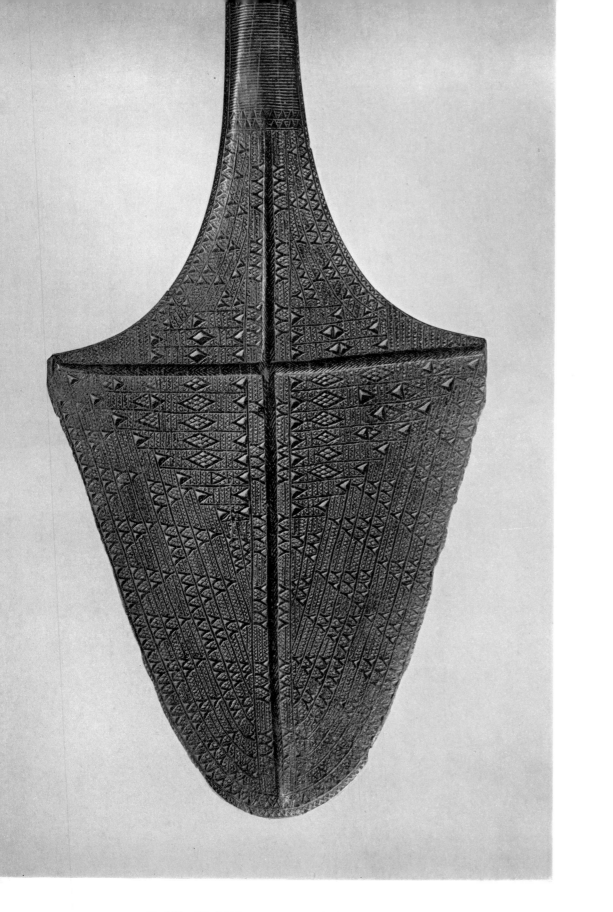

Paddle Club (Reverse)
274159
128.6 cm.

176.

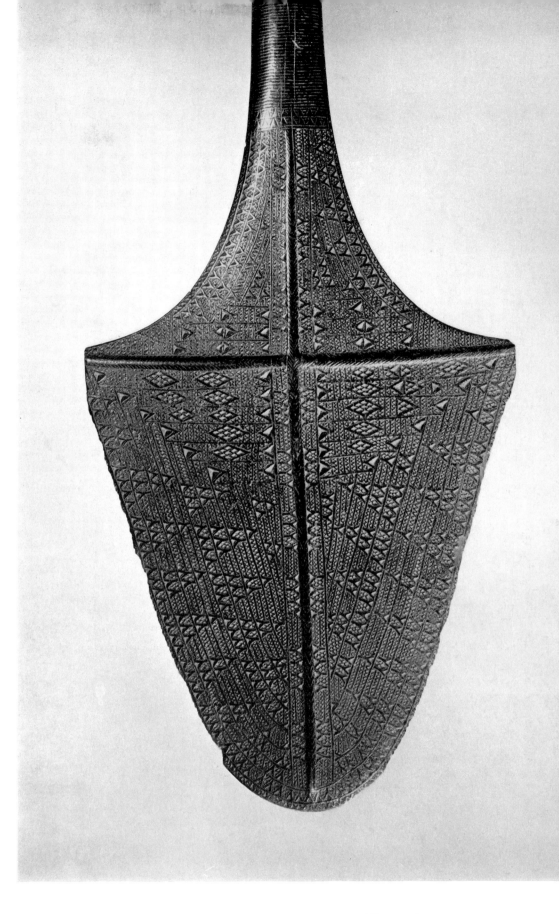

Grip Detail
274159

(Obverse)
274159

177

MISCELLANY

The Fuller Collection holds some important materials from islands outside of main groups or from groups on the fringe of Polynesia. For example, it contains a single tapa beater of typical Samoan form from Futuna. This is not surprising since one theory is that Futuna was settled from Samoa.

Niue Island lies east of Tonga, west of Rarotonga, and southeast of Samoa. Captain James Cook first landed on Niue in 1774. He was met with such hostility that he named the place Savage Island. The Fuller Collection contains thirty-six pieces from Niue. A club of wood is from the London Missionary Society Collection, and a neck ornament of small yellow shells from the same collection was originally collected by the Reverend Dr. R. Wardlaw Thompson. There are other clubs, a tapa beater, a fan, spears, necklaces, and a model canoe also from Niue. There is a large carved box and a few fishhooks from the Tokelau Group. The box was collected by the Reverend Dr. R. Wardlaw Thompson. From the isolated Chatham Islands there are three pieces – two adz blades and a crude hand club.

Three pieces in the collection are attributed to the descendants of the *Bounty*. They are from Pitcairn Island. One is a wooden club, another a whale tooth with an inscription, and the last is a piece of tapa cloth obtained by Rear-Admiral Lowther on the island in the 1850's. From the Ellice Islands the collection has a tool of turtle carapace, a bone awl, a bone knife, and an adz with an iron blade. All were collected on Funafuti by W. F. Collingwood in 1896. In addition there are a dozen fishhooks. Rotuma is the source of twenty-three artifacts, mostly clubs.

MELANESIA

NEW CALEDONIA

When compared with those from some other parts of Melanesia, the cultural materials from New Caledonia which have survived in the museums of the world are not numerous. Most are to be found in Europe, especially in France, which has held administrative responsibility for the area since mid-19th century. Fuller collected nearly one hundred items from New Caledonia.

New Caledonia, one of the largest islands in the Pacific, is about 700 miles east of Australia. Cook discovered it in 1774, naming it New Caledonia because its appearance suggested Scotland. Numerous others visited the island over the years but, possibly because of the truculent natives, it was three quarters of a century before the island was finally claimed by France. The nearby Loyalty Islands are customarily considered as ethnographically related.

In New Caledonia, masks, architectural carvings, and small naturalistic images were associated with kinship and religion. The Fuller Collection includes a carved mask (277508) with the *182* characteristically large nose, and two standing figures (277509-10). *182, 183* The mask is black with painted red nostrils and lips and white eyes and teeth. The two figures are roughly carved and are unpainted. Perhaps the most unusual piece in the collection is a bone implement or ornament (277507) originally obtained by the *185* Reverend Dr. R. Wardlaw Thompson of the London Missionary Society. It consists of two long bird bones fastened together at each end and a handle of cord and flying-fox fur. Another specimen not generally found in collections is a necklace of 108 disk-shaped green amphibolite beads (277558) with flying-fox fur tassels at each *185* end.

There are four ceremonial clubs or 'axes' with mottled green-brown stone disk-shaped heads (277499, 520, 21, and 59). The *186, 187* bindings of the handles are variously decorated with shells, flying-fox fur, native fiber, and trade cloth. Another artifact illustrating fine workmanship is an ax (277526) which has a stone *189* blade and a handle decorated with shells and flying-fox fur. It was originally in the Rosehill Collection. Two of four short-handled working adzes so characteristic of New Caledonia are illustrated

189, 190, 188 (277497 and 525). Another type of adz is 277527 with a large green
191 blade of ground stone. Bindings are of sennit. One ax (277500)
illustrates an effect of acculturation. This large ax, originally
from the Hemming Collection, has an iron blade instead of a blade
of stone.

There are clubs of three main types in the collection. The bird-
193 headed clubs display excellent workmanship. Number 277551 is an
especially fine old piece with the grip of the handle wrapped in
bark and a series of flying-fox fur tassels and knobs at the end. A
192, 194, 195 variety of dome-headed clubs is shown (277532, 34, 36, 38-41, and
192 43). One item of clothing deserves mention. It is a short woman's
skirt of fiber, formerly in the London Missionary Society Collec-
184 tion. A Loyalty Islands gourd container (277491) has a decorative
cord binding and carrying strap of sennit.

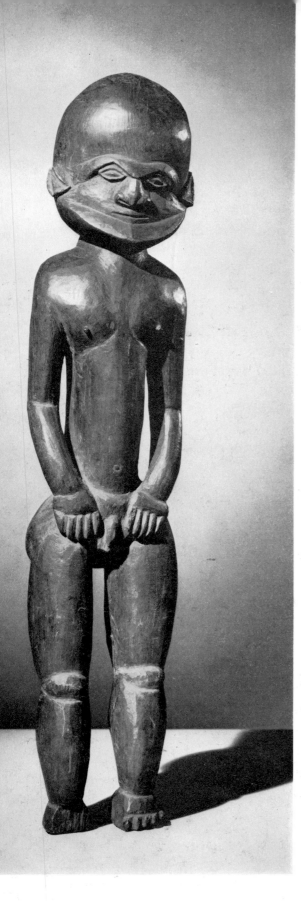

Carved Figure
277509
66.5 cm.

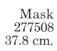

Mask
277508
37.8 cm.

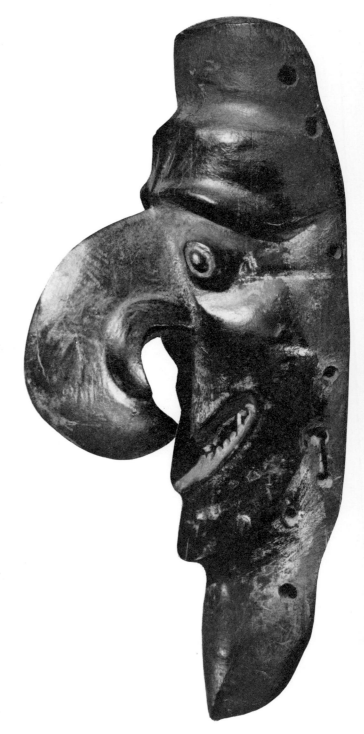

182

Carved Figure
277510
60.0 cm.

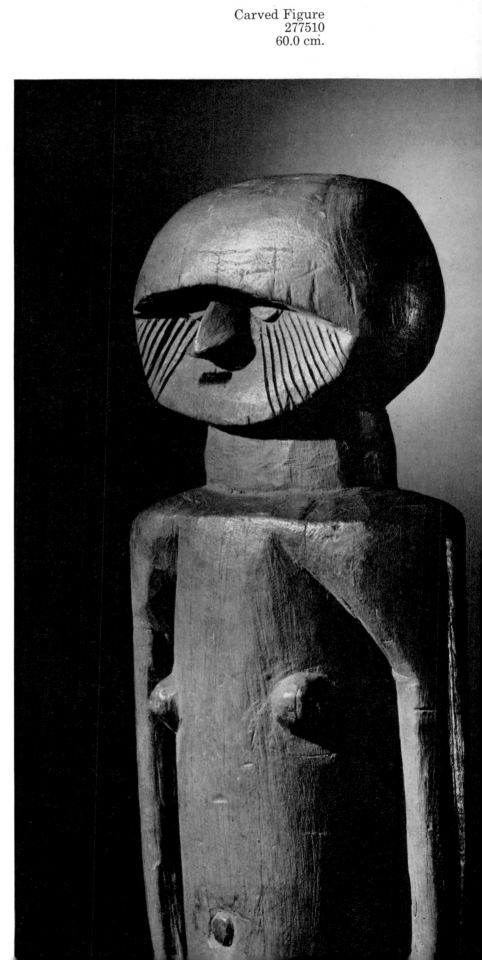

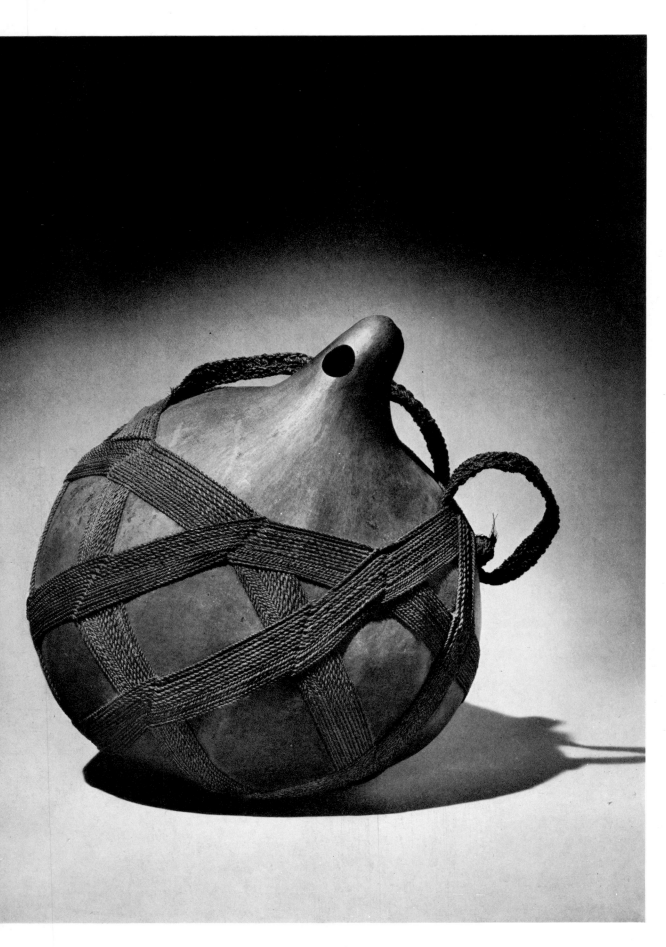

Gourd Container
277491
Height 32.0 cm.

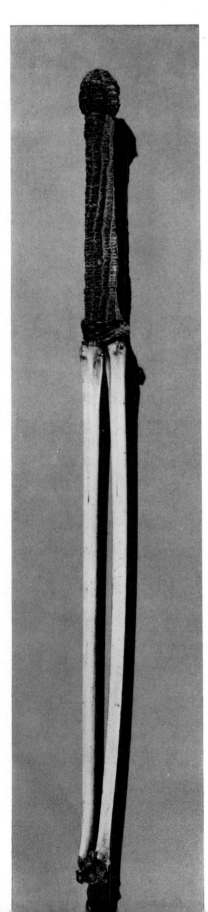

Bone Implement
277507
57.2 cm.

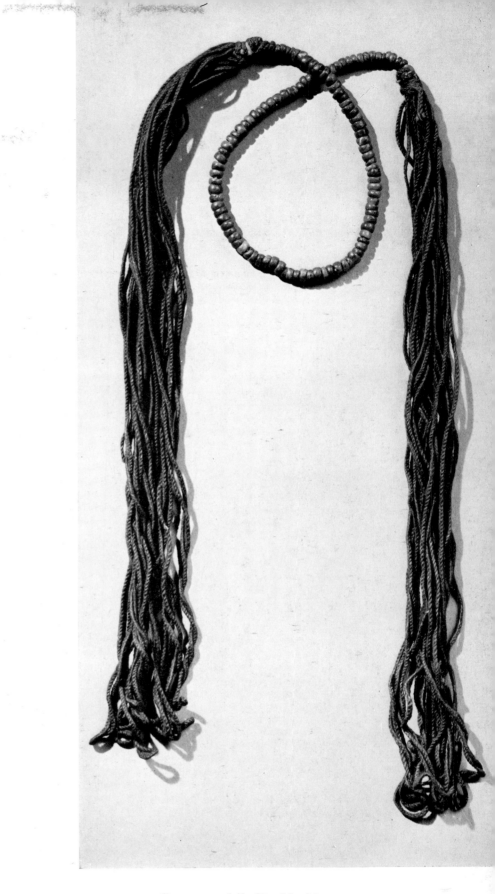

Green amphibolite Necklace
277558

185

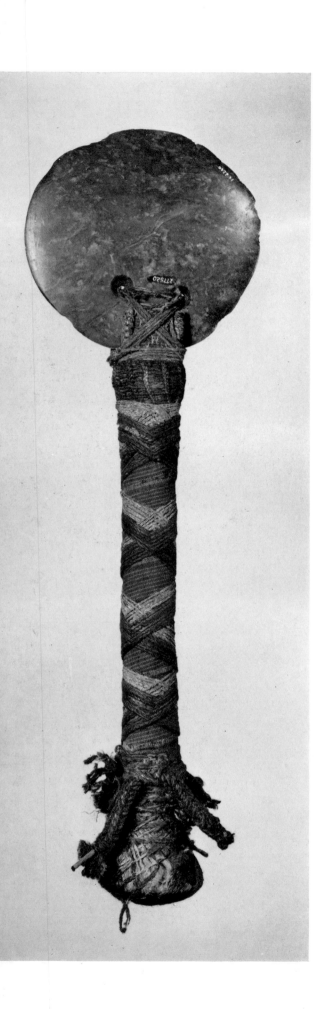

Ceremonial Adzes
277520
57.0 cm.

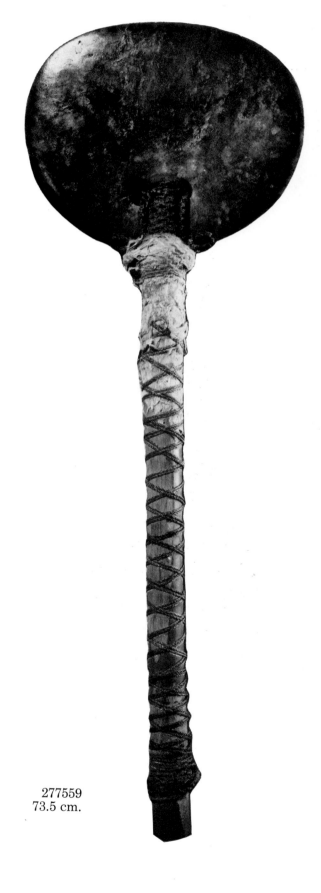

277559
73.5 cm.

186

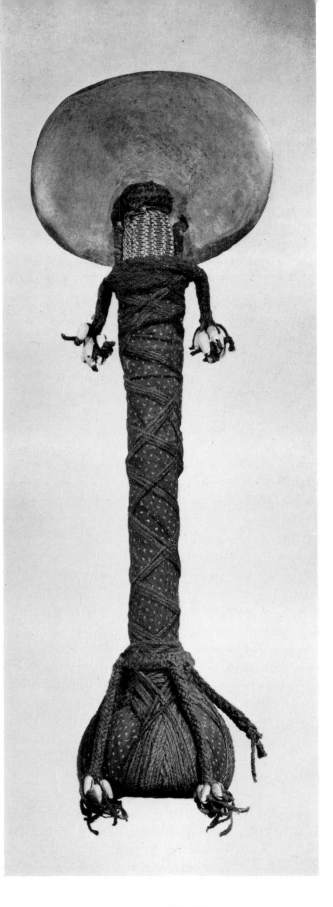

277499
62.5 cm.

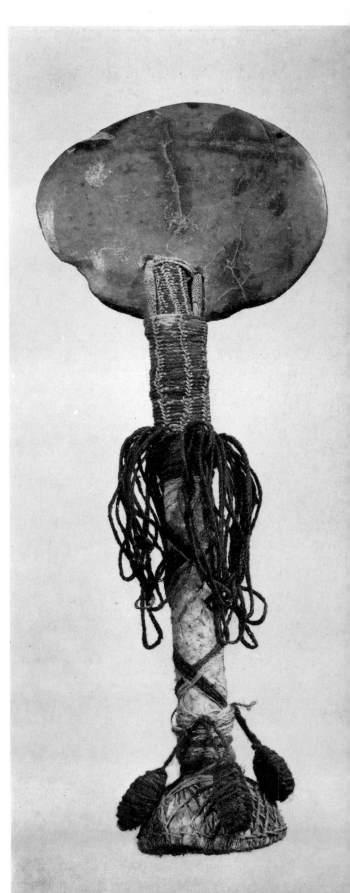

Adz
277527
51.9 cm.

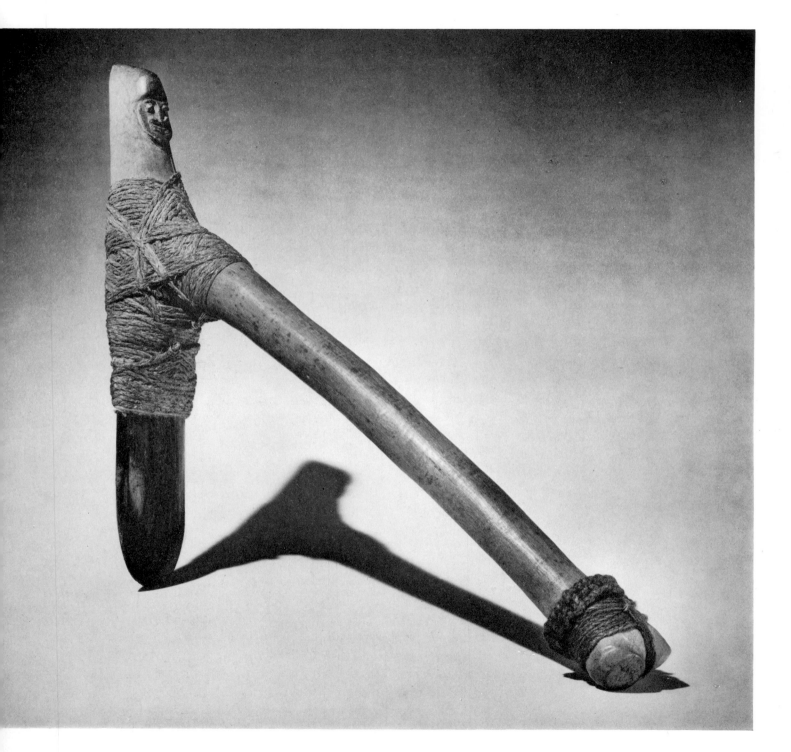

188

Working Adz
277497
21.7 cm.

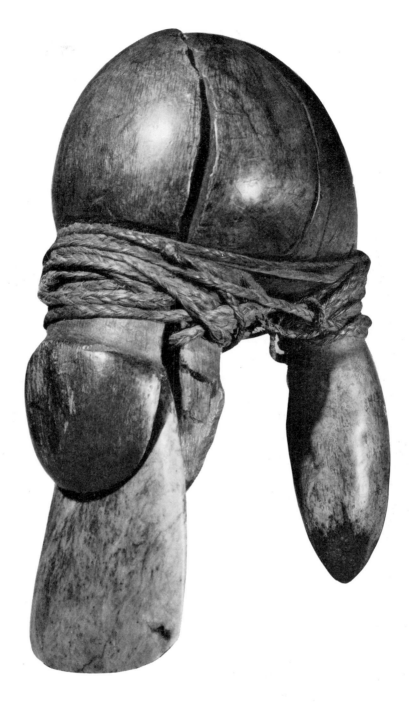

Ax
277526
58.6 cm.

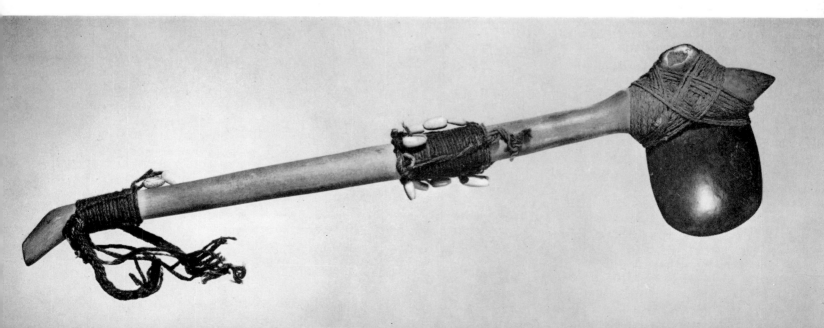

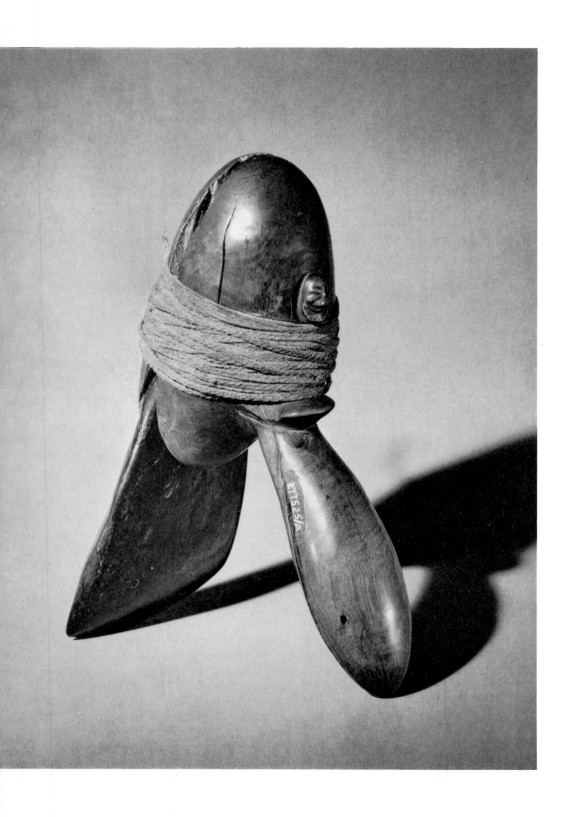

Working Adz
277525
23.5 cm.

Iron-bladed Ax
277500
64.7 cm.

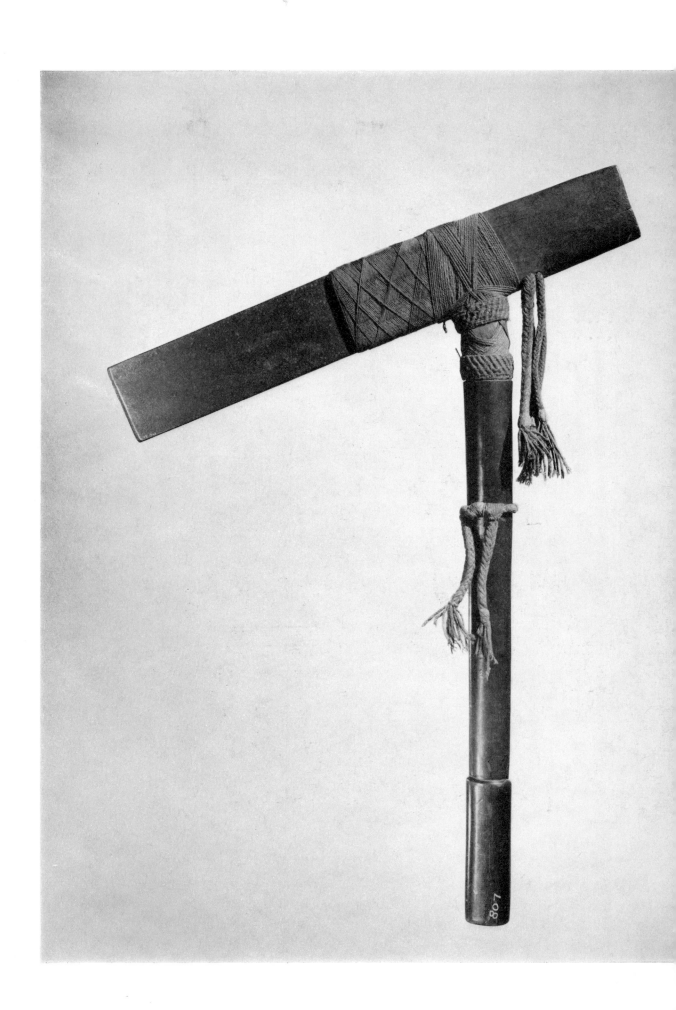

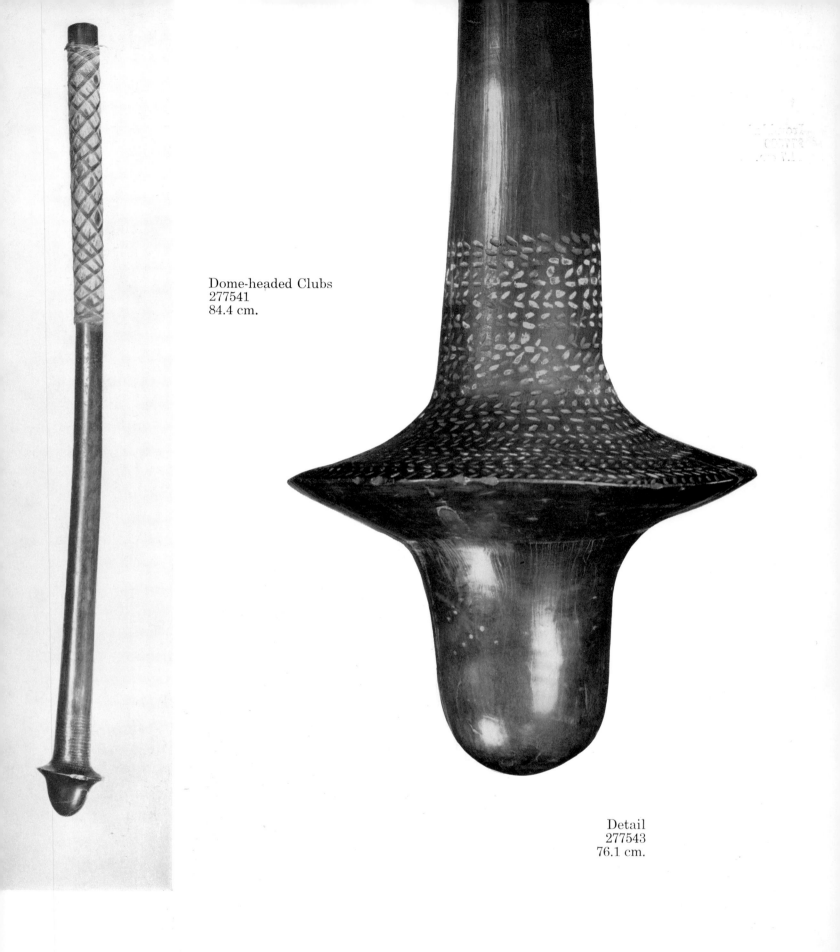

Dome-headed Clubs
277541
84.4 cm.

Detail
277543
76.1 cm.

192

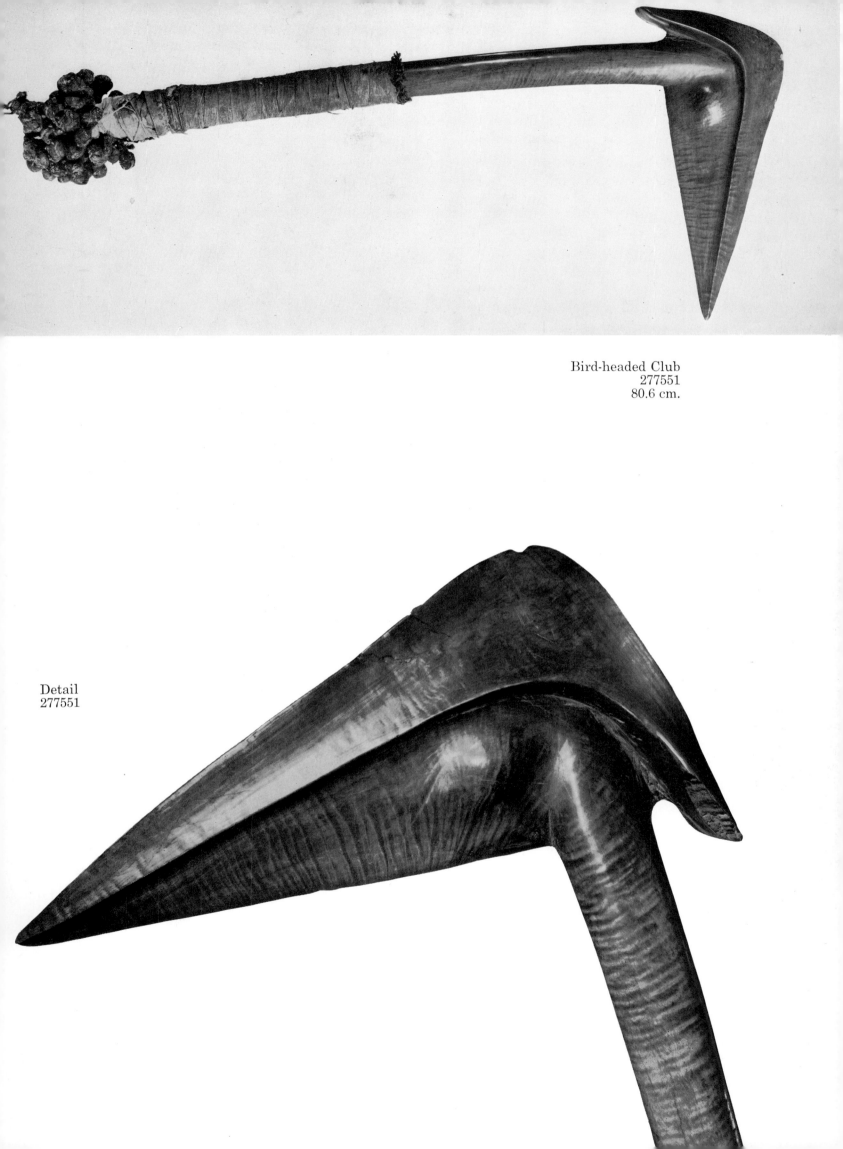

Bird-headed Club
277551
80.6 cm.

Detail
277551

Dome-headed Clubs
277534 (left) 64.8 cm.
277538 (center) 65.6 cm.
277536 (right) 63.3 cm.

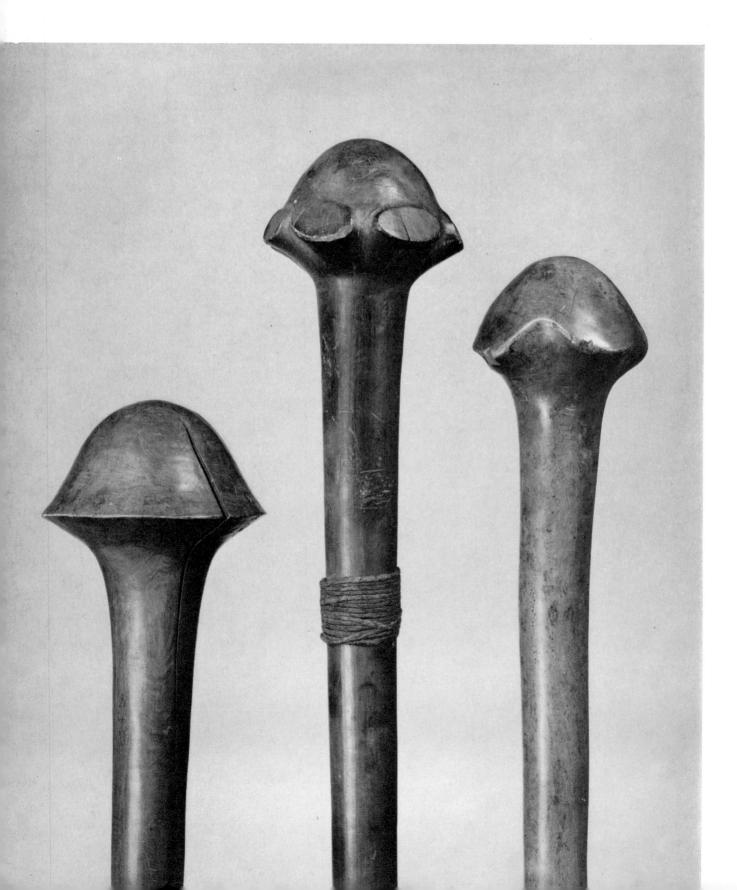

Dome-headed Clubs
277540 (left) 79.8 cm.
277532 (center) 76.0 cm.
277539 (right) 92.0 cm.

NEW HEBRIDES

In early 1606, the Spanish explorer Quiros came upon several of the eighty islands in the New Hebrides Group which are spread over a distance of about 500 miles. The settlement he established was abandoned after a short time. No significant contact was made again until Cook was able to carry on extensive exploration in 1774. Missionary activity began in 1839, but earlier visits had been made by traders. British and French interest in the islands led eventually to joint political control.

Ethnographic work in the New Hebrides has been limited. We know from such evidence as has been produced that the people of the area were concerned with secret ceremonial activities which utilized tree-fern and wooden figures; masks; modeled figures of fiber, gum, and clay; wooden slit drums or gongs; bead arm bands; and woven goods. There was also some work in stone. In general, there was a preoccupation with the delineation of exaggerated facial features in artistic renderings.

There was considerable local variation in the artifacts produced in the New Hebrides. In Malekula the ancestral dead were accorded great distinction. Sometimes they were represented by painted fiber figures, some of which were topped by the skull of the deceased over which a face had been modeled in clay. In such figures the faces are painted and simulated hair is sometimes affixed. Such a modeled or reconstructed skull is 277317. Its facial *199* features are painted with blue and red pigments and the top of the skull is covered with a spider web and a band of red cotton trade cloth. Masks such as 277339 and 40 often were used as parts of *200, 198* funerary figures in Malekula. The faces are painted in red, green, black, and white. Boars' tusks curve backward from the mouths. Spider-webbing covers the back of the masks.

Secular objects shared in the decorative propensities of New Hebridean carvers. On these, stylized human figures are found, often with sharply pointed chins. Examples are 277413 and 14. *199, 202* Two finely carved Janus-faced clubs said to be from Pentacost Island (277450-51) are of hard brown wood. Each has a knob at the *203* grip end and 277450 has shell disk beads for eyes and a bulky cord *203* loop on the handle. The collection features a great number of

other clubs from the New Hebrides and a selection of spears, one 202 of which (277463) is shown. It has a long, tapering bamboo shaft that is decorated with incised marks. The point is of black wood. Other spears (and some arrows) were tipped with human bone. A 201 particularly intricate example is 277327, an ornate and delicately carved spear point.

Stones were sometimes carved with faces. They served as amulets. Some were painted. Of the three in the Fuller Collection 205 (277324, 30, and 31), the first is said to have been a 'fetich worshipped by Chief Malo N.H. from Rev. J. D. L.' The quoted text is from an old manuscript label which is attached. Two specimens of similar appearance in the British Museum are listed from Aitchin Island and are said to have been used as charms against snakes.

201 Several carvings in wood are shown. One (277390) is a shallow 207 bowl. Number 277319 is a dance implement in the form of a pig killer. It is probably from Malekula. Two 'pudding knives' from 207 the Torres Islands (277380 and 478) are of the type used there in the preparation and serving of vegetable food on special occasions. Boat-shaped wooden blocks with pierced ends to which are attached wrapped fiber strings with tiny glass trade beads are said to have served as women's belts. Of the two examples shown 204 (277325 and 26), one is from Hogg Harbor on Espiritu Santo. An 206 arm band (277344) is made of heavy black and white shell beads. Other ornaments include nose pins, bracelets, and combs. Half a hundred clubs, spears, bows, arrows, bags, needles, and adzes contribute to an assemblage of about 200 items.

Mask
277340
13.6 cm.

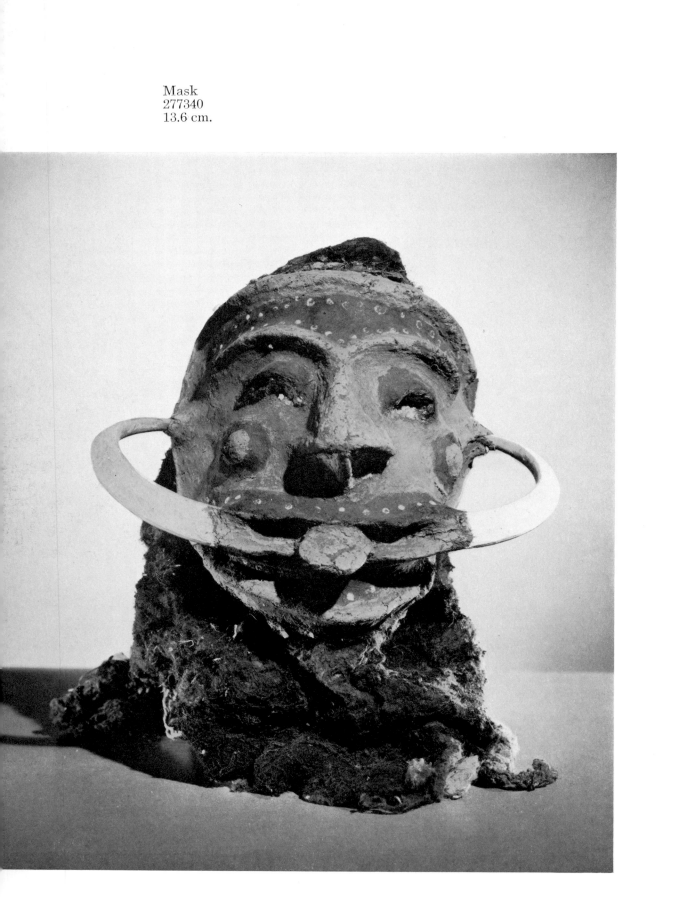

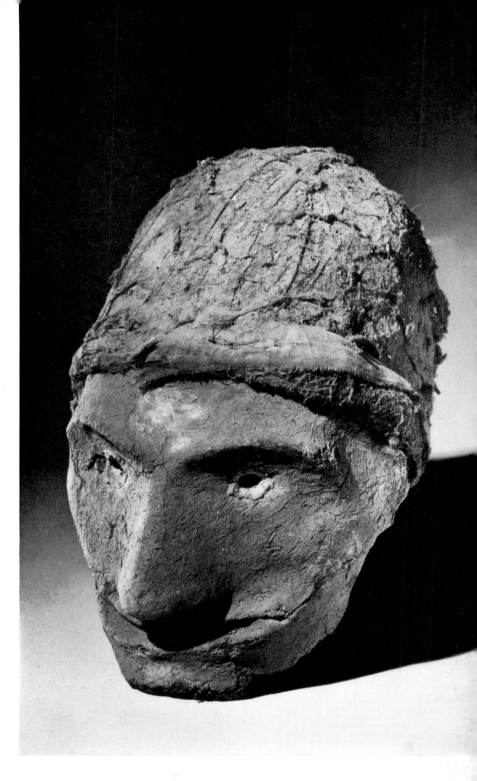

Modeled Skull
277317

Club or Pounder Detail
277413
115.1 cm.

199

Mask
277339
17.3 cm.

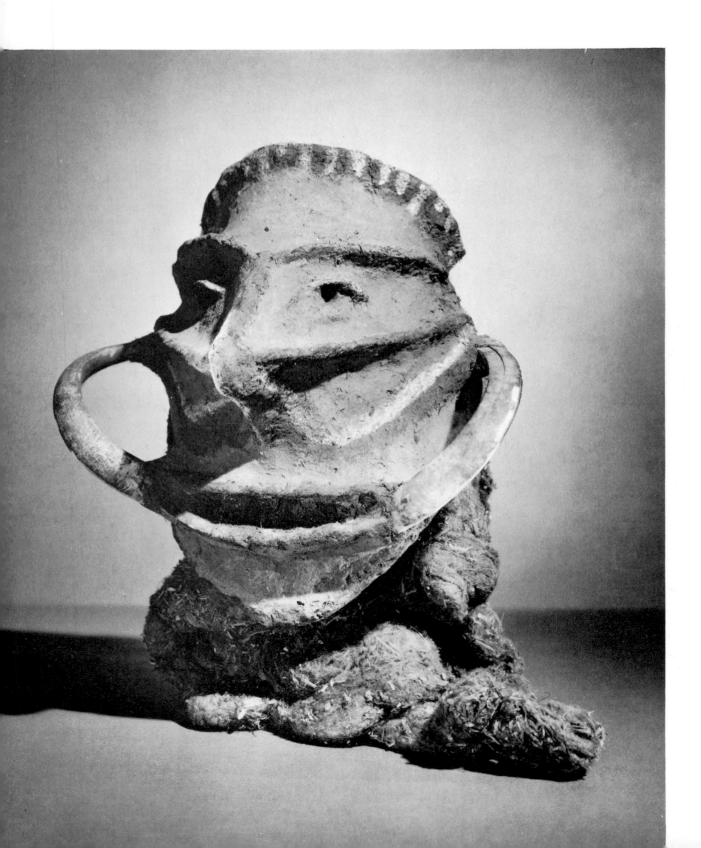

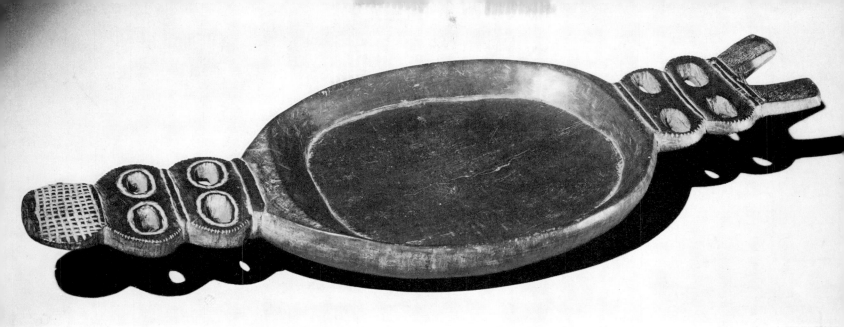

Bowl
277390
73.2 cm.

Bone Spear Point
277327

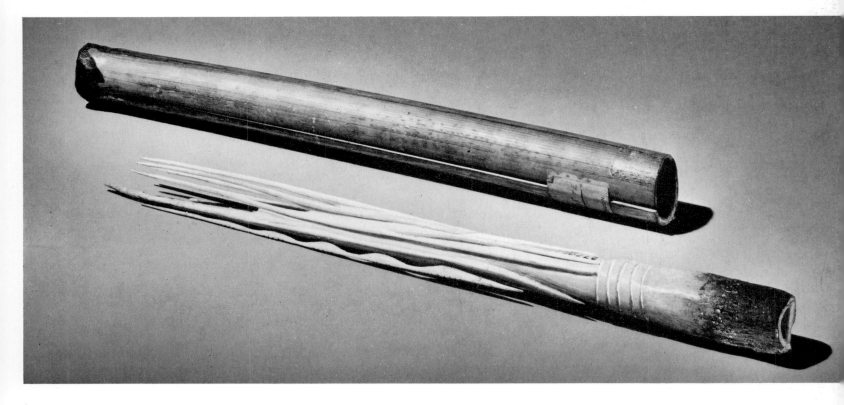

201

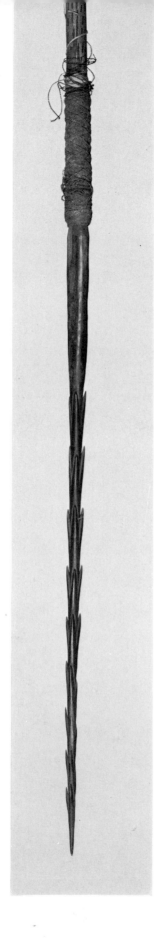

Spear
277463
285.5 cm.

Club Detail
277414
112.8 cm.

202

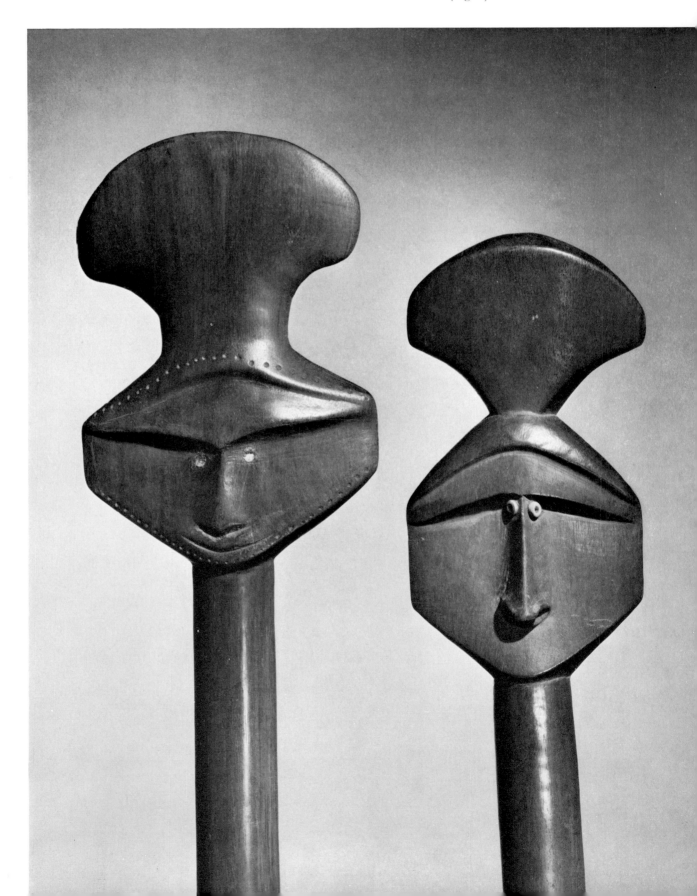

Women's Belts
277326 (top) 24.2 cm.
277325 (bottom) 31.0 cm.

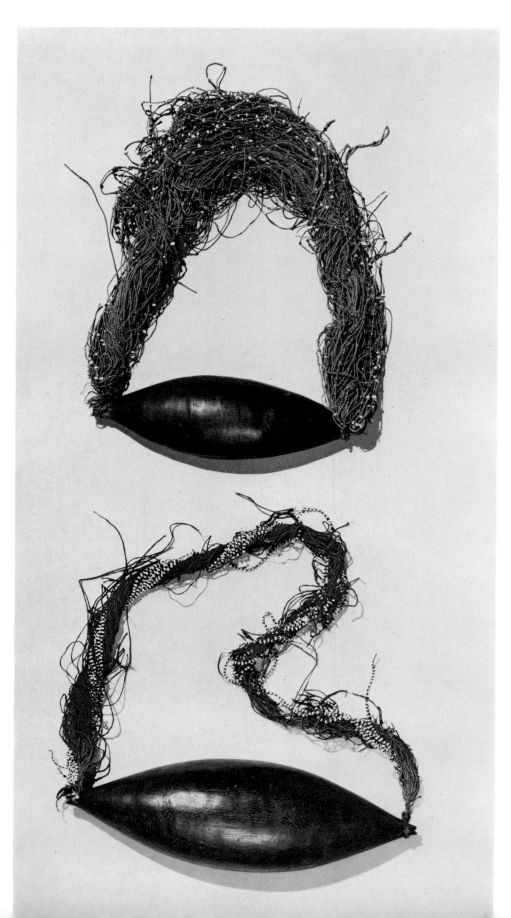

Carved Stones
277330 (left) 12.0 cm.
277324 (center) 15.8 cm.
277331 (right) 19.7 cm.

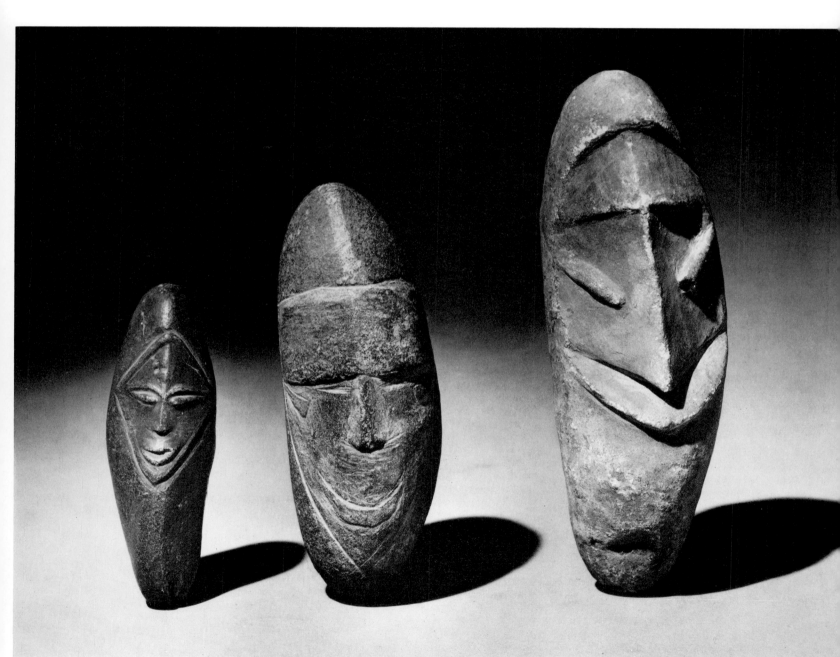

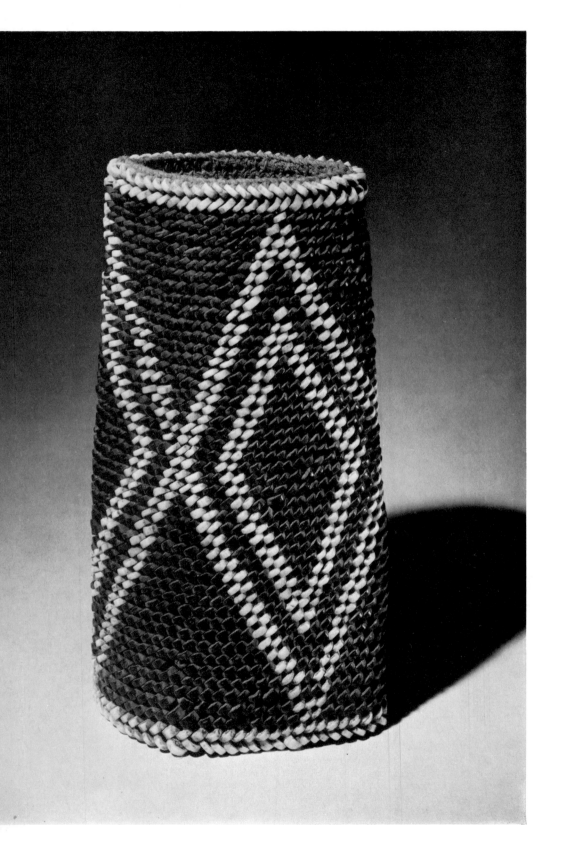

Arm Band
277344
22.7 cm.

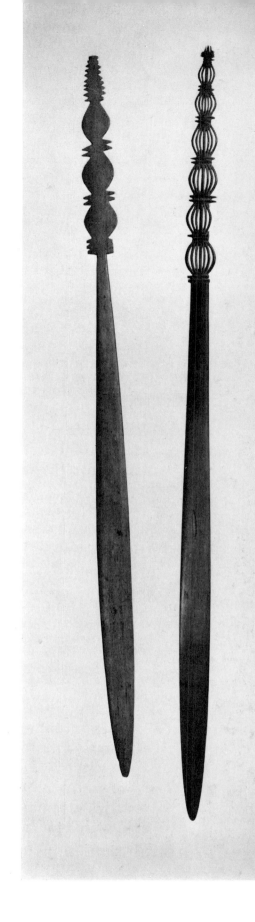

Pudding Knives
277380 (left) 63.1 cm.
277478 (right) 67.6 cm.

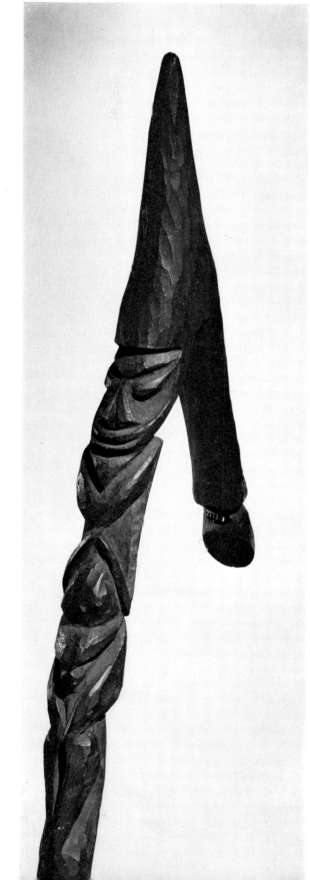

Pig-killer Dance Implement
277319
70.5 cm.

207

THE SOLOMON ISLANDS

The ten principal islands of the Solomon Group and the many small ones lie in a double-row arrangement nearly a thousand miles long directly east of New Guinea. They are mountainous and covered with vegetation. Their people, once warlike and inhospitable, were among the more reluctant to accept outsiders. Contact with Europeans began in 1568, when Mendaña's first expedition reached Ysabel, Guadalcanal, and San Cristobal. For the next 200 years the islands proved elusive as numerous voyagers passed them by. When contacts were made, they were consistently disastrous. When European missions were founded in the 19th century they suffered tragic losses from marauding islanders.

The products of Solomon Islands craftsmen are among the more dramatic and distinctive in the Pacific. The richness and strength of these materials in the Fuller Collection are considerable. They are distinguished by pearl-shell inlay work, blackened wooden carvings, worked tridacna shell, and colorful plaited fiber sheaths for objects from nose pins to bows and clubs. Much attention was paid to fish and bird motifs and to prognathous humanoid treatments.

Among the rarest of Solomon Islands artifacts are inlaid shields. Three (276870-72) are present in this collection. Stylized mosaiclike *ii, 209, 215, 214* designs on the surface of the woven shields are executed by setting small pearl-shell fragments in a red and black mastic base. Human figures and faces, borders, and symmetrical alignments cover the surface in intricate patterns.

Several other shields without inlay are present. Numbers 276873 *217* and 74 and one other unillustrated are of rattan. Another of soft, *216* light-colored wood with painted designs in blue, black, and red is 276985. *217*

Solomon Islands items of adornment are numerous. Ornaments include breast pendants, ear plugs, arm bands, nose pins, and cone- and disk-shell beads. Ears were not only adorned with plugs such as 276821, 24, and 25, but with pendants made of various materials *218, 219* including (as in 276700-1) nuts, shell inlay, human teeth, and *218, 219* trade beads. Other pendants (such as 276703) were made of worked *218*

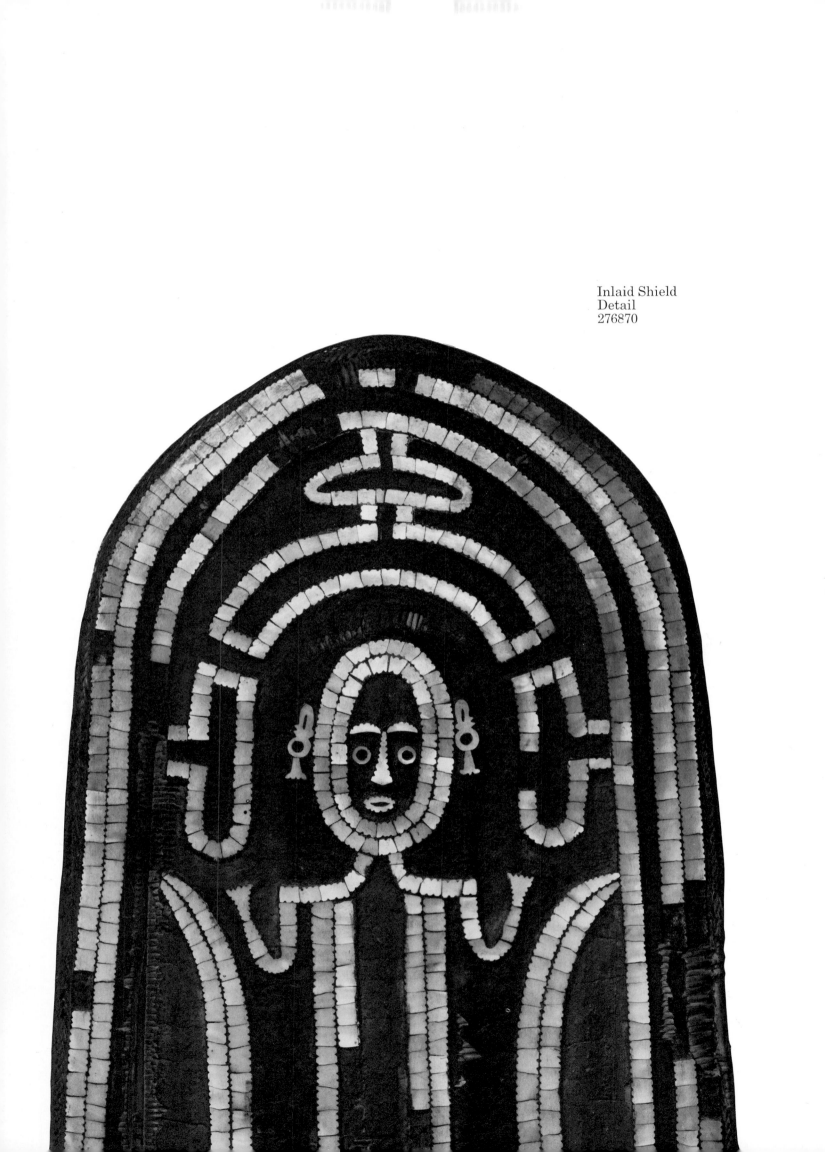

Inlaid Shield
Detail
276870

cone-shell disks, flying-fox teeth, tortoise shell, and shell-disk beads. The illustrated specimen has a native repair which utilizes two disk beads. Breast pendants or necklaces from the Solomons are of many types. Some are pearl-shell crescents, both plain and of openwork (276708). Tridacna-shell and other shell disks, faced *223* with intricately carved over-disks of tortoise shell (276731) are *223* another variety, as are tridacna-shell rings such as 276710. Other *220* ornaments of pearl and tridacna shell with serrations at the base are similar to 276777. The spiraled interior of a cone shell, when *220* revealed in a medial section (see 276722), provides an appealing *221* ornament. Especially delicate animal form designs were created on tridacna-shell pendants by incising. Black pigment was rubbed in the incised lines for contrast. See 276704-7. *224*

Ornamental 'maces' of pearl-shell inlay (277012-14 and 16), worn *225* suspended from the neck and falling upon the back of the wearer, are uniquely Solomons. Those in the Fuller Collection are of unusual beauty. Numbers 277012 and 13 were formerly in the *225* Gruning Collection. Wooden combs, some with pearl-shell inlay, others with woven fiber designs, and some with fiber streamers, were used to ornament the hair. Examples are 276789, 91, 92, and *226, 227* 94. There are many other combs in the collection which stem *227* variously from the Reverend L. P. Robin, Sir H. E. M. James, Boddam-Whetham, and Oldman collections.

Blackened wooden bowls with pearl-shell inlay are typical Solomon Islands containers. Two examples are shown (276597 and *228* 607). A finely carved coconut cup (276766) with shell inlay and a *229* flying-fox head carved in the round at one end was given to Fuller by the famous 19th-century missionary Dr. R. H. Codrington, who was also a canon of Chichester Cathedral. Unique containers of mastic-coated coconuts with painted designs outlined in small white glass beads originated in the Treasury Islands. An example is 277313. Designs are painted in black on a red background. In *222* addition to such 'bottles,' the Fuller Collection includes a number of decorated bamboo lime containers which were components of the betel-nut complex.

Ancestral skulls, decorated with tridacna- and cone-shell rings, were, in olden times, placed in small houselike shrines in remote bush country. Two such skulls are in the Fuller Collection. One (276646) is illustrated. These skulls were taken with ten others *230* from a shrine on Vella Lavella Island in 1909. A funerary stick of bamboo with a cluster of shell ornaments affixed is 276854. Number *231* 276772 is a single grave ornament of tridacna shell. *221*

Two truly magnificent decorated human skulls with molded

233, 232 and carved features and pearl-shell inlay embellishment are illustrated (276594-95). Another such head, less fine, is in the collection, but is not shown. The features of these objects are formed of a hardened black gum and the hair is of bleached bast
232 fiber. Number 276595 was formerly in the collection of Sir H. E. M. James and is reputed to have been purchased from a trader on Gizo.

Among Solomon Islands carvings of special importance are canoe-prow charms or guardian spirits. There are some fine
234, 235 examples in this collection. Number 276855 is a seated figure from which the feet are missing. Red paint on the forehead is faded, as are black stripes on the arms. Mastic on the ears indicates the probable presence of shell inlay at an earlier time. The object was formerly in the Bompas Collection. The inlay in the ear lobes of
236 276593 is of black-lipped pearl shell. A lug at the back is pierced by
239 three holes. A smaller charm (276592) has a rather grisly history. One shell eye is absent. A red glass bead forms the pupil of the remaining eye. A rear lug has three holes for attachment, and there is a row of small holes along the jaw-line to allow for the insertion of fiber 'hair.' The glass disks which appear in the lobes of the ears are explained on a label attached to the specimen by a former owner. It reads as follows:

Female idol, Solomon Islands, with glass lenses in the ears. These lenses were in the spectacles of one of a number of Marist Catholic missionaries who in a body were slaughtered and eaten in the islands. The British warship *Rosario* was sent to punish the perpetrators. Lt. Bower, who on returning from the expedition, gave me the idol asserted that these very glasses were the only clue in finding out in which particular village the outrage was committed. A friendly native giving the information and proving his statements by pointing out the respective idol. Soon after, when again going to the same island, poor Lt. Bower, who was fishing in an inlet and out of sight of his vessel, was also murdered, roasted, and eaten by natives who followed the boat. The incident is mentioned in the Admiralty records.

An elaborately carved Janus-faced ornament designed to protect
237 the canoe to which it was affixed is 276644. The distended and plugged ear lobes are carved of separate pieces of wood. The charm is painted red and black and was formerly in the Erskine Collec-
237 tion. Number 276853 was formerly in both the Boynton and Wallace collections. The specimen was used secondarily as a hearth for fire-plowing. Above its stylized head are fastened four white cowrie shells. The eyes are of shell inlay and impressions in the mastic on chin and brows indicate that such inlay was formerly there. Seeds set in mastic must have served as 'hair.'

There are several carved wooden figures in the collection which are not shown. Two excellent fishing floats are featured here (276882-83), one of which (276883) incorporates a stylized human carving which has sharklike characters. The floats are of soft, light-colored wood stained black. *238, 243*

Some of the finest Solomon Islands carving is found on the handles of canoe paddles. A number of such paddles are included in the Fuller Collection and a selection of well-carved handles is shown here (276918, 20, 24-28). They feature openwork, shell inlay, *238, 240-242* and human and animal representations. One of several types of Solomon Islands paddles incorporates a fish motif with inlay on both the blade and the butt (see 276918). A dance paddle (276971) *242, 246* with a curved blade is similar, but has a different butt. An interesting feature is the button used as an eye inlay piece. Views of the blades of three paddles (276904, 6, and 276417) are shown. *244, 245*

The range of Solomon Islands weapons in the collection includes spears, bows and arrows, and clubs. Several clubs are shown (276876, 959, and 77), along with some detail views of an ax-club *248, 249, 246* (276982). Altogether the Solomon Islands segment of the Fuller *250, 251* Collection comprises more than 600 specimens. Approximately a third of the segment is made up of ornaments and there are more than eighty fishhooks.

Inlaid Shields
276872
82.0 cm.

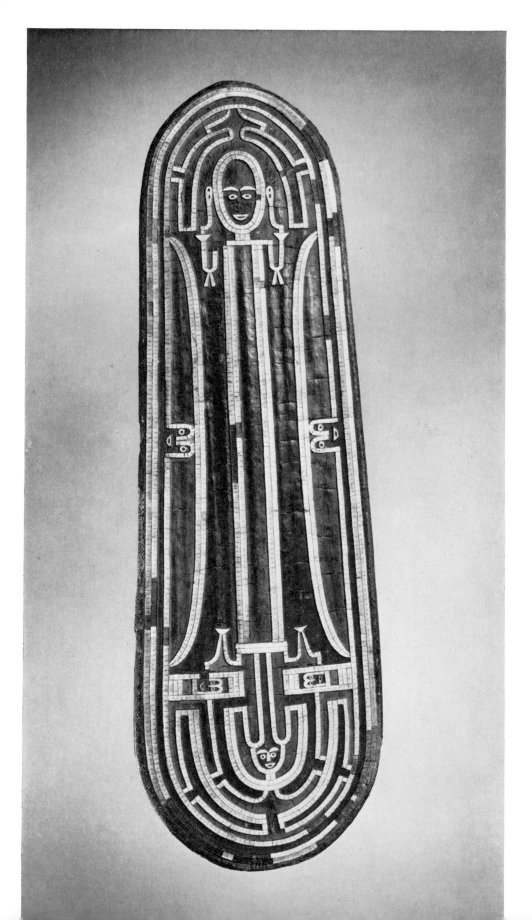

276870
79.0 cm.

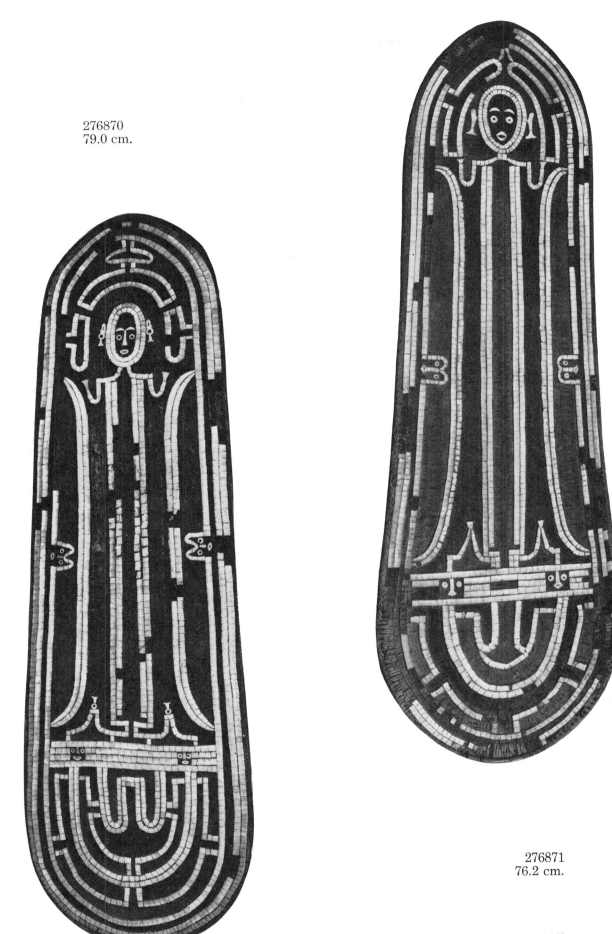

276871
76.2 cm.

215

Shields
276874
81.2 cm.

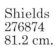
216

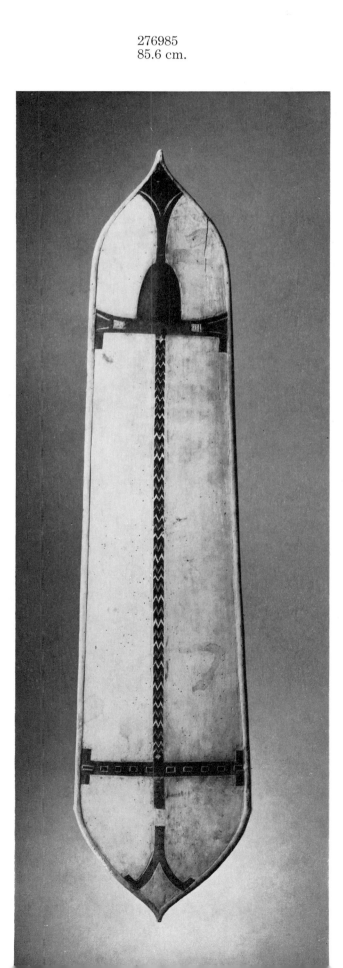

276985
85.6 cm.

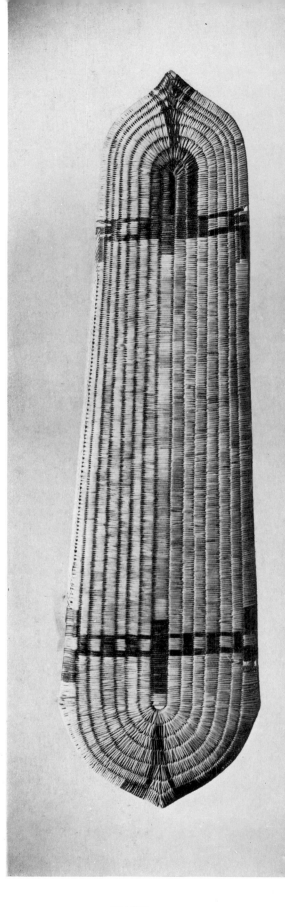

276873
82.3 cm.

217

Ear Ornaments
276703 (left)
276701 (right)

Ear Plugs
276825 (left) Dia. 5.8 cm.
276824 (right) Dia. 5.9 cm.

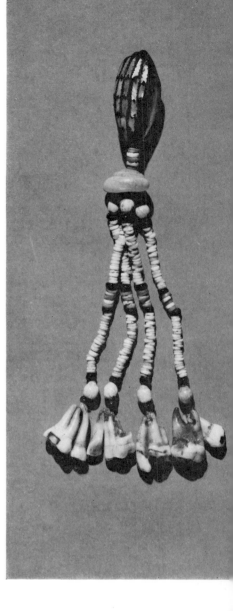

Ear Ornament
276700

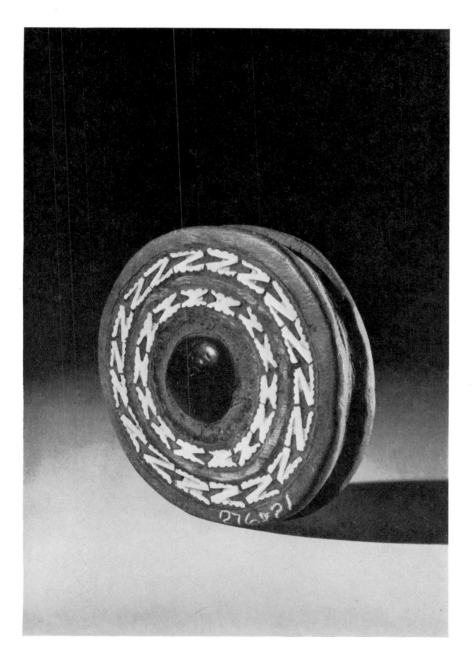

Ear Plug
276821
Dia. 9.0 cm.

Shell Pendants
276777
2.7–3.9 cm.

Neck Ornament
276710
Dia. 9.7 cm.

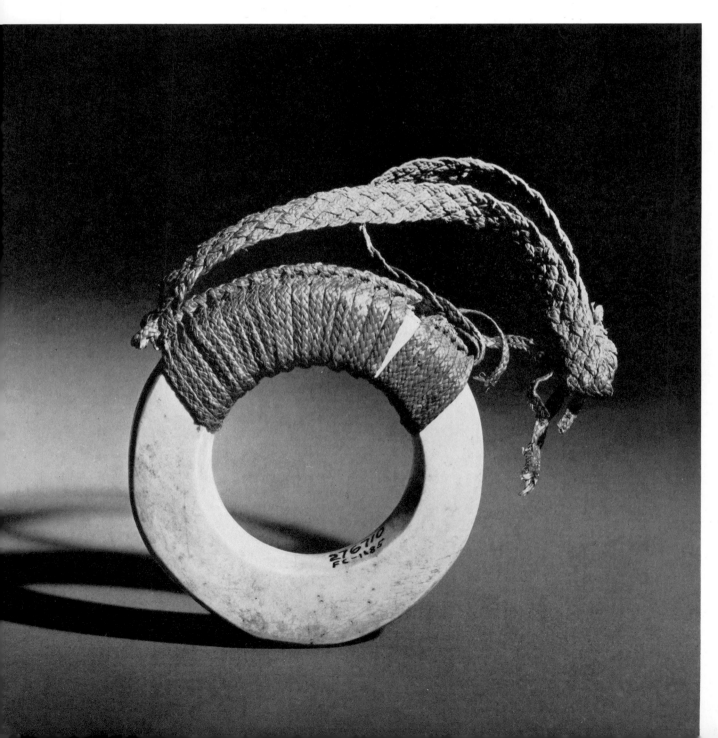

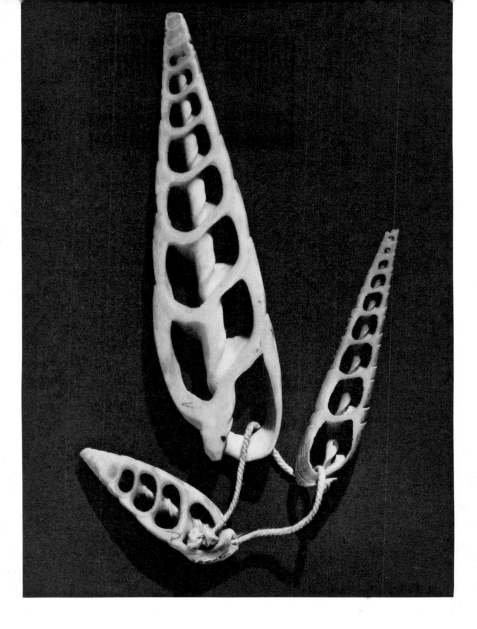

Ornaments
276722
5.3–13.4 cm.

Grave Ornament
276772
11.5 cm.

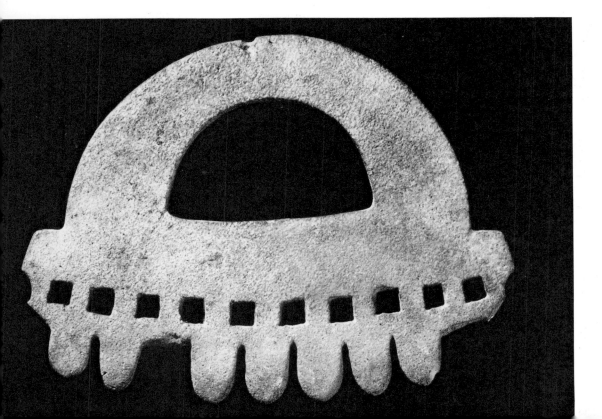

221

Coconut 'Bottle'
277313
24.9 cm.

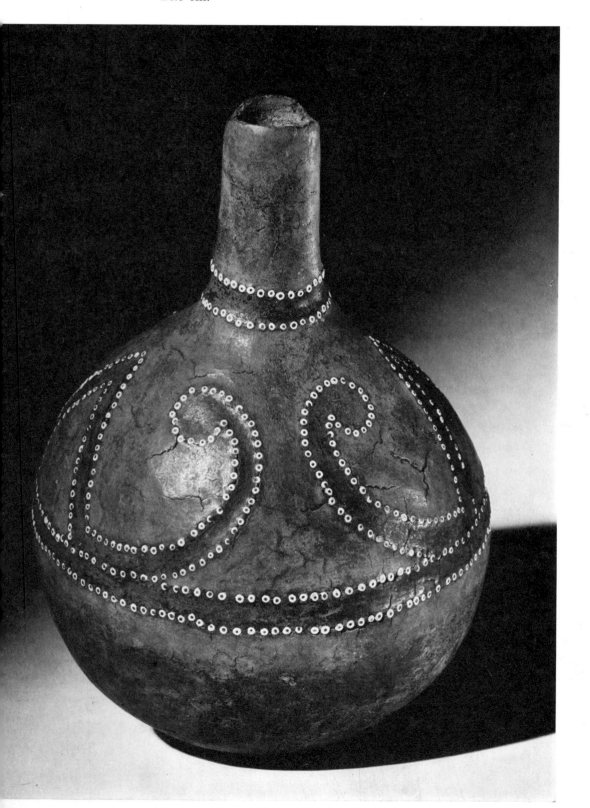

Breast Ornament
276731
Dia. 10.7 cm.

Shell Pendant
276708
14.6 cm.

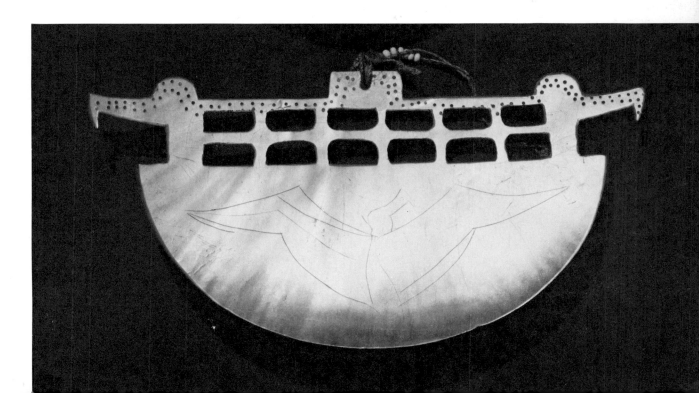

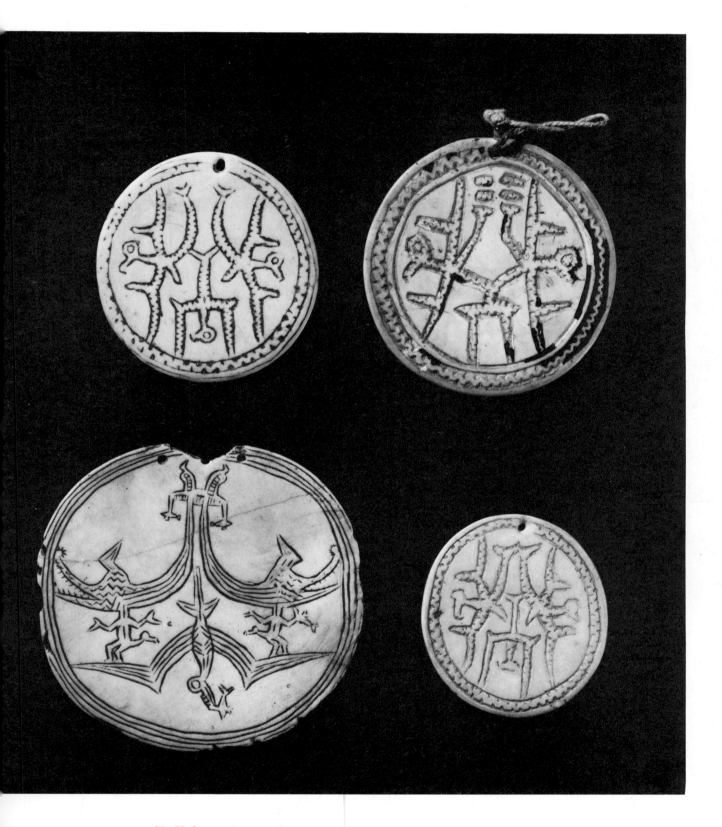

Shell Ornaments
276705 (upper left) 5.9 cm.
276707 (upper right) 6.7 cm.
276704 (lower left) 8.5 cm.
276706 (lower right) 5.5 cm.

Inlaid Maces (left to right)
277012 39.7 cm.
277014 41.9 cm.
277013 39.2 cm.
277016 38.1 cm.

Ornamental Comb
276792
44.8 cm.

Inlaid Comb
276789
19.2 cm.

226

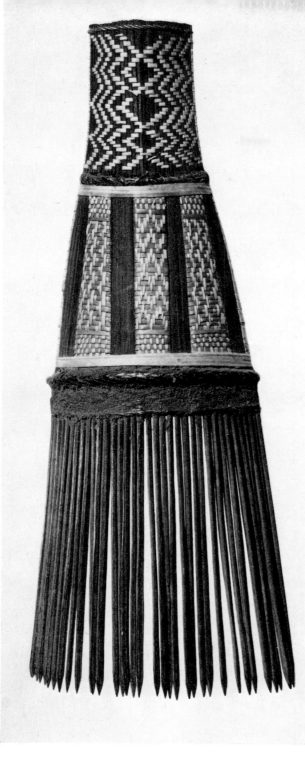

Ornamental Comb
276794
22.8 cm.

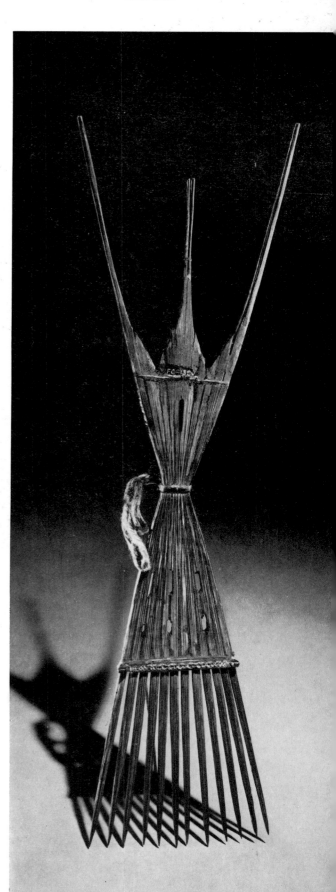

Wooden Comb
276791
33.5 cm.

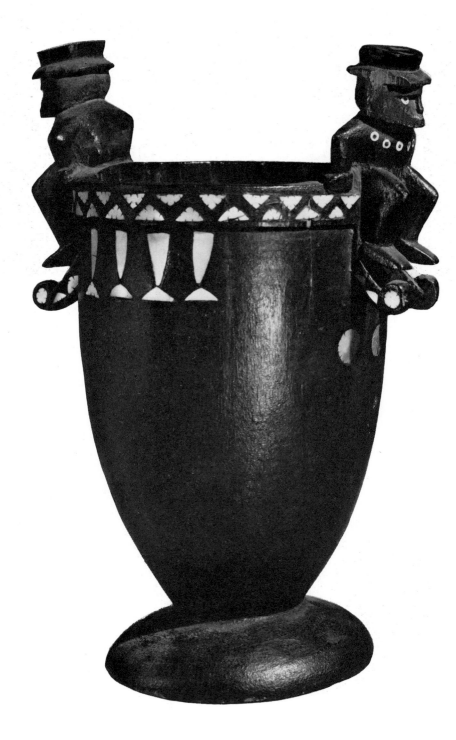

Bowl
276597
30.2 cm.

228

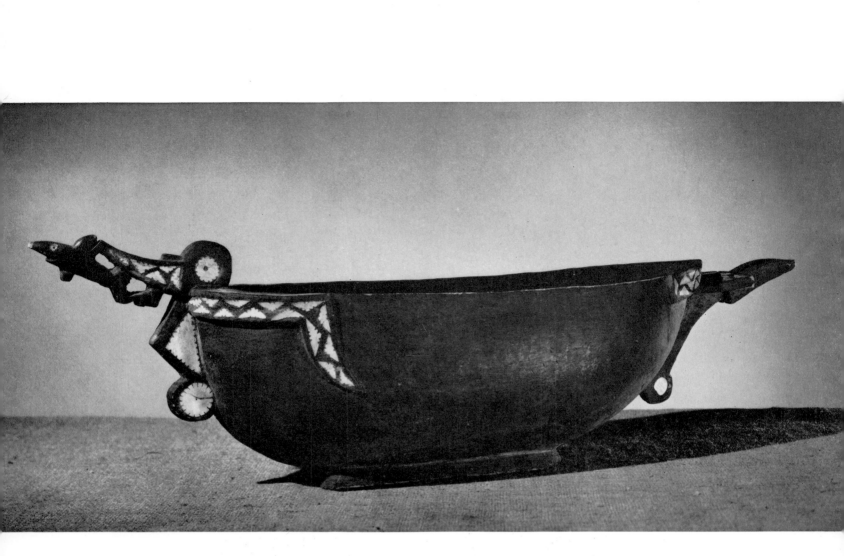

Inlaid Bowl
276607
64.5 cm.

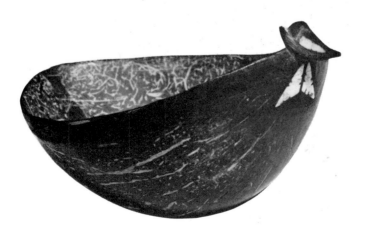

Coconut Cup
276766
12.8 cm.

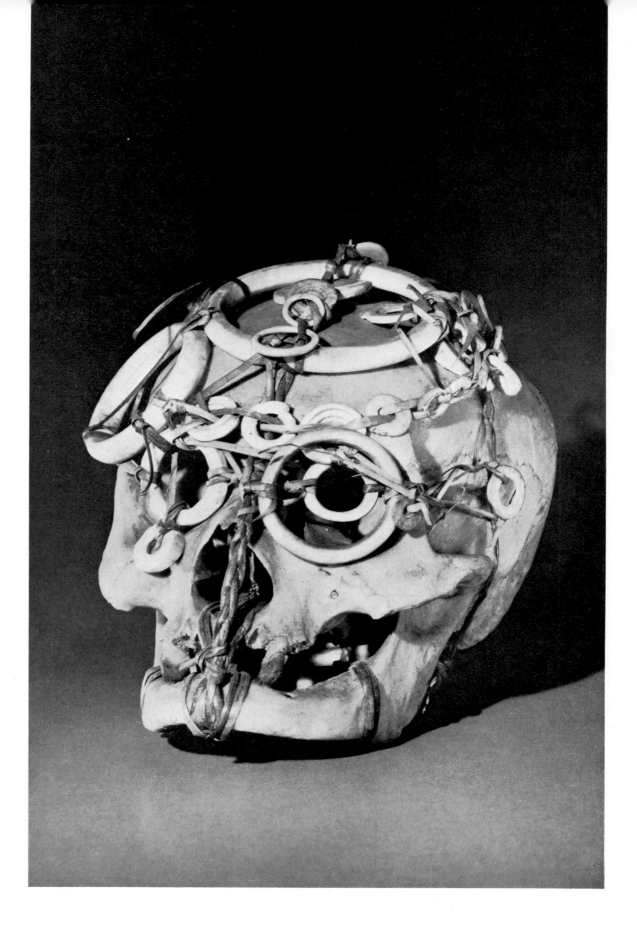

Ancestral Skull
276646

Funeral Stick
276854
103.9 cm.

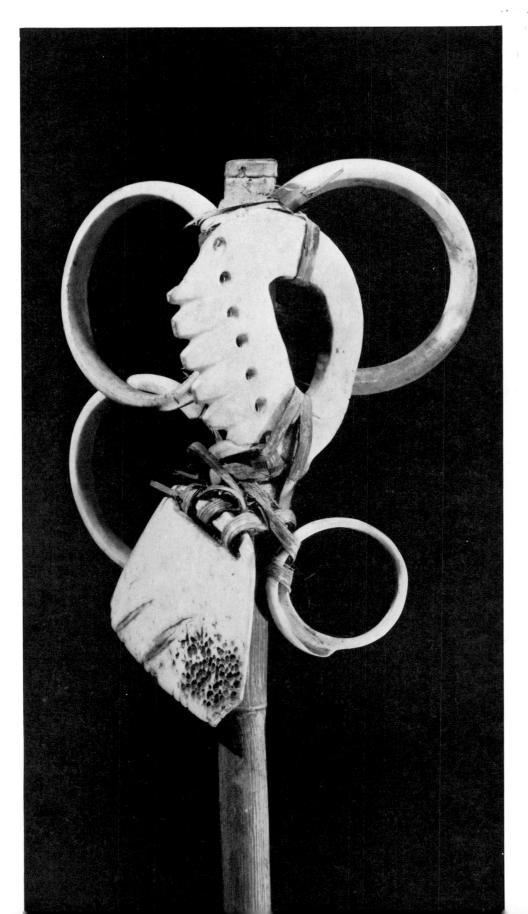

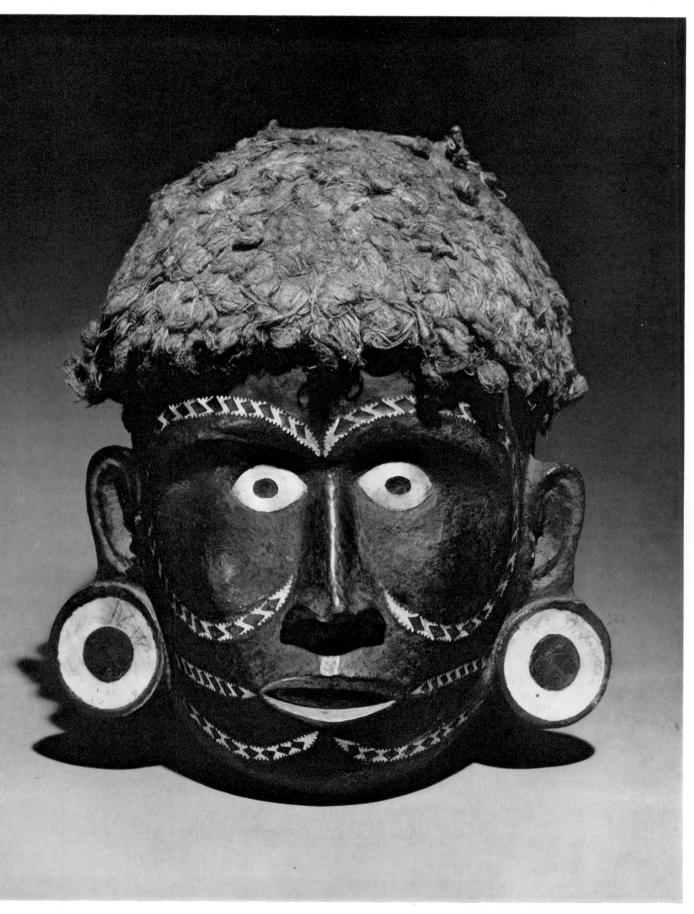

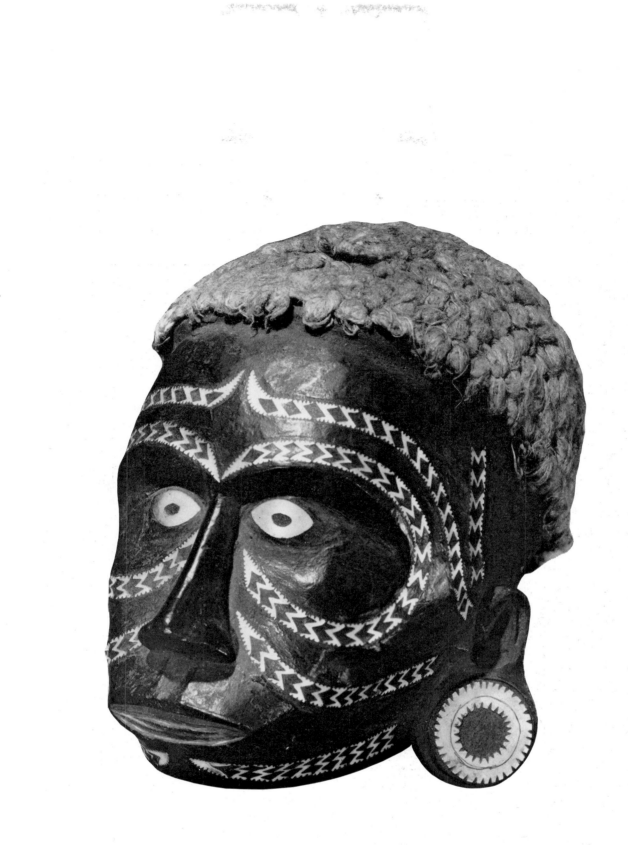

276594

233

Canoe-prow Charm
276855
26.0 cm.

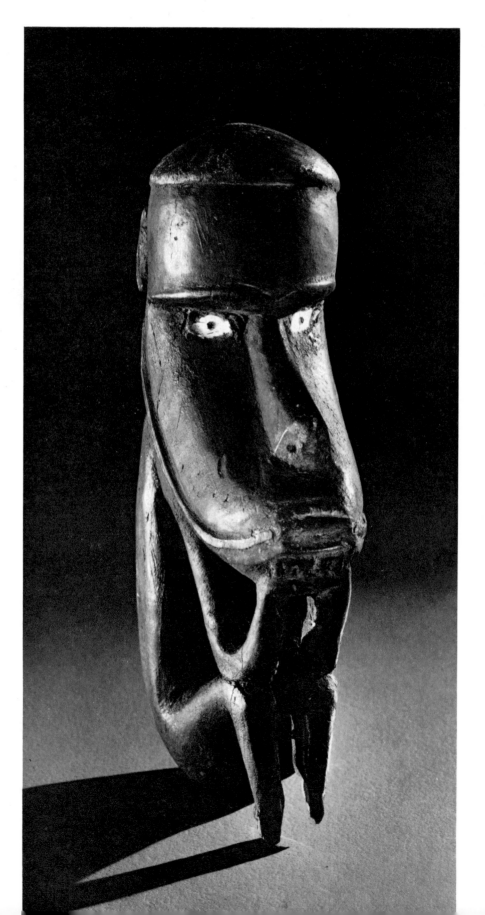

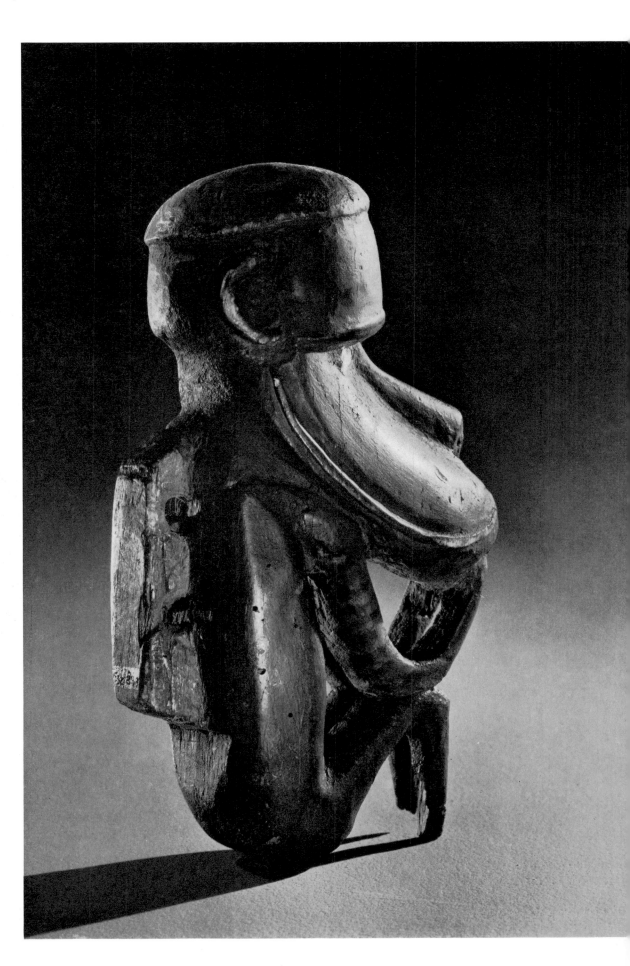

276855
Back View

Canoe-prow Charms
276593
26.0 cm.

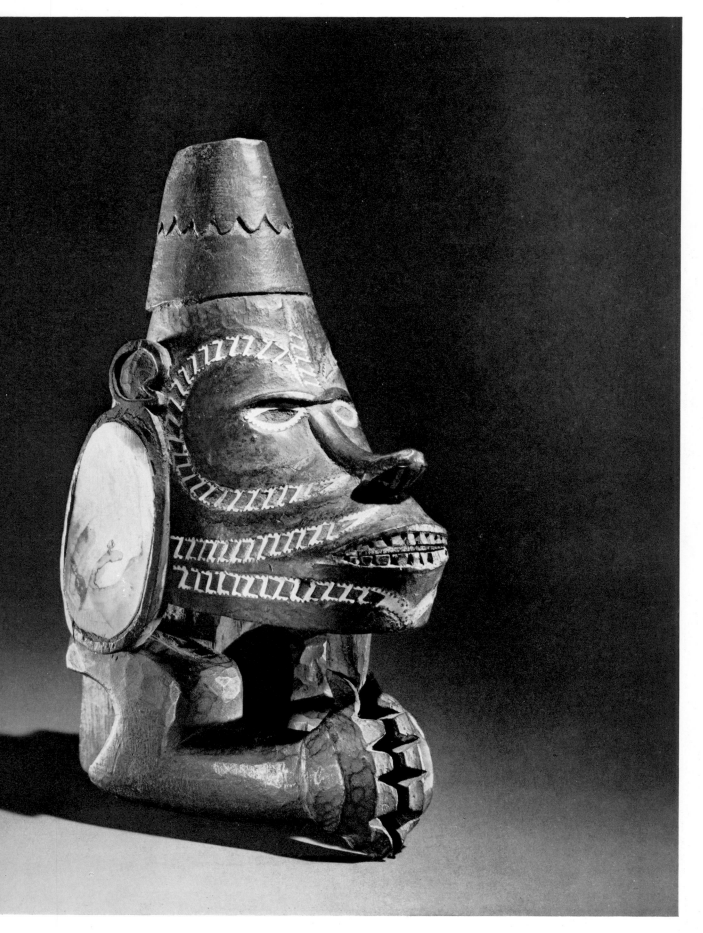

276644
51.0 cm.

276853
56.7 cm.

237

Canoe-paddle Handle Detail
276920 122.6 cm.

Fishing Float
276882
87.5 cm.

238

Canoe-prow Charm
276592
21.0 cm.

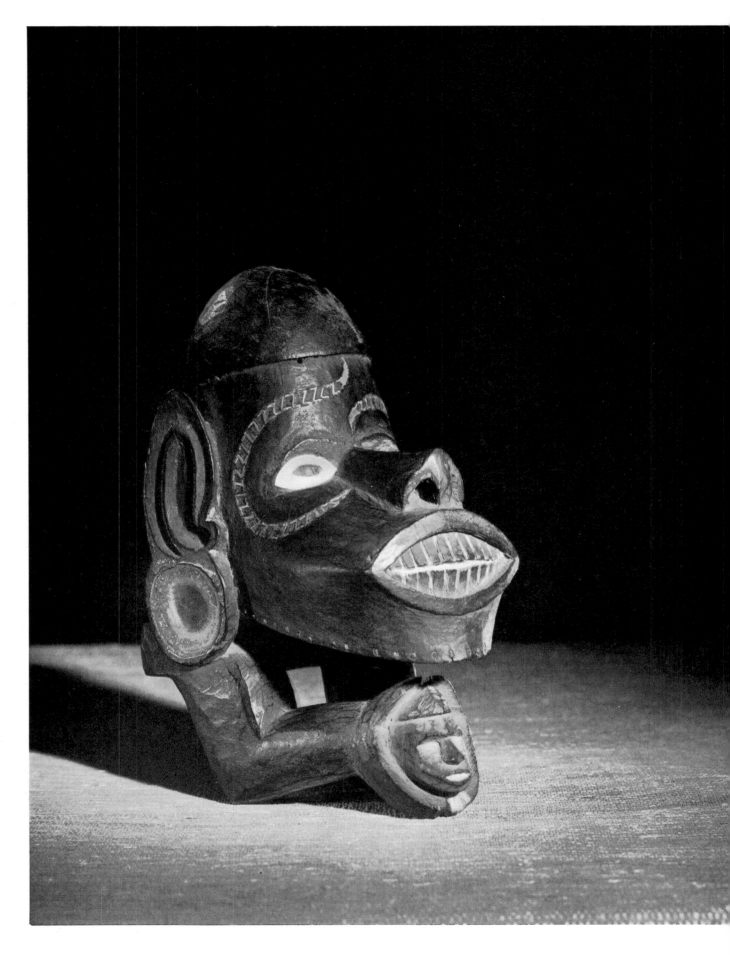

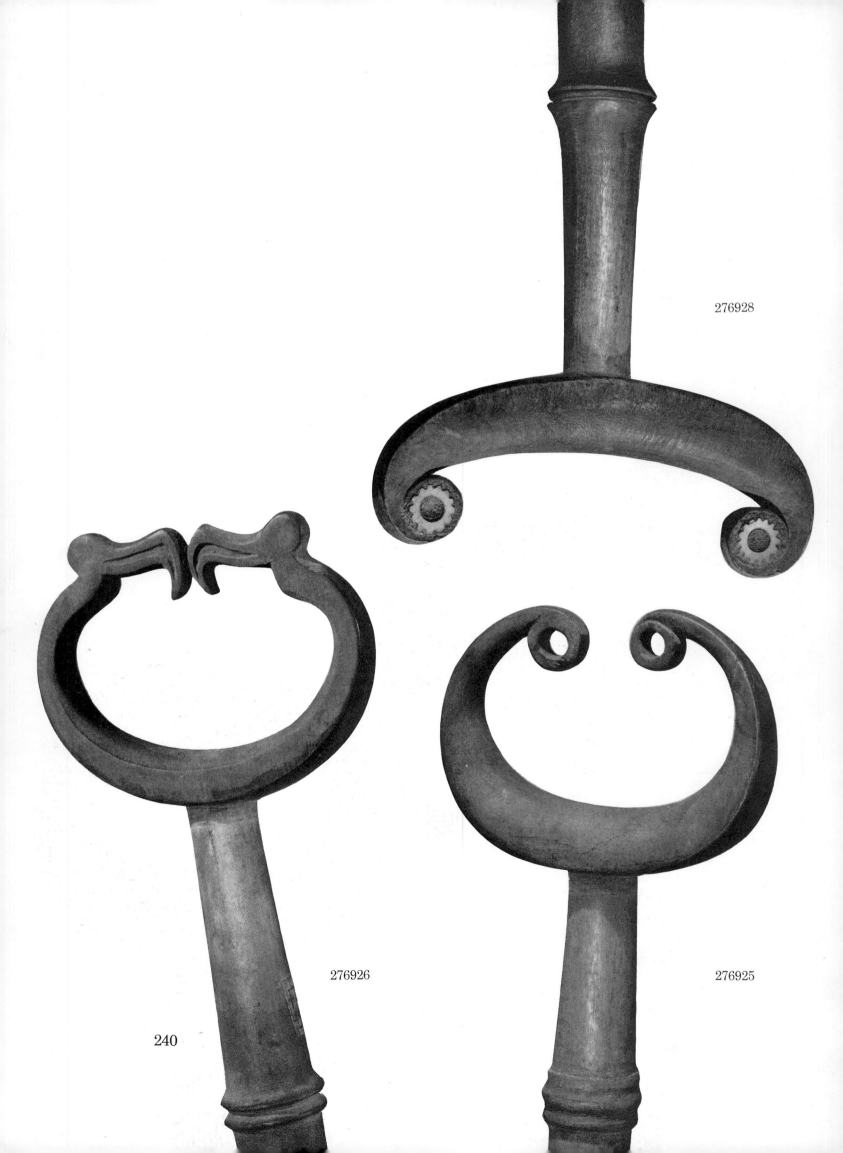

276928

276926

276925

240

Canoe-paddle Handle Details

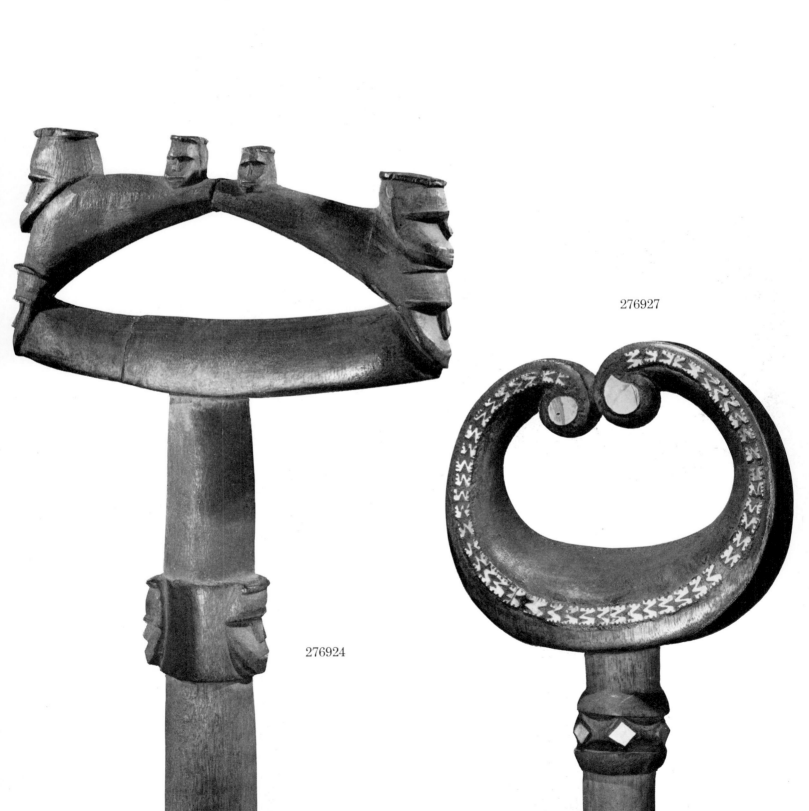

276924

276927

Paddle
Blade Detail
276918
154.0 cm.

Paddle
Butt Detail
276918

242

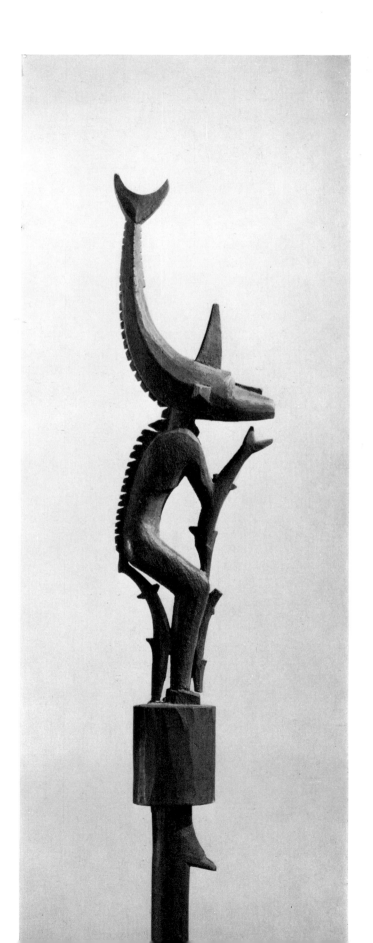

Fishing Float
276883
87.0 cm.

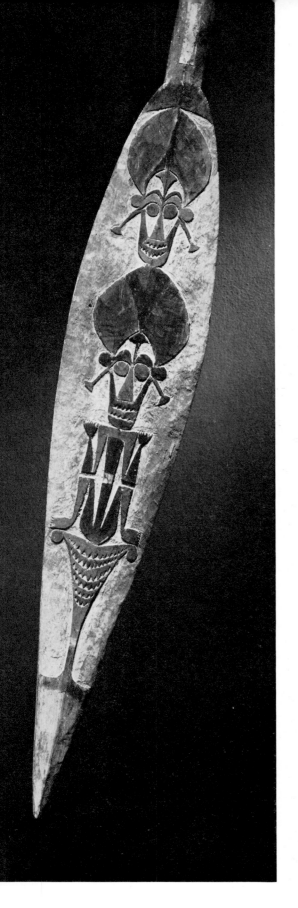

Canoe Paddle
276417
185.0 cm.

244

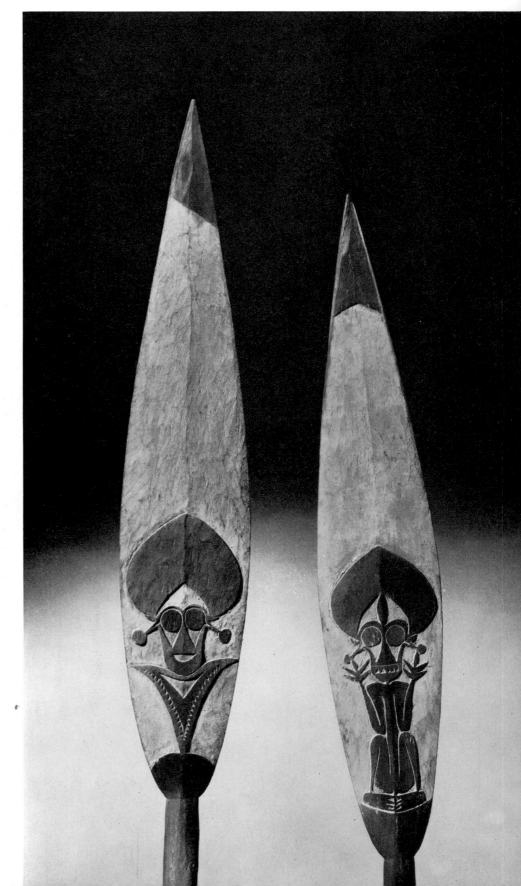

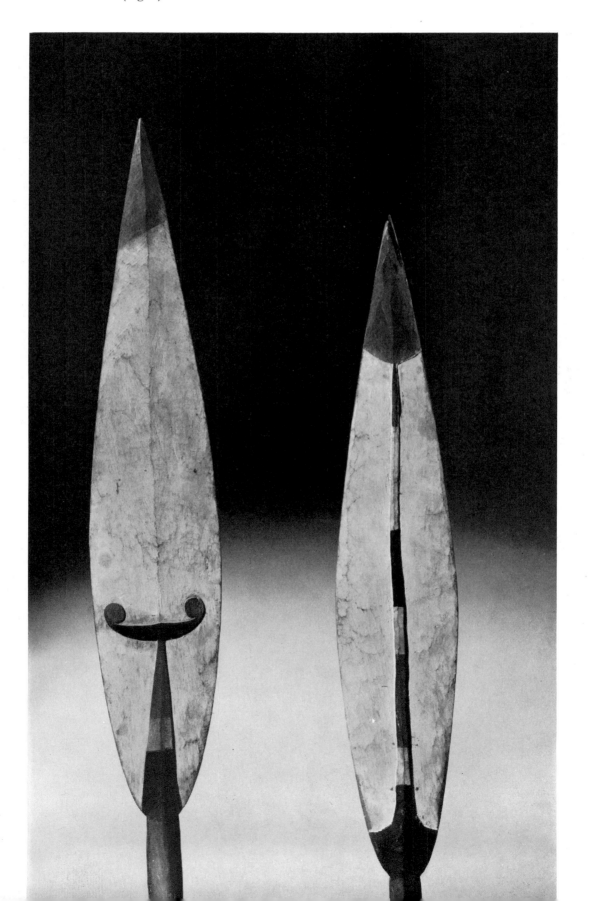

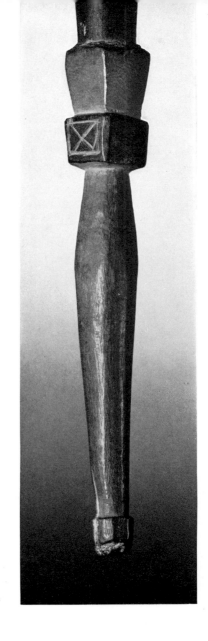

Butt Detail
276971

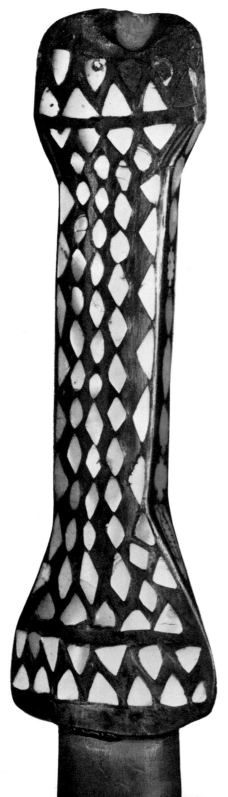

Club Grip Detail
276977
99.2 cm.

246

Dance Paddle
276971
92.8 cm.

247

Club
276876
79.0 cm.

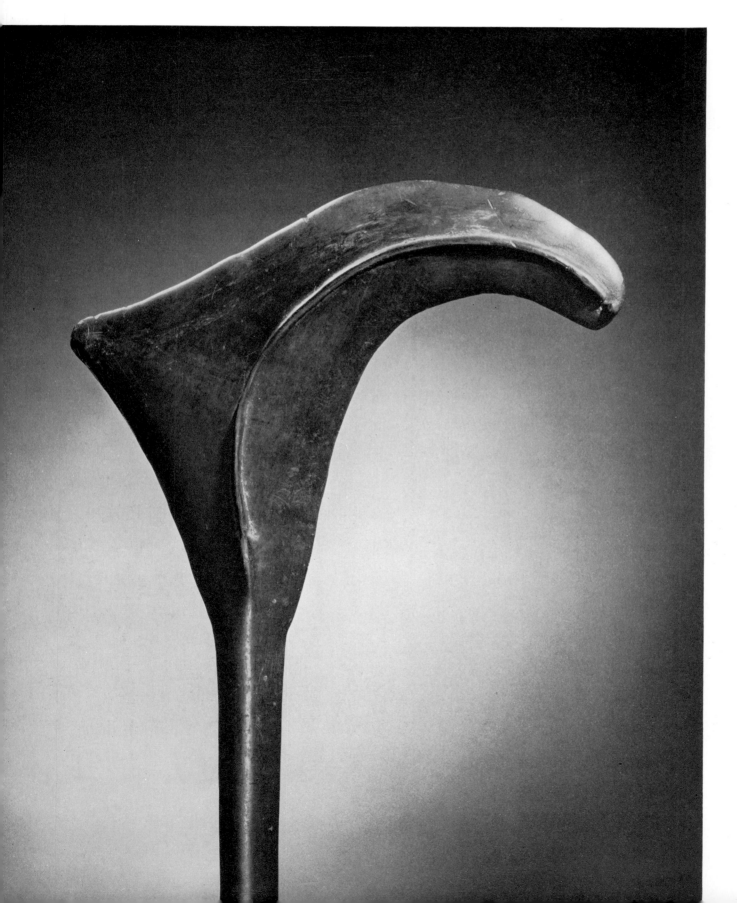

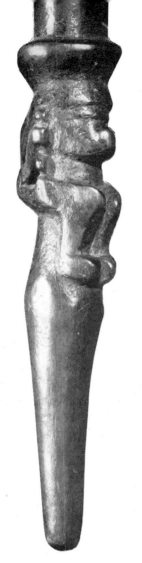

Butt Detail
276876

Club
276959
79.4 cm.

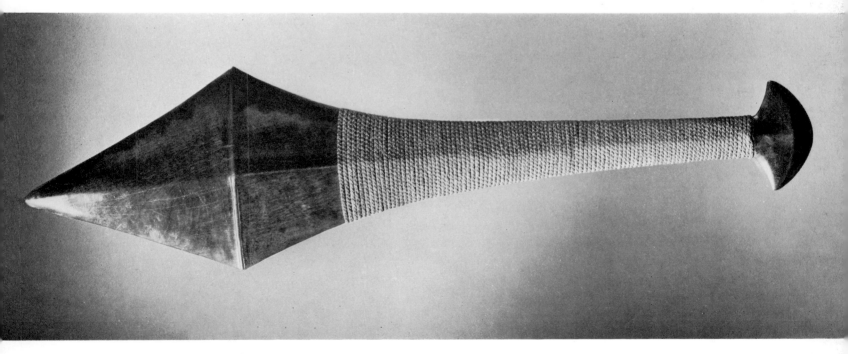

249

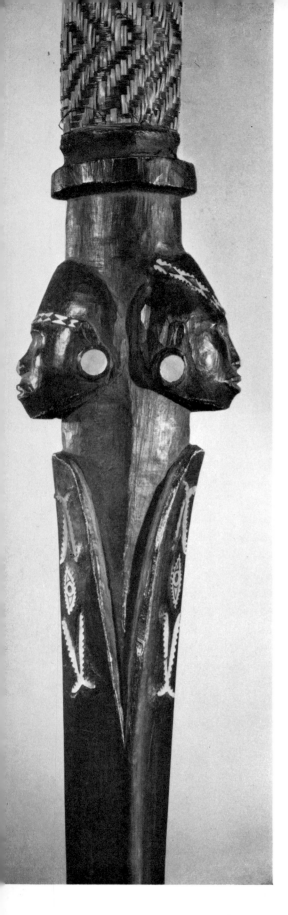

Shaft Detail
276982

250

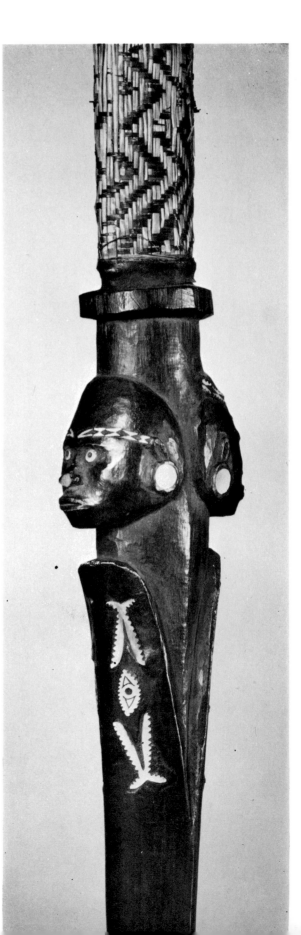

Ax-club
276982
127.4 cm.

Shaft Detail
276982

251

SANTA CRUZ

The three main islands of the Santa Cruz Group (Santa Cruz, Utupua, and Vanikoro) and other smaller islands support people who are Polynesian rather than Melanesian. Contact with Europeans for natives of Santa Cruz was early. In 1595, when on his second voyage to the Solomons, Mendaña sailed among the islands of this group by mistake. A colony was begun on Santa Cruz Island, but it failed within a year. The group was rediscovered in 1767 by Carteret. The ships of La Pérouse were lost at Vanikoro in 1788.

Santa Cruz Group material culture is set apart from that of the Solomons, the largest number of nearby islands. Santa Cruz designs are singular, as are the forms which are given to their manufactures. Woven goods are produced on rather simple tension or 'back-strap' looms. Banana fiber is customarily used. Looms were found on a limited number of islands in Melanesia. The trait is not a Melanesian one, and is found elsewhere in Oceania only in central Micronesia. It is believed that the presence in both locations is the result of incursions of people who had derived their looms and weaving techniques from Southeast Asia. Where looms are found the people tend to be either physically or culturally, or both, more Polynesian or Micronesian than Melanesian.

Two woven girdles, typical of those found in Santa Cruz, and illustrating attractive geometric patterns in panels with fringed ends and (in one illustration) pandanus-leaf strips as decoration, are shown (277291 and 93). Number 277291 was once in the Cohn *255, 256* Collection. A detail of 277292 shows the quality of the weave. *254* Similar in appearance to the girdles are some of the Santa Cruz lime-gourd bags (277230). Such fancy woven bags were made of *258* banana and grass fiber with pandanus-leaf trim pieces. Decorative panels identical to those on the girdles are present, but difficult to discern. Turmeric covers most of the fiber tassels in the example illustrated. Lime gourds similar to 277218 and 25 are carried in *257* these bags. Designs are burned into their surface. The lime is a part of the betel-nut complex. Small mortars (277249 and 56) of *260* wood and L-shaped pestles (277258) were used to crush and *261*

premasticate betel nuts. Some lime-gourd stoppers of wood are
261 nicely carved with small figures (277219). Although betel nut – a
Melanesian characteristic – was found in Santa Cruz, so was kava
– a Polynesian attribute.

Among the more beautiful shell pendants in the Pacific are
those from Santa Cruz. The simplicity of bird-inspired tortoise-
shell overpieces against the smooth white surface of tridacna-shell
262, 263 disks is emphasized by 277236-38.
259 Several leaf and grass fiber dance wands such as 277229 are
among the Santa Cruz materials. The pattern painted in black and
orange on the two pandanus-leaf strips is typical. Boat-shaped
254 dance 'clubs' of the type represented by 277281, with streamers of
hibiscus bark and with the soft, light-colored wood of which they
are carved, painted with designs in black, are found only in
Santa Cruz.
259 Cylindrical fishing floats of wood, weighted with stones (277222
259 and 62) have red-painted bases and shallow V-shaped tortoise-shell
262-263 gorges attached. An interesting dugong-shaped charm is 277212.
Of these 250-odd Santa Cruz items, close to 100 are arrows.

Dance 'Club'
277281
91.3 cm.

Girdle
Detail
277292

254

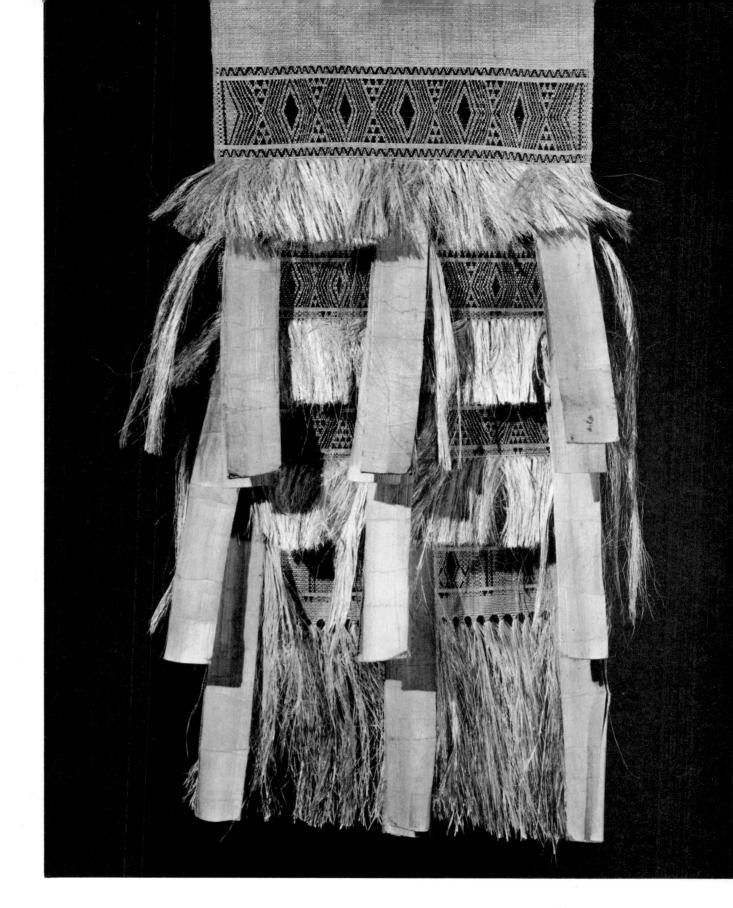

Girdle
277293
259.5 cm.

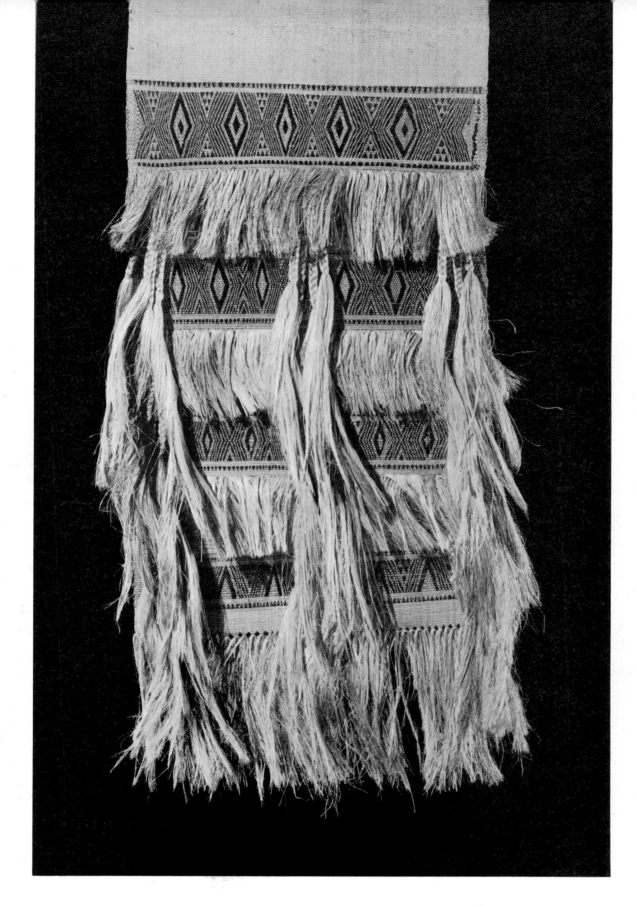

Girdle
277291
321.0 cm.

Lime Gourds
277225 (left) 15.9 cm.
277218 (right) 19.4 cm.

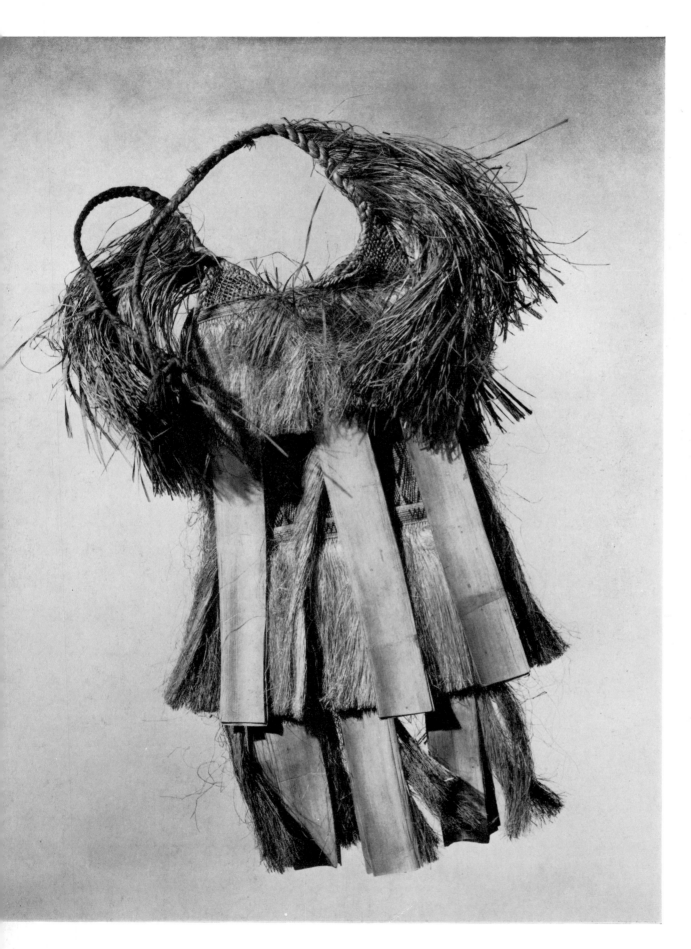

Lime-gourd Bag
277230

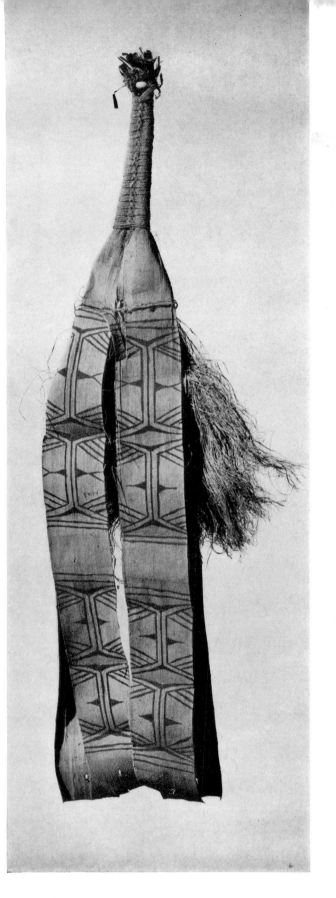

Dance Wand
277229
40.0 cm.

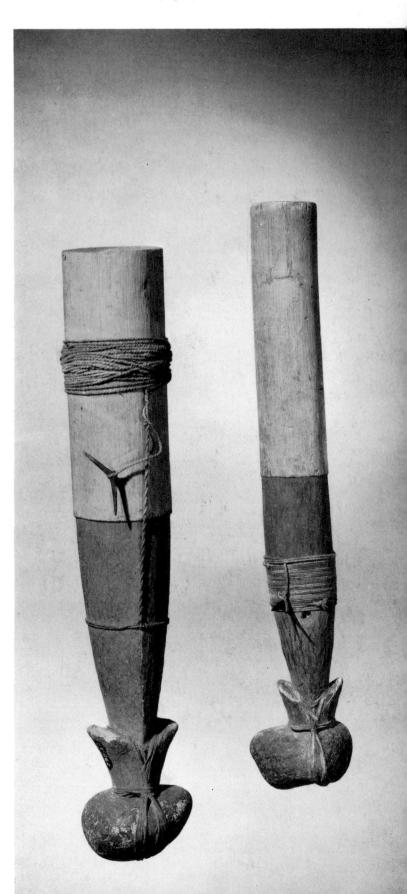

Fishing Floats
277262 (left) 30.0 cm.
277222 (right) 31.6 cm.

Betel Mortar and Spatula
277249
Mortar 9.0 cm.

Betel Mortar
277256
11.1 cm.

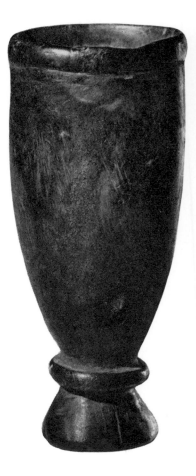

Betel Pestle
277258
20.8 cm.

Lime-gourd Stopper
277219
6.8 cm.

Dugong-shaped Charm
277212
43.9 cm.

Breast Ornaments
277236 (left) 14.0 cm.
277238 (right) 12.4 cm.

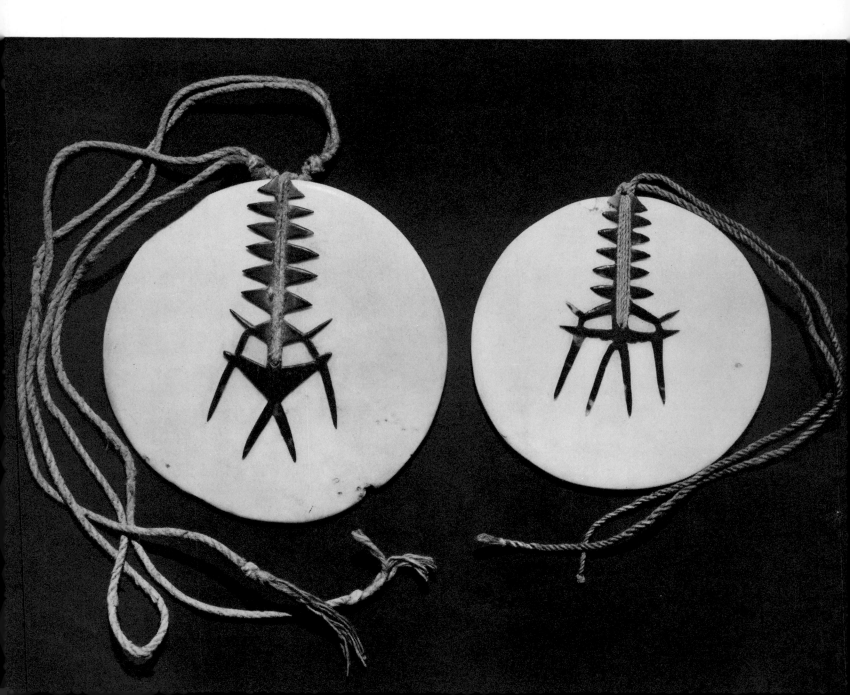

Breast Ornament
277237
13.9 cm.

OTHER POLYNESIAN OUTLIERS

On the fringes of the Solomon Islands are a number of small islands or groups of islands which, although physically located in Melanesia, are classified as Polynesian Outliers. Cultural traits, language, and racial characteristics link these people with Polynesian islands to the east – and to Micronesian islands in the north. In addition to items from the Santa Cruz Group, the Fuller Collection contains a few objects from some of the other outlying islands.

Tikopia is a Polynesian island located south of the Solomon Islands. The Fuller Collection contains two pieces from Tikopia. The first is a whalebone betel-nut pestle; the second, a netting needle of wood. Both specimens were collected by Professor Raymond Firth in 1928.

There are several tridacna-shell adz blades from Ontong Java (Lord Howe Island), north of the Solomons. Just west of the southern tip of the Solomons lie the islands of Rennell and Bellona. Two arm bands of plaited coconut fiber which were collected by the Reverend L. P. Robin of the Melanesian Mission *266-269* Society are from one or the other. A series of clubs (275065, 72-75, *268, 266* and 77) of Rennell Island type are illustrated. Number 275065 is of special interest in that the 'head,' which is actually a part of the same piece of wood as the handle, is 'tied on' with a binding of finely plaited sennit and rattan. Stone-headed clubs with similar form are more usual.

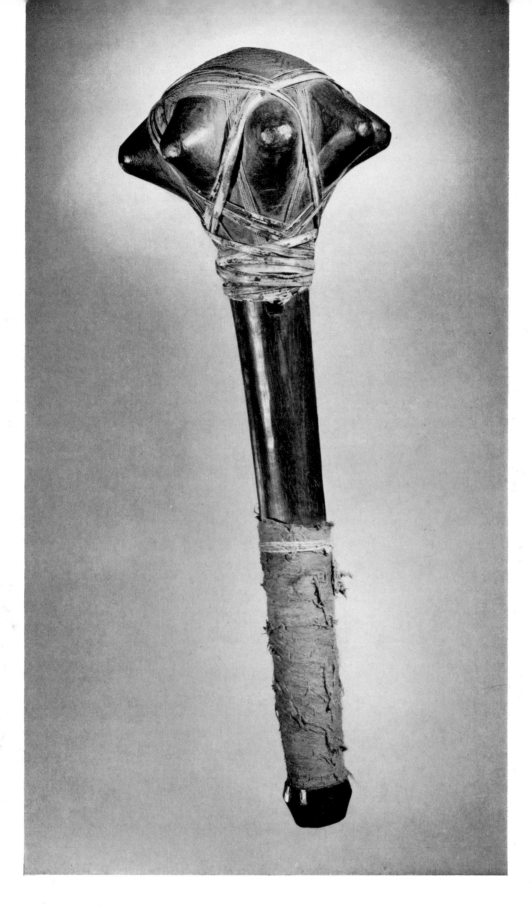

Hand Club
275065
36.5 cm.

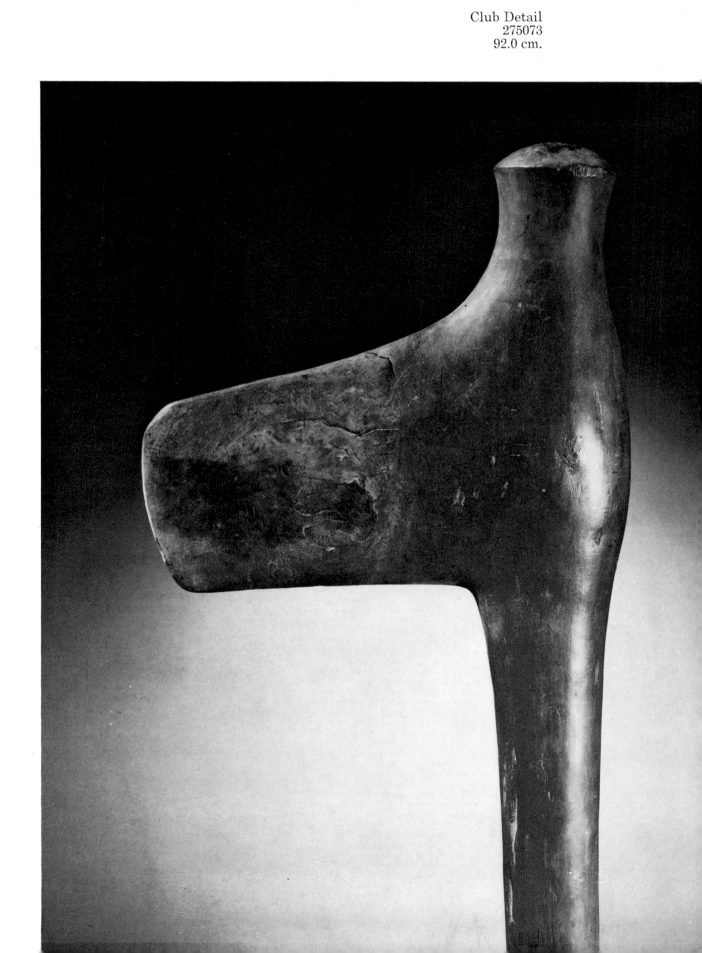

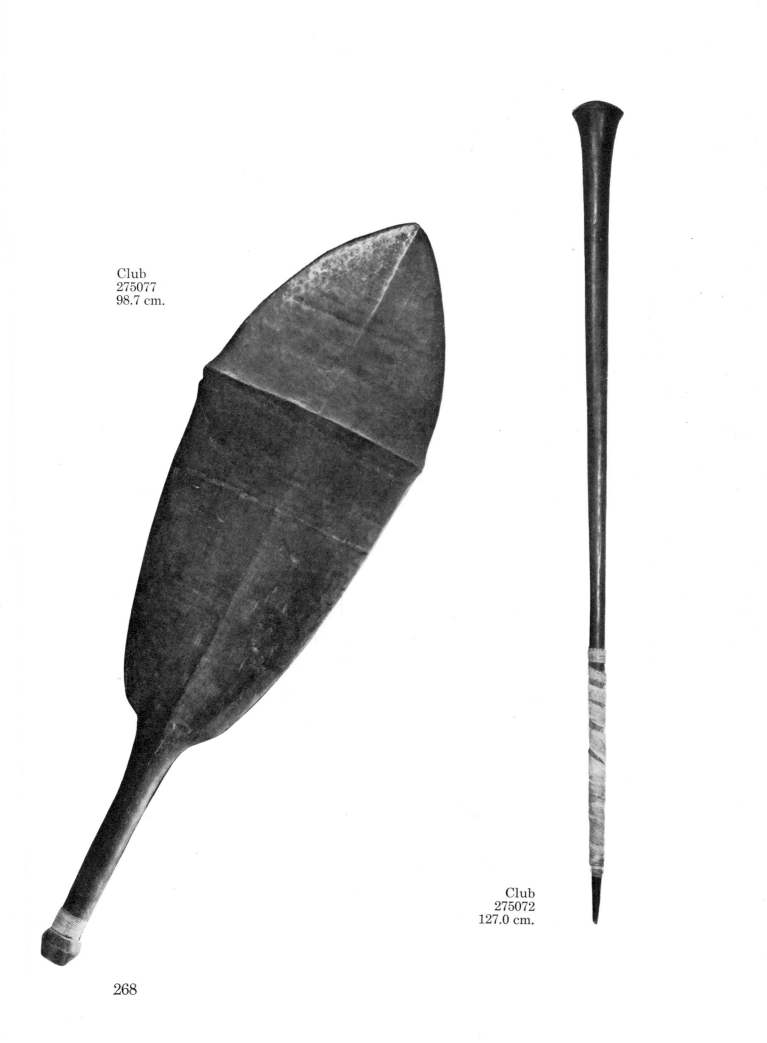

Club
275077
98.7 cm.

Club
275072
127.0 cm.

268

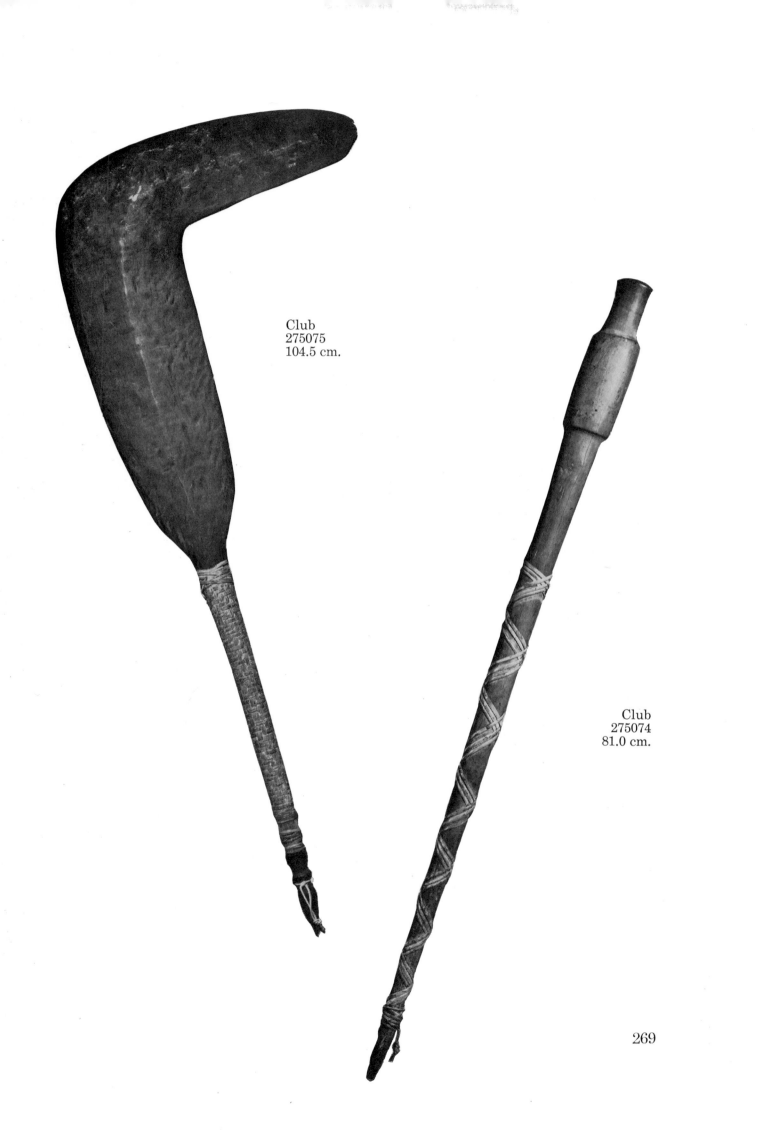

Club
275075
104.5 cm.

Club
275074
81.0 cm.

269

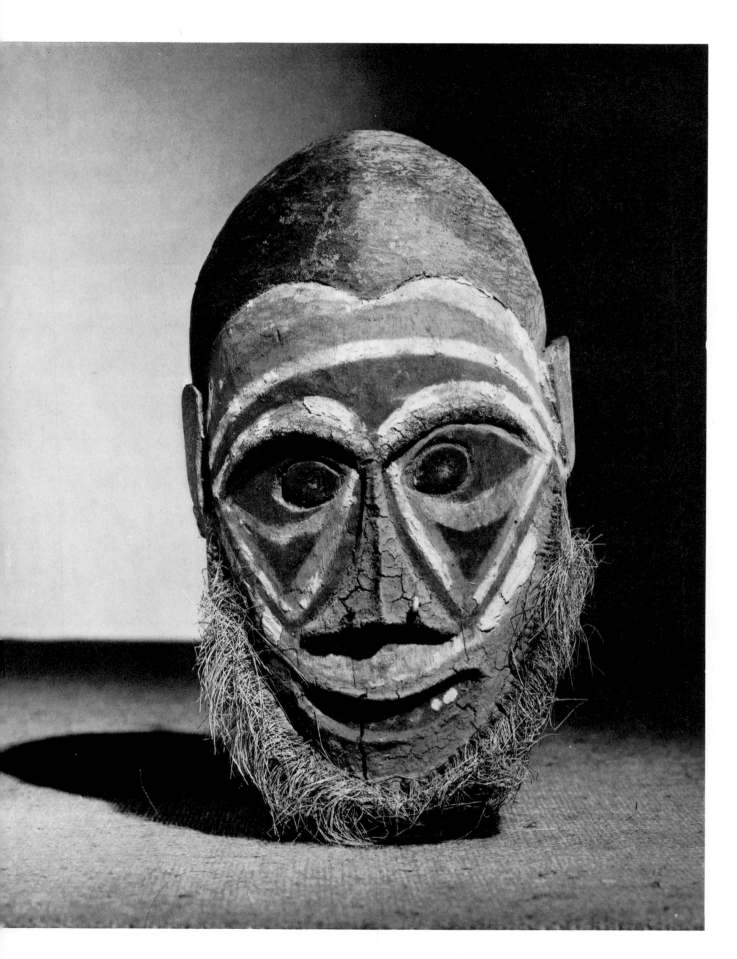

270

Mask
276419
134.4 cm.

THE BISMARCK ARCHIPELAGO

The curving chain of islands large and small, known as the Bismarck Archipelago, sweeps in a sharp arc northeast of New Guinea from tiny Wuvulu (Matty) in the north and west through the Admiralties and New Ireland to New Britain in the south.

New Britain, the largest island in the archipelago, was first visited by Europeans in 1700, when William Dampier sailed between its shores and New Guinea. New Britain displays more variation than cultural uniformity, there being great differences in the cultural practices in groups from one part of the island to another. The dramatic Baining masks of tapa cloth are well known. Less well known are the many smaller masks which typify New Britain material culture as much as anything. One of *270* these is 276419, a wooden mask with a fiber beard around the lower face. The nose, mouth, brows, and back have a mastic covering which has allowed for some modeling. A small animal tooth protrudes upwards from the left nostril. One was present in the other nostril at some earlier time, but is now absent. The mask is colored with pigments of white, blue, and orange. There are fewer than 100 specimens in the collection from this area, and of these, more than half are weapons, mostly clubs.

As early as 1616 LeMaire and Schouten stopped at New Ireland. Tasman sailed along the coast in 1642, and Carteret named the island in 1767. The elaborate and colorful carved masks, figures, and memorial boards from New Ireland are easily identified. Human and animal forms abound. The carvings are far from robust and their general fragility has been a disability so far as intact survival is concerned. Furthermore, they were made to serve as elements of commemorative mortuary observances and customarily were destroyed following their exhibition. Many of these carvings allowed for the placement of 'cat's eyes' (the operculum from the turbo shell) in the faces of masks or in panels or figures in which human or animal forms were represented. There were massive solid humanoid carvings of wood, and chalk ancestral figures as well. Such work contrasts sharply with the polychrome openwork of carvings such as the three masks which *272, 273, 275* are included here (276488, 98, and 99). The last of these has twisted

271

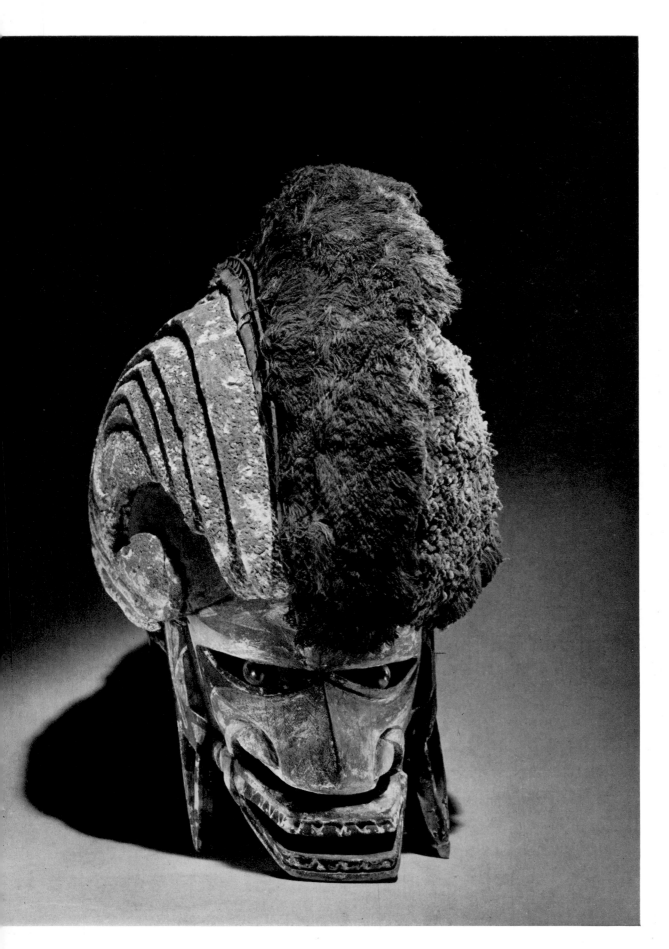

Mask
276488
33.0 cm.

272

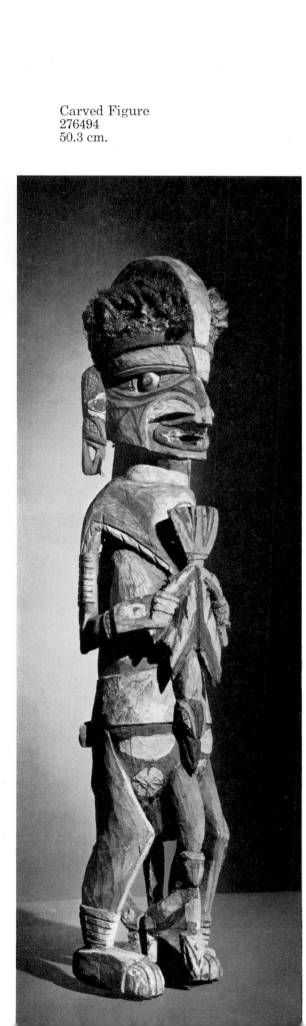

Carved Figure
276494
50.3 cm.

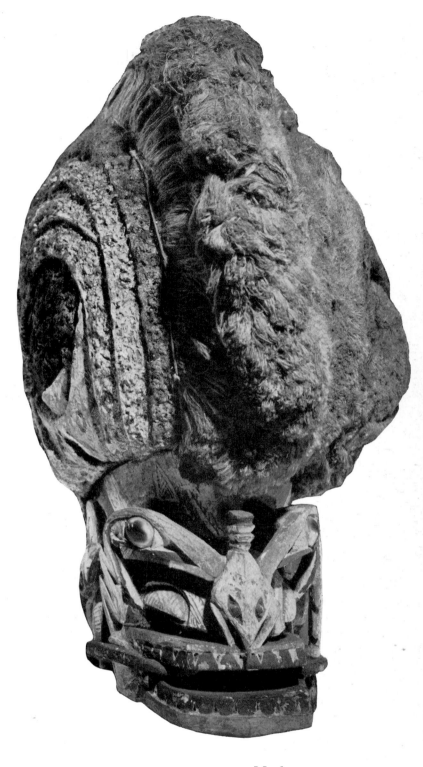

Mask
276498
29.0 cm.

273

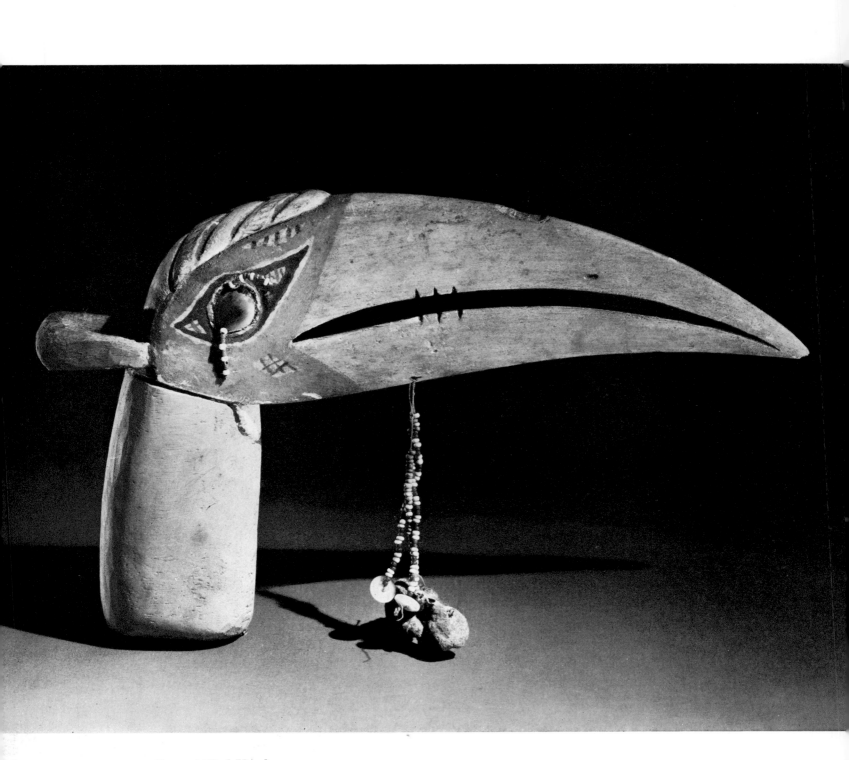

Carved Bird Head
276489
16.0 cm.

Mask
276499
22.5 cm.

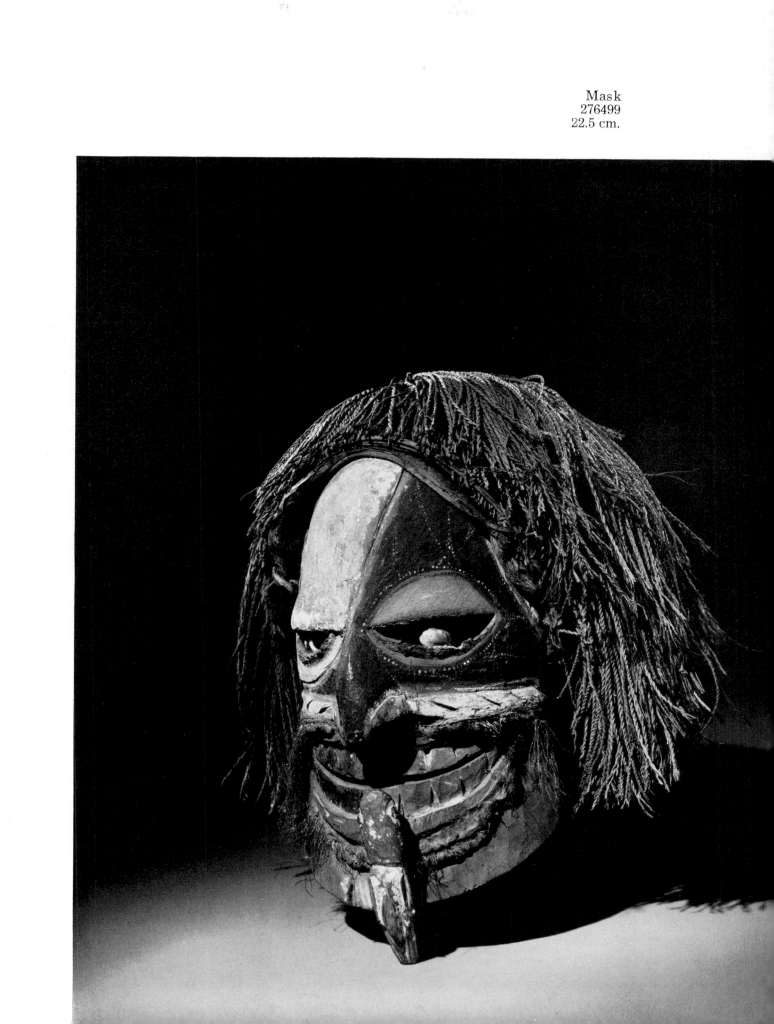

Chalk Figures
276492
27.6 cm.

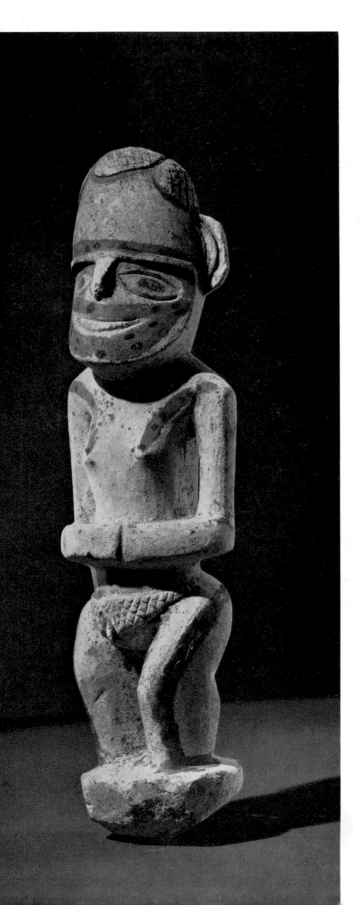

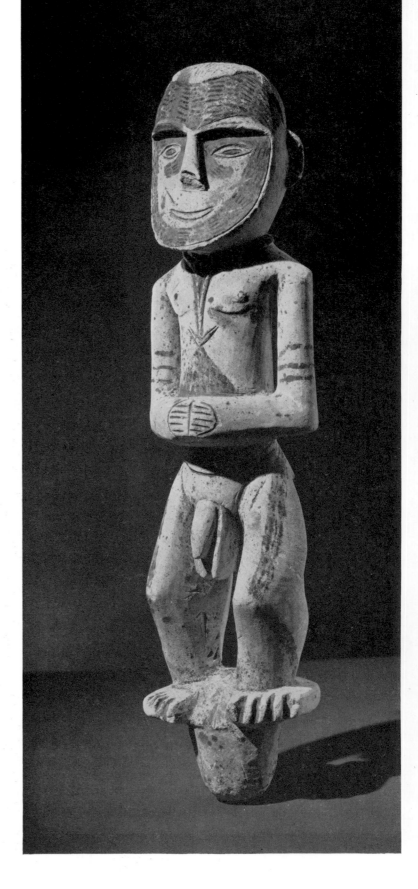

276491
47.4 cm.

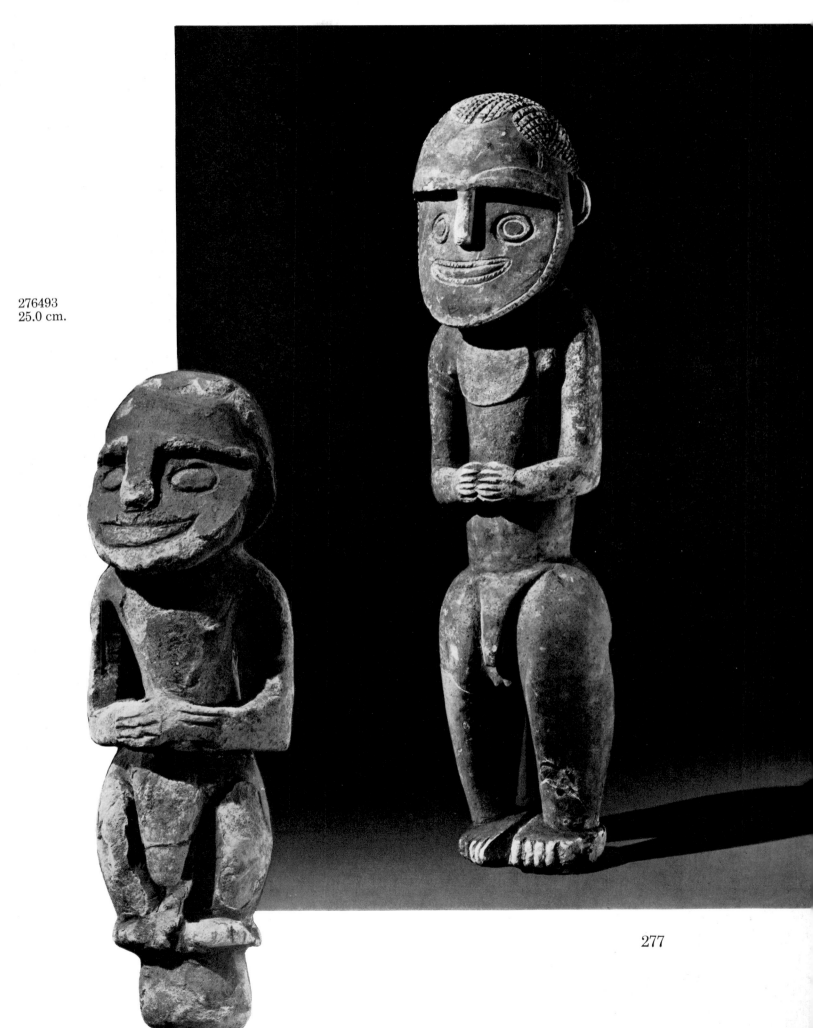

276487
69.0 cm.

276493
25.0 cm.

277

Spears
276552,3,5,7,8, and 60
221.0-266.1 cm.

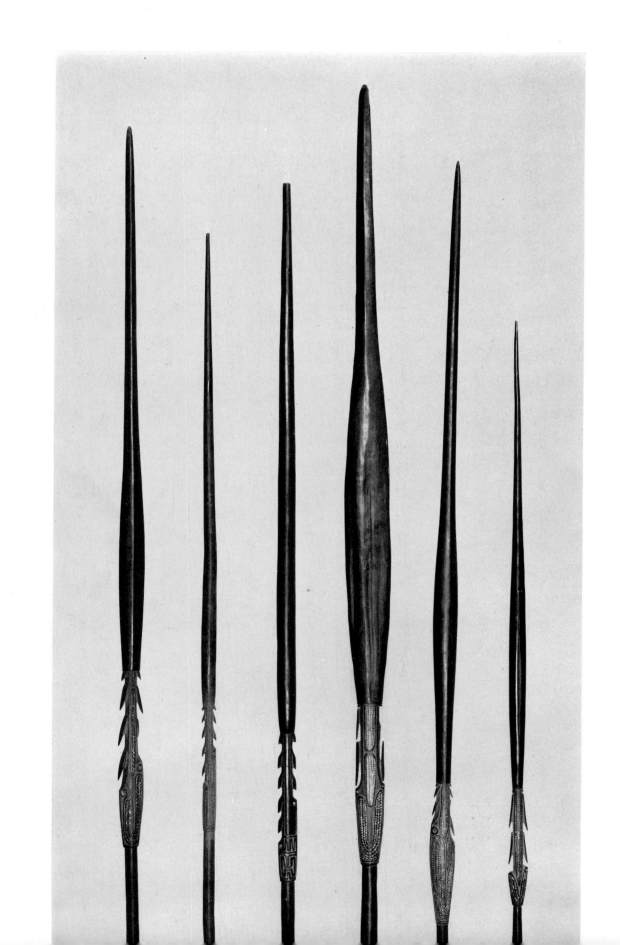

Shell Ornament
276520
Dia. 13.2 cm.

fiber hair which is positioned over a rattan and bark framework. It has a much-worn coconut-husk fiber beard and mustache. A bird figure is carved in relief on the chin. The face is painted with white, black, and red pigments. The mask was presented to the Chichester Museum in 1859. Number 276488 was formerly in the *272* Wilfred Powell Collection. Its crest is of fiber with another fiber of pulpy composition on one side and modeled chalk on the other. The pattern on the crest of 276498 includes a stylized fish on the *273* right side. A small figure, of the same type of carving, is 276494. *273*

Colonel Loftus Thackwell collected in New Ireland and elsewhere in Melanesia in 1904. One of the artifacts he secured was 276489, a bird head with operculum eyes, trade beads, and painted *274* designs. Fuller purchased much of Thackwell's collection in 1930.

Four chalk figures (276487, 91-93) are fine examples of such *276, 277* carvings. An ornament of the type called *kapkap* made of tridacna shell and tortoise shell is 276520. Finally, representing the many *279* weapons from New Ireland, are shown a group of six spears of fine workmanship (276552, 53, 55, 57, 58, and 60). More than half of the *278* nearly 100 specimens in this segment of the collection are spears.

The Admiralty Islands were found by LeMaire and Schouten in 1616 on the same voyage that took them to New Ireland, 200 miles to the east. The Admiralties are about the same distance north of the mouth of the Sepik River on New Guinea's north coast. The people of the Admiralties were great wood carvers, producing massive food bowls with short legs and intricately carved handles. They also produced long-snouted humanoid figures in red with white and black trim. Nonrepresentative carving was also done. Other materials were often combined with wood to produce artifacts of ingenious beauty. Great blades of obsidian were fitted into handles to form handsome daggers (272001 and 4). A great *282, 283* range of such specimens (more than 100 and about half of the items in the segment) is included in the collection allowing a comparative approach to the study of motif on the handles. Another type of dagger or spear point was produced by setting sting-ray spines into a handle or shaft of wood. The carving on such weapons is often quite elaborate (272135-37). *285, 283, 282*

Decorated coconut containers with spouts often show representations of human or animal faces (272182-83). Mastic made of *284* *Parinarium* nuts was used to affix spouts, to set sting-ray spines in sockets, for holding a section of *Trochus* shell into the wooden shanks of shark hooks, and for a wide variety of other purposes. The shark hook shown (272144) is from the Thackwell Collection. *285*

An exceptionally fine example of Admiralty Islands carving is a

286 dog-shaped food bowl of wood (272145). Some of the most intricate Admiralty Islands carving is seen on the handles of lime spatulas
287 such as 272139-40, both of which were collected by Colonel Loftus Thackwell.

West and slightly north of the Admiralties lie some small islands whose people have marked affinities with Micronesia. Even the Admiralty Islands people show certain physical resemblances to Micronesian populations. The closest of these outlying islands to the Admiralties is the Hermit Group. Two bowls from this group
289 are shown (276585-86). The larger of these (276585) was formerly in the Edge-Partington Collection. It has a sennit carrying strap. Each bowl has intricate openwork carving on extended end 'lugs' and small notches cut in the sharp edge formed when two planes join. West of the Hermits is the Ninigo Group. A large Ninigo
288 tridacna-shell adz (276589), possibly with ceremonial significance, is shown. The blade is fitted into a wooden socket which, in turn, fits into the handle. Bindings are of rattan. The adz was collected in the islands by Thackwell in 1904.

The atolls of Wuvulu (Matty) and Aua (Durour) are distinguished by weapons with shark teeth embedded in them. Such an emphasis may represent Micronesian and/or Polynesian influences. One such weapon, formerly in the Edge-Partington
290, 291 Collection, is 274992. Another (275006) was in the Beasley Collec-
291 tion and 275004 and 5 were collected by Colonel Thackwell.
292 Shallow bowls with incurving sides, such as 274998, were found
292 only in Wuvulu. A turtle-bone 'ax' (274989) probably was used to split breadfruit.

Obsidian Dagger
272001
33.5 cm.

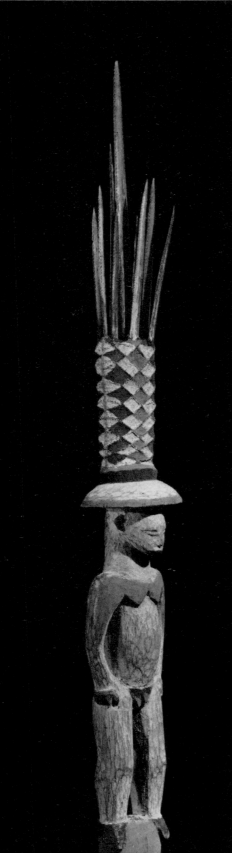

Dagger
272137
46.3 cm.

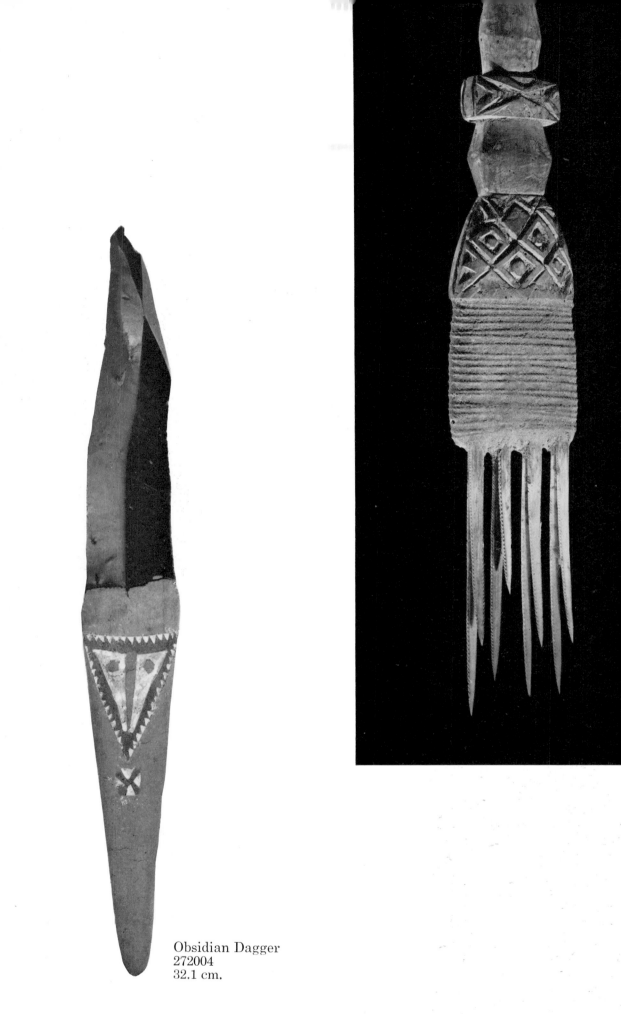

Obsidian Dagger
272004
32.1 cm.

Dagger
272136
44.8 cm.

283

Decorated Containers
272183 (left) 21.2 cm.
272182 (right) 20.4 cm.

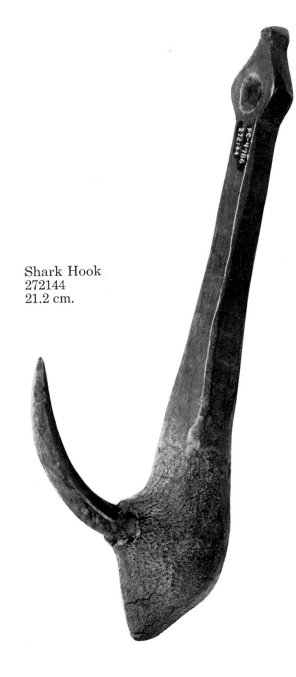

Shark Hook
272144
21.2 cm.

Dagger
272135
41.8 cm.

Dog-shaped Bowl
272145
84.0 cm.

Lime Spatulas (Detail)
272139 (left) 48.5 cm.
272140 (right) 35.0 cm.

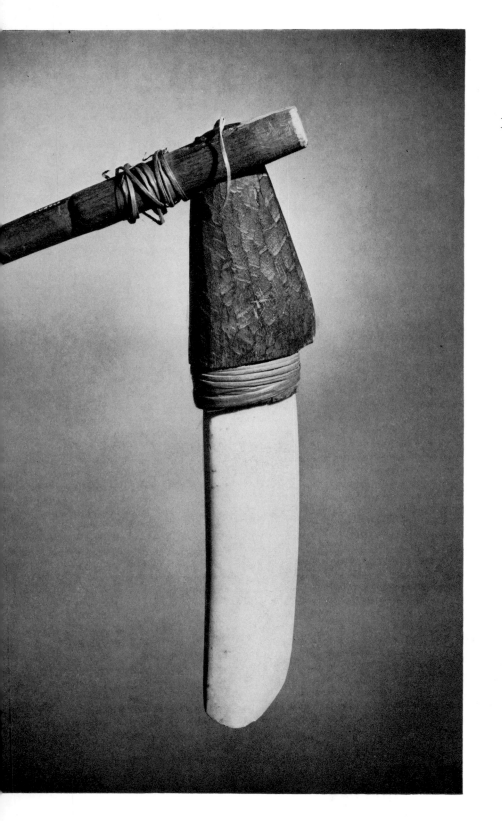

Shell Adz
276589
Blade Length 32.1 cm.

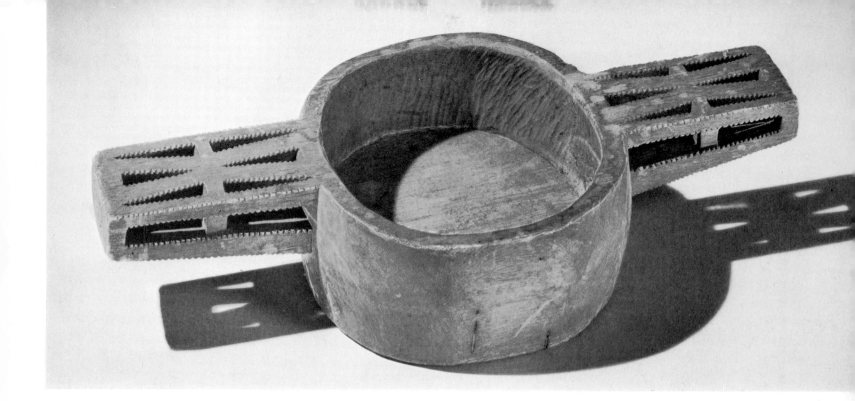

Food Bowls
276586
37.4 cm.

276585
109.4 cm.

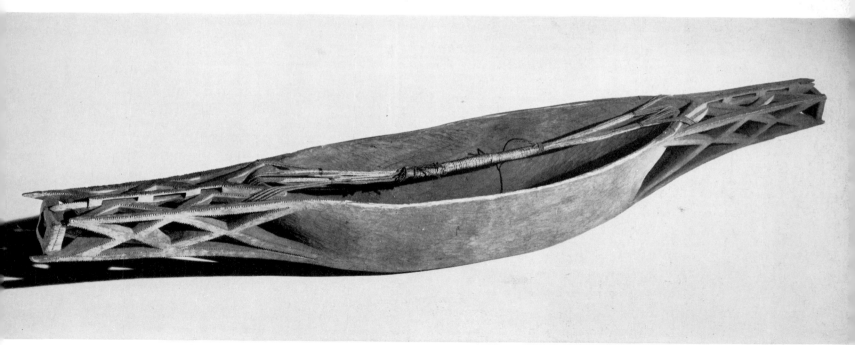

289

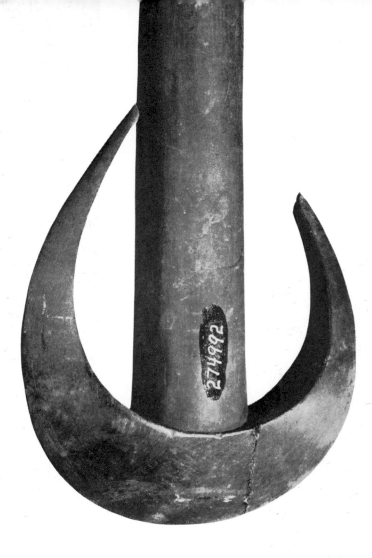

Butt Detail
274992

Shark-tooth Weapon
274992
156.0 cm.

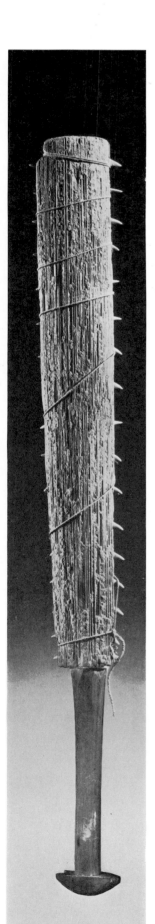

Shark-tooth Weapon
275004
60.7 cm.

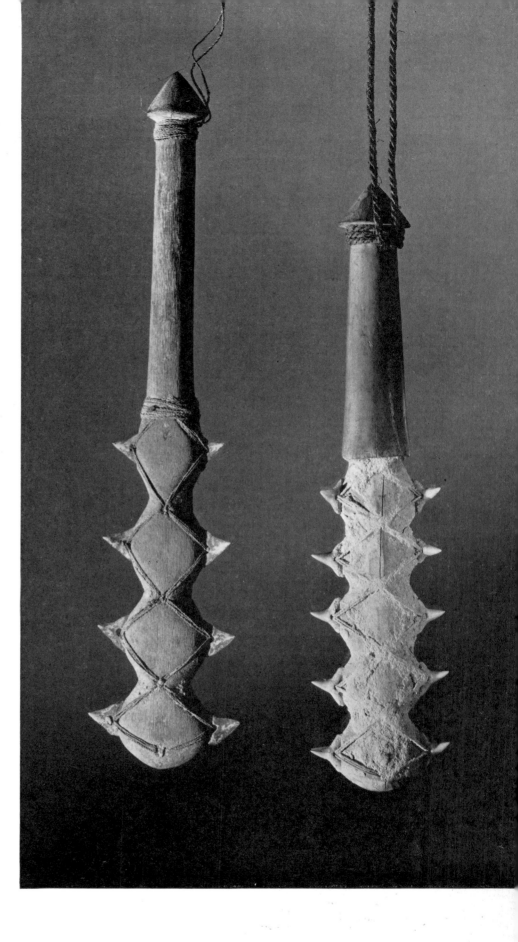

Shark-tooth Weapons
275005 (left) 24.6 cm.
275006 (right) 21.4 cm.

291

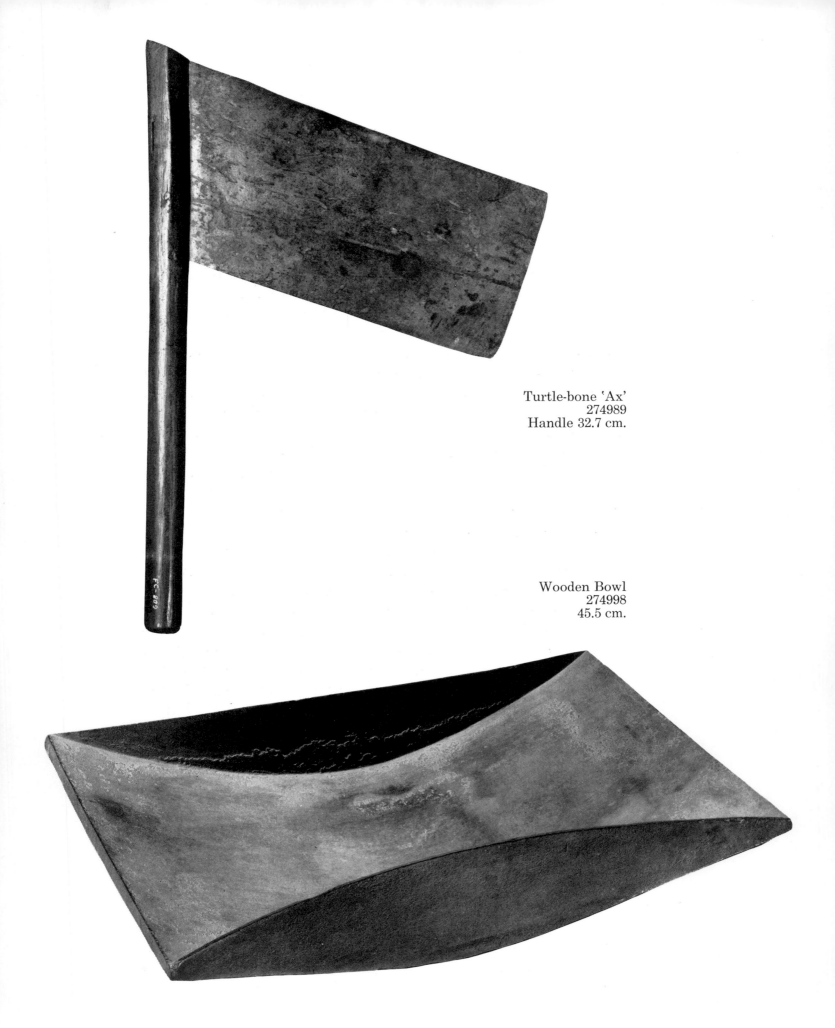

Turtle-bone 'Ax'
274989
Handle 32.7 cm.

Wooden Bowl
274998
45.5 cm.

292

NEW GUINEA

New Guinea is an island 1,300 miles long, second in size only to Greenland. Its 306,600 square miles range from muggy coastal swamps to soaring snow-covered elevations. The contour of its shore line is a contorted maze, its bush country impenetrable in places, its resources enormous by comparison with those of insular Oceania. Although New Guinea was discovered in the 16th century by Spanish and Portuguese explorers and has thus been long known to the world, parts of the island have not been mapped and there are fierce tribes of head-hunting natives yet to be brought under administrative control. Some have yet to see an outsider. The great numbers of people in New Guinea and the extreme cultural variation, combined with a limited amount of ethnographic field work, have made it impossible to know and understand as much about the cultures of the peoples of New Guinea as one would like. Neither do anthropologists always know as much as they should in order to provide specific designations of provenience, use, or meaning for artifacts which originated in the area, but which were removed by nonspecialists whose records either left something to be desired or which have become lost. Specialists have learned to identify materials from a number of regions and to rely upon their notions of attributes and general character as being valid. Broadly speaking, Papuan materials may be readily distinguished from those of the Massim area, the Huon Gulf, or the Sepik region of the north coast. There is less awareness of the distinctions which belong to West New Guinea (West Irian) materials – except for general characteristics. It is in remote inland areas and in areas which lie between major style regions, and which share influences from two or more such regions, that difficulties are found.

New Guinea artisans were prolific, much of their work being in wood. Elaborate, often grotesque, representations designed for ceremonial occasions typify New Guinea carving. Masks, house parts, weapons, household utensils, musical instruments, and water craft all bore the effects of creative imagery inspired by supernatural beliefs and nature. Great attention was paid to ornamentation. There are several hundred New Guinea ornaments

of various kinds in the Fuller Collection. Arm and leg bands, breast pendants, and headdresses all reveal a general imaginative creativity. Seeds set in gum, boars' tusks, dog teeth, parrot or cassowary feathers (more than 200 cassowary-feather ornaments were acquired by Fuller in 1912), bright pigments, and powdered lime which contrasted with rich dark wood were among materials commonly used by New Guinea craftsmen. Ancestors were revered and feared, and body parts, particularly skulls, were often decorated in a wide variety of ways.

In New Guinea artifacts there is to be seen a vigor of design, an excellence of quality which contrasts with primitive surroundings, and great inventiveness. This is amply demonstrated by sculpture in the round, relief carving, painted bark cloth, constructions of vegetable fibers, worked shell and bone, netlike containers, and a broad range of similar materials.

The Fuller Collection contains a great bulk of New Guinea material, of which only a very small number of items may be shown here. It includes headrests, arrows, spears, masks, clubs, dance wands, drums, utensils, belts, necklaces, and other ornaments. Ancestor figures, called *korwar,* are commonly found in the region of Geelvink Bay and the adjacent north coast area. They are found nowhere else in New Guinea, but have affinities with similar sculptures from islands north of New Guinea. Some, including the three in the Fuller Collection, have been attributed to the Schouten Islands. The seated posture with elbows on or near the knees is conventional. Number 276393 is smaller than *298* either 276394 or 95 and has cassowary feathers for hair. Such *299* images are often explained as the dwelling place of ancestral spirits.

North coast material is not abundant in the collection. Half of the slightly more than 100 items are belts. From the Sepik River region there is a decorated human skull (275702). The eyes are of *300* cowrie shells and the features are modeled of clay which is painted in red, black, and white. The hair is human and is set in mastic. The skull was formerly in the E. L. Gruning Collection. Another skull with incised decorative treatment and red ocher paint is 275700. A betel-nut mortar (275684) with two masklike *303, 301* faces carved on opposite sides is reminiscent of the beak-nosed masks (275724-25) also from the Sepik River area. A small red *302, 301* standing figure (275691) rounds out the objects clearly from the *303* Sepik region.

The collection contains a wide variety of artifacts from northeastern New Guinea, some of which are marked as to provenience

and some of which are given only general designations. There are a few items from Astrolabe Bay such as ornaments and arm bands. Among several shields are two from Karkar Island. Two more shields, these from the lower side of the Huon Gulf where the
307 Waria River reaches the sea, are 275755 and 56. Several artifacts displaying typical Huon Gulf carving are shown. They are a drum
304, 305 (275749), a food scoop (275758), and two headrests (275752 and 57). Among the few other artifacts from the area are fishhooks and ornaments.

The collection has one fine specimen in it from the New Guinea
306 Highlands. It is a Mount Hagen ax (276412) and it has a finely ground stone blade.

Southeastern Papua is known as the Massim area. Within it, on the fringes of the Island of New Guinea and in the many offshore groups such as the Trobriands, the D'Entrecasteaux, the Woodlarks, and the Louisiades, there is a great richness of treatment. The Massim materials in the collection include a great many clubs, lime spatulas, ornaments, axes and adzes, containers, staves, drums, and shields. Items from the Trobriand Islands comprise about half of the 300 specimens and are of high quality. Most provenience designations for the Massim materials are general, but in some instances a particular place of origin is
308 known. Such is true of 275886, a carved figure from Bartle Bay.
308 Similarly, 275816 is a shield from Killerton Island. One of two
309 clubs with stone heads is shown (275948). The carving is representative of the Massim, but the use of stone heads on clubs is a
310 characteristic of Papuan areas to the west. Another club is 275846.
311 Axes, such as 275777, with massive handles and rattan bindings with finely ground stone blades are found in various parts of the
310 Massim area. An unusual armlet of a human mandible (276031) is from the Louisiades.

Betel nut is chewed in the area, and equipment – particularly mortars and pestles – is greatly elaborated. Some mortars, such as
311 275899, are of a boat-shaped variety. Lime spatulas are made of
312, 313 whalebone, as with 275867 and 68, other animal bone, tortoise shell
312 (275869), and wood. An example from the Trobriand Islands is
315, 313 275965. Some mortars and pestles were carved to match (275784).

Trobriand Islands staves were similar to some lime spatulas in
314, 315 their over-all design. See, for example, 275922 and 275965. Many
316 clubs, such as 275923, were made of hard, black wood. This example, one of about two dozen in the collection, was embellished with pandanus leaves. A rare old weathered carving of dramatic
317 beauty is a canoe prow ornament (275882). It was acquired by the

missionary, James Chalmers, who gave it to the Reverend Dr. R. Wardlaw Thompson. He passed it to W. David Chamberlin of the London Missionary Society, from whom Fuller secured it in 1932.

There is a great wealth of lime spatulas from the Trobriands in the collection. Those shown (275977-81, 98, and 6021) are exemplary. Number 275902 is a dance paddle, typical of the Trobriands, showing curvilinear patterns. Two carved figures, one of ebony wood (275881) (Trobriands) and the other of brown wood (275815) (Trobriands or Woodlarks), and two Trobriand drums (275895-96) are illustrated. Trobriand shields are decorated in complex curvilinear patterns, as are the two shown (275908-9). *318, 319, 321-323* *320* *321, 323* *324, 322* *325*

A principal feature of Papuan carving was relief work on memorial tablets (276051-52), shields (276301), hand drums (276068), coconut charms (276168), combs (276198 and 321), bark belts, bull-roarers, coconut-shell spoons, and arrows. Stone-headed clubs with disk or bossed heads (276096, 97, and 102) are present in the Fuller Collection in great numbers. A carved head (276268) is of the type from the Bamu River. A decorated pottery container (276353) shows a design in relief. Among other artifacts from Papua in the collection are a series of string bags, a trophy skull, a head carrier, sago pounders, bark belts, head ornaments, dancing rattles, headrests, bowls, beheading knives, cassowary-bone daggers, bows and arrows, grave markers, and slings. The collection contains about 350 items from Papua. *327, 329, 331* *326, 330* *326* *329* *328*

Of more than 500 general New Guinea artifacts which are classified without more specific provenience, nearly four-fifths are ornaments, mostly of feathers. Similarly, of about 100 specimens identified only as general Melanesia, more than half are ornaments.

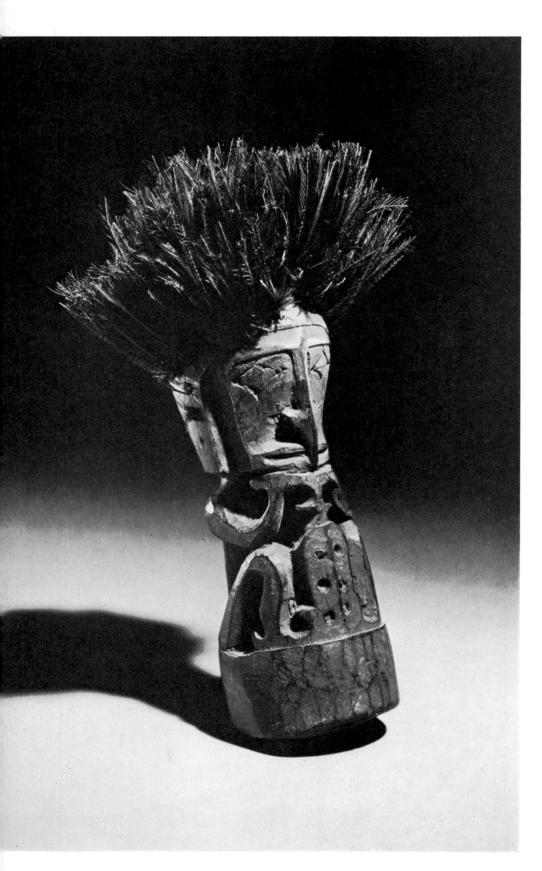

Ancestor Images
276393
15.5 cm.

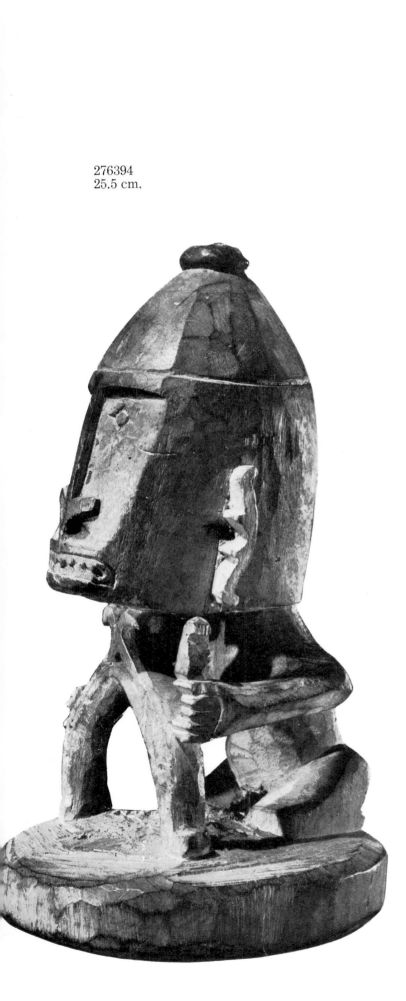

276394
25.5 cm.

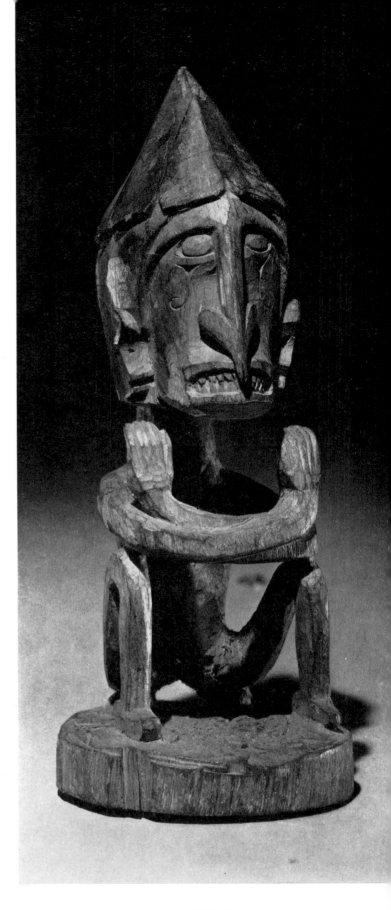

276395
25.5 cm.

299

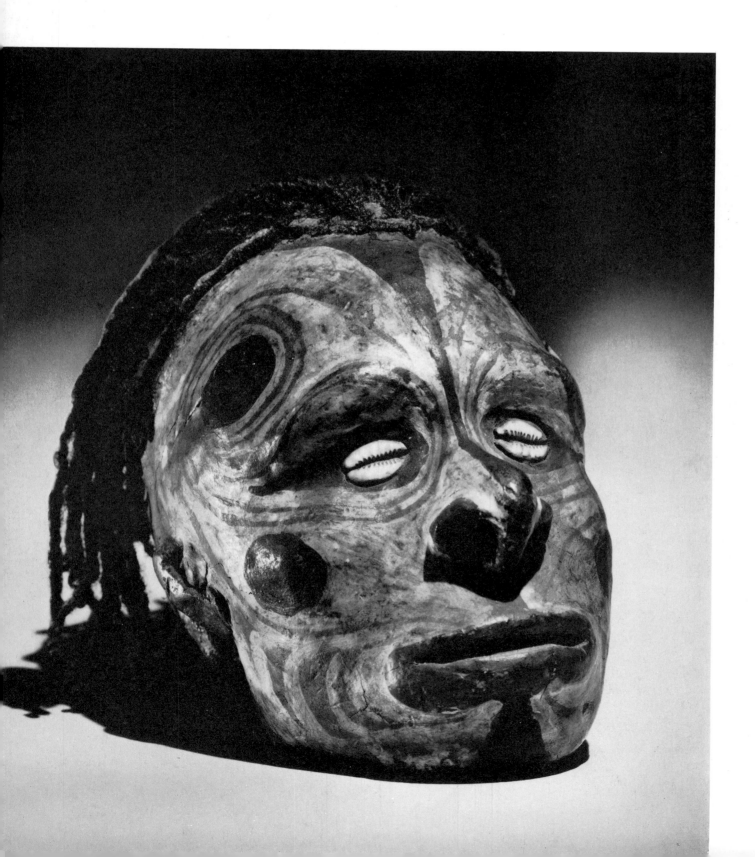

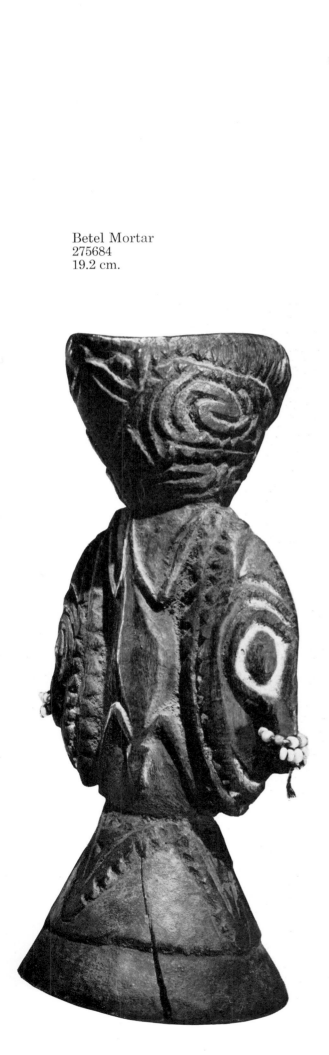

Betel Mortar
275684
19.2 cm.

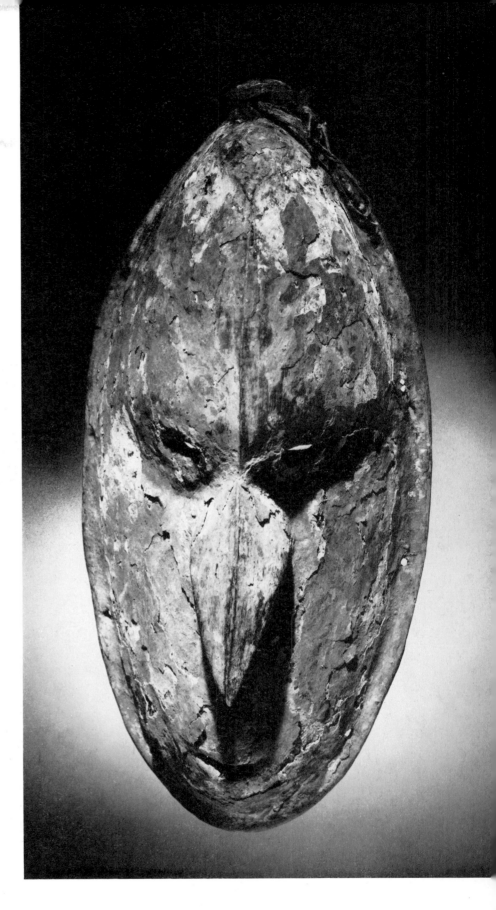

Mask
275725
32.9 cm.

301

Mask
275724
50.5 cm.

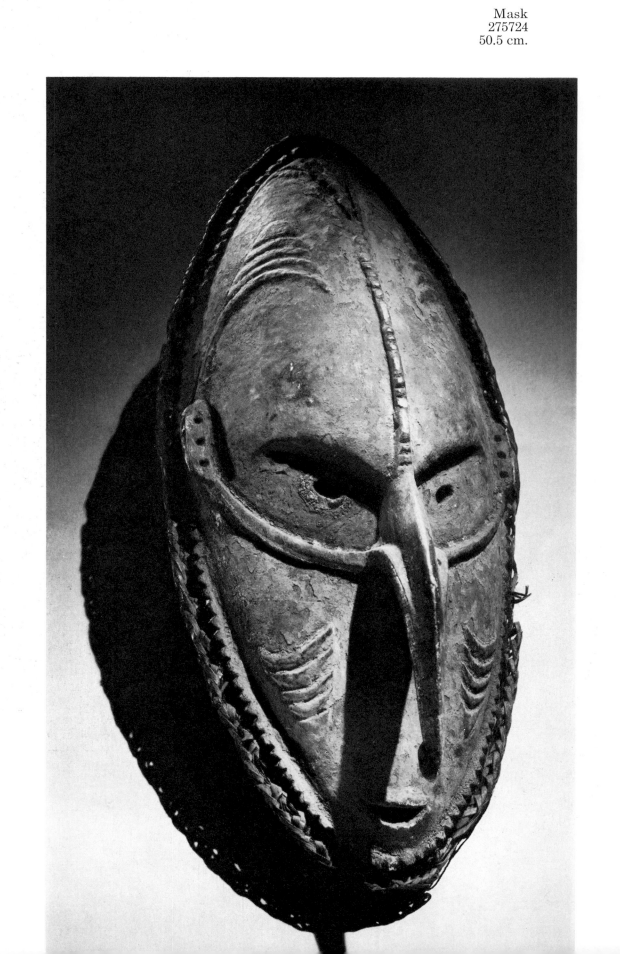

Carved Figure
275691
32.5 cm.

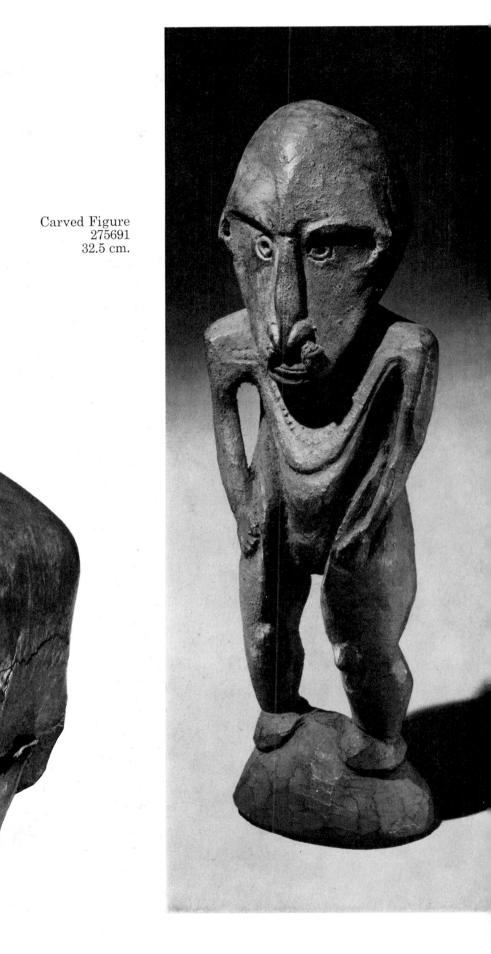

Decorated Skull
275700

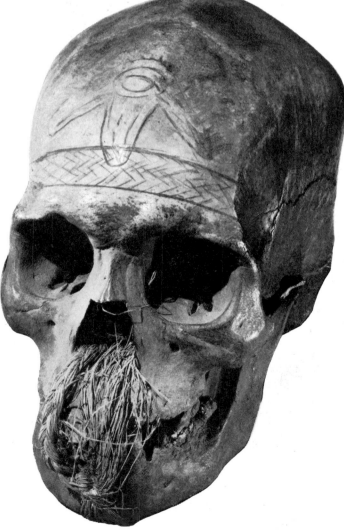

303

Drum
275749
78.5 cm.

304

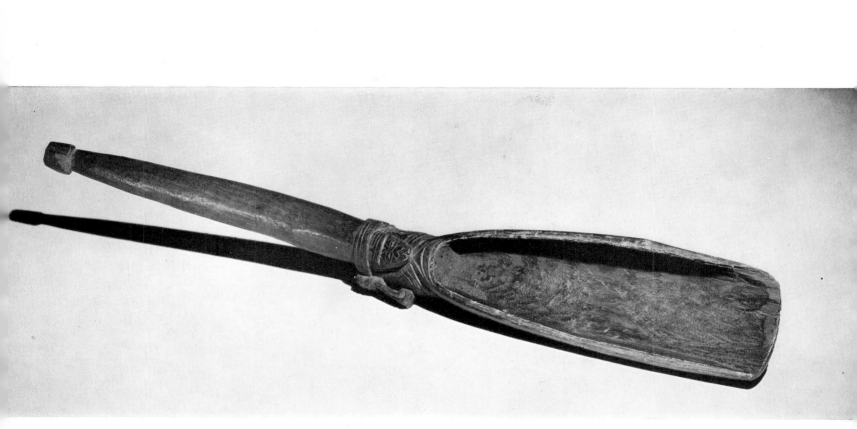

Decorated Food Scoop
275758
63.0 cm.

Headrests
275757 (left) 15.8 cm.
275752 (right) 12.5 cm.

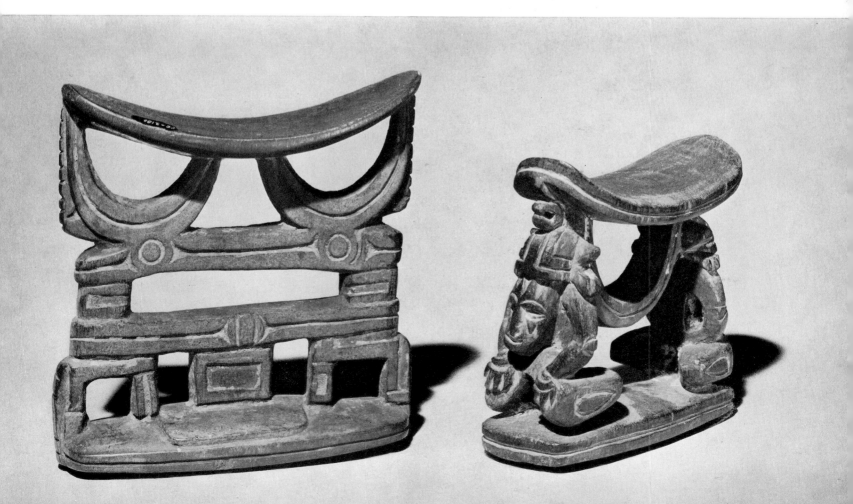

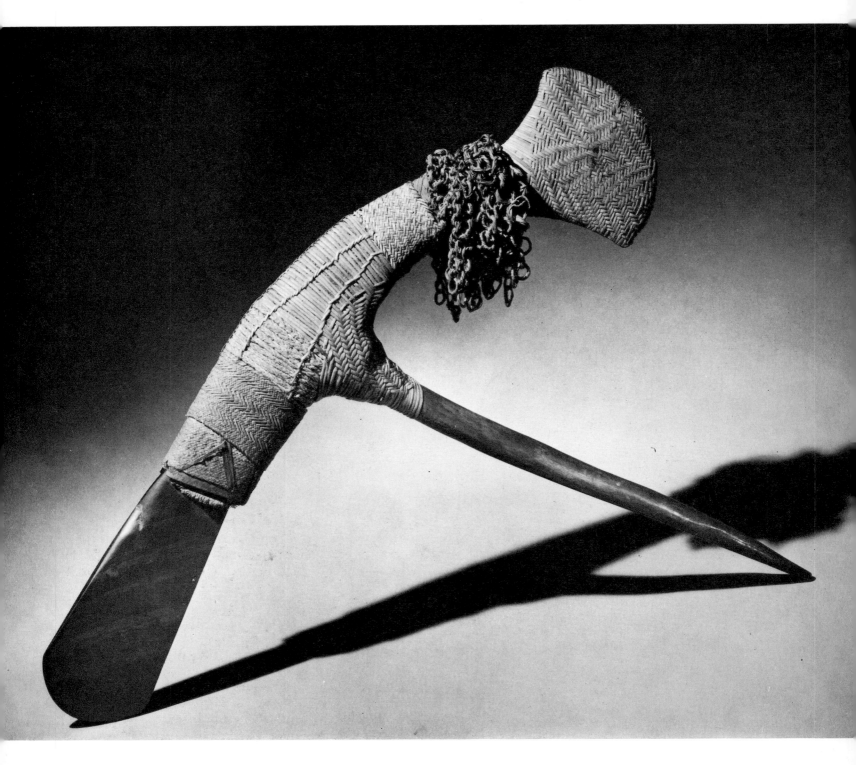

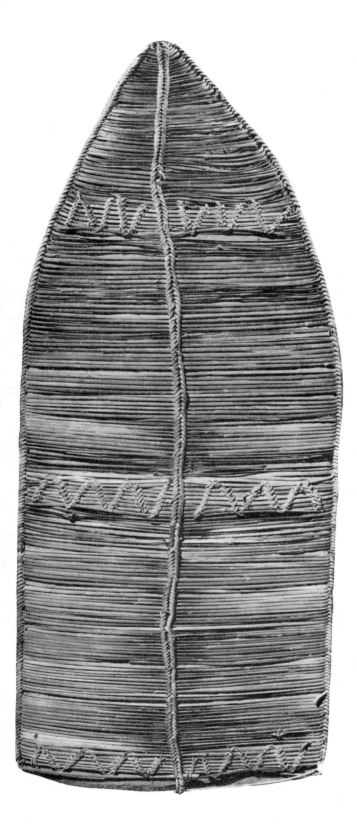

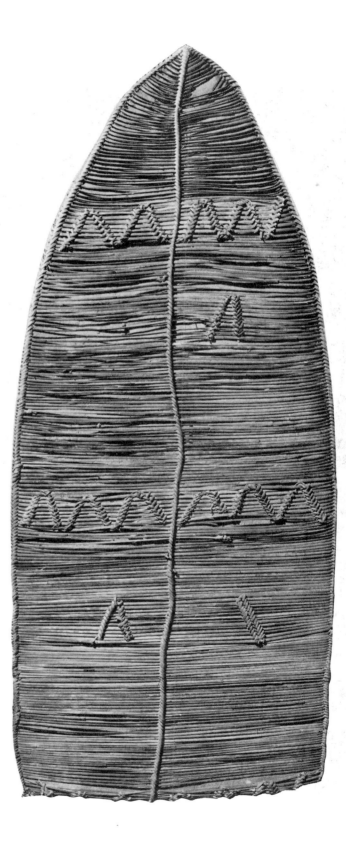

Shields
275756 (left) 73.5 cm.
275755 (right) 77.4 cm.

Carved Wooden Figure
275886
43.5 cm.

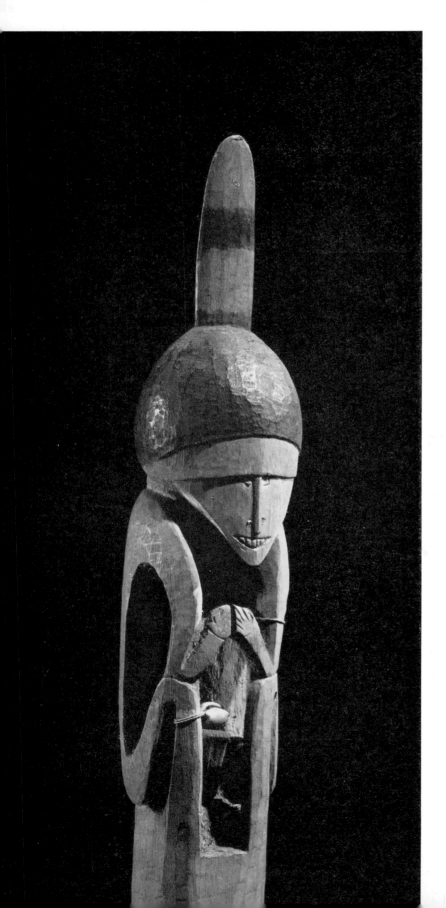

Shield
275816
73.9 cm.

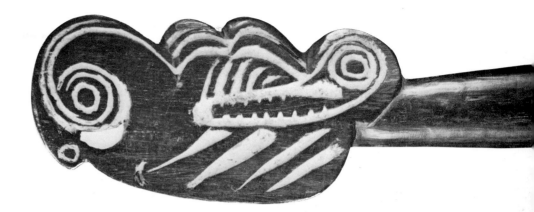

Butt Detail
275948

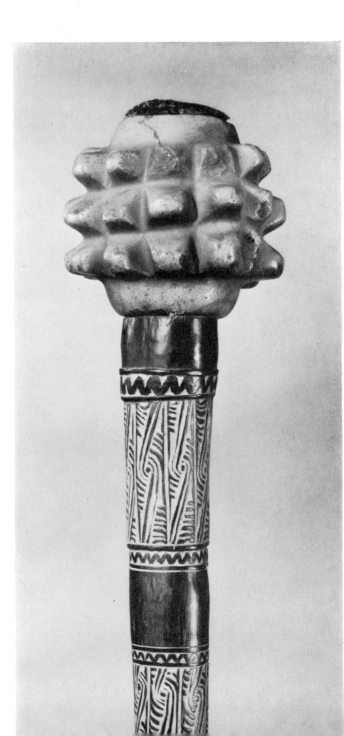

Stone-headed Club
275948
72.7 cm.

309

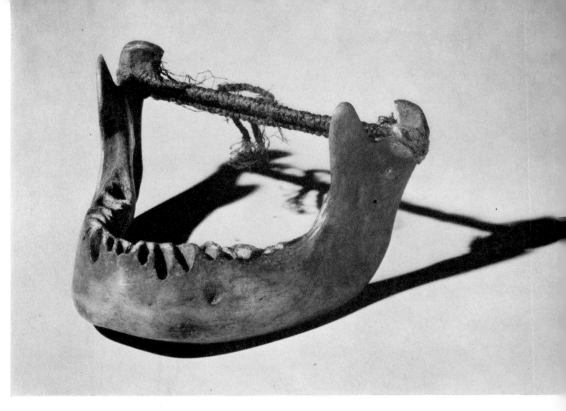

Mandible Armlet
276031

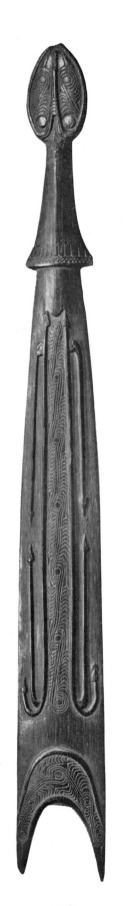

Club
275846
100.0 cm.

310

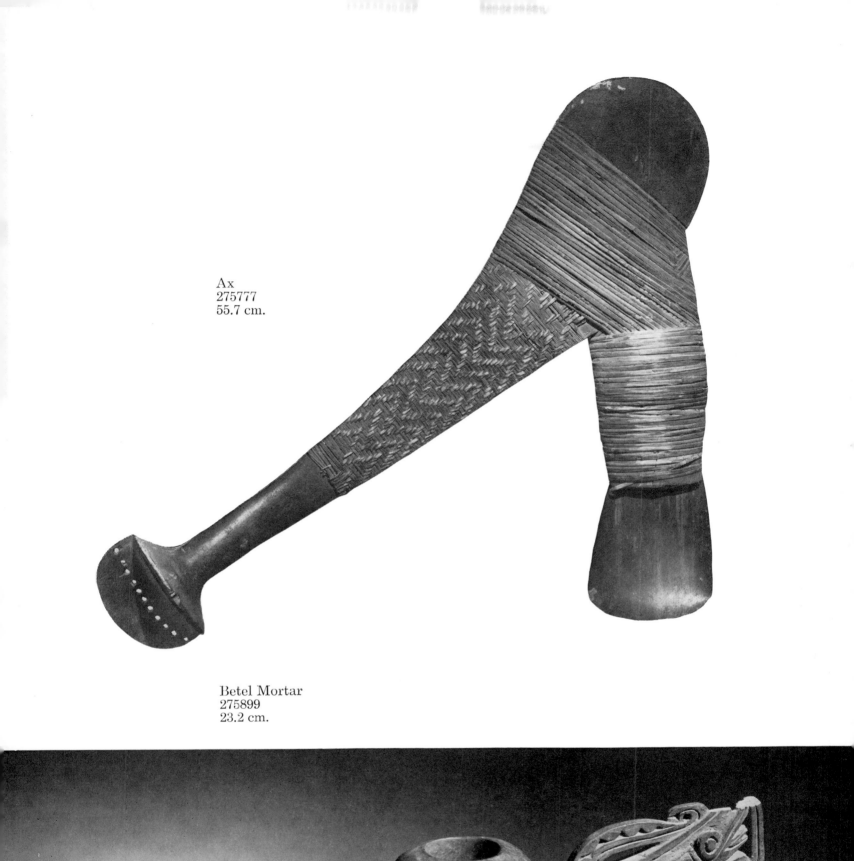

Ax
275777
55.7 cm.

Betel Mortar
275899
23.2 cm.

Lime Spatula
275867
24.0 cm.

312

Lime Spatula
275869
27.3 cm.

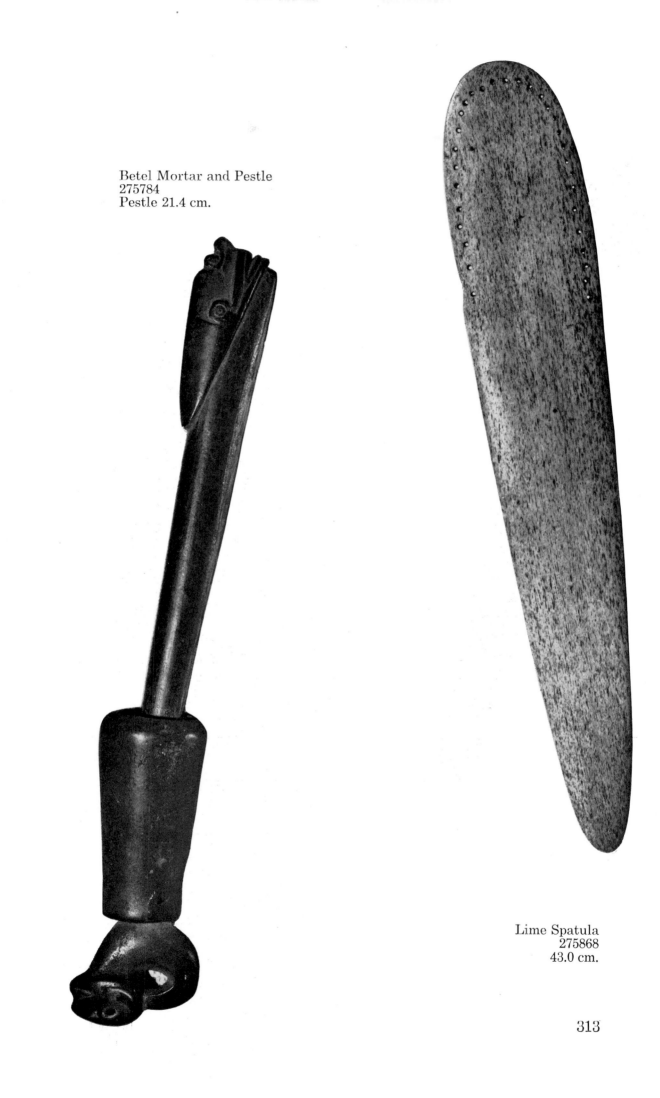

Betel Mortar and Pestle
275784
Pestle 21.4 cm.

Lime Spatula
275868
43.0 cm.

313

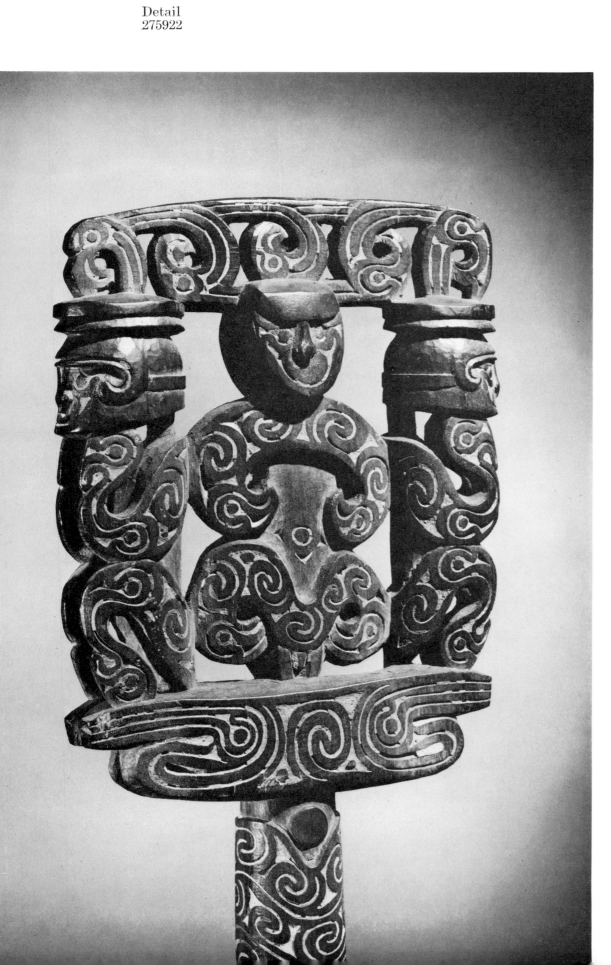

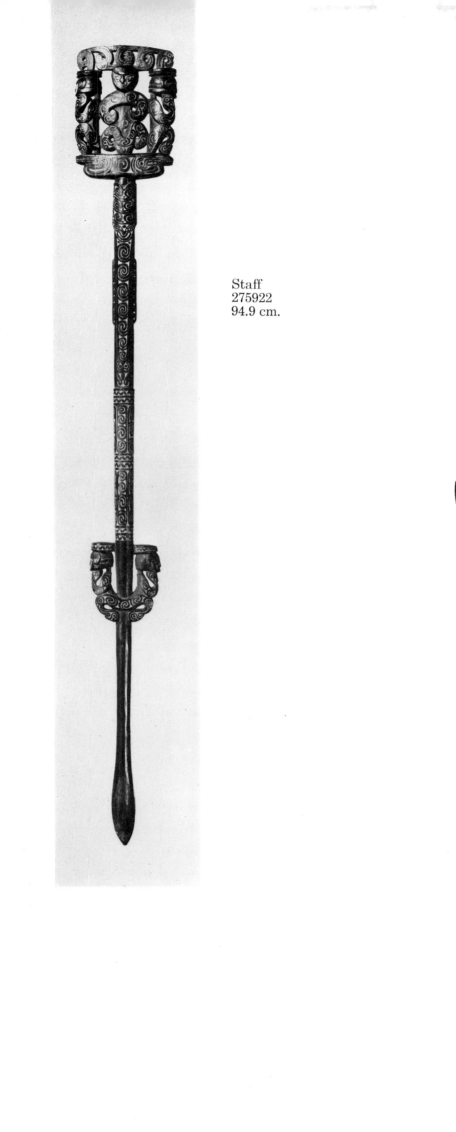

Staff
275922
94.9 cm.

Lime Spatula Detail
275965
33.6 cm.

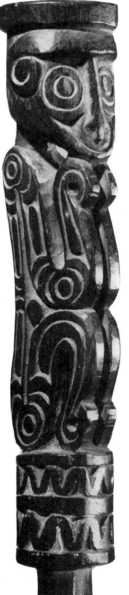

315

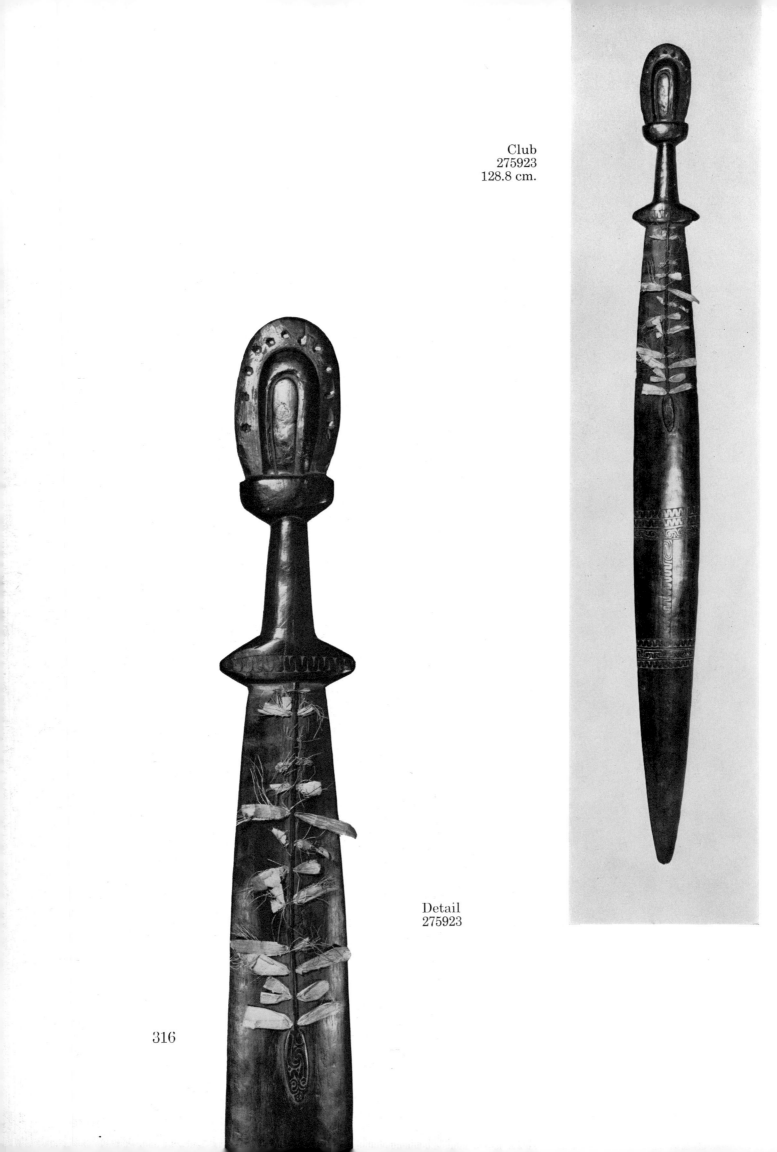

Club
275923
128.8 cm.

Detail
275923

316

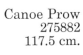

Canoe Prow
275882
117.5 cm.

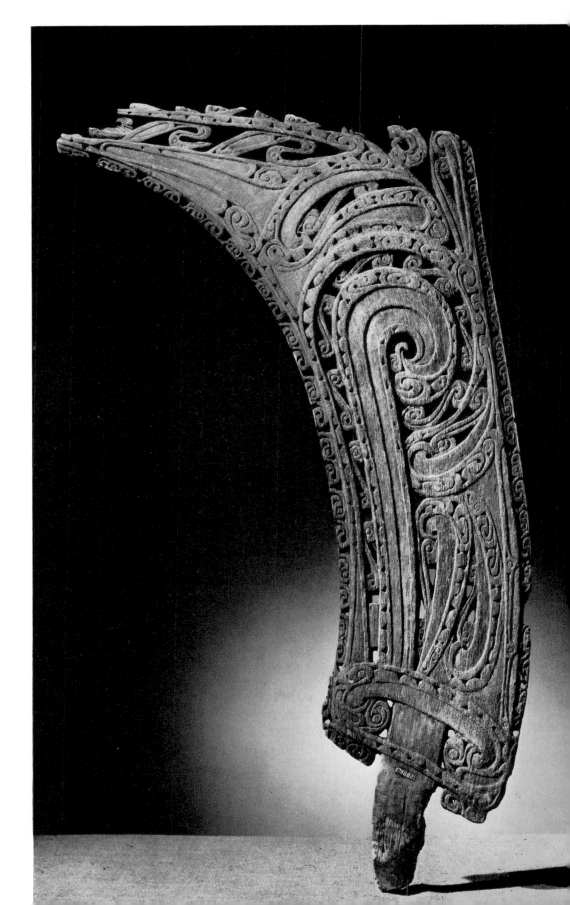

Detail
275977

Lime Spatula
275998
29.0 cm.

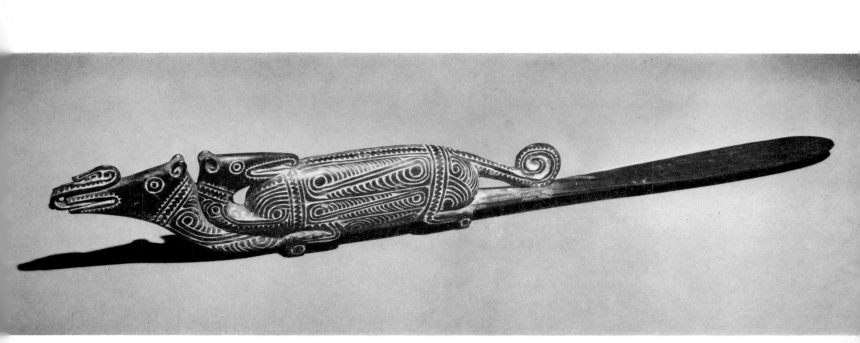

Lime Spatula
275981
55.3 cm.

Lime Spatula
275977
36.7 cm.

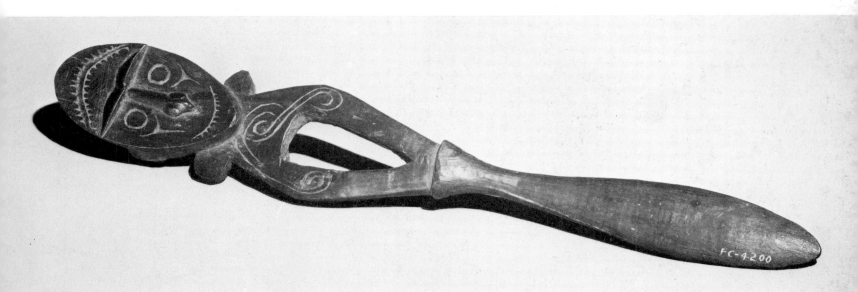

Dance Paddle
275902
77.6 cm.

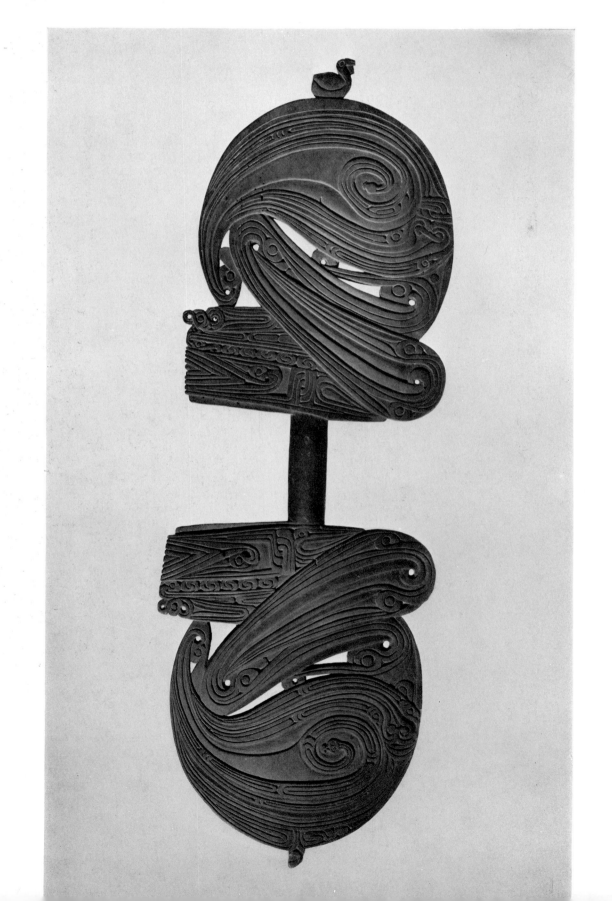

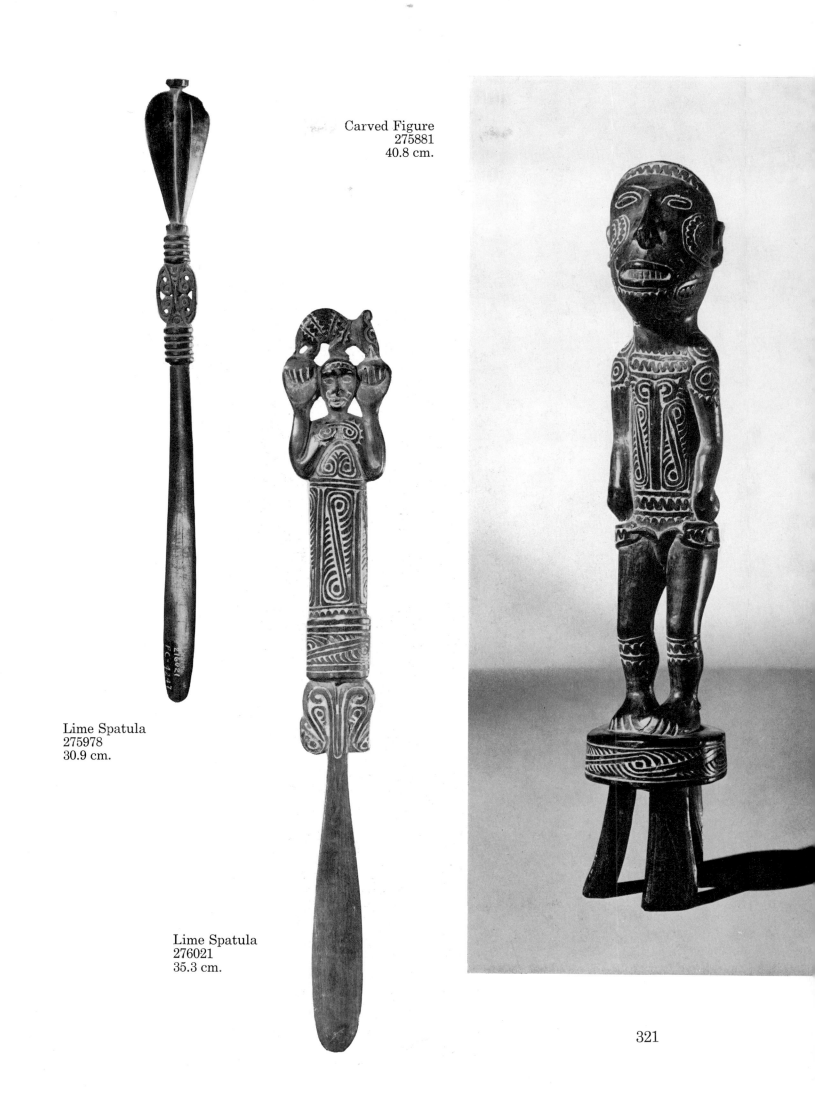

Lime Spatula
275978
30.9 cm.

Carved Figure
275881
40.8 cm.

Lime Spatula
276021
35.3 cm.

321

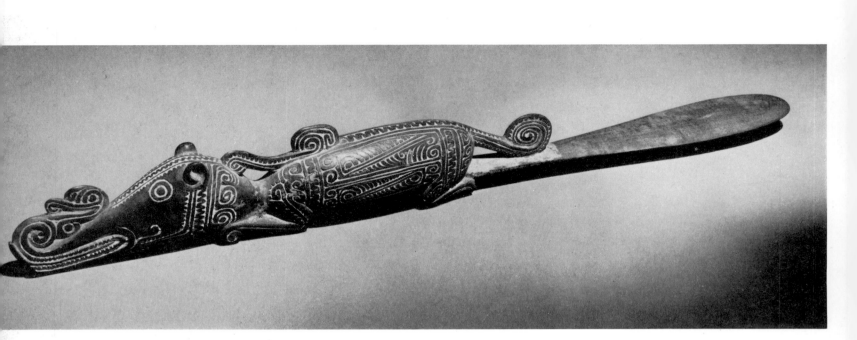

Lime Spatula
275980
55.1 cm.

Drum
275896
30.4 cm.

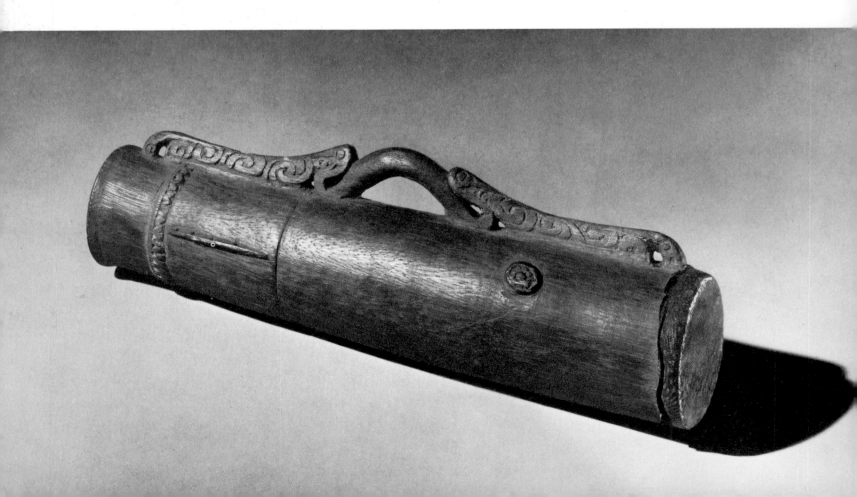

Carved Figure
275815
47.3 cm.

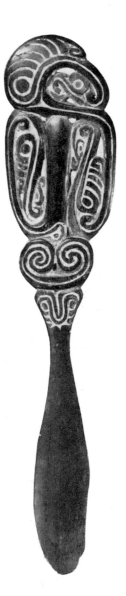

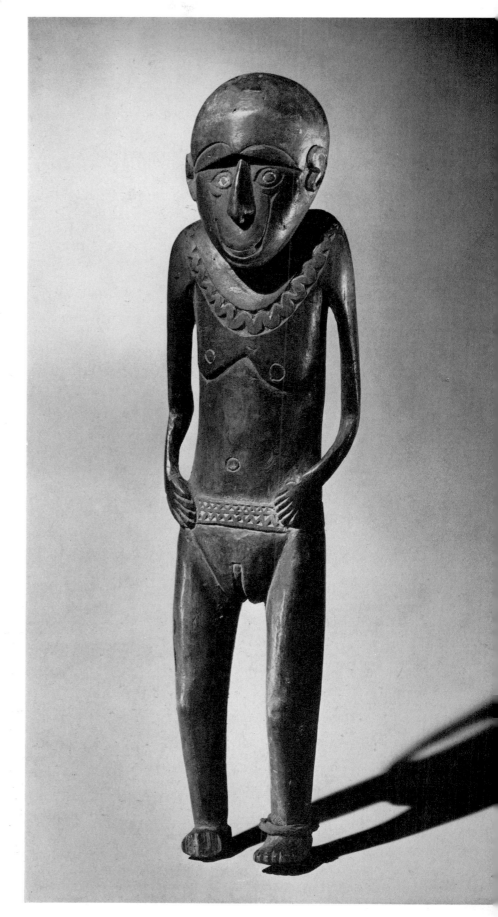

Lime Spatula
275979
30.9 cm.

Drum
275895
30.7 cm.

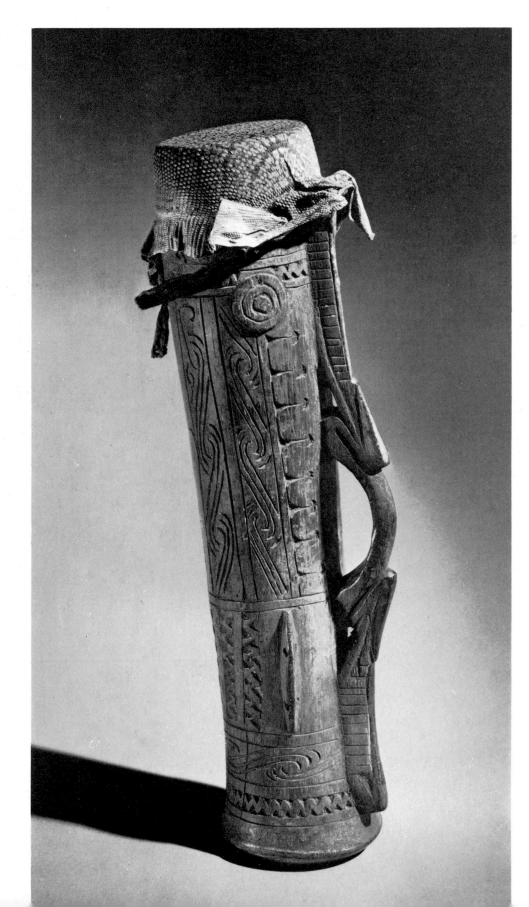

Shield
275909
73.2 cm.

Shield
275908
69.1 cm.

325

Coconut Charm
276168
12.1 cm.

Stone Club Heads
276096 (left) 10.6 cm.
276102 (center) 6.3 cm.
276097 (right) 8.9 cm.

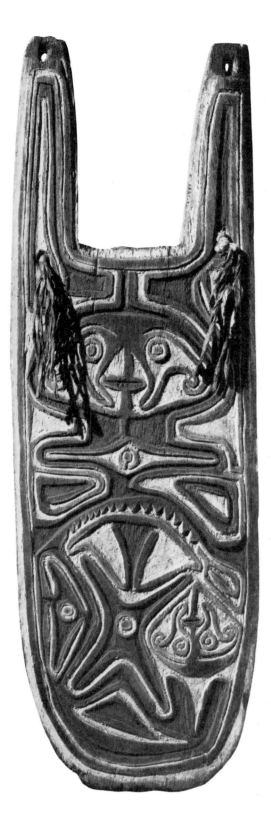

Shield
276301
81.5 cm.

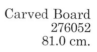

Carved Board
276052
81.0 cm.

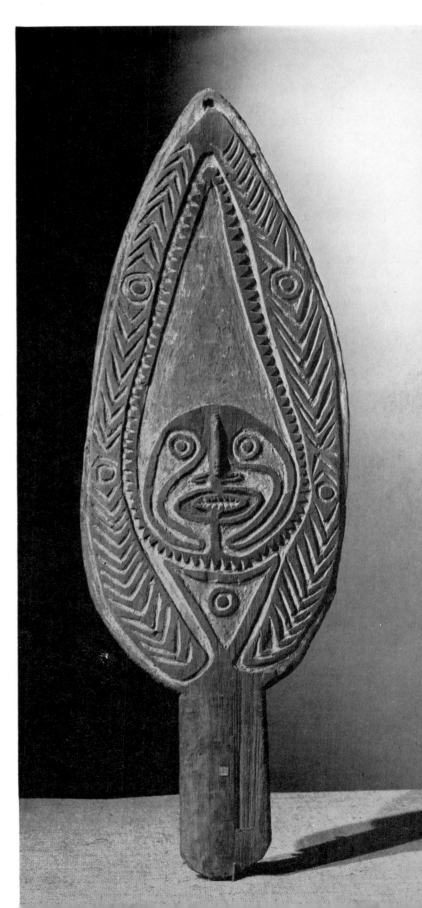

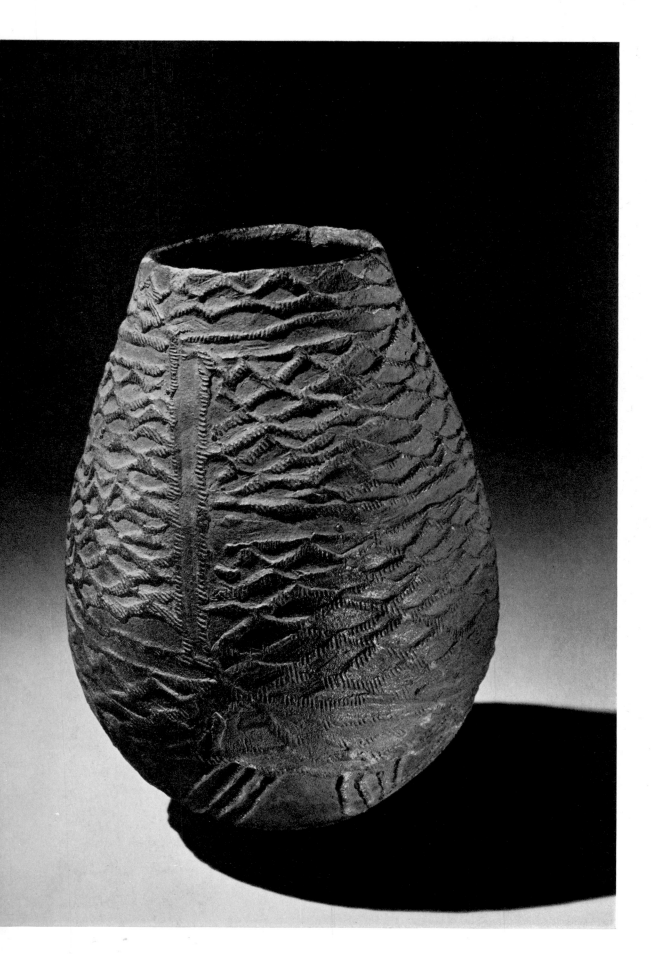

Pot
276353
26.5 cm.

328

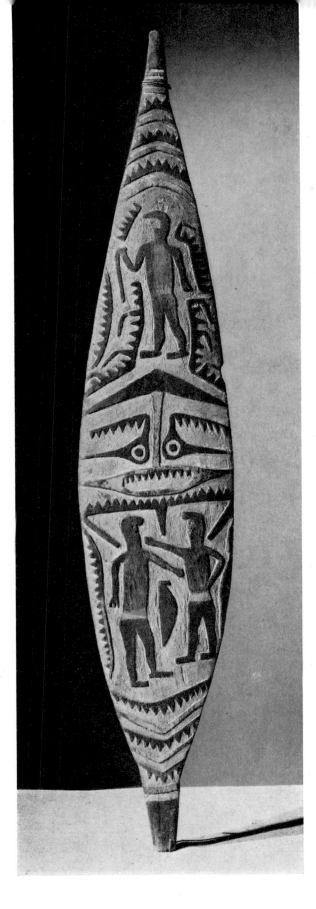

Carved Board
276051
121.2 cm.

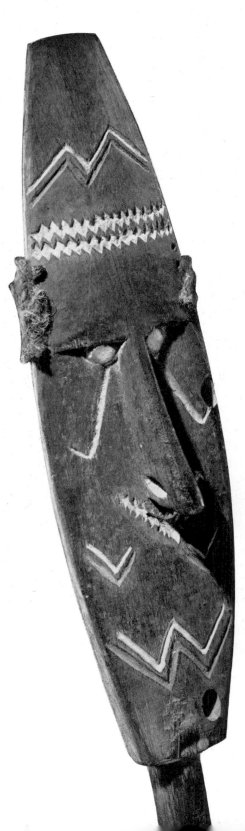

Carved Head
276268
49.0 cm.

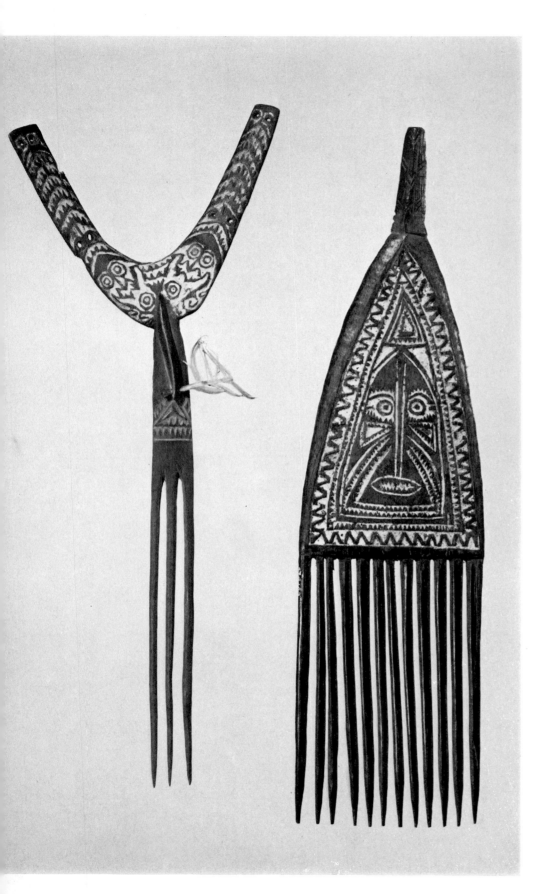

Combs
276321 (left) 38.3 cm.
276198 (right) 38.0 cm.

Club Head
276096
10.6 cm.

Drum
276068
74.5 cm.

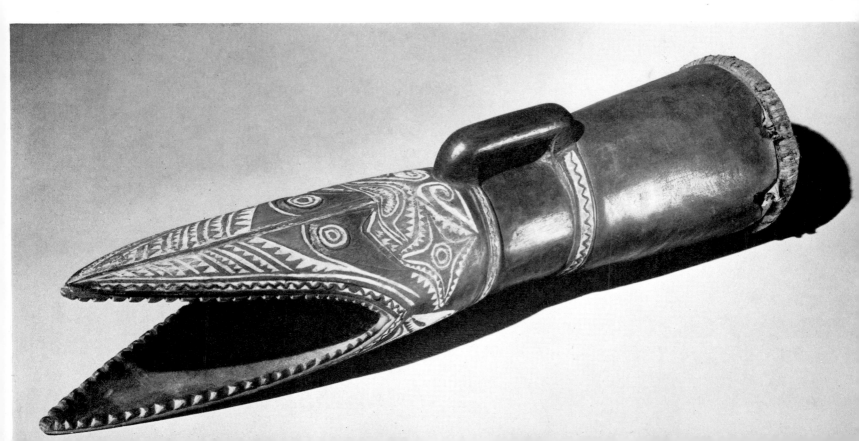

THE TORRES STRAIT ISLANDS

334

336

337

335

At the northern tip of Australia between Cape York Peninsula and Papua lie the small and numerous Torres Strait (sometimes written 'Torres Straits') Islands. Artifacts from these islands are not numerous. The items in the Fuller Collection are few, but fine. Two are funeral masks made of tortoise-shell plates. Both are excellent pieces, but the larger of the two (276363) is one of the finest extant. The tortoise-shell plates are secured to each other with fine sennit cord and human hair is used on the forehead and to simulate a beard. The smaller mask (276364) is also an outstanding piece, but it is somewhat overshadowed by the dramatic larger one.

Another superb piece from the Torres Strait is an hourglass drum (276365). It is of wood with a reptile-skin head. Cassowary feathers and nut rattles provide decoration. The incised area at the head end features white and red pigment. This drum was originally in the London Missionary Society Collection.

When Cook landed at the islands in the strait in 1770, he noted that the native men were armed with bows and arrows. Later on, missionaries were also to learn of the arrows, at times in a more direct way. There are more than eighty-five arrows from the Torres Strait in the collection of a few more than 100 specimens from this area. An example (276380) is illustrated. Arrows were used not only as weapons, but also in ceremonies, and as a medium of exchange. Other items include two feather headdresses, a ground-stone disk, a spear point, a carved wooden charm in the likeness of a dugong, and a shield. The latter was collected by Dr. A. C. Haddon during the Torres Straits Expedition and presented to Fuller by him.

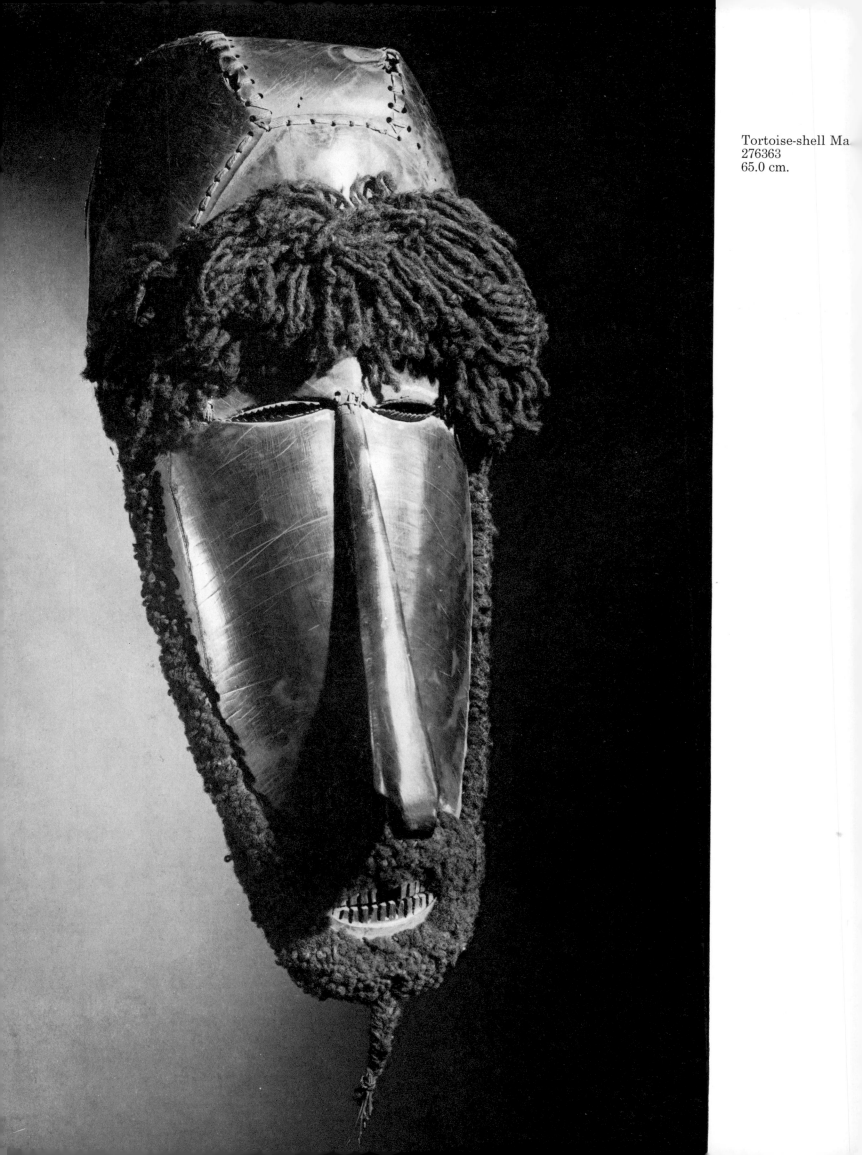

Tortoise-shell Ma
276363
65.0 cm.

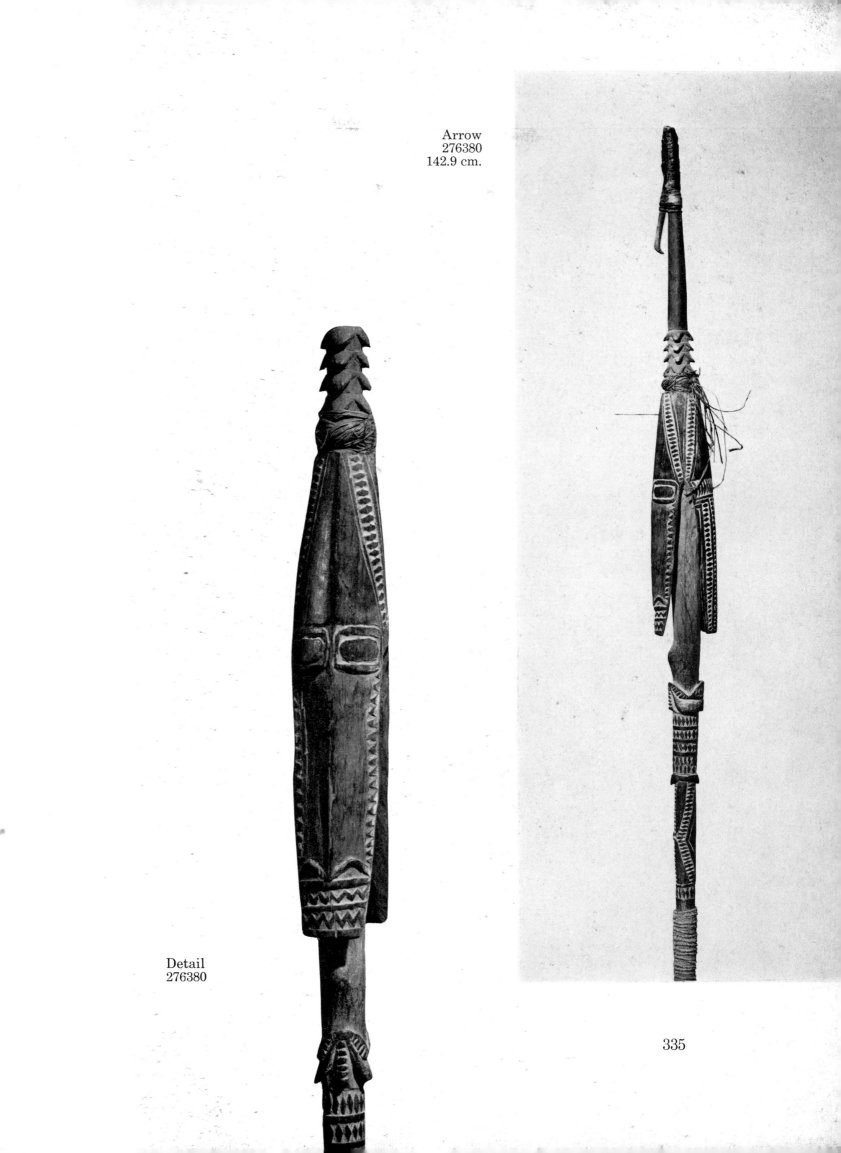

Arrow
276380
142.9 cm.

Detail
276380

335

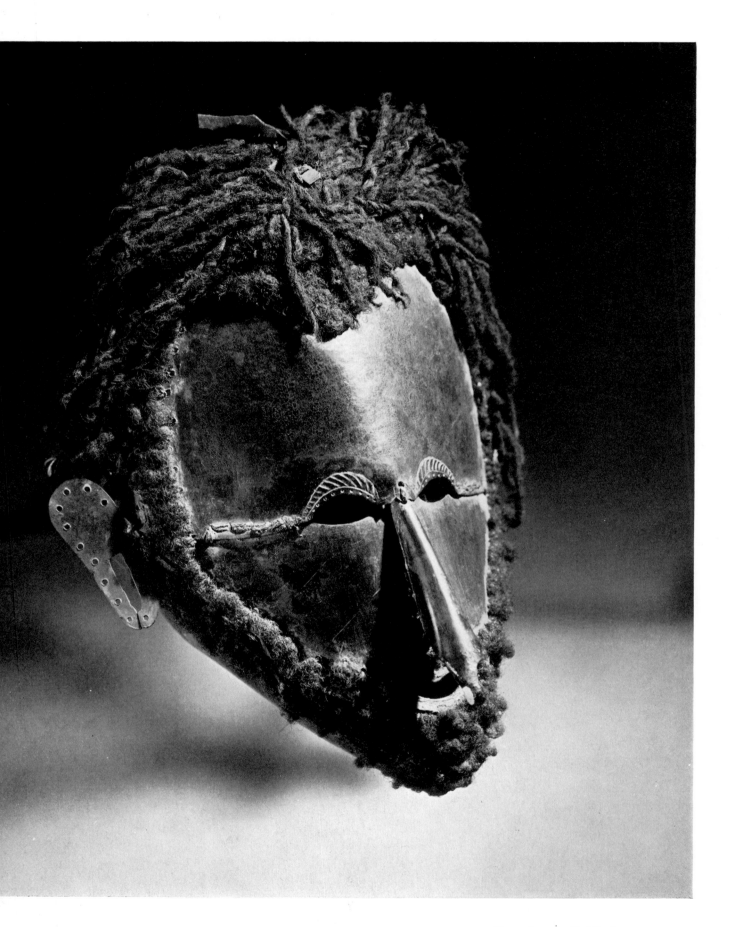

Tortoise-shell Mask
276364
32.0 cm.

Drum
276365
91.5 cm.

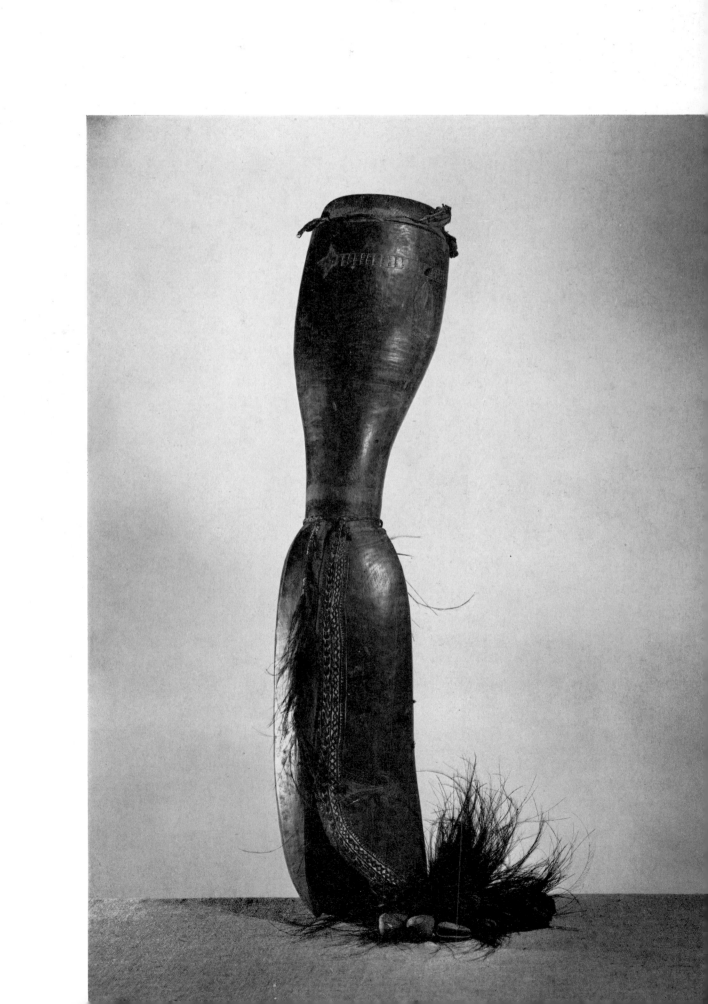

AUSTRALIA

Various voyagers encountered the coasts of Australia in the early 17th century, but Tasman was the first to sail all the way around it. Captain Cook found that exploration of the east coast had yet to be done as late as 1770.

The subcontinent of Australia contrasts sharply with the island world of the Pacific. Its vast arid wastelands of the interior, once inhabited by small roving bands of hunters, are the very antithesis of the lush and crowded tiny atoll or volcanic island. The aboriginal population, too, was derived from different roots than those of the island folk of the Pacific. The Australians formed an older stock and theirs was a rudimentary material culture. They produced very little, and what was produced was usually crudely executed. They made shields and weapons such as spears, spear throwers, clubs, and boomerangs. They produced wooden bowls, but no pottery. Their bull-roarers and sacred slate or wooden tablets called *churinga* were decorated with human blood and feathers as well as paint. Totemism was reflected in ritual behavior, body decoration, bark and rock paintings, ground drawing, dancing, and in a variety of behavioral proscriptions. Initiation of boys at puberty was usual. Human hair and that of animals such as the dingo and the opossum were used in the manufacture of certain artifacts. Pearl shell, bone, and kangaroo teeth all found their way into the tool kit of the Australian craftsman. Rough chisels set in the ends of spear throwers were the principal carving implements, there being no adzes. Despite the relatively limited variety of artifact types and the poverty of their elaboration in comparison with those of New Guinea, for example, the Fuller Collection includes more than 600 Australian objects. Some of the finer ones are included here. It is fortunate that the segment of the collection from Australia is as extensive as it is. The aboriginal population is no longer large and the effects of cultural change are such that there are likely to be no more truly authentic specimens produced.

There are more than 450 artifacts in the collection listed only as Australian. They are objects whose characteristics are so widespread in Australia as to allow no more precise designation of provenience. Among them are human hair and feather sandals, death-pointing sticks, boomerangs, clubs, *churinga,* knives, fire sticks, bowls, ax blades, spears, fishing spears, baskets, string bags, shields, ornaments, and stone tools. Comparable categories of materials exist for various parts of Australia, but with provenience determinations made possible because of well-defined stylistic features or documentation. Identifying characteristics or

information on their acquisition allow for the separation of certain materials into the following categories: Queensland, New South Wales, Victoria, and western central and northern Australia.

A number of Australian specimens in the Fuller Collection were secured by Miss Daisy Bates, who lived among the Australian aborigines for many years. She provided good information about each item she collected and also provided the vernacular term for it. Henry James Hillier, who lived for some years at the mission station at Alice Springs, also collected materials of which Fuller secured a number. He, too, provided good documentation for the collection he made about 1909. A third individual through whom this portion of the collection grew was Postmaster Byrne of

343 Charlotte Waters. Two stone-bladed daggers (272866-67) were collected by Byrne in central Australia at Tennant Creek from the Warramunga tribe.

Spear throwers were of many types in Australia. Several are

342 shown. Number 272327 is from Victoria or New South Wales;
342 272296, formerly in the Lord Charles Beresford Collection, is from
344, 349 western Australia; 272328 and 29 are from northern Australia, and
345 272281 is from Queensland. Two boomerangs are shown; one, a
344 swan-neck type (272205), is from the north and the other, a
345 nonreturning type (272226), is from Queensland. Slate *churinga,*
347 such as 272494 and 99, came from central Australia. Both were
346 collected by Henry James Hillier in 1909. Number 272860 is a cluster of bone death-pointing 'sticks.' It was collected by Postmaster Byrne. Pearl-shell pendants were incised with angular designs and red ocher was rubbed into the incisions to produce

348 contrast. Numbers 272514 and 15 are shown as examples. The latter is from the Bompas Collection.

Supplementing the artifacts which constitute the Australian segment of the Fuller Collection are two human craniums from southeast Australia. They were formerly in the collection of J. Turner-Turner and one was found near Blandford in 1826.

Additionally, the collection contains three exceedingly rare craniums from Tasmania. All are from the Chichester Museum. Among other items listed from Tasmania are a stick-club, a fire stick from Lord Avebury's Collection, more than fifty disklike pounders, and nearly ninety chipped- and ground-stone tools.

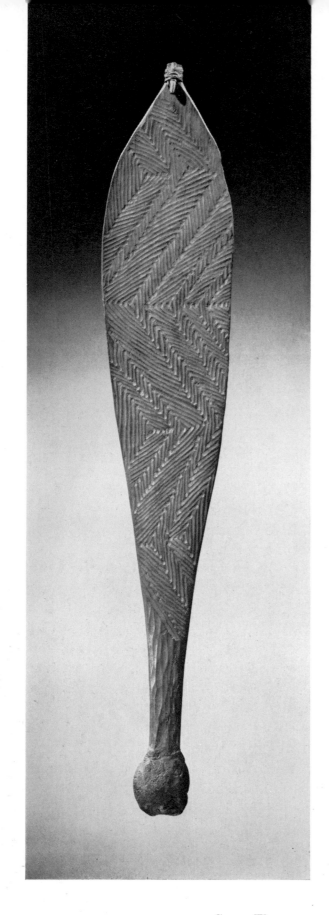

Spear Thrower
272296
68.0 cm.

Spear Thrower
272327
78.4 cm.

342

Stone-bladed Knives
272867 (left) 35.7 cm.
272866 (right) 22.5 cm.

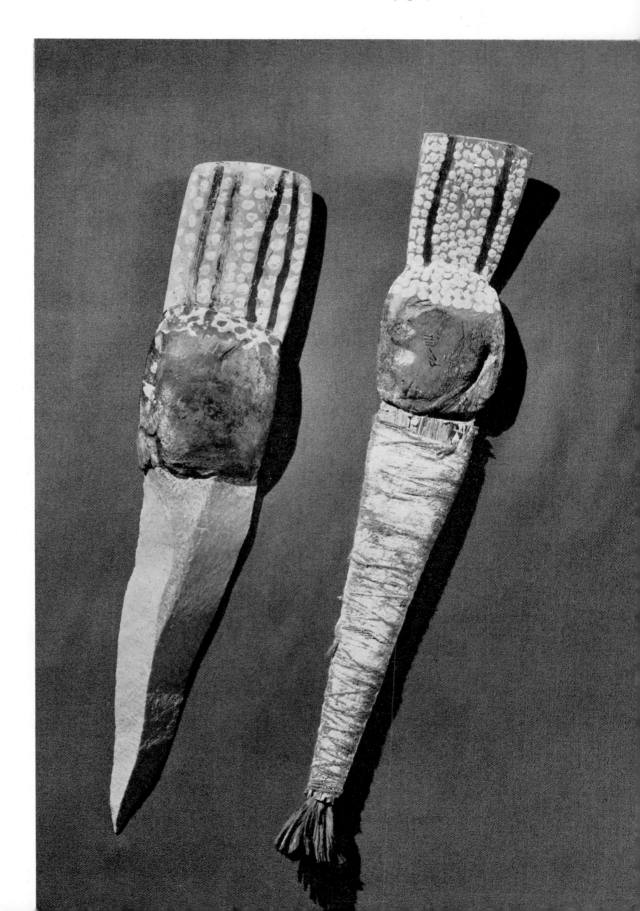

Spear-thrower Detail
272328
101.5 cm.

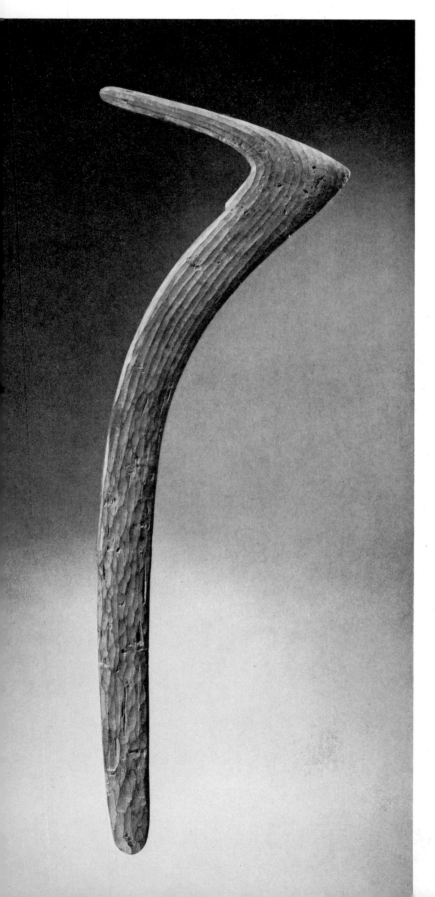

'Swan-neck' Boomerang
272205
74.9 cm.

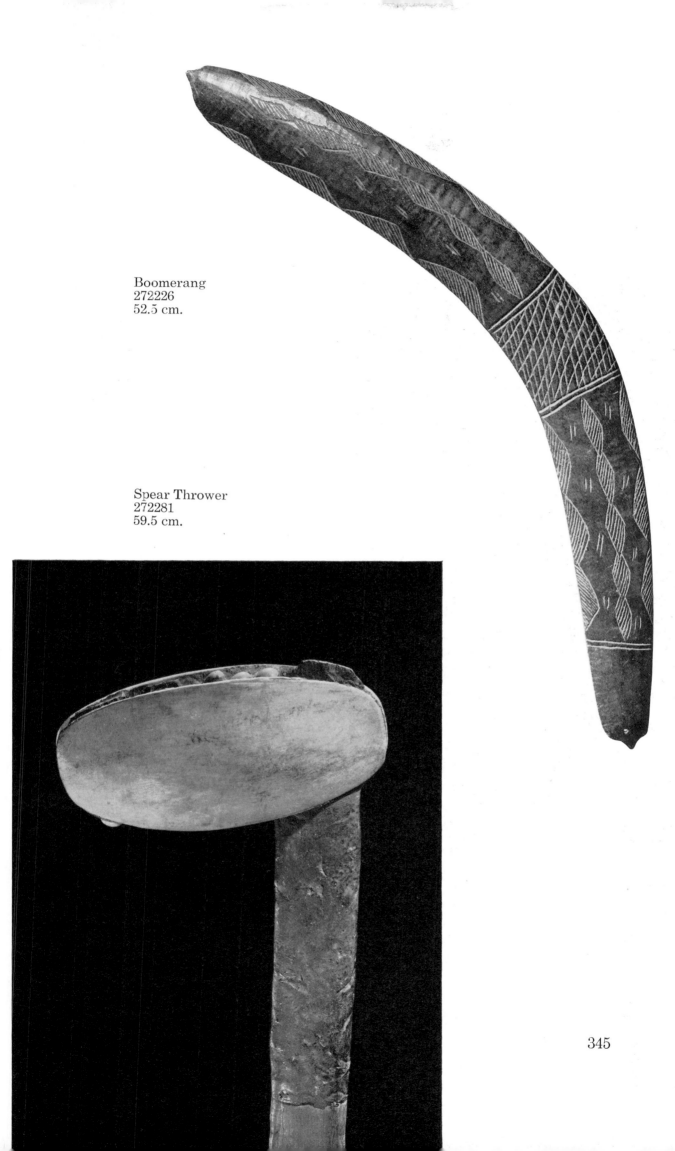

Boomerang
272226
52.5 cm.

Spear Thrower
272281
59.5 cm.

345

Death-pointing Bones
272860
Ca. 25.0 cm.

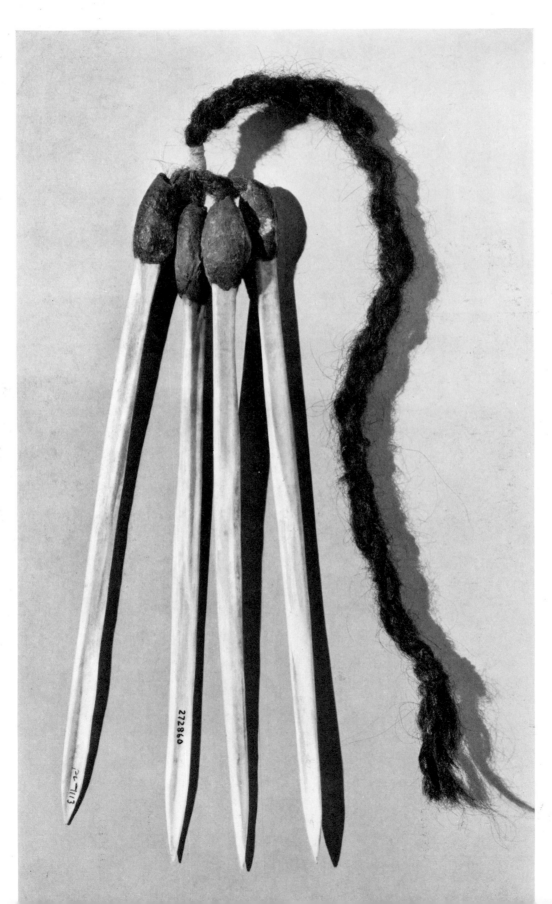

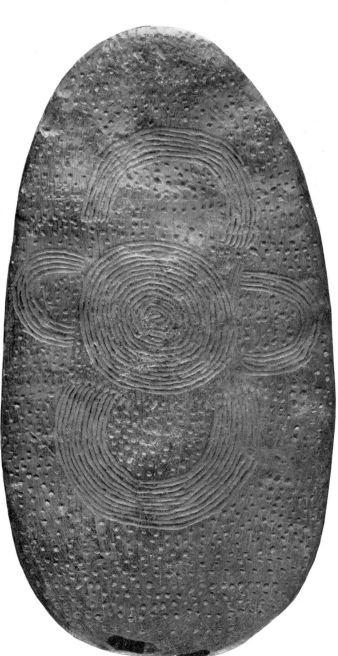

Stone *Churinga*
272499
28.2 cm.

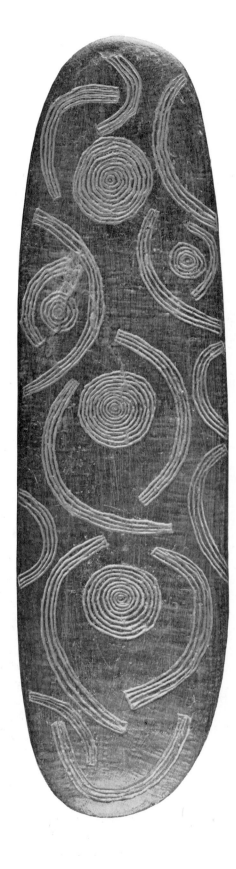

272494
35.0 cm.

347

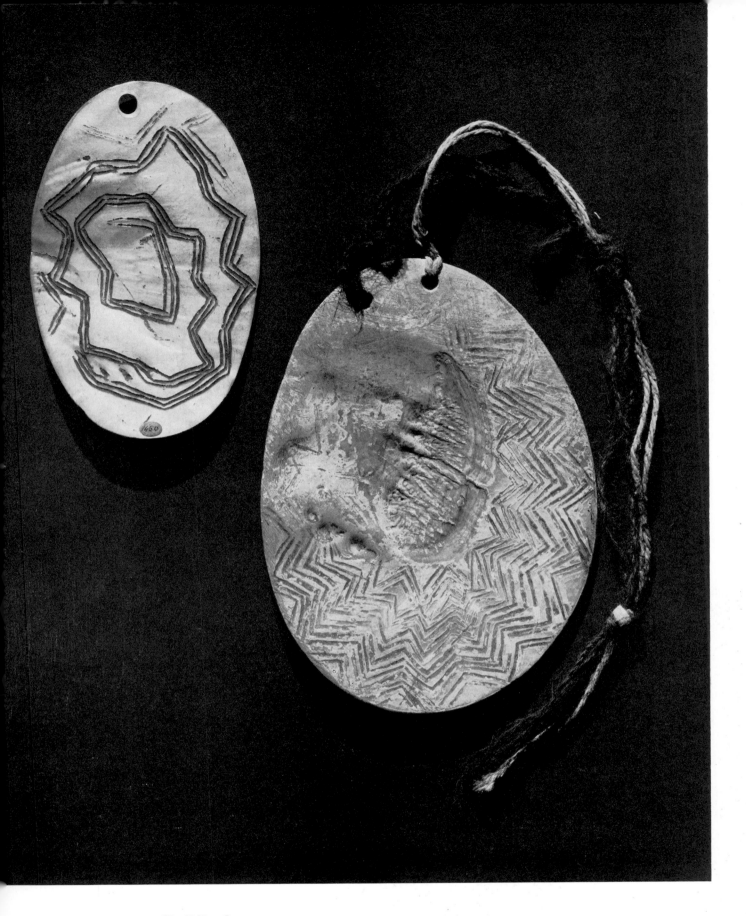

Shell Pendants
272515 (left) 13.0 cm.
272514 (right) 16.5 cm.

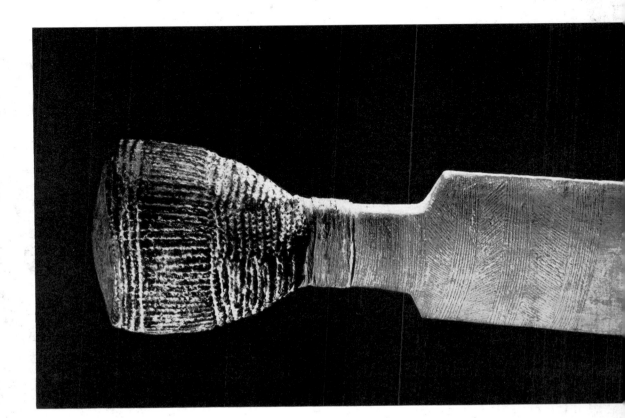

Spear-thrower Detail
272329

Spear-thrower Detail
272329
115.6 cm.

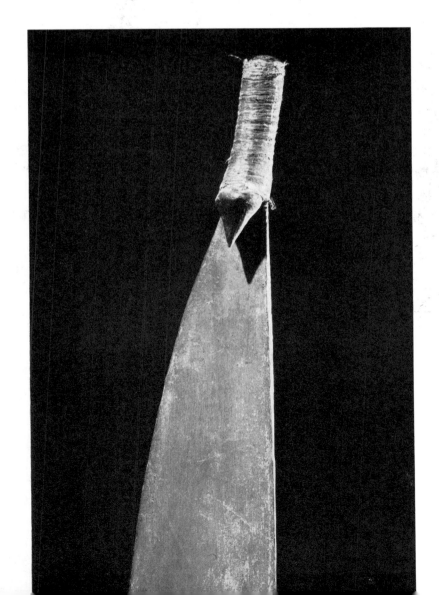

349

EPILOGUE

The only constant aspect of culture is its inconstant nature. The cultures of the Pacific were changing through contact with each other and from within long before the explorers, missionaries, traders, or colonial administrators arrived upon the scene. The impact of the changes brought about by representatives of the Western world was, however, vastly greater; its effects more telling. From the moment of their first exposure the cultures of the Pacific were destined to experience changes which would cause their traditional configurations to accommodate to the new influences. These influences caused all aspects of the cultures to change, including technology, art, religion, political organization, kinship patterns, and so on. Tangible evidence of this change is seen in artifacts. Those in the Fuller Collection, by and large, represent the era when the cultures were yet unaltered by European influences. Captain Fuller sought such items for he realized that no more would be made. He knew that the old ways were lost.

Fuller did include some later material in the collection for comparative purposes, but, to him, it represented 'degradation.' He referred to handicraft items always as 'fakes.' These later manufactures he saw as degenerate and, despite the anthropological tendency toward relativism, one must agree that in terms of the ancient canons, the new products of the artist and craftsman *were* 'degenerate.'

We may draw a parallel with the world of biology. Because of changes in the environment some species have become extinct – others have adapted to new conditions. Both categories are important to the scholar. He is, of course, interested in the altered form of life, but he is especially concerned with specimens from extinct populations for he knows that these are all that are available for study – they comprise the only record extant of what once was flourishing. Just as the only record of an extinct biotic species is found in study collections, so it is with the products of man's ingenuity and creativity. Were it not for museums – and collectors – the record of the past would be lost forever.

BIBLIOGRAPHY

Archey, G.

 1949. *South Sea Folk: Handbook of Maori and Oceanic Ethnology of the Auckland War Memorial Museum* (2nd ed.). Auckland: New Zealand Newspapers Ltd.

 1965. 'The Art Forms of Polynesia.' *Auckland Inst. and Mus. Bull.* 4: 1-78.

Bates, D.

 1967. *The Passing of the Aborigines.* New York: Praeger.

Beasley, H. G.

 1928. *Pacific Island Records: Fish Hooks.* London: Seeley, Service.

Berndt, R. M., Editor

 1964. *Australian Aboriginal Art.* New York: Macmillan.

Brigham, W. T.

 1899. 'Hawaiian Feather Work.' *B. P. Bishop Mus. Mem.* 1(1): 1-88. Honolulu.

Buck, P. H. (Te Rangi Hiroa)

 1927. *The Material Culture of the Cook Islands.* Mem. Board of Maori Ethnological Res., Vol. I. New Plymouth.

 1930. *Samoan Material Culture.* B. P. Bishop Mus. Bull. 75. Honolulu.

 1934. *Mangaian Society.* B. P. Bishop Mus. Bull. 122. Honolulu.

 1944. *Arts and Crafts of the Cook Islands.* B. P. Bishop Mus. Bull. 179. Honolulu.

 1957. *Arts and Crafts of Hawaii.* B. P. Bishop Mus. Spec. Pub. 45. Honolulu.

Buehler, A.

 1947. *Heilige Bildwerke aus Neuguinea.* Basel: Mus. Völkerkunde.

Christensen, E. O.

 1955. *Primitive Art.* New York: Crowell.

Churchill, W.

 1917. *Club Types of Nuclear Polynesia.* Carnegie Inst. Washington Pub. 255. Washington, D. C.

Cranstone, B. A. L.

 1961. *Melanesia: A Short Ethnography.* London: British Mus.

352

Davidson, D. S.

1947. *Oceania: The Oceanic Collection of the University Museum.* University Mus. Bull. 12 (3-4). Philadelphia.

Dodd, E.

1967. *Polynesian Art.* New York: Dodd, Mead.

Dodge, E. S.

1949. *Handbook to the Collections of the Peabody Museum of Salem.* Salem: Peabody Mus.

Edge-Partington, J., and C. Heape

1890, 1895, 1898. *An Album of the Weapons, Tools, Ornaments, Articles of Dress, etc., of the Natives of the Pacific Islands: Drawn and Described from Examples in Public and Private Collections in England.* Ser. I, II. . . . *Drawn and Described from Examples . . . in Australasia.* Ser. III. Manchester.

Elkin, A. P.

1950. *Art in Arnhem Land.* Chicago: Univ. Chicago Press.

Ellis, W.

1829. *Polynesian Researches.* London: Fisher and Jackson.

Emory, K. P.

1927. 'The Curved Club from a Rurutu Cave.' *Bull. Soc. Etudes Océaniennes,* No. 21, pp. 304-306.

1939. 'Manihiki: Wooden Bowls.' *Ethnologia Cranmorensis* 4: 20-26.

Firth, R.

1936. *Art and Life in New Guinea.* London and New York: Studio Ltd.

Flinn, J. J.

1893. *Official Guide to the World's Columbian Exposition.* Chicago: Columbian Guide Co.

Force, R. W.

1961. 'The Arts of Oceania.' *Delphian Quart.* 44 (2): 35-40; 44 (3): 16-19.

Force, R. W., and M. Force

1968. *Art and Artifacts of the 18th Century.* Honolulu: Bishop Mus. Press.

Fraser, D.

1962. *Primitive Art.* New York: Doubleday.

Fröhlich, W.

1967. *Exotische Kunst im Rautenstrauch-Joest Museum.* Köln: Rautenstrauch-Joest Mus.

Golden Gate International Exposition

1939. *Golden Gate International Exposition, Pacific Cultures.* San Francisco.

Guiart, J.

 1963. *The Arts of the South Pacific.* A. Christie (trans.). London: Thames and Hudson.

Haddon, A. C.

 1894. *The Decorative Art of British New Guinea.* Dublin: Academy House.

 1935. *Reports of the Cambridge Anthropological Expedition to Torres Straits: Arts and Crafts.* Vol. I. Cambridge: Cambridge Univ. Press.

Hamilton, A.

 1896-1901. *The Art Workmanship of the Maori Race in New Zealand.* Dunedin: New Zealand Inst.

Heydrich, M., and W. Fröhlich

 1954. *Plastik der Primitiven.* Stuttgart: Die Schönen Bücher.

Hooper, J. T., and C. A. Burland

 1953. *The Art of Primitive Peoples.* London: Fountain Press.

Kooijman, S.

 1961. 'The Art Areas of Western New Guinea.' In *Three Regions of Primitive Art,* pp. 41-59. New York: Mus. Primitive Art.

Kreiger, H. W.

 1932. 'Design Areas in Oceania: Based on Specimens in the United States National Museum.' *Proc. United States National Mus.* 79 (30): 1-53. Washington, D. C.

Leenhardt, M.

 1950. *Arts of the Oceanic Peoples.* London: Thames and Hudson.

Lewis, A. B.

 1925. *Decorative Art of New Guinea: Incised Designs.* Anthropology Design Ser. 4. Chicago: Field Mus.

 1931. *Carved and Painted Designs from New Guinea.* Anthropology Design Ser. 5. Chicago: Field Mus.

Linton, R.

 1923. 'The Material Culture of the Marquesas Islands.' *B. P. Bishop Mus. Mem.* 8 (5): 263-471.

 1926. *Ethnology of Polynesia and Micronesia.* Field Mus. Natural History Guide, Pt. 6. Chicago.

Linton, R., P. S. Wingert, and R. d'Harnoncourt

 1946. *Arts of the South Seas.* New York: Mus. Modern Art.

Luquiens, H. M.

 1931. *Hawaiian Art.* B. P. Bishop Mus. Spec. Pub. 18. Honolulu.

McCarthy, F. D.

 1938. *Australian Aboriginal Decorative Art.* Sydney: Australian Mus.

Mason, L.

 1964. 'Art of Micronesia.' In *Encyclopedia of World Art,* Vol. IX, Cols. 923-930. New York: McGraw-Hill.

Mead, M.

 1945. *The Maoris and Their Arts.* American Mus. Natural History Guide Leaflet 71. New York.

Mead, S. M.

 1969. *Traditional Maori Clothing: A Study of Technological and Functional Change.* Wellington: Reed.

Museum of Primitive Art

 1960. *The Raymond Wielgus Collection.* New York: University Publ.

Newton, D.

 1961. *Art Styles of the Papuan Gulf.* New York: Mus. Primitive Art.

 1967. *The Art of the Massim Area, New Guinea.* New York: Mus. Primitive Art.

Oldman, W. O.

 1938a. *The Oldman Collection of Maori Artifacts.* Polynesian Soc. Mem. 14. Wellington.

 1938b. *The Oldman Collection of Polynesian Artifacts.* Polynesian Soc. Mem. 15. Wellington.

O'Reilly, P.

 1951. *Art Mélanésien.* Paris: Nouvelles Editions Latines.

Otago Museum

 1963. *Craftsmanship in Polynesia.* Text by D. R. Simmons, illus. by R. R. Forster. Dunedin, New Zealand.

Phillipps, W. J.

 1946. *Maori Art.* Wellington: Tombs.

Poignant, R.

 1967. *Oceanic Mythology: The Myths of Polynesia, Micronesia, Melanesia, Australia.* London: Hamlyn.

Read, C. H.

 1910. *Handbook to the Ethnographical Collections of the British Museum.* Oxford: Oxford Univ. Press.

Robley, G. H.

 1896. *Moko: Or Maori Tattooing.* London: Chapman and Hall.

Robson, R. W., Compiler

 1963. *Pacific Islands Year Book and Who's Who.* (9th ed.) Judy Tudor (ed.). Sydney: Pacific Publ.

Skinner, H. D.

 1940. *The Maori Hei-tiki.* Otago Mus. Booklet 1. Dunedin, New Zealand.

Straley, W.

 1908. *Paragraphs from a Collector's Note-Book.* Privately printed.

Tippett, A. R.

 1968. *Fijian Material Culture: A Study of Cultural Context, Function, and Change.* B. P. Bishop Mus. Bull. 232. Honolulu.

Tischner, H., and F. Hewicker

 1954. *Oceanic Art.* London: Pantheon Books.

Von den Steinen, K.

 1925-1928. *Die Marquesaner und ihre Kunst.* Berlin: Vohsen.

Wardwell, A.

 1967. *The Sculpture of Polynesia.* Chicago: Art Inst.

Webster, K. A.

 1948. *The Armytage Collection of Maori Jade.* London: Cable Press.

Williams, T., and J. Calvert

 1858. *Fiji and the Fijians.* Vol. I, *The Islands and Their Inhabitants,* by Williams; Vol. II, *Mission History,* by Calvert. London: Heylin.

Wingert, P. S.

 1953. *Art of the South Pacific Islands: A Loan Exhibition.* De Young Memorial Mus., Golden Gate Park, San Francisco. London: Thames and Hudson.

 1962. *Primitive Art: Its Traditions and Styles.* New York: Oxford Univ. Press.

INDEX

* Page numbers in italic type refer to illustrations.

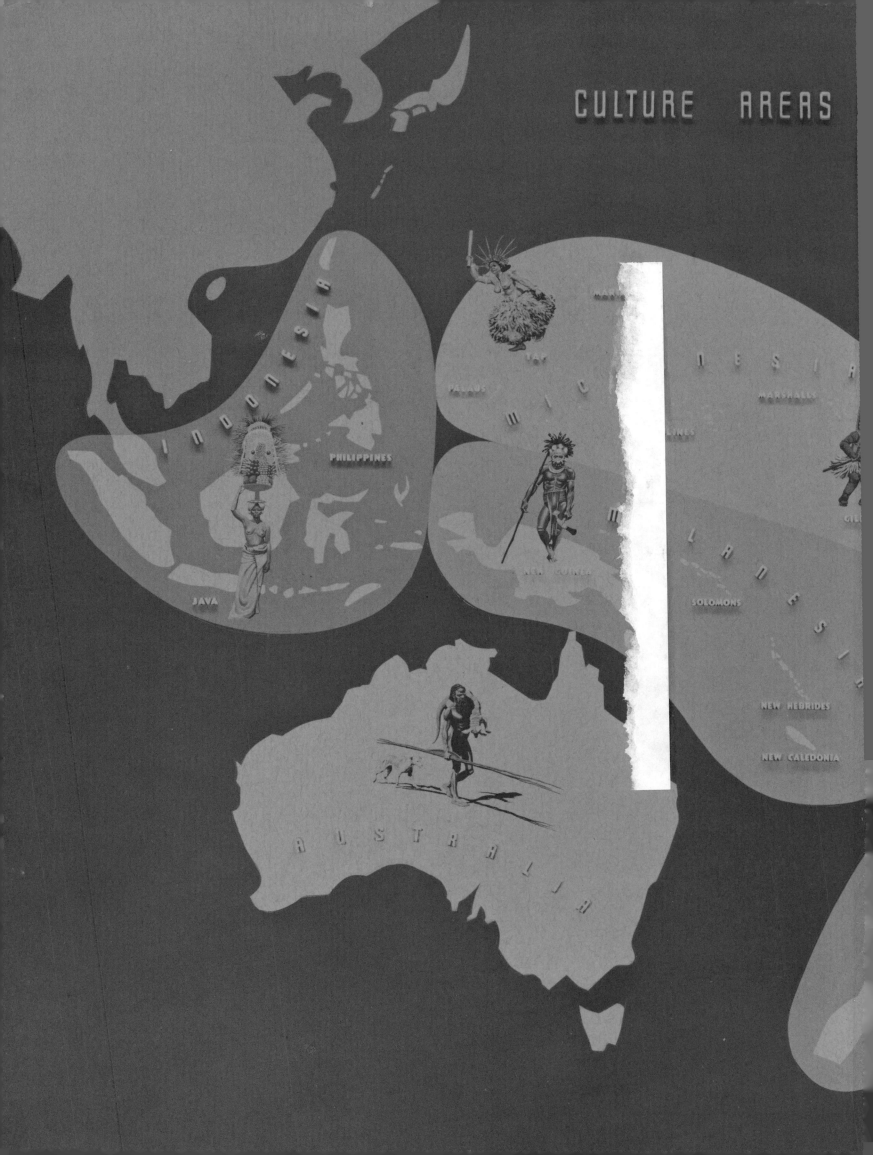

CULTURE AREAS

INDONESIA

PHILIPPINES

JAVA

MICRONESIA

MARIANAS

PALAUS

CAROLINES

MARSHALLS

GILBERTS

MELANESIA

NEW GUINEA

SOLOMONS

NEW HEBRIDES

NEW CALEDONIA

AUSTRALIA